Looking into Walt Whitman

American Art, 1850–1920

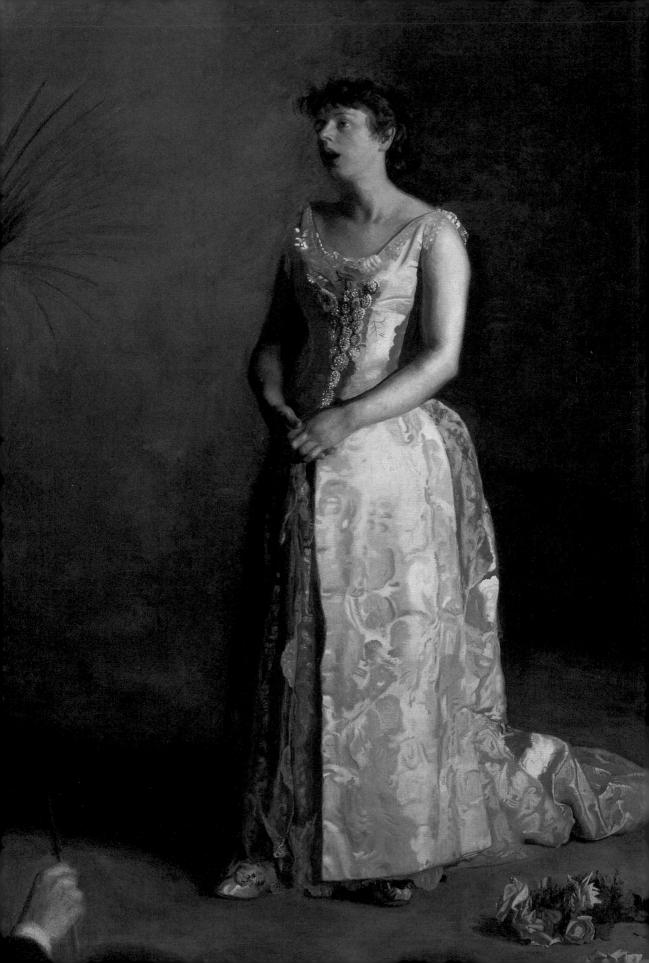

Ruth L. Bohan

Looking into Walt Whitman

American Art, 1850–1920

THE PENNSYLVANIA STATE UNIVERSITY PRESS — UNIVERSITY PARK, PENNSYLVANIA

Published with the assistance of THE GETTY FOUNDATION.

Library of Congress Cataloging-in-Publication Data

Bohan, Ruth L.
 Looking into Walt Whitman : American art, 1850-1920 / Ruth L. Bohan.
 p. cm.
Includes bibliographical references and index.
ISBN 0-271-02702-9 (cloth : alk. paper)
1. Whitman, Walt, 1819–1892—Knowledge—Art.
2. Art and literature—United States—History—19th century.
3. Art and literature—United States—History—20th century.
4. Whitman, Walt, 1819–1892—Appreciation—United States.
5. Whitman, Walt, 1819–1892—Influence.
6. Whitman, Walt, 1819–1892—Portraits.
7. Modernism (Art)—United States.
I. Title.

PS3242.A66B64 2006
811'.3—dc22
2005012194

Designed by Savitski Design, Ann Arbor, MI
Printed by Everbest Printing Co., through Four Colour Imports, Louisville, KY

The Pennsylvania State University Press is a member of the Association of
American University Presses.

It is the policy of The Pennsylvania State University Press to use acid-free
paper. Publications on uncoated stock satisfy the minimum requirements of
American National Standard for Information Sciences—Permanence of Paper
for Printed Library Materials, ANSI Z39.58–1992.

FRONTISPIECE: Thomas Eakins, *The Concert Singer*, 1890–92 (see fig. 64).

Contents

Part 1 Imaging Whitman:
 The Nineteenth Century

Part 2 Whitman and the Modernists:
 The Twentieth Century

Illustrations

Acknowledgments

I AM EXTREMELY GRATEFUL to the many individuals and institutions that have supported this project throughout its long gestation. I owe special thanks to the professional staffs of the Archives of American Art; Bates College; Brooklyn College; the Brooklyn Historical Society; Duke University Library; the Hirshhorn Museum and Sculpture Garden; Kent State University Library; the Manuscript Reading Room, the Rare Book Room, and the Prints and Photographs Divisions at the Library of Congress; the New York Public Library; Ohio Wesleyan University's Beeghly Library; the Philadelphia Museum of Art; the Smithsonian American Art Museum; the University of Pennsylvania Rare Book and Manuscript Library; the University of Missouri–St. Louis Thomas Jefferson Library; the Walt Whitman Birthplace Association; the Walt Whitman House in Camden, New Jersey; Washington University's Olin Library; and Yale University's Beinecke Rare Book and Manuscript Library.

This book would never have been completed without the advice, encouragement, and assistance of many colleagues who generously shared their research or commented on portions of the manuscript. I wish to acknowledge in particular Marion Walker Alcaro, Barbara Day-Hickman, Terry Dolan, Ed Folsom, Mary Anne Goley, Janet Headley, Jeanne Hokin, Colleen McDannell, Patricia McDonnell, Sarah J. Moore, Joan Moser, Kenneth M. Price, Gail Scott, Diane Tepfer, and Barbara Wolanin. I would also like to thank John Hodge, Jennifer Galida, and Ruth Maasen for their assistance. My editor, Gloria Kury, provided expert guidance and direction as she skillfully shepherded this book through to its completion at Penn State Press. I am also grateful for the services of Stephanie Grace and Laura Reed-Morrisson.

This project has been generously supported by a number of grants and fellowships. I am grateful for a J. Paul Getty Postdoctoral Fellowship in the History of Art and the Humanities, a Smithsonian Institution Short Term

Visitor Fellowship, two NEH Travel to Collections Grants and an NEH Summer Seminar on Literature and Painting offered by Wendy Steiner at the University of Pennsylvania. I appreciate the financial assistance I have received from the University of Missouri–St. Louis in the form of two Faculty Summer Research Grants, a Chancellor's Humanities Fund Award, a Weldon Spring Humanities Seminar Award, a University of Missouri Research Award, a Small Grant, and a University of Missouri Research Board Award.

Finally, I wish to thank family and friends for their unwavering encouragement and support. My parents, Ethel Margaret and the late John L. Bohan, my sisters, Nancy and Jane (and Jane's husband, Jean), my brother, Timothy (and his wife, Sarah), and Robert Traver have all sustained me with their goodwill, good humor, and good food.

Introduction

I and mine do not convince by arguments, similes, rhymes,
We convince by our presence.

—Walt Whitman, *Leaves of Grass*

LEAVES OF GRASS, first published in 1855, transformed the art of poetry and the relationship between poet and reader. Whitman charms, seduces, shocks, cajoles, exhorts, and inspires audiences as he takes on his multiple and overlapping roles as poet, performer, and brazen self-promoter, offering in place of "the old smooth prizes . . . rough new prizes" (*LG* 155). Whitman is "the poet of the Body and . . . the poet of the Soul" (*LG* 48), "the bard of personality" (*LG* 22), and "he that walks with the tender and growing night" (*LG* 49). "I know perfectly well my own egotism" (*LG* 77), he advises. "I too am not a bit tamed, I too am untranslatable, / I sound my barbaric yawp over the roofs of the world" (*LG* 89).

Commensurate with Whitman's refusal to be contained between his hat and his boots was his alertness to the powers of visual representation. He maintained numerous friendships with artists and posed for an impressive number and variety of portraits, including more than a hundred photographs and several dozen drawings, paintings, prints, and sculptures. The noted engraver, author, and political activist William J. Linton was among Whitman's friends. In the early 1870s, Whitman commissioned Linton to design the provocative wood block portrait that confronts readers of the Centennial edition of *Leaves of Grass* (see fig. 17). Hatless, his head turned in the direction of the viewer, Whitman appears to deny the flatness of the page and the constructed space of the image. Barely contained by the rectangular boundaries of the frame, the poet leans outward toward his reader and the future. The intensity of his gaze, like the poet himself, will not be denied. In "Out from Behind This Mask," a poem subtitled "(To Confront a Portrait.),'" Whitman contemplates the engraving's representational strategies, focusing attention on the intricate relationship between the work's technical qualities and the sense of presence radiating from this "bending rough-cut mask," this

"condensation of the universe," this "mystic handful wrapt" (*LG* 381–82). Whitman notes in particular the portrait's "burin'd eyes, flashing to you to pass to future time," radiating "[t]o you whoe'er you are—a look."

> Lingering a moment here and now, to you I opposite turn,
> As on the road or at some crevice door by chance, or open'd window,
> Pausing, inclining, baring my head, you specially I greet,
> To draw and clinch your soul for once inseparably with mine,
> Then travel travel on.
>
> (*LG* 382–83)

Here as elsewhere, a crucial aspect of Whitman's appeal is the almost palpable intimacy with which he engages his reader's attention. "I dote on myself, there is that lot of me and all so luscious" (*LG* 54), he exults. At times humble and self-effacing, Whitman can also be pompous, self-absorbed, defiant, overbearing. He is a lover, a guide, a showman, a seer, a prophet—the voice of freedom, democracy, and the common workingman and -woman. "I carry the plenum of proof and every thing else in my face" (*LG* 55), he asserts. "I am not to be denied, I compel" (*LG* 74).

Today, 150 years after its first publication, *Leaves of Grass* remains a landmark of American literary achievement. Whitman, we are taught, rejected European models of poetry to craft a new poetics based in the country's democratic principles of self-determination. His poetry celebrates the nation by celebrating himself, "Walt Whitman, a kosmos, of Manhattan the son, / Turbulent, fleshy, sensual, eating, drinking and breeding" (*LG* 52). Native themes, a love of the commonplace, and unprecedented frankness in treating the body and sexuality set his work apart from everything that had come before in American literature. So, too, did the open-ended structure and conversational tone of *Leaves of Grass*. In place of the elevated diction and intricate rhyme schemes favored by his contemporaries, including William Cullen Bryant and Henry Wadsworth Longfellow, Whitman offered what seemed an exchange between equals. In placing himself at the center of his poetic enterprise, Whitman confounded the long-standing boundaries that separated private from public, divided life from work, and kept the poet apart from (and elevated above) his audience.

Whitman announced his intentions in the Preface to the first edition of *Leaves of Grass*:

> Of all nations the United States with veins full of poetical stuff most need
> poets and will doubtless have the greatest and use them the greatest. Their
> Presidents shall not be their common referee so much as their poets shall. . . .
> [The poet] is the arbiter of the diverse . . . the equalizer of his age and land.
>
> (*LG* 714)

The new poet would be called upon to do far more than simply record the beauty of "dumb real objects." He would also be expected to indicate for his

readers "the path between reality and their souls" (*LG* 716). "The greatest poet," Whitman added, "forms the consistence of what is to be from what has been and is" (*LG* 718). He concluded his essay with a standard for success: "The proof of a poet is that his country absorbs him as affectionately as he has absorbed it" (*LG* 731).

No one today doubts that Whitman has been absorbed into the fabric of American culture. Such was not always the case, however. In the 1850s, Whitman attracted few readers and even fewer supporters. Bewildered reviewers objected to the structure of *Leaves of Grass*—it seemed inchoate, overgrown— and to its explicit sexual content. Ralph Waldo Emerson was all but alone in his unqualified praise of *Leaves of Grass*. In a letter that Whitman later published without his permission, Emerson termed it "the most extraordinary piece of wit and wisdom that America has yet contributed."[1]

With Emerson's praise ringing in his ears, Whitman immediately set about revising, rearranging, and adding new poems. The twelve unnamed poems of the first edition grew in time to encompass nearly four hundred poems, the most celebrated of which is the lyric "Song of Myself." The organic development of the book echoes the organicism of the poems. Whitman issued new editions in 1856 and again in 1860; several more would appear before the "death-bed edition" of 1891–92. After the Civil War, Whitman turned increasingly to prose, publishing *Democratic Vistas* in 1871 and *Specimen Days and Collect* and "A Backward Glance O'er Travel'd Roads" the following decade. In all of his writings, regardless of format, Whitman integrates the personal and the philosophical in ways that speak directly to the reader. "Behold," he announces, "I do not give lectures or a little charity, / When I give I give myself" (*LG* 73).

Whitman began his slow rise in public standing in the 1860s, stimulated in large part by the hagiographic writings of William Douglas O'Connor, a Washington friend and champion of liberal causes. O'Connor's pamphlet, *The Good Gray Poet: A Vindication* (1866), and his short story "The Carpenter" represented Whitman in exalted, quasi-divine terms. This larger-than-life image of the poet would dominate defenses of Whitman's verse for decades to come. Both John Burroughs's 1867 biography and William Michael Rossetti's 1868 publication of selections from *Leaves of Grass* in England conveyed much the same view of Whitman. In his introduction to the London volume, Rossetti portrayed Whitman as one of the greatest poets in the English language. Two years later, Anne Gilchrist, a member of Rossetti's circle, informed readers of the Boston *Radical* that "only a young giant of a nation could produce this kind of greatness, so full of the ardour, the elasticity, the inexhaustible vigour and freshness, the joyousness, the audacity of youth."[2]

By the 1880s, Whitman attracted larger, more diverse audiences, thanks in no small measure to the efforts of Richard Watson Gilder. Gilder, the editor of *Scribner's* and later *Century Magazine*, commanded considerable cultural authority in post–Civil War America. Publishing new poems and prose pieces by Whitman alongside those of such leading authors as Henry James and Mark Twain, Gilder strengthened Whitman's standing among the

country's literary elite. Anthologies also began to include Whitman's verse. (For decades, though, his most frequently anthologized poem was his lament for Lincoln—the atypical, rhyming "O Captain! My Captain!")

Even as his poetry attracted new readers, Whitman continued to face harsh criticism, much of it directed at the bodily emphasis and explicit sexual content of his verse. Boston's district attorney, under pressure from the New England Society for the Suppression of Vice, threatened legal action as late as 1882 against *Leaves of Grass* on the grounds that it violated anti-obscenity statutes. The list of offensive poems was extensive and included "To a Common Prostitute" as well as passages from "Song of Myself" and "I Sing the Body Electric." Surprisingly, none of the objectionable poems was from the "Calamus" cluster, Whitman's songs in praise of "comradeship" and "manly attachment." Nineteenth-century audiences were far more likely to disapprove of Whitman's explicit treatment of the body and heterosexual love than of the poems' suggestions of homosexuality. Contemporary customs allowed for and even encouraged open demonstrations of male friendship and affection to an extent unthinkable just a few decades later.

If poems like "When I Heard at the Close of the Day" from the "Calamus" section did not arouse the wrath of the censors, they did attract the attention of a growing international cadre of homosexual readers who identified their sexual feelings in the poems. British author John Addington Symonds repeatedly pressed Whitman to affirm his homoerotic yearnings, something Whitman steadfastly refused to do. By the early twentieth century artists and writers eager to throw off the mantle of gentility and express their homosexuality in their art were increasingly drawn to Whitman as an important precursor and guide.

Whitman spent the last decade of his life, much of it in poor health, surrounded by a group of loyal admirers who endeavored to secure lasting fame for the poet. Horace Traubel filled notebooks with his daily conversations with Whitman and edited *The Conservator*, a journal devoted to promoting Whitman and his writings within the context of the Ethical Culture movement. With assistance from Richard Maurice Bucke, Thomas Harned, Burroughs, and others, Traubel founded the Walt Whitman Fellowship International, which soon had branches in a number of American cities, including New York, Philadelphia, and Boston. After Whitman's death in 1892, his followers inundated American readers with dozens of publications that extolled Whitman's poetic genius, nobility, humanity, and capacity for spiritual illumination. The ten-volume *Complete Writings of Walt Whitman* appeared in 1902, followed by the first three volumes of Traubel's *With Walt Whitman in Camden* (1906, 1908, 1914), the record of his conversations with the poet that eventually filled nine volumes, and Bucke's *Cosmic Consciousness* (1901), which championed Whitman as the "best, most perfect, example the world has so far had of the Cosmic Sense."[3]

Stimulated by the writings of Traubel, Bucke, and others, the audience for Whitman's verse expanded dramatically in the first turbulent decades of the twentieth century. Socialists, anarchists, and freethinkers from Emma

Goldman and Floyd Dell to Abbott Leonard, John Spargo, and John Reed found a source for their personal and political activism in Whitman's radical egalitarianism. Modern artists, writers, architects, dancers, composers, and critics also acknowledged Whitman's authenticating presence in their development of new modes of self-expression. American modernism, Alan Trachtenberg has argued, "shaped itself at least in part as a diverse collective response to Whitman's call, an answer to the Answerer."[4] In an arena dominated (particularly in the pre–Armory Show years) by European artists and art theories, Whitman became a catalyst for a modernism grounded in American cultural experience. A generation revolting against the heritage of its predecessors—yet at the same time in search of its own cultural and artistic footing—found in Whitman a unique combination of change and rootedness. "My call is the call of battle," he had exclaimed. "I nourish active rebellion" (*LG* 158).

Anarchist poet Adolf Wolff voiced the sentiments of many in his generation when he hailed Whitman's verse as

A clarion call to freedom,
A gesture of revolt,

. . . .

A declaration of the right of all
To live, to love, to dare and to do.[5]

Modernists as diverse as Marsden Hartley, John Sloan, Joseph Stella, William Carlos Williams, Robert Coady, Alfred Kreymborg, Isadora Duncan, Charles Ives, Louis Sullivan, Frank Lloyd Wright, Sadakichi Hartmann, Benjamin De Casseres, and Van Wyck Brooks took up Whitman's charge. The poet's endorsement of the entire spectrum of human experience—from the mystical to the mundane—as well as his glorification of the body and sexuality and, above all, his faith in the potential of an "unfettered" self emboldened and inspired this first generation of American modernists to defy the old certainties in art as in life.

The modernists' intense embrace of Whitman as a vital progenitor was what first caught my attention when I commenced this study more than a decade ago. I set out to explore Whitman's reception within the expansive network of artists, writers, critics, and gallery owners active in New York City during the first two decades of the twentieth century. As I delved more deeply into the creative interchanges between Whitman and his modernist sympathizers, I became increasingly aware of Whitman's involvement with the artists and artistic practices of his own century. Initially, I focused on Whitman's relationship with Thomas Eakins, but soon I was probing further into Whitman's past. If Whitman connected his verse to his person, he also related his poetry to the vivifying potential of visual representations. Artists responded with their own visual constructions of the poet, many of them subject to Whitman's searching critique. As my research broadened, I found myself mapping the shifting landscape of Whitman's involvement with American visual culture across nearly three-quarters of a century.

In "Song of the Open Road," a favorite among Whitman's modernist supporters, the poet ordained himself "loos'd of limits and imaginary lines" (*LG* 151). In the same spirit, this study collapses traditional disciplinary boundaries to evaluate the dynamic reciprocity between Whitman and American visual culture. My investigation starts with the "long foreground," the preparatory years leading up to the publication of the first edition of *Leaves of Grass,* and concludes with the outpouring of support for Whitman that accompanied the centennial of his birth. During this seventy-year period, Whitman functioned both as a powerful agent of change and as the object upon and through which artists focused their evolving perceptions of the self, masculinity, the body, and the very nature of art.

Whitman was not alone among American writers in forging significant alliances with artists and the visual arts. Recent monographs examine similar interartistic connections among authors as diverse as Herman Melville, Wallace Stevens, Marianne Moore, William Carlos Williams, Gertrude Stein, and others.[6] Still, the intimacy and self-representational nature of his writings make Whitman's case special. Whitman would have his readers believe that *Leaves of Grass* is not a book but "a *Person,* a human being (myself, in the latter half of the Nineteenth Century, in America)" (*LG* 573–74). Whitman is far more than the constructor of poems. He is a force, a compulsion: "I teach straying from me, yet who can stray from me? / I follow you whoever you are from the present hour, / My words itch at your ears till you understand them" (*LG* 85). This powerful sensory presence goes a long way toward explaining why Whitman has attracted the attention of a continuous stream of artists espousing a diverse range of cultural and artistic beliefs. These encounters constitute one of the richest but least understood of Whitman's prodigious legacies.

In *American Renaissance* (1941), his classic study of "art and expression in the age of Emerson and Whitman," F. O. Matthiessen identified a number of provocative links between Whitman and the art of his contemporaries. The most pervasive was a fundamental commitment to the democratic spirit and unpretentious reality of everyday life—what Matthiessen termed "concrete observation."[7] In the more than sixty years since the appearance of *American Renaissance,* only a handful of scholars have attempted to expand and refine Matthiessen's judgments. The most perceptive have examined Whitman's interest in and mobilization of the new medium of photography.[8] Whitman's importance for the arts of painting, sculpture, printmaking, and architecture has received significantly less attention, perhaps because historians have been intimidated by the scale and complexity of Whitman's legacy.[9]

My book pushes back the frontiers of Whitman studies while focusing attention on the shifting dynamics that transformed the relationship between literature and the pictorial arts in the nineteenth and early twentieth centuries. I locate Whitman's interactions with American visual culture within the changing circumstances of his life, the evolving character of his verse, and developments within the American art community. Above all, I recover the many ways in which Whitman and the expansive persona of his verse

infused American visual culture during a period of intense social and artistic change. Combining biography, cultural history, and art history, my book examines Whitman as an active participant in American visual culture both as an object of the artist's gaze and as an "agent provocateur" of the avant-garde. I probe the intersections between the biographical Whitman, the constructed persona of the verse, and the Whitman reinvented by artists spanning the visual spectrum from traditionalists like Charles Hine and Edwin Forbes to progressive individualists like Thomas Eakins and Robert Coady.

Investigations into the creative interplay between the verbal and visual arts have increased significantly in recent years, spurred on by the theoretical writings of scholars such as Wendy Steiner and W. J. T. Mitchell and by the cross-disciplinary perspectives of Cultural Studies.[10] Mitchell's concept of the "imagetext" is helpful insofar as it provides a model not of "influence" but rather of a composite or synthetic work in which image and text coalesce.[11] With this organic model in hand, I illuminate the image-text relationship in the many portraits and caricatures made of Whitman from life as well as in a host of other works, ranging from the landscapes of Marsden Hartley to the urban abstractions of Joseph Stella.

All too often, scholarly investigations of Whitman's interest in photography have obscured his enthusiasm for the more traditional arts. Discussions of Whitman's interest in photography have repeatedly stressed the democratic nature of that medium (and hence Whitman's attraction to it). Some have constructed an elitist, retrograde view of painting to bolster, in part, the association between this quintessentially modern poet and the new medium of photography.[12] Swayed by the panoramic sweep of Whitman's verse, studies probing his relationship to the arts of painting and sculpture have tended to identify a range of vaguely defined "Whitmanesque" qualities in the work of a broad array of artists without sound, corroborating evidence. My study provides a much-needed corrective to such ahistorical and acontextual approaches—and an enlarged understanding of Whitman's place in history. For coherence (and because the material linking Whitman with the pictorial arts is more than sufficient for a book), this study refrains from any discussion of Whitman's importance for architecture and confines itself to the arts of painting, sculpture, and printmaking.

The first five chapters focus on the nineteenth century. Here, little-known aspects of Whitman's biography illuminate the poet's substantial interactions with artists and American visual culture from his early days as a Brooklyn journalist until his death at age seventy-two in Camden, New Jersey. While I cover some of the ground analyzed by David S. Reynolds in his massive *Walt Whitman's America* (1995), I go beyond Reynolds and other biographers to bring to the fore previously overlooked material—including, for example, Whitman's and Bryant's shared involvement in midcentury systems of art patronage—and to extend the discussion of Whitman's associations with artists well beyond the decade of the 1850s. I situate Whitman's early enthusiasm for the visual arts within the context of the Horatian tradition, which classified painting and poetry as "sister arts" rooted in the imagination and in

human achievements and emotions. Whitman's friendships with artists and involvement with organizations like the Brooklyn Art Union stimulated him to plumb the shifting persona of his verse visually as well as verbally. Beginning with the 1855 edition of *Leaves of Grass* and continuing through many of the book's later editions, Whitman paired his verse with carefully fashioned and judiciously placed portraits of himself. I investigate how these portraits mediate the dynamic interface of the poet, his audience, and the poetic text.

Few have documented and assessed Whitman's interactions with artists during the last fifteen years of his life. Following a series of debilitating strokes that deprived him of much of his physical strength, he played host to a number of mostly younger artists who reinvigorated his commitment to nurturing a visual counterpart to his poetic achievements—to nurturing, that is, a Walt Whitman in paint or clay. Two of his most loyal followers were the sculptor, lay preacher, editor, and writer Sidney H. Morse and Herbert Gilchrist, the London-trained painter and son of Anne Gilchrist. Together with John White Alexander, whose ennobled portrait of the poet became the most widely reproduced of Whitman's many painted likenesses in the years after his death, these artists devoted considerable energy to drawing, painting, and sculpting Whitman's likeness. By the late 1880s, Whitman's Mickle Street residence bustled with the lively give-and-take of an artist's workshop.

Thomas Eakins is at once the best known and the most provocative of the artists to ally himself with Whitman during his last years. I center my investigation of Eakins's relationship with Whitman on two paintings: Eakins's half-length portrait of the poet, begun in 1887, and *The Concert Singer* of 1890–92. These paintings frame their five-year friendship and celebrate their shared passion for the expressive powers of the human voice. While the ostensible focus of *The Concert Singer* is Weda Cook, a singer and friend of both Whitman and Eakins, the painting is primarily about the poet and his verse. Whitman had first glimpsed the possibility of expressing qualities of his verse without recourse to his person while pondering works by the Barbizon painter Jean-François Millet, in whose spiritually resonant scenes of rural life he felt a kinship with his own spiritual and nationalist objectives. Eakins's painting, in forgoing conventional notions of referentiality, inaugurates a dynamic new dimension in the creative interplay involving Whitman and visual modes of representation.

In the last three chapters, I examine the ways in which Whitman offered the first generation of modernist artists a "usable past." The protean nature of Whitman's verse, together with its powerful theme of self-discovery, struck a responsive chord among artists eager to assert their independence from social, cultural, and artistic norms. I pay close attention to the modes of transmission that carried the poet's ideas outward to a new generation of readers. Several members of the poet's own coterie moved within modernist circles. Hartley, Kreymborg, and Alfred Stieglitz were all personally acquainted with Traubel; Hartley was also a friend of William Sloane Kennedy, Whitman's ally and the author of several books on the poet, and enjoyed a passing

acquaintance with Pete Doyle, the Washington streetcar driver who may have been Whitman's lover. Traubel was equally well known through his poems and extensive writings about Whitman, some of which were published in the modernist journal *Glebe*. These intergenerational ties strengthened Whitman's reception within the modernist community. Indeed, perhaps as a result of such connections, early-twentieth-century American modernists proved to be among Whitman's staunchest supporters and most creative visual interpreters.

While Whitman's impact was felt internationally, I concentrate on its American manifestations. I focus in particular on the work of Marsden Hartley, Robert Coady, and Joseph Stella. Together their efforts represent a broad cross section of the thematic, stylistic, and conceptual bases of modernism. My book recovers the amalgam of personal and inherited systems of belief—what Hans Robert Jauss has termed the viewer's "horizon of expectations"[13]—with which these artists constructed their individual and collective responses to Whitman. I make no distinction here between the mythic Whitman and the historical creator of the verse.

Hartley enjoyed the strongest and most direct link to Whitman of any artist of his generation. I assess his sexual, spiritual, and musical engagements with Whitman's poetry as filtered through his associations with Traubel and an aging group of Whitman loyalists. Where Jonathan Weinberg and others have written extensively on the element of homoerotic desire in Hartley's figural art and in his abstract homages to the German officer Karl von Freyburg,[14] I shift the focus to an earlier period of his career and to his landscape paintings. Those early landscapes, the basis of his inaugural exhibit at Stieglitz's 291 gallery, offer a disguised narrative of Whitman's "manly comradeship."

More urban and populist themes characterize Coady's short-lived journal, *The Soil* (1916–17). Unlike other "little magazines" of the period, including the better-known *Seven Arts*, *The Soil* functions less as a conventional journal and more as a composite work of art. Coady celebrates Whitman's championship of vernacular and popular traditions. The bard's democratic idealism and enthusiasm for the broadest range of American cultural experience stimulated *The Soil*'s attempts to level artistic hierarchies and its excursions into the arenas of technology, mass entertainment, and the cinema.

My final chapter examines Stella's immigrant identification with Whitman and America. A native of Italy, Stella symbolized his commitment to Whitman's cosmic internationalism in the landmark structure of the Brooklyn Bridge, the monumental successor to the poet's beloved Brooklyn ferry. Stella forged important connections with an active network of Whitman supporters on both sides of the Atlantic. Like his painting, he, too, was a bridge. I map Stella's struggle to meld his Italian heritage with Whitman's vision of a spiritually enriched and globally integrated world order.

In death as in life, Whitman resisted fixed interpretation. In an address before the Philosophical Union in 1911, George Santayana attributed Whitman's appeal in part to his willingness "to express, not the polite and conventional American mind, but the spirit and inarticulate principles that

animate the community." He further proposed that Whitman's "work, for the very reason that it is so rudimentary, contains a beginning, or rather many beginnings."[15] Certainly the discussion that follows bears out Santayana's assertion. In the decades after the first publication of *Leaves of Grass,* an astonishing number of artists—conservatives, moderates, and radicals alike, the known and the unknown among them—absorbed Whitman into the very fiber of their art. In recovering their stories, this study begins the daunting but exciting task of exposing the myriad new beginnings Whitman fostered across seventy years of American visual culture.

Imaging Whitman

The Ninetcenth Century

Part One

The "Gathering of the Forces" in Brooklyn

DURING THE YEARS PRIOR to the 1855 publication of *Leaves of Grass*, the "long foreground" Emerson alluded to in his congratulatory letter welcoming the poet "at the beginning of a great career,"[1] Whitman immersed himself in the cultural tide of midcentury New York. By his own admission, he encountered more to nurture and sustain his revisionist poetics in the company of artists than writers.[2] Like his good friend William Cullen Bryant, the poet, editor, and noted arts patron, Whitman enjoyed extended personal friendships with artists, actively nurtured New York's expanding arts community, and focused substantial journalistic energy on advancing the arts in his beloved Brooklyn. Whitman shared as well Bryant's involvement in the discursive practices that circulated around the ancient Horatian doctrine of *ut pictura poesis*. The discourse on the mutuality of the verbal and visual arts, in concert with the possibilities of the exhibition experience, would figure prominently in Whitman's efforts to yoke both his person and his poetry to the expressive power of the visual.

At the time Whitman launched his journalistic career, New York was experiencing a period of sustained growth and increasing public interest in the arts. For the first time the city surpassed Boston and Philadelphia as the country's premier art market. The National Academy of Design, long the city's principal arts organization, was joined by a spate of newer galleries and arts institutions offering artists and the general public richer and more extensive viewing opportunities. The Apollo Association, soon to become the American Art-Union, opened in 1839. Within a few years it was joined by the International Art Union, the New York Gallery of Fine Arts, the Düsseldorf Gallery, and the Spingler Institute. A range of daguerreotype galleries, too, offered regular exhibitions, and in 1842 the arts established a foothold in

Brooklyn when the Brooklyn Institute, the city's leading cultural institution, began hosting an annual month-long art exhibition. There were also increasing numbers of well-publicized temporary exhibitions showing everything from American sculptor Hiram Powers's sensationalized *Greek Slave* to large-scale dioramas. Stimulated both by the city's active cultural life and by the promise of making a living from their art, artists settled in New York in record numbers. Art patronage flourished, and wealthy collectors, inspired by the example of grocer Luman Reed, began opening their private collections to the viewing public, if only for a few hours each week.[3]

Whitman was an avid consumer of the city's expanding arts venues and a staunch advocate of the arts' importance in a democracy. During his alignment with the Free Soil movement, he encountered a number of like-minded individuals—Charles Edwards Lester among them. Lester, a prolific writer on historical and topical subjects and a respected correspondent for the *London Times*, approached the arts as Whitman did, with the sympathetic but untrained eye of a layman. When the two met as Brooklyn representatives at the 1848 Free Soil convention in Buffalo, Lester had just returned from five years as U.S. Consul at Genoa under President Polk. While in Italy he had visited Hiram Powers's studio in Florence and authored two books, both of which

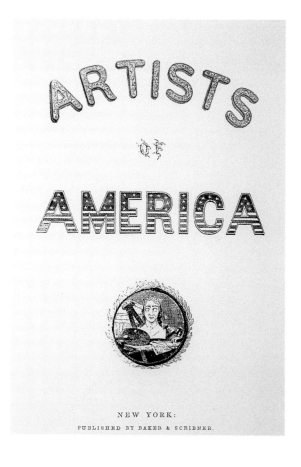

FIGURE 1 Title page in Charles Edwards Lester, *Artists of America*, 1846

Whitman reviewed, extolling in highly nationalistic terms the virtues of American art. In a florid passage from *The Artist, the Merchant, and the Statesman* (1845), part of which Whitman quoted in his review, Lester wrote longingly of "the day to come when the Arts in America shall, by the judicious but generous aid of the State, take the high eminence they held in Greece under Pericles, and, in Florence, under Lorenzo de' Medici—."[4] No less flamboyant in its nationalist sentiment was the graphically explicit title page of Lester's *Artists of America* (fig. 1), on which the word "America" was boldly festooned with the stars and stripes and a laurel wreath encircled the traditional emblems of the visual arts.[5]

Where Lester championed the arts from the background and perspective of a statesman, Gabriel Harrison—an actor, playwright, biographer, essayist, short story writer, painter, opera enthusiast, and photographer—brought to the task the able and experienced eye of an artist. Before moving to Brooklyn in 1850 to set up his own photographic studio, Harrison served as the principal operator at Plumbe's Daguerreotype Gallery in Manhattan, a studio that Whitman frequented and often discussed in his journalistic rambles through New York. Harrison's Brooklyn studio, located in the Whitehouse Building at 283 Fulton, was just a short distance from Whitman's Myrtle Avenue residence and not far from the Fulton Ferry that shuttled Whitman daily between Brooklyn and Manhattan. Harrison was a respected leader in the effort to gain recognition for photography as a legitimate art form and a passionate defender of local arts initiatives, including the Brooklyn Art Union, which Whitman would also promote. He is perhaps best known for having taken the famous daguerreotype, discussed in Chapter 2, that Whitman had engraved and placed opposite the title page of the 1855 *Leaves of Grass*.[6]

Whitman knew Harrison, like Lester, through their activities in the Free Soil Party. Years later Whitman apprised Horace Traubel that his Free Soil comrade had "always been a good friend."[7] Sympathetic though Whitman was to Harrison's political activities, it was his colleague's photographic abilities that garnered the poet's most ardent praise. In one of several reviews of Harrison's work, Whitman called this Brooklyn operator "among the very best [daguerreotypists] in the world" and hailed his works as "models of all that can be done by that process."[8] Harrison served as a model for Whitman of the engaged artist-innovator. Not only did the two share a strong foundation in politics and the arts, including opera, but the sheer variety of Harrison's endeavors and his commitment to advancing the arts in Brooklyn also gave a pattern to Whitman's own multiple pursuits. Surely Whitman recognized aspects of himself in this individual, whose "fine artist soul" he judged "wild and unpruned as nature itself."[9]

William Cullen Bryant was a generation older than Lester and Harrison and considerably better known. Widely recognized in both art and literary circles, Bryant provided an even stronger model for the visualist poet and artist-activist Whitman would become. As Ezra Greenspan has perceptively observed, Whitman probably considered himself "a younger version of the distinguished journalist-poet."[10] An ardent democrat, outspoken defender

of liberal causes, and beloved national poet, Bryant was also a prominent art patron and friend, colleague, and mentor to some of America's most distinguished artists. Bryant truly embodied the range of personal, professional, and artistic qualities Whitman would nourish in himself. Throughout his life, but particularly during his years as editor and later owner of the *New York Evening Post*, Bryant cultivated a diverse network of social, political, and cultural leaders, many of them active in the arts. He regularly sought out the company of practicing artists and championed their cause on the pages of his newspaper. Bryant also helped launch several of this country's leading arts organizations, including the National Academy of Design and the American Art-Union. In 1826 he and painter Samuel F. B. Morse, the National Academy of Design's first president (and, later, the inventor of the telegraph), lectured on the relationship between poetry and painting at the New York Athenaeum. Among Bryant's closest friends were Thomas Cole, founder of the Hudson River School of landscape painters; Asher B. Durand, one of its leading practitioners; and three generations of the Weir family of artists. For three consecutive one-year terms, beginning in 1844, Bryant presided over the American Art-Union, the country's largest subscription-based arts organization and a major force in the exhibition and marketing of works by American artists. Twenty years later, on the occasion of Bryant's seventieth birthday, more than forty members of the Century Club, all artists, honored him for his many years of service to the fine arts in America. Painter Daniel Huntington, then president of the National Academy of Design and a close friend of Bryant, spoke for all assembled when he lauded Bryant as "a brother of the pencil most dear to all our hearts." "Sir," he intoned, "the artists love you very much . . . we claim you as one of us."[11]

Whitman always considered Bryant "a man to become attach'd to," and on lengthy rambles through Brooklyn and its neighboring communities discussed with him a broad range of topics, including art.[12] Particularly interesting to Whitman were Bryant's vivid recollections of the art and architecture he and Charles Leupp, a close associate in the management of the American Art-Union, had encountered during a six-month tour of England and the Continent. The two visited many of the world's preeminent museums and art galleries and sought out practicing artists in their studios. Florence and Rome were then favored destinations of American artists, and the pair met many established and aspiring artists, including Horatio Greenough, Hiram Powers, and the young Henry Kirke Brown.[13] It was no doubt with Bryant's and Lester's experiences in mind that in 1848, while editor of the *New Orleans Daily Crescent*, Whitman published a letter by the American painter Thomas Hicks. Dated "Rome, Italy, Feb. 1843," Hicks's letter lamented the many difficulties faced by American artists abroad as they struggled to gain for themselves the knowledge and experience required to achieve even a modicum of personal and financial success. In prefatory remarks, Whitman described Hicks as a "highly promising native artist" who he hoped would "one day attain a distinction which will reward labors and sacrifices so great."[14]

While considerably less sophisticated in his taste than Bryant,

Whitman shared many of the older man's interests in the arts, particularly his fondness for landscape painting and portraiture. Among Whitman's earliest artist friends was Charles Heyde, a landscape painter and native of France who was shortly to become Whitman's brother-in-law. In 1852, the year of his marriage to Whitman's sister Hannah, Heyde listed 106 Myrtle Avenue, the Whitman family residence, as his address when he entered work in the National Academy of Design's annual exhibition. Whitman would later revile Heyde, calling him a "serpent," "a viper," and "a damned lazy scoundrel,"[15] but in the early 1850s the future author of *Leaves of Grass* thought highly enough of the painter to invite Bryant to join him on a visit to Heyde's studio.[16] Whitman was also a friend of Jesse Talbot, who specialized in literary themes and scenes of the New Jersey and New England countrysides. Talbot's landscape paintings appeared regularly in the exhibitions of the National Academy of Design, and in 1847 the American Art-Union selected his painting *Christian and the Cross, Pilgrim's Progress* to be engraved for distribution to its membership. Whitman owned a copy of the print (perhaps given him by the artist) and by 1850 was visiting Talbot regularly at his studio, where his daughter recalled their "long and instructive chats over good coffee and paintings."[17] In several reviews Whitman extolled Talbot's art as "strictly identical with American scenery" and judged his encounters with the American land "better than even 'visiting Europe.'" Echoing Lester's nationalist rhetoric, he exclaimed: "Has Europe any better models in her galleries than Nature offers on American hill tops, and all over the broad spread of our fertile fields?"[18]

By far the best known of Whitman's artist friends was the Long Island genre painter William Sidney Mount. Like Whitman, Mount was an astute observer of the human condition and an ardent admirer of phrenology.[19] His paintings of daily life in rural Long Island—like Whitman's journalism and, later, his poetry—showed a commitment to representing quotidian concerns in a language that mediated elite and popular cultures. The two shared as well a fondness for the theater, which they indulged on frequent visits to the Park Theatre. Years later Whitman expressed "wonder and admiration" at Mount's habit of recording with "a few deft lines" snatches of the people and events the two encountered on their outings.[20] Whitman's own habit of filling a series of small notebooks with abbreviated verbal commentaries on his daily experiences seems a striking counterpart to Mount's visual musings. For both, such everyday visual stimulation proved an essential resource for their art.

More typical of Whitman's friends was Walter Libbey, a minor genre painter who is today virtually unknown. During his brief life, Libbey exhibited frequently at both the National Academy of Design and the American Art-Union, where he attracted favorable notice in the local press. The painting of a young street urchin prompted the *New York Home Journal* to hail him as the "young American Murillio" [*sic*].[21] Whitman was particularly fond of Libbey's *Boy with a Fife*, also known as *The New Fife* (fig. 2), a genre portrait of a young country lad playing his fife in a lush, rural setting. In an article in Bryant's *New York Evening Post*, Whitman claimed to have "looked several long looks at this picture, at different times" and expressed nationalist pride

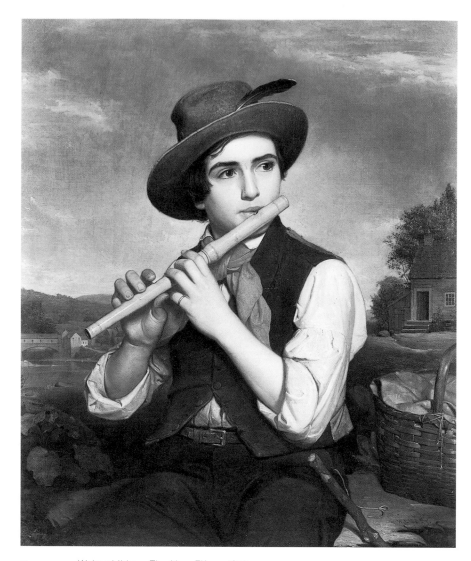

FIGURE 2 Walter Libbey, *The New Fife*, c. 1850

in the fact that in America "there is nothing to prevent [this young boy from] becoming a President, or even an editor of a leading newspaper."[22]

Such sympathetic moralizing was typical of Whitman's visualist perspective and informed much of his early writing on art. In his capacity as editor of the *Brooklyn Daily Eagle* and contributor to the *Brooklyn Evening Star* and other newspapers in the years immediately preceding the publication of *Leaves of Grass*, Whitman indulged his fascination with the visual arts in fully one-third of his journalistic writings. In the visual arts as in music, Whitman showed himself a leveler of artistic hierarchies and a staunch advocate of free public access to the arts. He made no distinction between artistic masterpieces and inexpensive reproductions, once admitting to being as captivated by "a tastily illustrated" book as by an original work of art.[23] Whitman

shared the sentiments of moralists like Catherine Beecher and her sister Harriet Beecher Stowe, who in their popular book *The American Woman's Home* (1869) stressed the "educating influence" that works of art could bring to the home environment.[24] Anticipating their work by more than two decades, Whitman wished that "every mechanic and laboring man and woman of Brooklyn, would have *some* such adornment to his or her abode—however humble that abode may be."[25] As a commentator, Whitman revealed an eclectic sensibility and strong nationalist sentiments. "I am no connoisseur, (thank Heaven!)" he exclaimed in an 1845 article in the *Brooklyn Evening Star*, yet a display of paintings "at the topmost top of Clinton Hall" left him "strangely enchanted."[26] He judged George Catlin's extensive collection of American Indian artifacts of "decided importance to Art and to our national History" and urged its immediate acquisition by the federal government.[27] He was similarly enthusiastic about plans to erect a monument to George Washington in the nation's capital.[28]

Consistent with his commitment to assuring a strong national presence for the arts was his desire to enhance the standing of the arts in Brooklyn. He had often lamented the city's lack of a permanent venue for the display of art and in 1850 became one of the staunchest advocates of the newly founded Brooklyn Art Union.[29] Housed in the prestigious Brooklyn Institute, the Brooklyn Art Union seemed poised to provide the city with the high quality and free public access enjoyed by the country's other art unions. Whitman wrote three articles over a ten-month period extolling the benefits of the undertaking. One of the pieces received prominent billing on the editorial page of the *New York Evening Post*.[30] In it Whitman proselytized on the need to nurture an active fine arts presence at both the local and national levels. "Nearly all intelligent boys and girls have much of the artist in them," Whitman advised, and he urged his readers "to give them an opportunity of developing it in one of the fine arts." Sounding a patriotic note, Whitman sought to dissuade young artists from considering Europe either the sole arbiter in aesthetic matters or the requisite destination for all serious art training. No less detrimental to the success of art in America, he noted, was the excessive esteem placed on art's monetary value by the American business community: "for the thrift and shrewdness that make dollars, are not every thing that we should bow to, or yearn for, or put before our children as the be all and the end all of human ambition." As a countermeasure to such destructiveness, Whitman recommended that artists establish a strong collective identity through the formation of "a close phalanx, ardent, radical and progressive." Such an effort, he believed, would bolster the country's fledgling art community and provide crucial moral and spiritual support among artists. Only then could the arts in America achieve the authority and visibility essential to advancing the country's democratic foundations.[31]

Two months later, Whitman was invited to deliver the keynote address at the Brooklyn Art Union's first distribution of prizes. By accepting the honor, Whitman took his place with such other literary supporters of the arts as Bryant, Prosper Wetmore (Bryant's successor at the American Art-

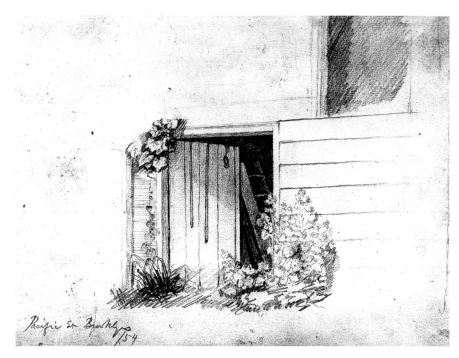

FIGURE 3 John Quincy Adams Ward, *Back Entrance to Henry Kirke Brown's Studio on Pacific Street, Brooklyn, New York*, 1854

Union), and Henry Wadsworth Longfellow, a prominent backer of the New England Art Union. In an act of solidarity with these distinguished colleagues, Whitman peppered his remarks with quotations from and indirect references to a number of prominent literary sources, including Emerson, Ruskin, Shakespeare, Socrates, and the Bible. As always, though, it was Bryant who commanded Whitman's strongest sympathy and against whom he was most likely to measure himself. Whitman recited several lines from Bryant's poem "Forest Hymn" midway through his remarks, and he concluded with a lengthy passage from "Resurgemus," one of his own early free-verse poems. Although Bryant's name was never mentioned, the intention was clear: to pay homage to Bryant and simultaneously establish himself as Bryant's heir-apparent, both as a poet and as a spokesperson for the visual arts in Brooklyn.[32]

Shortly thereafter Libbey nominated Whitman to be the organization's next president, a post to which Whitman was subsequently elected but prevented from claiming by the demise of the whole system of art unions later that year.[33] Undeterred, Whitman continued his advocacy for the arts in Brooklyn by seeking out new alignments with the city's expanding population of artists. By far his most stimulating association was with the dynamic circle of artists, writers, and arts patrons who gathered regularly in the studio of sculptor Henry Kirke Brown. Brown was one of Bryant's protégés and, like him, a staunch artistic nationalist. To Bryant's well-practiced eye, Brown's ideal sculpture was "informed with a deep human feeling" lacking in repre-

sentations by more established artists. In 1846 Bryant was instrumental in securing for Brown an important one-person exhibition at the National Academy of Design. This was Brown's first major exhibition and the first solo exhibition ever accorded a sculptor in New York.[34] Even before Whitman and Brown met, Whitman reviewed the exhibition and praised the "young American" for his "genius and industry." At the time Whitman was particularly taken with Brown's marble bas-reliefs of Pleiades and Hyades, modeled in Rome, but less pleased with a life-size Adonis: "Though a noble statue, it did not, however, come up to our (perhaps too lifted) ideas of 'Myrrha's immortal son.'"[35] Over the course of their friendship, both Whitman and Brown would shift away from such overtly European sources toward more emphatically American subject matter.

In 1849, three years after returning from Rome, Brown moved his studio from Manhattan to Brooklyn (fig. 3), where it became a working model of the "phalanx" Whitman had called for in his remarks before the Brooklyn Art Union. The group included some of the leading practitioners of the day working in the diverse arenas of landscape, portraiture, and ideal subjects. Prominent among them were painters Sanford Gifford, Daniel Huntington, William Page, Asher B. Durand, William James Stillman, and Samuel Colman; sculptors John Quincy Adams Ward and Larkin G. Meade; banker and art patron Henry G. Marquand; and Bryant himself.[36] Stillman was also one of the future founders of *The Crayon* (1855–61), the country's first art journal, which debuted the same year as Whitman's *Leaves of Grass*.[37] Whitman recalled that he "fell in with Brown" about the time of Samuel Longfellow's arrival in Brooklyn, which would make it late 1853—but he may well have begun visiting Brown much earlier. "[T]here we all met on the freest terms," Whitman noted, a situation he happily contrasted with the "literary polite" atmosphere prevailing in most literary circles.[38]

Like Bryant, Brown and members of his circle were committed to establishing a strong American art tradition, something their experiences abroad had convinced them needed to be done "mainly upon American ground, and amidst American influences."[39] In 1852 Brown confided to his friend Daniel Huntington.

> I feel that my humble mission is here [in America], and I begin to rejoice in my freedom from old masters both ancient and modern; I have received from them my patrimony and have gone out into the world to work for myself, and to work back if possible into the simple boyish love of nature which I came near losing sight of. If any object gets between us and the sun its beautiful light is partially obscured, so if we allow any master old or young to stand between us and nature we work only in his shadow.[40]

In a field that all too readily accepted the practices of the ancients as the sole arbiter of artistic taste, Brown preferred American to mythological themes, contemporary to vaguely classical dress, and a robust naturalism to the uncompromisingly smooth lines of the neoclassical. Brown and those close to

him proved an important sounding board for Whitman's maturing artistic sensibilities. Whitman recalled being "often in his studio, where he was always modelling something—always at work."[41] Brown's commissions during the early 1850s included a colossal monument to New York's former governor DeWitt Clinton, an impressive equestrian monument of George Washington for New York's Union Square, and several Indian sculptures based on sketches made from life among the Chippewa and Ottawa Indians.[42] Brown and his colleagues were similarly committed to expressing in their art the simple and the commonplace. They aimed to develop an art responsive to the everyday experiences of Americans. In 1856 Brown wrote architect Montgomery Meigs that "all art to become of any national importance or interest must grow out of the feelings and the habits of the people."[43]

The group's discussions about what constituted a truly "American" art, their preference for American over European subject matter, their concern with artistic naturalism over the more traditional language of classicism, and their technical challenges to the prevailing norms of their profession served as important visual corollaries for the literary challenges Whitman was beginning to set for himself as a poet. Whitman's experiences as a carpenter allowed him to understand the physical demands and technical skills required of a sculptor. At the same time, prolonged exposure to a studio environment helped strengthen Whitman's appreciation of the process, as much as the product, of the art-making endeavor. In the Preface to *Leaves of Grass*, Whitman proudly classed himself as "one among the wellbeloved stonecutters" (*LG* 714) and in later years looked back on his associations with Brown and his colleagues with telling appreciation: "They were big, strong days—our young days—days of preparation: the gathering of the forces."[44]

This "gathering of the forces" entailed a crucial reassessment of the significance of the arts in a democracy. Whitman took great pleasure in the fact that members of Brown's circle likened him to Jean-Pierre Béranger, the popular French poet whose songs of liberty and brotherhood earned him a strong following in his native country, particularly among the working class. "In this crowd I was myself called Beranger," Whitman recalled. "My hair had already commenced to turn gray."[45] Equally important were the group's investigations into the centuries-old ideal of the sister arts. Since antiquity, practitioners of the verbal and visual arts had embraced the Horatian doctrine of *ut pictura poesis*, which regarded painting and poetry as homologous arts. Such ideas held particular resonance among mid-nineteenth-century artists. Brown's *Ruth*, a work that had earlier attracted Bryant's attention, was inspired by lines from Keats's "Ode to a Nightingale." Poems about paintings and visits to artists' studios abounded in the literature of the period, especially in publications like *The Knickerbocker* (1833–65).[46] And Gabriel Harrison was affectionately known as the "Poet Daguerrean" for his evocative, narrative images.[47] Paintings were often accompanied by poetic texts, and one of the highest compliments accorded an artist was that which Bryant bestowed on Thomas Cole in his 1848 funeral elegy: "Cole's several series of pictures were in themselves poems—poems with a lofty epic flow."[48]

Bryant and his poetry figured prominently in the period's exploration of the affinities between painting and poetry. Some twenty-seven artists recast Bryant's poems in visual terms, producing forty works of art.[49] Asher B. Durand alone completed five paintings on Bryant's poetry. Overall, two dozen of Bryant's poems served as the basis for visual artworks. In *Kindred Spirits* (1849), a work that Bryant owned and that one recent scholar has judged the period's "most complete visual statement of the Sister Arts ideal," Durand celebrated the bond yoking Bryant, Cole, and the natural landscape by situating the two men on a dramatic precipice in the Catskill Mountains, gazing and gesticulating over what for both constituted the source of moral and artistic inspiration.[50] In all, more than forty of Bryant's artist friends saw fit to celebrate the mutuality of their concerns by painting, sculpting, and sketching his likeness. Whitman praised one of these—a marble bust by Henry Kirke Brown—for its "strongly-marked, manly expression."[51]

Whitman, too, encouraged artists intent on representing his likeness, and he also owned works imbued with the sister-arts ideal.[52] Supportive of the genre subjects of both Libbey and Mount, he once commented on the genre potential of his own life experiences, finding in his 1848 travels through the Allegheny Mountains en route to New Orleans "first rate scenes for an American painter."[53] An article Whitman read and heavily annotated in the January 1851 issue of *The American Whig Review* furthered his assessment of the relationship between the verbal and visual arts. Entitled "Lessing's Laocoön: The Secret of Classic Composition in Poetry, Painting, and Statuary," J. D. Whelpley's article detailed the revisionist thinking of German philosopher and theorist Gotthold Ephraim Lessing, whose *Laocoön* (1766) posed a provocative challenge to the *ut pictura poesis* ideal.[54] In notes Whitman made on Lessing's life and principal achievements, he praised the German scholar as "a severe and almost perfect critic" who had "exposed . . . the false imitations of the classics." Whitman considered him no less than "the R. W. Emerson of his age."[55]

While Lessing agreed with the ancients that mimesis constituted the underlying goal of the arts, he also asserted that each art had unique characteristics. Description was the rightful province of the painter; the presentation of progressive motion, that of the poet. With this in mind, Lessing cautioned poets not "to compete with the painter on a point on which they must of necessity be surpassed by him." Whitman found added encouragement in a passage he marked for future reference. In it Whelpley stressed Lessing's insistence that the poem be conceived as a unified whole, with "every word . . . [having] a vital connection with every other in the entire work, and every word . . . expressing, an act which is a part of the entire action, the whole, together and apart, having a defined and certain aim." In a related line, Whelpley yoked such thinking to the development of a national school of literature. "If a new school of constructive art shall ever arise in this country," Whelpley argued, Lessing's directives "must be taken as its corner-stone."[56]

Whitman once warned himself to be on guard against making his poems "in the spirit that comes from the study of pictures of things—and not

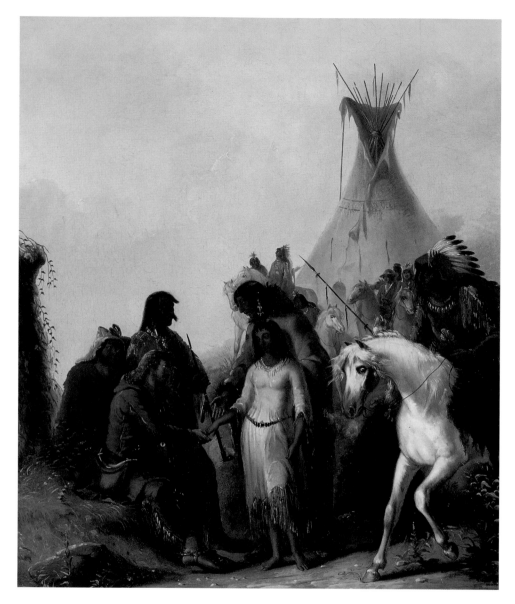

FIGURE 4 Alfred Jacob Miller, *The Trapper's Bride*, 1850

from the spirit that comes from the contact with real things themselves."[57] Shortly after the publication of *Leaves of Grass*, he contrasted his approach with that of his fellow poets: "The theory and practice of poets have hitherto been to select certain ideas or events or personages, and then describe them in the best manner they could, always with as much ornament as the case allowed. Such are not the theory and practice of the new poet. He never presents for perusal a poem ready-made on the old models."[58] Despite such denials, though, Whitman embraced a number of sister-art strategies favored by his contemporaries. He likened himself to a painter in "To You" (*LG* 234),

described "(what we call poems being merely pictures)" in "Spontaneous Me" (*LG* 103), and in "The Song of the Answerer," he grouped the artist with the builder, geometer, chemist, anatomist, and phrenologist as those who "underlie the maker of poems, the Answerer" (*LG* 170). On occasion, he crafted entire poetic passages out of his encounters with actual works of art.

The extended verbal description of the marriage of a trapper and an Indian woman in "Song of Myself," for example, reveals a studied familiarity with Alfred Jacob Miller's popular image on the same theme (fig. 4).

> I saw the marriage of the trapper in the open air in the far-west . . .
> the bride was a red girl,
> Her father and his friends sat near by crosslegged and dumbly
> smoking . . . they had moccasins to their feet and large thick
> blankets hanging from their shoulders;
> On a bank lounged the trapper . . . he was dressed mostly in skins . . .
> his luxuriant beard and curls protected his neck,
> One hand rested on his rifle . . . the other hand held firmly the wrist of the
> red girl,
> She had long eyelashes . . . her head was bare . . . her coarse straight
> locks descended upon her voluptuous limbs and reached to her feet.[59]

Despite differences in details, the similarities between Whitman's account and Miller's several versions of *The Trapper's Bride* suggest how strongly Whitman connected Miller's representation with the democratic themes of his verse.[60] As Ed Folsom has observed, "this marriage on the frontier between the East and the West, the civilized and the savage, anticipates the birth of Whitman's new American character, emerging from the encounter of Europe and the New World, the refined civilization of the past penetrating the raw topography of the future."[61] No less penetrated is the liminal space of Miller's painted representation. Whitman forcefully recast the scene in the first-person narrative synonymous with his purposes. Direct personal experience, not experience mediated through the actions and visions of others, formed the core of Whitman's new democratic poetry and compelled him to transform his visual appropriations into vibrant, participatory events.

Whitman's borrowings from the visual arts were not restricted to his poetry. In 1862, seven years after the initial publication of *Leaves of Grass* and under the pen name "Velsor Brush," Whitman published a series of articles in the *New York Leader* under the heading "City Photographs."[62] He derived the pseudonym from the names of two of his ancestors (Louisa Van Velsor and Hannah Brush), but its painterly implications recalled Washington Irving's earlier trans-genre invention, Geoffrey Crayon.[63] Like Crayon's *Sketch-Book*, Whitman's "City Photographs" series consisted of abbreviated descriptions, character sketches, and observations from life, and like Irving, Whitman referred to his vignettes as "sketches." Employing the terms "photograph" and "sketch" interchangeably, Whitman made no distinction between the newer mechanical art and its more traditional counterpart, strikingly indicat-

ing the ecumenical foundations of his enthusiasm for the visual arts.

Far more than the isolated work of art, the exhibition experience stimulated Whitman's revisionist poetics. Whitman is known to have been a frequent visitor to the large Exhibition of the Industry of All Nations that opened in an eye-catching, glass-domed structure in July 1853 in what is now Bryant Park. "I went a long time (nearly a year)," Whitman wrote,

> —days and nights—especially the latter—as it was finely lighted, and had a
> very large and copious exhibition gallery of paintings (shown at best at night,
> I tho't)—hundreds of pictures from Europe, many masterpieces—all an
> exhaustless study—and, scatter'd thro' the building, sculptures, single figures
> or groups—among the rest, Thorwaldsen's "Apostles," colossal in size—and
> very many fine bronzes, pieces of plate from English silversmiths, and curios
> from everywhere abroad—with woods from all lands of the earth—all sorts of
> fabrics and products and handiwork from the workers of all nations.[64]

Here works of every imaginable size, quality, and thematic variation vied for the viewers' attention in a riotous cacophony of visual, intellectual, and emotional display. In an era noted for its large exhibitions, the Crystal Palace housed the largest ensemble of paintings and sculpture yet seen in America. Period engravings show displays densely hung from floor to ceiling and wall to wall, with very little space intervening (fig. 5). Large works were frequently hung over smaller ones, their upper edges projecting out several inches from the wall to facilitate viewing. In such an environment, the artworks seemed literally to bombard the spectator with unresolved tensions and juxtapositions. A similar exhibition strategy, modified only by the works' smaller scale, general lack of color, and narrower thematic range, shaped the viewing experience in the newer daguerreotype galleries. Once, while reviewing an exhibition at Plumbe's Daguerreotype Gallery, Whitman described with glee the fascination of seeing so many images together in one space. "What a spectacle!" he exclaimed.

> In whatever direction you turn your peering gaze, you see naught but human
> faces! There they stretch, from floor to ceiling—hundreds of them. Ah! what
> tales might those pictures tell if their mute lips had the power of speech!
> How romance then, would be infinitely outdone by *fact*.[65]

The poem "Pictures" records Whitman's earliest exploration of the poetic potential of the exhibition experience. Most likely written during his association with the Brown group, the poem employs the then-popular conceit of representing the imagination as a picture gallery of the mind. The poem describes "a little house" that is "round" with "many pictures hanging suspended." Although small, the house "has room enough—in it, hundreds and thousands [of pictures], all the varieties" (*LG* 642). Whitman's poem follows closely suggestions in an undated notebook that advised creating a "Poem of Pictures. Each verse presenting a picture of some characteristic scene, event,

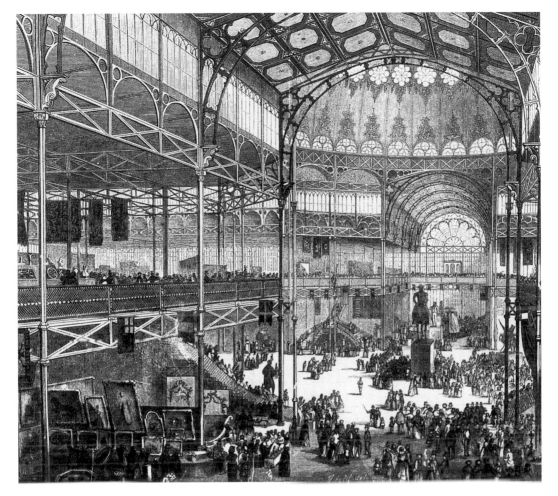

FIGURE 5 Interior of the New York Crystal Palace

group or personage—old or new, other countries or our own country."[66] In the poem these pictures range from panoramic landscapes and genre scenes to intimate still lifes and portraits, historical subjects, and evocative tales of the imagination. Briefly sketched, each scene represents the verbal equivalent of a work of visual art. The themes reflect the range and types of art displayed in the city's public galleries and on view at the Crystal Palace. Thus Whitman identifies "Lucifer's portrait—the denied / God's portrait" (*LG* 645), "scenes painted from my Kansas life—" (*LG* 646), "[a]nd here, (for I have all kinds,) here is Columbus setting / sail from Spain on his voyage of discovery" (*LG* 644). There are also scenes of Adam and Eve in the Garden of Eden, a fish market, a still life with "flowers and fruit" (*LG* 645), and "a picture of once imperial Rome, full of palaces" and "masterful warriors" (*LG* 643).

A recent critic has suggested that Whitman's poem represents "a direct poetic reply" to Alfred, Lord Tennyson's "Palace of Art," recast in more immediate and democratic terms.[67] Closer to home, though, were any number of similar examples. In "Art," Emerson likened his fellow human beings to

the statuary in an art gallery, and the minor poet Lily Graham prefaced her 1851 poem in *The Knickerbocker*, "A Heart-Picture," with an excerpt from one of Percy Bysshe Shelley's poems, which told of "A picture, drawn within the brain, / By Memory's faithful pencil."[68] Bryant was similarly fond of such tropes, writing in 1851 to thank his friend Charles Sedgwick "for some of the finest landscapes in the picture-gallery of my memory, collected during our late pleasant visit to Berkshire."[68] The multi-paned, glass-enclosed dome at the Crystal Palace exhibition, like a cranial version of Emerson's "transparent eyeball," offered the viewer a sweeping, panoramic experience of the hundreds of objects displayed within. (Similarly, the chart of bumps used by phrenologists projected a bare cranium divided into a proliferation of bounded, numbered zones abutting one another like framed pictures in a gallery [fig. 6]. Whitman, in fact, once remarked on the importance of art exhibitions in the development of bump seventeen on Fowler's phrenological chart, the bump identified with conscientiousness.)[70]

As long ago as the 1920s, Emory Holloway proposed that Whitman's "plan" for *Leaves of Grass* was "to make an exhibition."[71] The naturalist John Burroughs, Whitman's friend, once termed the catalogues "one line genre word paintings" and judged "every line . . . a picture."[72] They detail in clear, concise, and graphically compelling language the excitement and visual range of the material in the Manhattan and Brooklyn galleries Whitman frequented during the 1840s and 1850s. Images of contemporary, historical, and imaginary scenes compete for the reader's attention like paintings on a gallery wall. Like their visual counterparts, Whitman's verbal catalogues arrest the reader's attention by their forceful, immediate presentation. Miles Orvell and Justin Kaplan have argued for the singular importance of the daguerreotype gallery in the formation of Whitman's catalogue technique.[73] More recently, Ed Cutler and Paul Benton have proposed significantly broader models in their assessments of Whitman's fascination with the Crystal Palace exhibition. Cutler has emphasized the formative significance of that display's eclectic mélange of fine and industrial production, while Benton has stressed Whitman's focus on the traditional displays of painting and sculpture.[74] A closer examination of the "pictures" in Whitman's early poem of the same title provides a rare opportunity to examine this strategy in its infancy. The poet presents mythical and biblical scenes,

FIGURE 6 Cover of L. N. Fowler, *The Illustrated Phrenological Almanac for 1851*

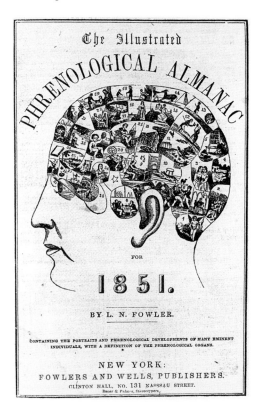

contests between the gods and warring armies, exotic and historical displays, and portraits of deceased world leaders. All were common fare for American and European academic painters at the time, yet totally unavailable to the lens of contemporary daguerreotypists. On the basis of this evidence, Whitman clearly derived the strongest incentive for his catalogue technique (at least in its initial manifestation) from his frequent encounters with the grand salon-style exhibitions of painting and sculpture sponsored by organizations like the National Academy of Design and the Brooklyn Art Union.

In 1850, when the minutely detailed canvases of Düsseldorf-trained artists were enjoying particular vogue in the New York galleries, Whitman cautioned his contemporaries not to equate exactness of presentation with spiritual content. "Whatever the piece may be," Whitman wrote, "landscape, historical composition, portrait, comic group, even still life, it is the spiritual part of it you want above all the rest. That is its soul, its animose, and makes live art. The rest is but the matter, necessary to give embodiment to the life; but what is matter without life? The most exquisite draughting, the finest coloring, and the minutest truth to the mere forms of nature, are but the cold, dead corpses of art, if they have not the vivifying principle."[75] Five years later, in the Preface to *Leaves of Grass*, Whitman invoked this same principle to distinguish the efforts of the new poet from the more conventional achievements of his forebears. Speaking now about poetry, Whitman explained that "folks expect of the poet to indicate more than the beauty and dignity which always attach to dumb real objects . . . they expect him to indicate the path between reality and their souls." Just as the finest art was not measured solely by the artist's strict adherence to the formal foundations of the discipline, so in the verbal arts "poetic quality is not marshalled in rhyme or uniformity or abstract addresses to things but is the life of these and much else and is in the soul" (*LG* 716).

Whitman's immersion in the visual culture of antebellum New York strengthened his commitment to the mutuality of verbal and visual modes of representation. Friendships with artists and frequent visits to the area's art galleries and exhibition venues honed his understanding of the artistic process while solidifying his support for the arts in a democracy. Whitman was particularly captivated by the powerful immediacy with which the visual arts attracted and held the viewer's attention. As he gathered unto himself the forces necessary to launch his radical new poetry, his experiences in the visual arts proved a valuable ally and significant point of departure. They would continue to nurture his creative thinking for years to come. As he exclaimed in "Song of Myself," "Myself moving forward then and now and forever, / Gathering and showing more always and with velocity" (*LG* 60).

Chapter 2

Masks, Identity, and Representation

WHITMAN ACKNOWLEDGED a special enthusiasm for portraiture, which he often commented on in his writing. "There is always, to us, a strange fascination in portraits," Whitman explained following a visit to Plumbe's Daguerreotype Gallery. "We love to dwell long upon them—to infer many things, from the text they preach—."[1] For him, some of the most compelling inferences centered on matters of identity. These issues generated even more intense scrutiny when the poet himself was the subject of the artist's gaze. Like his friend and colleague William Cullen Bryant, Whitman repeatedly indulged his passion for portraiture by encouraging a broad array of artists, most of them friends and sympathetic admirers, to paint, sculpt, draw, photograph, and engrave his likeness. These mute products of the artist's hand ran the gamut from caricatures and sketches to formally staged portraits. Particularly revealing are those representations that peer out at the reader from the pages of *Leaves of Grass*. Together they constitute the most tangible legacy of Whitman's belief in the creative reciprocity between verbal and visual modes of representation. Late in life Whitman affirmed that each of the portraits selected for inclusion in the book "has its place: has some relation to the text . . . whether the fortunate (or unfortunate) reader sees it or fails to see it."[2] These carefully constructed efforts at visual self-fashioning mediate the dynamic interface of the poet, his audience, and the poetic text. Like the text they inhabit, the images challenge established repertoires of artistic representation. In their combination of denotative and connotative functions, these creative constructs give visual form and physical dimension to the multiple selves embedded in the text while acknowledging the fluidity of the image-making process.

Much has been written about the engraved daguerrean portrait with which Whitman introduced himself to an unsuspecting American public in

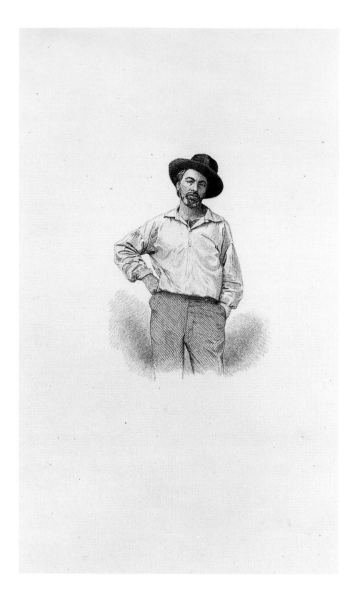

the summer of 1855 (fig. 7). In a pose exuding what one London critic termed "an all-pervading atmosphere of Yankee-doodle,"[3] Whitman registers his dissent "not only from the design of books and the portrayal of authors, but from ideas about public decorum and cultural propriety," as Alan Trachtenberg has so ably observed. In lieu of the formal attire and seated posture expected of a professional man of letters, Whitman presents his reader with a defiant but accessible workingman-poet. He stands relaxed and supremely self-confident, "at ease with himself, touching his own body, deferential to no one and accessible to all."[4] His open-necked work shirt exposes a coarse undershirt beneath, while a broad-brimmed hat worn jauntily back from his brow projects the casual appearance of one dressed more for the pavement or the prairie than the parlor.[5]

This highly unorthodox effort at self-fashioning was central to Whitman's strategy of establishing himself—"Walt Whitman, an American, one of the roughs, a kosmos, of Manhattan the son"[6]—as the protean, if fictive, persona of his verse. Above all, Whitman sought to connect this visual representation's air of open nonchalance, defiant workingman's costume, and barely concealed sexuality with the multiple unorthodoxies of the text. The book "fairly staggers us," he wrote in one of several unsigned reviews. "Its author is Walter Whitman, and the book is a reproduction of the author. His name is not on the frontispiece, but his portrait, half length, is. The contents of the book form a daguerreotype of his inner being, and the title page bears a representation of its physical tabernacle."[7] Several of the book's reviewers commented specifically on the work's emblematic power. One London reviewer detected the "singularity of the author's mind" in the "roystering blade" represented in the frontispiece. Another found this "portrait engraved on steel of the notorious individual who is the poet presumptive" expressive of

all the features of the hard democrat, and none of the flexible delicacy of the civilised poet. The damaged hat, the rough beard, the naked throat, the shirt exposed to the waist, are each and all presented to show that the man to whom these articles belong scorns the delicate arts of civilisation. The man is the true impersonation of his book rough, uncouth, vulgar.

Boston writer Charles Eliot Norton put it most succinctly when he observed that "the portrait affords an idea of the essential being from whom these utterances proceed."[8]

Whitman's frontispiece constitutes what W. J. T. Mitchell calls an imagetext, a composite or synthetic work that fuses image and text.[9] The structural and thematic unorthodoxies of the verse are recast in the concentrated forms of this ideologically resonant engraving. The self-representation reifies essential features of the poetic text. "The portrait," Whitman asserted, "in fact is involved as part of the poem."[10] In lieu of the peripheral status accorded most frontispieces, Whitman's engraved image was, as Ed Folsom has demonstrated, "as essential a part of the book as the poetry was, and . . . demanded the same athletic involvement from the reader."[11] Part of that essentiality was the image's role in helping the reader "feel at home in the natural world."[12] "Before anything else," writes Jeffrey Steele, "'Song of Myself' is an audacious work of self-dramatization."[13] The engraving gives concrete expression to the poet's self-actualization and simultaneously assists the reader in visualizing and eventually inhabiting his or her own new model of being.

Whitman was actively involved in the portrait's construction. The engraving originated as a daguerreotype, the result of an impromptu photo session in the Brooklyn studio of Gabriel Harrison.[14] When technology prevented Whitman from reproducing the daguerreotype directly, he had it engraved in steel by Samuel Hollyer, a young British engraver who would achieve artistic recognition for his finely crafted portrait engravings after the Civil War.[15] Years later Hollyer recalled how Whitman had inserted himself into the engraving

process by insisting on "one or two trifling alterations." Only upon their completion did Whitman judge the image "to his entire satisfaction."[16] Neither the nature nor the extent of these alterations is known today. Still, the incident speaks to the importance Whitman attached to the engraving's inaugurating presence within the discursive space of the twelve as-yet-unnamed poems that followed. Whitman's insinuation of himself into the engraving process testifies both to his easy familiarity with artistic procedures and to his commitment to fashioning an image emblematic of his poetic text.

Hollyer's engraving after Harrison's daguerreotype supports the sharp focus specific to the art of the daguerreotype and simultaneously acknowledges the linear tradition of portrait engraving. The element of drawing, manifest in the use of the roulette to convey textures and the illusion of three-dimensionality, draws attention to the image's handcrafted status. So, too, do the lines of the pant legs, which diminish in verisimilitude toward the bottom of the image until they register as little more than suggestions of either trouser or leg. The image, as Folsom has pointed out in an illuminating essay, creatively "advertises its constructedness."[17] Far more than the silent and immobile figures Whitman admired on the walls of Plumbe's Daguerreotype Gallery, Hollyer's engraving after Harrison's daguerreotype contains traces of its own evolution from unfinished sketch to finished representation. Engravings, by their very nature, celebrate process, a quality essential to Whitman's poetic enterprise and one that distinguished his work from that of other mid-nineteenth-century poets. The initiating hand of the artist remains forever in view, always present in the work of art, doubling, as it were, the viewer's response to the image. The engraved status of the image, as much as the disposition of the figure represented, invokes the essential complementarity of text and image that Whitman sought.

Whitman repeated the Hollyer engraving in the 1856 edition, but in 1860 he sought a radically revised portrait—one indicative of significant shifts in his personal and poetic selves. At the time Whitman was a regular at Pfaff's beer cellar, then the center of New York's bohemian community and a gathering spot for an emerging generation of artists, writers, and actors. For the first time in his life, Whitman found himself "something of a local celebrity: a literary rebel and an eccentric . . . in the company of a drinking crowd almost half his age."[18] The group included Henry Clapp Jr. and Fitz-James O'Brien, editor and drama critic, respectively, for the *Saturday Press*, a short-lived publication that promoted Whitman and his verse with great entrepreneurial enthusiasm. Also present were actress Ada Clare, comedian Artemus Ward, painter Elihu Vedder, illustrator John McLenan, and caricaturist Frank Henry Temple Bellew. Vedder, who lived nearby at Broadway and Bond, would later enjoy a reputation as one of the century's most accomplished visionary painters. Recently returned from a productive period of study in Florence, he visited Pfaff's in the company of a group of young artist-illustrators, many of them, like himself, employed by *Frank Leslie's Illustrated Newspaper.* Their task was to make engravings of Civil War battles, sometimes, he ruefully admitted, "even before [the battles] had taken place."[19] And although Vedder

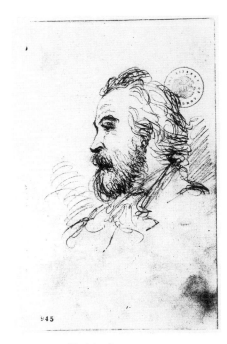

FIGURE 8 Sketch of
Walt Whitman, c. 1860

FIGURE 9 Sketch of
Walt Whitman, c. 1860

considered Whitman one of Pfaff's lesser literary figures, he found that the
atmosphere stimulated significant visual-verbal correspondences, particularly
among those with strong visionary or Orientalist sensibilities like his own.[20]

Evidence suggests that matters concerning Whitman's self-image fig-
ured prominently in the group's discussions, encouraged no doubt by prodding
from the poet himself. Particularly provocative are several drawings of the
poet, some bordering on caricature, that are interspersed with drawings of
unidentified individuals throughout one of Whitman's notebooks. All of the
drawings of Whitman appear to be by the same unknown hand, whose sophis-
tication rules Whitman out as a possible source. Three of the four center on
the head (or, in one case, the face). Only one is completely sympathetic, a sen-
sitive and closely observed rendering of the poet's head in profile (fig. 8). In
three, a darkened nose, the signifier of inebriation (fig. 9), reinforces
Whitman's own observation that Pfaff's was a place "where the drinkers and
laughers meet to eat and drink and carouse."[21] And although Whitman—the
author of an earlier temperance novel—was not known to have been a heavy
drinker, the drawings suggest otherwise.

More noteworthy even than these markers of inebriation are the ways
in which two of the drawings humorously exaggerate qualities that connect
Whitman with the constructed persona of his verse. The floppy brim and over-
sized crown of the hat worn by one of the figures seem to refer whimsically to
Whitman's insistence, both in person and in his poetry, on wearing his hat as
he pleased "indoors or out" (fig. 10).[22] In the most obviously caricatural of the
drawings and the only one to represent him at full length, Whitman's head and

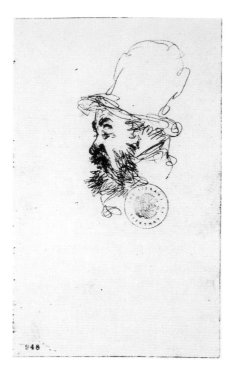

FIGURE 10 Sketch of
Walt Whitman, c. 1860

FIGURE 11 Sketch of
Walt Whitman, c. 1860

extended right hand are greatly enlarged (fig. 11). Similarly exaggerated but more abstractly rendered is a giant phallus paralleling the gesticulating hand. The boisterously extended hand, the phallus, and the animated stance collapse the space between Whitman and the flamboyant persona of his verse. The gesturing right hand visually enacts the democratic persona of "Song of Myself," who with his "right hand points to landscapes of continents, and the plain public road."[23] The thrusting phallus, although crudely constructed and lacking altogether the myriad subtleties of the text, dramatically affirms Whitman's complicity in the poetry's explicit sexual content.

A similar conflation of the real and the fictive characterizes John McLenan's whimsical sketch of Whitman. In it a cocky, bust-length drawing of the poet is surrounded by smaller drawings of four unidentified males, perhaps other Pfaffian regulars. A verbal text accompanies each drawing. Ablaze in a high-crowned hat, open-collared dress shirt, and loosely knotted tie, Whitman radiates defiant self-confidence (fig. 12). The phrenological readings that accompany two of the other (bareheaded) caricatures on the page suggest that Whitman's likeness may have been conceived in a similar burst of phrenological investigation, despite the hat that obscures the identifying contours of his head.[24] Whitman's enthusiasm for phrenology was no secret. It dated back at least to 1849, when he sat for his first phrenological reading.[25] The crescent-shaped text accompanying Whitman's representation exudes the bravado characteristic of one of Barnum's streetside hawkers.

FIGURE 12 John McLenan, *caricature of Walt Whitman*, c. 1860

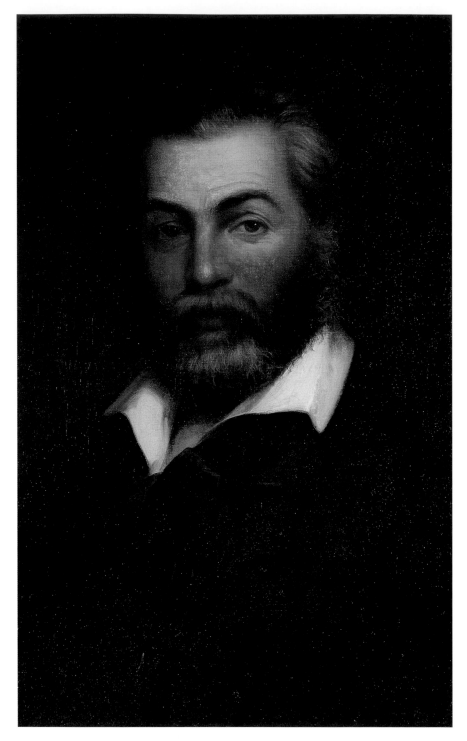

FIGURE 13 Charles Hine, *Walt Whitman*, 1860

The head Ladies and Gentlemen, shows the want of knowledge in parents selecting a profession suitable for a youth—Here is a case in point: Gifted by nature, this subject with a head that is swollen with literary talent is alowed [sic] to go to grass—With all the fire and fancy of a Byron. This subject has been toiling, dealing and pincing over and amongst Clams, Shedders and Yaups from child hood up—I turn your attention to Literature—and the Temple of Fame will have an occupant, Shure.

Irreverent and deliberately unsophisticated, the text projects a witty defiance akin to that of the drawing. Its author seems a near relative of the "boatmen and clamdiggers" with whom the poem's earthy persona "went and had a good time."[26] Both text and image also enjoy a good laugh at the expense of the book's title. (The figure's scratchy hair and beard construct a visual pun on the grass in Leaves of Grass.) Together, these verbal and visual texts project Whitman's optimism on the eve of the publication of the 1860 Leaves of Grass. With his tipped hat and showy necktie, McLenan's rakish bard anticipates great literary success—the "Temple of Fame" noted in the text.

Charles Hine, the Connecticut-trained artist whose painted portrait of the poet formed the basis for Whitman's visual representation in the 1860 edition, may have joined Whitman and his friends at the celebrated beer cellar following his move to New York in 1857. Whitman and Hine met shortly after Hine's arrival in New York and remained friends until Hine's untimely death some fifteen years later.[27] Although little known today, by the late 1860s Hine would enjoy sufficient stature as a portraitist to be considered a possible successor to Charles Loring Elliott, New York's premier portrait painter.[28] Hine hoped to exhibit his portrait of Whitman at both the prestigious National Academy of Design and in Boston, "where the Fellows will see it."[29] It inscribes aspects of the professional aspirations of both painter and sitter. In place of the bumptious, devil-may-care attitude celebrated in the Pfaffian sketches, Hine's Whitman projects an air of elegant refinement and detachment (fig. 13). The poet has decisively exchanged his "barbaric yawp" for the mantle of respectability. No longer the coarsely dressed individualist, Hine's Whitman sports a dignified double-breasted charcoal gray coat, crisp white-collared shirt, and ample silk necktie. The poet's full but neatly trimmed beard, ruddy cheeks, and steady gaze confront the viewer with a direct and absorbing sense of his own humanity. Only the open-necked shirt, which even with a necktie refused to be buttoned snugly at the neck, recalls the former iconoclast celebrated in the Hollyer/Harrison representation.[30]

Hine's desire to advance his standing among the country's conservative artistic elite with this painting provides telling evidence of how far removed the likeness was from both the Pfaffian sketches and the rough-hewn image with which Whitman had launched his initial book of verse just five years before. To include the likeness in the expanded 1860 edition of his poetry, Whitman had Hine's painting engraved by Stephen Alonzo Schoff, an engraver famous for his portraits of William Penn and Emerson, among others (fig. 14). A comparison of the engraving and the surviving Hine painting reveals a

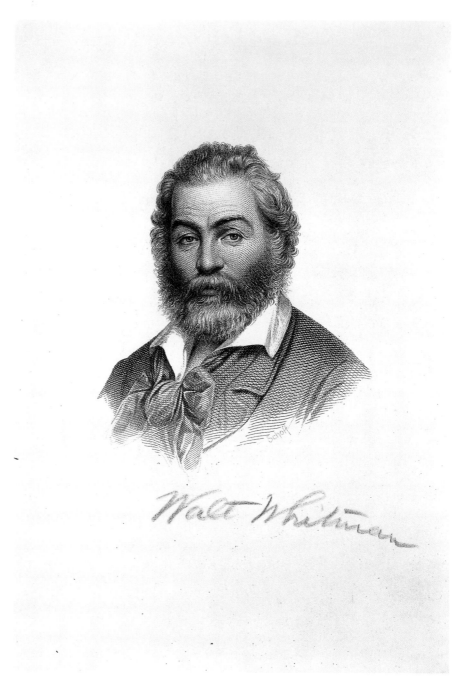

FIGURE 14 Stephen Alonzo Schoff,
steel engraving after Charles Hine,
Walt Whitman, 1860

number of distinctive deviations, however. While some resulted from techni-cal differences between the two media, others clearly did not. Together, these multiple transformations of the Hine original—all done under Whitman's watchful eye—suggest a highly self-conscious and carefully orchestrated effort to reconstitute the paradigmatic relationship between text and image intro-duced in the 1855 *Leaves of Grass.*

The tonal emphasis in the Hine painting concentrates attention on the illuminated face and the white collar that frames it. By comparison, the linear foundations of the engraving process establish two focal centers: the poet's face and his flamboyant tie. The greater attention accorded the necktie, together with the more manicured treatment of the poet's hair and beard, recast the dignified presence in the painting as a dandy, one more akin to the caricatures. Also of note is the replacement of the painting's dark background, which enveloped the poet in the reassuring calm of tradition, with the shrill white-ness of the blank page.

The Schoff engraving—even more than the Hine portrait—makes visible both Whitman's newfound status among New York's bohemian writers and his emboldened expectations for the public success of his book. The favor-able circumstances surrounding the publication of the 1860 edition, coupled with Whitman's enhanced public standing among the literary wits at Pfaff's, bolstered his confidence that the American public would now, at long last, openly embrace him as its national bard. In marked contrast to the first two editions of *Leaves of Grass* (which Whitman published privately and at his own expense), the 1860 edition enjoyed both the able publishing skills and enthusiastic marketing abilities of the Boston firm of Thayer and Eldridge. These "go-ahead fellows," as Whitman termed them, proved nearly as auda-cious as Whitman himself in promoting his work.[31] *Leaves of Grass Imprints,* the small pamphlet of advertisements that they issued together with the larg-er volume, contained an eclectic sampling of reviews from previous editions, including several from Whitman's own pen. Similarly encouraging were the articles, editorials, and excerpts published in Clapp's *Saturday Press* that had begun to appear even before the volume was issued and continued throughout the remainder of the year.[32]

As a projection of the public success Whitman sought, Schoff's engraving seemed calculated to elicit accolades like those offered by the *Brooklyn Standard,* which in November hailed Whitman as "*de facto* our poet laureate."[33] But this image of a potential poet laureate inscribes other, more conflicted meanings as well, meanings not present in either the Hine painting or the Pfaffian sketches. The face in Schoff's engraving has a considerably more troubled expression, especially in the area of the eyes, where a pro-nounced frown line has been added between the eyes and below the wrinkled brow. Whitman seems surely to be implicated in this telling transformation of the Hine painting. The disquieting gaze and furrowed brow suggest an inner self radically at odds with the comfort and prosperity registered by the cos-tume and neatly coiffed hair and beard. Taken as a whole, the likeness conveys

the crisis of identity that threatened Whitman's personal and public selves on the eve of the Civil War and that turned this volume into what Betsy Erkkila has termed "a kind of palimpsest" of "mixed and contradictory impulses."[34] The boisterous and assertive national bard now confronted both the unraveling of the Union and the emergence of a more intimate side of his own nature. The "Calamus" poems, which made their debut in this edition, challenged the expansive, universalizing tendencies of earlier poems, offering instead the quiet, inward, extremely personal closeness of lovers.

In several highly revealing poems new to the 1860 edition, Whitman explored the conflict between his public and private selves in ways that elucidate the Schoff engraving's ambiguity. In one of the most illuminating of these, originally titled "Calamus. 40," Whitman employed the same trope, a portrait likeness, to scrutinize his public self—"That shadow, my likeness, that goes to and fro, seeking a livelihood, chattering, chaffering." Pausing for a moment, he observed:

How often I find myself standing and looking at it where it flits,
How often I question and doubt whether that is really me;
But in these, and among my lovers, and carolling my songs,
O I never doubt whether that is really me.[35]

An even more explicit expression of self-doubt, one embracing the whole of Whitman's being, can be found in the poem now called "As I Ebb'd with the Ocean of Life."

Oppressed with myself that I have dared to open my mouth,
 now, that, amid all the blab whose echoes recoil upon me, I have
 not once had the least idea who or what I am,
But that before all my insolent poems the real Me still stands untouched,
 untold, altogether unreached[36]

Like the portrait in "Calamus. 40," the well-dressed figure in the Schoff engraving projects the outward, public side of Whitman's persona, that side "that goes to and fro, seeking a livelihood." The inner private self, inscribed in the poet's frowning facial expression, recoils from this constructed public persona, just as the "Calamus" poems turn away from the assertive public stance that infuses much of the earlier poetry.

This dichotomy—the contrast between inner and outer, public and private, personal and political—finds a visual analogue in Schoff's Janus-like figure, which is itself a trope for the multiple and frequently contradictory selves represented in the verse. This portrait, which Gay Wilson Allen judged "the most artificial and uncharacteristic portrait that Whitman was ever to use in any of his books,"[37] actually represents the first visual acknowledgment of the volume's competing poetic voices. Schoff's engraving rejects the view that selfhood is stable and unchanging, enacting instead a selfhood that is fluid, unstable, and inventive. As such it inaugurates a dynamic new perspec-

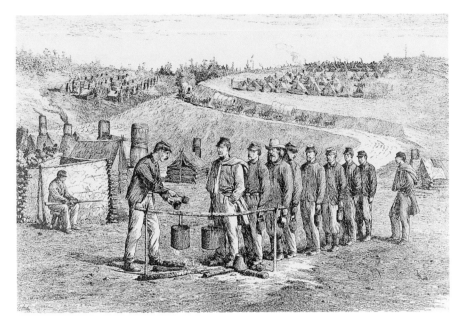

FIGURE 15 Edwin Forbes, *Fall in for Soup!*

tive on the relationship between text and image. And although Whitman would never again deploy Schoff's representation as the visual entry point into his verse, he seems clearly to have had it in mind when, on the eve of the publication of selections of his verse in England in 1868, he wrote Moncure Conway to assure him of his conformity with the traditions. "[T]he author of Leaves of Grass," Whitman intoned,

> is in no sense or sort whatever the "rough," the "eccentric," "vagabond" or queer person, that the commentators . . . persist in making him. He has moved, & moves still, along the path of his life's happenings & fortunes . . . with entire serenity & decorum, never defiant even to the conventions . . . ; and offering to the world, in himself, an American Personality, & real Democratic Presence, that not only the best old Hindu, Greek, and Roman worthies would at once have responded to, but which the most cultured European, from court or academy, would likewise, on meeting to-day, see & own without demur.[38]

A little more than two years after the publication of the 1860 *Leaves of Grass*, Whitman abruptly left New York to tend to his brother George, who had been wounded during the Civil War. Whitman would never again live in New York, nor would he again participate in the kind of literary high jinks that had sustained him at Pfaff's beer cellar. Whitman traded the comfort and stimulation of Pfaff's for the grim realities of an army campsite near Falmouth, Virginia. Finding his brother only slightly wounded, Whitman immersed himself, if only briefly, in the simple routines of camp life. He took pride, as he wrote, in the "endurance, perseverance, and daring" of the young

soldiers and enjoyed the warm camaraderie of the nighttime singing and story-telling "among the crowded crouching groups."[39] While at the camp Whitman encountered Edwin Forbes, a young illustrator on assignment for *Frank Leslie's Illustrated Newspaper*, whom he may have met earlier at Pfaff's. A native of New York County, New York, Forbes had trained as a painter specializing in animals, landscapes, and genre scenes before joining what became known as the Bohemian Brigade. With minimal equipment—usually no more than a large portfolio strapped over his shoulder—Forbes moved freely about the Union camps, compiling a pictorial record of the war effort. His preferences lay with the foot soldiers rather than the generals and with the daily routines of camp life over the more dramatic scenes of battle.[40] His sketches, like those of other illustrators, vividly complemented the narratives submitted by the writers. This complementarity of word and image greatly appealed to Whitman, who described with admiration the "characters and groups" in the camp as "worthy of Zenophon to narrate and Rembrandt to paint."[41]

Perhaps at Whitman's suggestion, Forbes included Whitman in one of his sketches of camp life. *Fall in for Soup!* (fig. 15), as the engraving based on the sketch was called, brims with the democratic spirit of which Whitman sang, the spirit that would dominate both *Drum-Taps*, his collection of Civil War poems published in 1865, and *Memoranda During the War*, which followed a decade later. In the engraving Whitman stands in a soup line with a group of Union soldiers. Whitman is distinguished by his greater age, full beard and hair, and broad-brimmed, high-crowned hat, but like the others in the group, he awaits his turn at the communal soup pot, tin cup in hand. The poet's coarse clothing and humble demeanor constitute a striking departure from the flamboyant urban dandy who faces the viewer from the pages of the 1860 *Leaves of Grass*. As the only non-soldier in the group, Whitman stands shoulder to shoulder, "a strong man, erect" among his beloved "unsurpass'd heroes."[42] In this quiet celebration of male comradeship, the engraving gives visual form to one of the essential themes of Whitman's verse—particularly of his Civil War poems. As Folsom has argued, "in his photographs with other people, Whitman used the others as props in the staging of radically new versions of the self, new subject positions that destabilized traditional categorizations of human relationships and that portrayed alternative familial and social bonds that he knew an emerging democracy would demand."[43] Forbes's engraving, one of the very few non-photographic representation made from life to locate Whitman in the company of others, performs a similar function. In its emphasis on male bonding and the egalitarian spirit of the camp, it both celebrates a new breed of common hero and constructs a dynamic alternative to the traditional single-family unit. Occupying almost the exact center of this exclusively male group, Whitman establishes with the men an enduring sense of community, one that extends well beyond the immediate gathering in the foreground to include those approaching along the winding road in the distance.

More than a decade earlier, Whitman had called on an artist to express the genre potential of his own life experiences.[44] Forbes's engraving fulfills that long-standing desire. Like the narrative vignettes of Whitman's verse,

this scene records in vivid but succinct detail a scene made memorable not by its dramatic incident, but by its quiet, quotidian character. To the left, a seated soldier keeps watch, while in the distance a caravan of baggage wagons pulled by six-mule teams advances along a curving, rutted road. Nearby and on the distant hillside are the soldiers' log and canvas huts, their distinctive mud-and-barrel chimneys puffing smoke to ward off the winter chill. (Whitman described just such a group of chimneys "lengthened out by a barrel with both ends knocked out" in notes made at the camp.)[45]

In early January 1863, Whitman left the camp and settled in Washington, D.C. During his decade-long residence in Washington, he ministered tirelessly to the war's many casualties confined in the city's makeshift hospitals. A visit to the studio of Vinnie Ream (the youthful sculptor of President Lincoln whom Congress would shortly commission to model a full-length portrait of Admiral Farragut) and friendships with Alexander Gardner and Mathew Brady, pioneers in the grisly art of battlefield photography, gave added dimension to his verbal tributes to the war and its suffering.[46] As Whitman's health declined over the course of the decade, precipitated by the physical and psychological turmoil of the war, the self-assurance of his prewar poetry declined with it. He struggled to redefine himself and his poetry in the war's aftermath, temporarily abandoning his practice of exploring the constructed persona of his verse by means of visual representations. Neither the 1867 nor the 1871–72 editions of *Leaves of Grass* bore portraits of the poet. Nor did any of the smaller books of prose and poetry issued during his time in Washington.[47] Whitman would resume the practice only in the 1870s, following the death of his mother and his relocation to the Philadelphia area.

Whitman never intended to settle in Camden, New Jersey, when he hastened there in May 1873 to be at the bedside of his dying mother. His already fragile health had deteriorated markedly following his mother's death, though, and he had little choice but to remain. What Whitman initially considered a temporary displacement became his home for the remainder of his life.[48] The poor and largely industrial city of Camden offered few of the amenities and virtually none of the intellectual and cultural advantages that Whitman had enjoyed in both Washington and New York.[49] The city's proximity to Philadelphia was its most distinctive asset, but even that was initially off limits to Whitman due to his poor health. Until 1884, when he bought his own small house on Mickle Street, Whitman boarded with his brother George and sister-in-law Louisa, first at 322 Stevens Street and then in larger quarters just a block away at 431 Stevens Street. Despite the acknowledged comfort of his brother's home, Whitman remained despondent over his mother's death and physically infirm for months. He wrote his friend Charles Eldridge that he had "bad spells most every day, & sometimes very bad ones."[50] By September he was still confined largely to the house and feeling frustrated by the lack of a circle of friends. "It is socially here an utter blank to me—," he lamented, "my *heart* is blank & lonesome utterly—."[51]

As Whitman's health gradually improved and he had "*glimpses* again of my *real* self," he began to get out more and to make friends both in the

neighborhood and among "the [letter] carriers, ferry men, car conductors and drivers, &c. &c. . . . here & in Philadelphia," nearly all of whom, Whitman wrote his Washington friend Pete Doyle, were "young fellows."[52] The one important "older" fellow to enliven Whitman's life during his early years in Camden was Col. John R. Johnston, an artist. Johnston and his wife and two children hosted Whitman on a regular basis, becoming like a second family to him. Johnston clearly lacked the professional stature of either Brown or Walter Libbey, but at his home at nearby 434 Penn Street, Whitman met other artists and began again to ponder aspects of the art world that had first stimulated his imagination twenty years before.

Born in Ohio in the 1820s, Johnston had trained as an artist in Cincinnati, where he assisted Henry Lewis on his ambitious panorama of the Mississippi River.[53] Following several years in Baltimore, Johnston established a studio in downtown Philadelphia about the time of Whitman's arrival. The few paintings that can be safely attributed to Johnston's hand consist largely of landscapes and portraits, including likenesses of Andrew Jackson and Edwin Forrest as King Lear.[54] Immediately after they met in early November 1873, Whitman effusively described Johnston in a letter to Doyle as "the jolliest man I ever met, an artist, [and] a great talker." He particularly enjoyed what he described as Johnston's "real, natural, first-rate, off-hand cheerfulness & *comical-sensible* talk." Whitman was pleased to find him "a man of good information, too" and expressed pleasure in his having "travelled in Europe"—qualities he had earlier admired in William Cullen Bryant and the frequenters of Brown's studio. Whitman regularly enjoyed Sunday evening tea at the Johnston household and was in the habit of dropping in for a visit at Johnston's Philadelphia studio as well. "[A]n hour or two [with him] does me real good—,"[55] Whitman confirmed. In 1878, perhaps to mark the fifth anniversary of their first meeting, Johnston presented the poet with a small oil painting.[56] Although neither the subject of the painting nor its present whereabouts is known today, this token of artistic friendship would be repeated several times throughout the remaining years of Whitman's life as the poet continued to cultivate the company of artists.

Where Johnston offered Whitman friendship and a foothold in the local art community, the British engraver William James Linton provided more direct stimulus for the enhanced visual emphasis of the 1876 edition of *Leaves of Grass.* Whitman and Linton had first met in Washington during the poet's tenure with the Treasury Department. Years later Linton remembered Whitman as a "fine-natured, good-hearted, big fellow" whom he "liked . . . much."[57] Their fondness for one another derived in part from their shared backgrounds in radical journalism, literature, and the arts. Like Whitman, Linton was an outspoken proponent of egalitarian republicanism and a firm defender of Tom Paine's antimonarchical beliefs.[58] During the 1840s and 1850s, Linton had edited a series of short-lived radical journals and, through his friendship with the Italian exile Giuseppe Mazzini, engaged in a variety of international liberal causes. Linton remained active in the political arena following his move to America in 1866, self-publishing in 1871 *The House that*

Tweed Built, a scathing pamphlet detailing the excesses of the Tweed Ring. Linton was also a published poet who peppered his journals with examples of his own poetry and counted members of England's literati among his many friends and associates.[59] Far more significant than his literary achievements, however, were Linton's accomplishments in the difficult and demanding art of wood engraving. Linton's engravings for W. A. Chatto's *History of Art* (1848) were judged "the best specimens of wood-engraving of their kind that had ever been printed by means of a steam-press."[60] Fifteen years later, Anne Gilchrist and the Rossetti brothers employed Linton to engrave the plates for Alexander Gilchrist's *Life of William Blake*,[61] and following his move to America, Linton was invited to produce engravings for several books by Bryant, including the collaborative *Picturesque America* (1872).[62]

Linton no doubt reminded Whitman of the multitalented Gabriel Harrison, whose dual commitment to politics and the arts had energized Whitman in the 1850s and whose portrait of the poet boldly announced the radical intentions of the first edition of *Leaves of Grass.* As an engraver no less than as a political activist, Linton distinguished himself as "an uncommon common man."[63] Lithographs and line engravings then offered virtually the only means for reproducing works of art in the print medium, and Linton worked tirelessly to bring both contemporary and older art within the purview of middle-class audiences. His engravings were almost always disseminated in bound form, accompanying a verbal text. Throughout his life Linton contributed to the democratization of the arts in ways that Whitman, who made little distinction between original works of art and their engraved counterparts, had always favored.[64]

Whitman's friendship with Linton and his admiration for the latter's exceptional engraving skills proved key to the poet's decision to venture once again into the arena of visual representation in the "omnibus" edition he compiled during his first years in Camden. Shortly after issuing the portraitless 1871–72 edition, Whitman resolved to hire an engraver to translate a recent photograph of himself into the linear medium of the print. He wanted Linton but was unsure that he could afford him. "I will not have the job done by any second-rater," Whitman wrote Linton in March 1872, "& have concluded to give it up for the present—unless it could be done by you for $50, which, I am fully aware, would not be your due engagement."[65] Linton agreed to the commission and almost certainly brought the completed engraving with him when he visited Whitman in Camden in early November 1873. Fifteen months later Whitman requested that Linton "have printed very nicely for me 1000 impressions of the cut, my head, to go in book." In an act of friendship Linton supplied the prints free of charge, and upon their receipt in June 1875, Whitman assured his friend that "the engraving holds its own—satisfies me more & more—."[66] Years later Whitman was still pleased, declaring, "I like it—always have liked it."[67]

The Centennial edition that featured Linton's engraving constituted an important new chapter in Whitman's dual concerns with identity and the creative reciprocity between verbal and visual modes of representation.[68]

Whitman always considered the book a new edition, although technically it was not (a new edition requires a complete resetting of type). In a departure from earlier practices, however, Whitman issued it together with a companion volume. *Leaves of Grass* constituted little more than a reprinting of the 1871–72 edition; *Two Rivulets* contained a medley of new poems and a miscellaneous collection of new and previously published prose.[69] For this eclectic, two-volume format, Whitman selected not one but three self-representations: one for *Two Rivulets* and two for *Leaves of Grass.* The portraits served multiple and overlapping functions consistent with the hybrid form of the Centennial edition and the organicism of Whitman's poetic undertaking. In number, placement, and symbolic value, the images graphically reinforced the composite nature of Whitman's work, the multiple selves embedded in the text, and the centrality of what Whitman termed the "image-making faculty."[70] These several representations gave visual dimension and vivifying support to the evolving authorial self whose creative efforts now spanned more than two decades.

The expanded visual component of the 1876 publication inaugurated a vibrant new initiative in the poet's efforts to yoke his verse with the expressive power of the visual. In *Democratic Vistas,* one of the essays reprinted in *Two Rivulets,* Whitman identified artists along with teachers and poets as among America's most fit "national expressers."[71] The true artist, he stressed, did not literally copy nature but instead was engaged in the far more creative and difficult task of "coping with material creation, and rivaling, almost triumphing over it."[72] In a bold paraphrase of comments made at the opening of the Brooklyn Art Union a quarter of a century before, Whitman predicted in the Preface to the Centennial edition that "the true growth-characteristics of the Democracy of the New World are henceforth to radiate in superior Literary, Artistic and Religious Expressions, far more than in its Republican forms" (*LG* 749). To dramatize the complementarity of verbal and visual modes of expression, he drew analogies between his writing and each of the visual arts, beginning with architecture. "[E]stimating Death, not at all as the cessation, but as . . . the entrance upon by far the greatest part of existence," he characterized his writings on "Death, Immortality, and a free entrance into the Spiritual world" as "the key-stone to my Democracy's enduring arch" (*LG* 748). By contrast, his emphasis on "Birth and Life"—his desire, that is, to emphasize "the eternal Bodily Character of One's-Self"—drew sustenance from the pictorial emphasis of his verse, from his penchant "for clothing my ideas in pictures" (*LG* 750). In general, he likened the formal outline of his verse to the physicality of sculpture, except when "address'd to the Soul," where the greater resonance was with music and the painterly world of "half-tints, and even less than half-tints" (*LG* 755).[73]

In the portraitless first printing of *Democratic Vistas,* Whitman had lamented the sorry state of the Union in the aftermath of the Civil War. "I say," he wrote, "we had best look our times and lands searchingly in the face, like a physician diagnosing some deep disease. . . . Genuine belief seems to have left us. The underlying principles of the States are not honestly believ'd in, . . . nor is humanity itself believ'd in." Exasperated, he exclaimed: "What

penetrating eye does not everywhere see through the mask? The spectacle is appaling [sic]. We live in an atmosphere of hypocrisy throughout."[74] In 1876, Whitman sought once again to present the American public with a "face" it could trust. He characterized his book as a "type-portrait" (*LG* 752), a reference carefully chosen to acknowledge both the book's composition in moveable type and its grounding in the shared characteristics of a representative person, not the idiosyncrasies of a unique individual. In the Preface to the 1872 edition, reprinted in *Two Rivulets,* Whitman likened himself—and, by extension, his poetry—to "the modern composite Nation, formed from all, with room for all, welcoming all" (*LG* 743). "*Leaves of Grass* . . . is, in its intentions," Whitman affirmed, "the song of a great composite *Democratic Individual*" (*LG* 745). The distinction was crucial, for, Whitman stressed, he sought not only to express himself but also thus to capture "the prevailing tendency and events of the Nineteenth Century, and largely the spirit of the whole current World, my time" (*LG* 752) in his verse. Ultimately, he sought to create an image in which others saw themselves, "to furnish something toward what The States most need of all, and which seems to me yet quite unsupplied in literature, namely, to show them, or begin to show them, Themselves distinctively" (*LG* 754). As he noted in "Thoughts for the Centennial," his goal was to give "ensemble, and a modern American and democratic physiognomy," to the changing character of this republic.[75]

In a letter to William Rossetti, Whitman characterized this new edition of his verse as "a sort of omnibus" in which structure and purpose were carefully intertwined. "It is to be called *Two Rivulets,*" Whitman informed his friend, "(*i.e.,* two flowing chains of prose and verse, emanating the real and ideal)."[76] Whitman described in the Preface "two altogether distinct veins, or strata" running through his book: "Politics for one, and for the other, the pensive thought of Immortality. Thus, too, the prose and the poetic, the dual forms of the present book" (*LG* 748). Other dualities included the book's two-volume format and the complementarity of the book's verbal and visual modes of representation.

In the opening poem in *Two Rivulets*—itself entitled "Two Rivulets," another duality—Whitman guided his reader to a clearer understanding of the discursive possibilities informing the book's multiple dichotomies. The poem described "Two Rivulets side by side, / Two blended, parallel, strolling tides, / Companions, travelers, gossiping as they journey," both "[f]or the Eternal Ocean bound." These "streams of Death and Life, / Object and Subject . . . / The Real and Ideal" were to be seen as "[s]trands of a Trio twining, Present, Future, Past."[77] The physical division of the book's pages into two parts—poetry in the upper half, and prose in the lower—graphically reinforced the poem's principal theme. Just as in *Democratic Vistas,* where Whitman had characterized the words "America" and "democracy" as "convertible terms,"[78] so in the Centennial edition, the book's myriad dualities, most especially its verbal and visual modes, were to be viewed as "convertible terms" that would connect "Present, Future, Past."

The visual representations selected to complement the Centennial

FIGURE 16
G. Frank Pearsall,
Walt Whitman, 1871

edition's text dramatized issues pertinent to matters of change and continuity within and across the several editions of *Leaves of Grass*. The three images of Whitman included Linton's recent wood engraving, Hollyer's familiar steel engraving after Harrison's daguerreotype (now nearly twenty years old and making its third appearance in *Leaves of Grass*), and an 1871 photograph by the Brooklyn photographer G. Frank Pearsall. Only one, the Pearsall, occupied the traditional position opposite the title page; the remaining two engaged the reader's attention from strategic positions within the poetic text.

Whitman was especially concerned, as he wrote in the Preface, that the "interpenetrating, composite, inseparable Unity" of his work not get lost in the edition's hybrid format: "The varieties and phases, (doubtless often paradoxical, contradictory,) of the two Volumes, of *Leaves*, and of these *Rivulets*, are ultimately to be considered as One in structure, and as mutually explanatory of each other" (*LG* 751). To embody this unity in visual form, Whitman placed Pearsall's image opposite the title page (fig. 16). Conceptually and iconographically, this recent photograph of the poet, taken the year prior to his disabling stroke, shared essential features with both the controversial 1855 frontispiece and the more genteel 1860 representation. As in the Hollyer engraving, the poet slouches before the camera in a three-quarter view, wearing his signature wide-brimmed hat and a shirt open at the collar. A suit and vest have replaced the coarse working-man's clothing of the earlier image (as they did in the Schoff engraving) and the poet is now seated, a pose expected of a man of letters. But the image is far from the proper parlor likenesses Whitman abhorred. The poet lounges in his chair, rather than sitting politely; his suit is noticeably rumpled; his shirt remains defiantly unbuttoned at the neck; and his necktie, thinner than the flamboyant one of 1860, dangles untied several inches below his full-bearded chin.[79]

In both type and placement, this updated version of the Hollyer and Schoff representations suggests unity across the current and earlier editions of *Leaves of Grass* as well as within the present two volumes. Its appearance in *Two Rivulets* heightens this unity, for there it tethers the newer, more eclectic material in *Two Rivulets* to the older, more familiar poems in *Leaves of Grass*. In this way, the Pearsall image visually confirmed Whitman's observation that "the main points of all ages and nations are points of resemblance, and, even while granting evolution, are substantially the same" (*LG* 754). The Pearsall is also noteworthy for being Whitman's first use of a photographic print to perform the frontispiece function. Printing technology still did not allow photographs to be printed on the same machines and on the same pages as typeface, so the Pearsall was glued into each volume by hand. The act of

FIGURE 17 William J. Linton, *Walt Whitman*, 1873

FIGURE 18 George C. Potter,
Walt Whitman, 1871

setting each photograph in place individually gave the book a certain hand-fashioned status, complementing, in a way, the fashioning of the engraved frontispieces of earlier editions.[80]

Displaced from its former position as the main point of entry into the whole of the *Leaves*, the Hollyer/Harrison representation was recast to serve a conceptually narrower and more time-bound function. The precipitous decline of Whitman's health had placed his early poems, those "songs of the Body and Existence" (*LG* 748), in sharp relief: "I see now, much clearer than ever—perhaps these experiences were needed to show—how much my former poems, the bulk of them, are indeed the expression of health and strength, and sanest, joyfulest life" (*LG* 749). With its jaunty pose, healthy demeanor, and inviting sensuality, the Hollyer/Harrison image invoked the spirit of these early poems. No longer representative of the whole of *Leaves of Grass*, the image appeared opposite the opening lines of the poem "Walt Whitman," since retitled "Song of Myself," the poet's joyful ode to the time when he was "thirty-seven years old in perfect health" (*LG* 29). From this more focused vantage point, the Hollyer/Harrison engraving gave visual form to the poet's

ringing celebration of "flesh and blood, and physical urge, and animalism" (*LG* 752). Moved from the all-encompassing arena of the frontispiece to a direct, intimate encounter with a specific poetic text, the image acknowledged both the organicism of the poetic enterprise and the multiple selves embedded in the text.

The Linton (fig. 17), like the Hollyer/Harrison engraving, established physical and conceptual intimacy with an individual poem—in this case, "The Wound-Dresser," one of the poems in the "Drum Taps" sequence.[81] "The Wound-Dresser" recounts with power and compassion the poet's moving ministrations to the wounded during the Civil War. It opens with the poet's stepping forward to share his recollections: "An old man bending, I come, among new faces, / . . . / Now [to] be witness again."[82] It concludes with a highly personal and revelatory aside to the reader in which Whitman recalls how "(Many a soldier's loving arms about this neck have cross'd and rested, / Many a soldier's kiss dwells on these bearded lips)."[83] In an unsigned review in the *New York Daily Tribune*, Whitman paraphrased the poem's opening lines to describe the Linton: "Whitman gives his own portrait from life in the book—a large, bending, gray-haired man, 'looking at you'—."[84]

Linton based his engraving on an 1871 photograph by the Washington photographer George C. Potter (fig. 18), but he took sufficient liberties with the original to construct not so much a translation of the Potter as its forceful transformation.[85] Linton's creation is simultaneously bolder and more intimate than the cool, self-contained presence in the photograph. Through effective cropping, bolder use of chiaroscuro effects (particularly around the eyes and mouth), and the noticeable forward tilt given the poet's head, Linton transformed a rather bland photograph into a highly expressive, evocative representation. As noted above, Linton's Whitman seems barely contained by the rectangular boundaries of the frame. The figure leans decisively forward, engaging the viewer's attention in a gaze of compelling warmth and intensity. "I and mine do not convince by arguments, similes, rhymes," Whitman intoned in "Song of the Open Road." "We convince by our presence" (*LG* 155). In the Linton, the poet's presence ultimately attracts the spectator and endows the image with the mythic symbolism lacking in the photograph.

Whitman probably first saw the engraving in early November 1873, when Linton visited him in Camden. Within six weeks he had commenced the poem "Out from Behind This Mask," which bore the subtitle, "To confront My Portrait, illustrating 'the *Wound-Dresser*,' in *Leaves of Grass*."[86] Its second line, enclosed in parentheses and eliminated in subsequent versions of the poem, confirmed Whitman's attraction to the portrait's mythic power: "All straighter, liker Masks rejected—this preferr'd."[87] Subsequent lines called attention to the essential qualities that distinguished the engraving from the photograph. Principal among these were the bend of the head, the intensity of the gaze, and the powerful rapport established between poet and viewer.

Early versions of the poem preserved in the Whitman-Feinberg Collection at the Library of Congress record the poet's struggle to express the connection between himself, the portrait, and the book. In perhaps the

earliest draft, scrawled on the verso of a letter from an admirer dated 11 December 1873, Whitman wrote: *"Behind this mask / this is the real book."* On the same sheet he identified the book as "The poem of the head[,] the face."[88] In the finished poem Whitman drew attention to the artistic quality of the likeness, with its "burin'd eyes, flashing to you, to pass to future time," but gave primary emphasis to its ability to convey an inner, spiritual quality through the powerful gaze. He gestured to "the Idea—all in this mystic handful wrapt," writing "To You, whoe'er you are—a Look."[89] In the concluding stanza, the likeness became Whitman's backward glance at his reader in the face of what he then perceived as his own approaching death.

A Traveler of thoughts and years—of peace and war,
Of youth long sped, and middle age declining,

.

Lingering a moment, here and now, to You I opposite turn,
As on the road, or at some crevice door, by chance, or open'd window,
Pausing, inclining, baring my head, You specially I greet,
To draw and clench your Soul, for once, inseparably with mine,
Then travel, travel on.[90]

In the act of looking back toward his reader, Whitman simultaneously looks out to the future and to future generations of readers. His eyes establish direct contact with his reader—not the conflicted contact of the Schoff likeness, but the inviting and compassionate contact between equals. Linton's engraving, while occupying a position subservient to the more public frontispiece, is no less comprehensive in its representational function within the overall program of *Leaves of Grass.* Linton's Whitman collapses the temporal and psychological space between the poet and his viewer even as its engraved status announces the book's constructedness.

Both individually and collectively, the Pearsall, Hollyer, and Linton representations reinforce and expand Whitman's concern with the creative reciprocity of text and image. They are stamped with the temporal modalities identified in "Two Rivulets," those "[s]trands of a Trio twining, Present, Future, Past." Hollyer's representation of the youthful Whitman evokes the past, Pearsall's representation of an older Whitman the present (or, more precisely, the near present, as it represents the pre-stroke Whitman of 1871),[91] and Linton's representation of an outward-looking Whitman, the future. Together these three distinct but interrelated representations constitute that "great composite *Democratic Individual*" central to the poet's creative enterprise. In the sixteen years remaining before his death in 1892, Whitman would issue several more editions and reprintings of *Leaves of Grass.* All would return to the one-volume format initiated in 1855. Whitman repeated the Hollyer and Linton likenesses, each in the position it occupied in the Centennial edition, in 1882, 1888, and 1889. In 1884 and 1892 he used only the Hollyer, again in its placement opposite "Song of Myself." The Hollyer engraving would never again serve as a frontispiece, nor did Whitman again employ the Pearsall.

In the months immediately following the publication of the Centennial edition, recognition came initially from England, where Whitman's verse had been gaining readership since the 1868 appearance of the Rossetti volume. At least a half-dozen English artists and art critics were on a short list of subscribers who purchased the two-volume set for the substantial sum of $10. Subscribers included several members of the Pre-Raphaelite Brotherhood, including critic John Ruskin, painters Ford Madox Brown and Dante Gabriel Rossetti (the brother of William Rossetti), and poet-painter William Bell Scott, who hailed *Leaves of Grass* as "the queerest, the most startling, and in some sense the most catholic, of new oracles."[92] Other subscribers included the German-born painter and Oxford professor Sir Hubert von Herkomer as well as artist George Wallis, the keeper of the art collection at the South Kensington Museum (now the Victoria and Albert Museum). In gratitude and perhaps to stimulate other English artists to take up the cause of *Leaves of Grass,* Whitman sent a photograph of himself to the London School of Art.[93] American artists were generally slower than their English counterparts to seek Whitman out. Although several of Whitman's New York associates, including John Quincy Adams Ward, William James Stillman, and Elihu Vedder, requested copies of the Centennial edition, none sought to renew associations with the poet.[94] A younger generation of artists would compete for Whitman's attention and revive interest in the intersection of identity and visual representation during the poet's last years.

The portraits given prominent billing within the covers of *Leaves of Grass* graphically affirm Whitman's commitment to the creative reciprocity of the verbal and the visual. Their embedded multiple selves reify essential features of the poetic text while acknowledging the significance of the image-making function. Like the text they inhabit, these representations challenge traditional perceptions of authorship, and, just as dramatically, they accentuate the malleability of the self and the pictorial emphasis of the verse. For one who prided himself on being "untranslatable" (*LG* 89), Whitman offered his reader an abundance of entry points into his verse, beginning with these carefully scripted efforts at visual self-fashioning. As he advised, "Writing and talk do not prove me, / I carry the plenum of proof and everything else in my face" (*LG* 55).

Visual Self-Fashioning and Artistic (Re)Assessment

WHITMAN TERMED THE PERIOD following the publication of the Centennial edition "a critical and turning point in my personal and literary life."[1] Despite the social and intellectual isolation posed by life in Camden and his physical deterioration, Whitman drew strength from the outpouring of nationalist sentiment that circulated around the Centennial Exhibition and its aftermath. Among the Fair's largest and most celebrated displays were more than 3,500 works of painting, sculpture, photography, and decorative arts that filled the galleries of Memorial Hall and the nearby Art Annex. With nearly 800 works by American artists, the display constituted the largest assemblage of art yet mounted in the United States. It represented a sweeping overview of contemporary art practice—one far larger than the American showing at New York's Crystal Palace exhibition or the art exhibitions Whitman had frequented at the National Academy of Design and the American Art-Union. The selection committee included two of Whitman's former Brooklyn colleagues, Henry Kirke Brown and John Quincy Adams Ward.[2] Whitman visited the Fair at least twice, once in the summer of 1876 with poet and playwright Joaquin Miller, and again in October, when he spent an extended period studying the sculpture in the Art Annex.[3] Miller enthusiastically hailed the display as "emphatically an American exhibition." He declared, "With a rare exception or so, the best pictures to be seen here are American landscapes by American painters."[4] Three years later, critic S. G. W. Benjamin proudly beheld "every where abundant evidences of a healthy activity in American art."[5]

The Fair's emphasis on the strength and diversity of American visual culture confirmed Whitman's long-standing commitment to the potency of visual representation. In the months and years ahead, he would continue to enjoy the friendship of Col. John R. Johnston, the Camden painter he had met

shortly after his arrival in the city. The advent of younger artists into his orbit and his absorption in the art of the French Barbizon painter Jean-François Millet, however, would most invigorate his thinking on art. Slowly at first, but then with increasing frequency, artists sympathetic to the nationalist rhetoric and exultant sense of self projected in the verse sought commerce with Whitman, even making the trip to Camden specifically to seek him out. This new generation of artists, which included the son of one of the poet's most ardent English admirers, proved a significant stimulant and source of energy as Whitman began to reconsider the relationship between his person, his verse, and the possibilities of visual representation.

Two of the first artists to make contact with Whitman were also writers and active apologists for his verse. Painter, critic, and cultural commentator Eugene Benson was a self-described "literary frondeur," one who, as he explained, "affronts, defies, or rails at something which time or custom has made respectable."[6] During the 1860s Benson had written frequently for *The Galaxy*, the New York monthly that had done so much to advance Whitman's reputation in the immediate aftermath of the Civil War. Like Whitman, he strongly favored nurturing a democratic aesthetic that could infuse the efforts of artists and writers alike. In the early 1870s, as he began devoting more time to his art, Benson relocated to Europe, where he set up a studio first in Florence and then in Rome. The gift of Whitman's complete writings for Christmas 1876 reawakened his attachment to the poet, and on New Year's Day he wrote Whitman of his delight "to have your words, your brave sweet words, here where old Rome crumbles and new Rome grows; it is fine to have your visions of the States, of men and women in our land, while I am close to the Coliseum, not far from the Pantheon and the Appian Way." Like others, Benson experienced a strong surge of nationalist reaffirmation while reading Whitman on foreign shores. "Your poems are an Appian Way for the triumphal thoughts of the American," he declared. "You celebrate a theatre of action greater than Rome's Coliseum in celebrating our wide land." In closing, Benson expressed the hope, never realized, of meeting Whitman "before this year has gone."[7]

Lay preacher and former transcendentalist editor Sidney H. Morse endorsed a similarly intense but far less cosmopolitan perspective. Like Benson, Morse shared Whitman's progressive social views, and as editor of *The Radical* (1865–72) he had staunchly supported Whitman well before the poet's acceptance by more mainstream journals.[8] But where Benson was an established artist, Morse was little more than a spirited amateur. It was only after *The Radical*'s demise that Morse had turned to sculpture, a field in which he seems to have had little background and no formal training. Self-described as "in the first years of my art," Morse was completely lacking in artistic sophistication when he arrived in Philadelphia in the summer of 1876 with a commission to sculpt Whitman's likeness.[9] Nothing is known about the circumstances surrounding the commission or even the identity of the commissioner. Presumably, given Morse's background, his patron was motivated more by ideological than by aesthetic considerations.

Desperate for artistic contact and eager to explore anew the intersection between identity and visual representation following the publication of the portrait-rich Centennial edition, Whitman extended Morse every consideration. As a sculptor, Morse specialized in portraits (or "heads," as he preferred) of living and historic personages whose social, political, and ethical philosophies he admired.[10] Despite Morse's obvious lack of training, Whitman traveled regularly by ferry from Camden to Philadelphia to sit for the bust, which Morse modeled in an "extemporized studio on Chestnut street." Whitman also arranged to have himself photographed by a local photographer so that Morse could study in greater detail the contours of his face and head.[11] As he worked, Whitman read from his poetry: "Mystic Trumpeter," at Morse's request, and passages from "Song of Myself" and "The Singer in Prison," among others. For the sittings Whitman wore a broad-brimmed straw hat that Morse had "ransacked the Quaker city to find."[12] When the sculpted hat was accidentally damaged in the casting two years later, its original brim was replaced by what Morse described as "a narrow uncanny thing of [the caster's] own construction."[13] Upon viewing the results, Whitman scribbled "bad— wretchedly bad" in his commonplace book.[14] "Features not unlike," he wrote Morse, "but *hat-brim* looks like . . . How *could* you?"[15] Shortly thereafter, in a demonstration of the symbolic significance he attached to the hat's generously sheltering brim, Whitman "dashed [the sculpture] to pieces" in the backyard of his brother's home.[16] Morse, however, remained undeterred. Over the next eighteen months he would produce six or seven more "heads" of Whitman and still more before returning to Camden in the late 1880s to model the bust Whitman prized above all others.[17]

In mid-September 1876, as Morse was preparing to leave Philadelphia, Whitman was jolted by the arrival from England of Anne Gilchrist and three of her children.[18] Having published Mrs. Gilchrist's moving tribute to the poet six years earlier, Morse was well acquainted with the Englishwoman's powerful defense of Whitman's poetry and may have extended his stay in order that the two might finally meet. Then, too, Morse may have hoped to meet Mrs. Gilchrist's nineteen-year-old son, Herbert, who was an aspiring artist. Before long Herbert, too, would devote substantial energy to representing Whitman from life. Ten years later, when Morse and Herbert met again, it was as friendly rivals—each vying for the best light and for Whitman's attention in the parlor of the poet's Mickle Street home.

Whitman was at first apprehensive about what he termed Mrs. Gilchrist's "American trans-settlement," which he had tried his best to discourage.[19] Soon, though, he was spending days, even weeks, at a time at Mrs. Gilchrist's rented Philadelphia home. During the course of their twenty-month stay in Philadelphia, the Gilchrists became a second family to Whitman, offering him comfortable quarters ("the best room in the house," Whitman boasted, "breezy & cool [& the water in it]),"[20] good times, and, most important, stimulating conversation. "[I]t is all very pleasant here," Whitman wrote his young friend Harry Stafford several months after the Gilchrists' arrival: "every thing is so gentle & smooth, & yet they are all so jolly & much

laughing & talking & fun—we have first rate times, over our meals, we take our time over them, & always [have] something new to talk about."[21] Conversations ranged broadly over such topics as history, literature, opera, "the shoddiness and vulgarity of modern well-to-do life," Whitman's English supporters, medicine, and art.[22]

The Gilchrists were extremely well situated within British art circles, numbering among their friends such prominent members of the English art establishment as the painters Lawrence Alma Tadema and Ford Madox Brown, who first introduced Mrs. Gilchrist to *Leaves of Grass.*[23] Another family friend was the Pre-Raphaelite painter Dante Gabriel Rossetti, whose brother, William Michael Rossetti, had published *Poems by Walt Whitman* in 1868. Following the death of Mrs. Gilchrist's husband, the Rossettis assisted her in completing his massive two-volume biography of the poet and artistic visionary William Blake.[24] She brought several Blake engravings with her to Philadelphia, along with prints by a number of other English artists, including Thomas Gainsborough, Sir Joshua Reynolds, and Sir Peter Lely. Whitman, who would model his tomb on Blake's *Death's Door*,[25] demonstrated considerable interest in Mrs. Gilchrist's collection, which consisted primarily of portraits. Edward Carpenter, the English writer and socialist who visited Whitman in the spring of 1877, recalled one evening when Whitman regaled those present by "very deliberately, dwelling long and long over some of them," providing his personal critique on matters of "style, workmanship, composition, character, &c."[26]

As Whitman got to know the Gilchrists, matters of art came to assume even greater significance, particularly as he took a liking to young Herbert. "I am getting much nearer to Herby, & he is already a great comfort to me," Whitman reported to Mrs. Gilchrist.[27] Although Whitman would later disparage Herbert's artistic conventionality and rail against what he considered the artificial contrivances of his most important portrait of the poet, he was initially impressed with the young man's talents and eager to facilitate his artistic progress. Before coming to America, Herbert had studied art at the Royal Academy and spent hours copying from the antique at the British Museum—impressive credentials, Whitman must have thought, for someone not yet twenty. Perhaps for this reason Whitman took a proprietary interest in Gilchrist's artistic development and offered Mrs. Gilchrist periodic updates on her son's achievements.

Like his mother, Herbert prided himself on being an avid student of *Leaves of Grass,* which, Mrs. Gilchrist informed the poet, he had read "with a large measure of responsive delight" by age seventeen.[28] Like Marsden Hartley and other later artist-admirers, Gilchrist considered Whitman something of a father figure (a substitute, it would seem, for his own father, who had died when he was very young). A highly impressionable young man, Gilchrist also accepted without question the proposition that, as Carpenter wrote, "Whitman seemed to fill out 'Leaves of Grass,' and form an interpretation of it."[29]

In the summer of 1876, just before the Gilchrists' arrival, Whitman

had begun making regular visits to Timber Creek, a secluded, wooded spot on
the farm of his friends George and Susan Stafford. Despite the series of strokes
that had racked both his body and his spirit some three years earlier, Whitman
gained considerable strength—"a sort of second wind, or semi-renewal of the
lease of life," as he explained—while basking in the sun and taking mud baths
in an abandoned marl pit. For hours at a time, Whitman would sit by the creek
on a simple, lightweight chair, ruminating on the natural beauty of the spot
and recording his impressions in a small notebook. These observations, "care-
lessly pencilled in the open air," were later reworked for inclusion in
Specimen Days (1882). "How they and all grow into me," Whitman recalled,
"the wild, just-palpable perfume, and the dapple of leaf-shadows, and all the
natural-medicinal, elemental-moral influences of the spot."[30] Herbert often
accompanied Whitman on these visits, and it was here that he began his first
portrait of the poet in the summer of 1877.

Timber Creek and the prose essays it inspired formed part of
Whitman's autobiographical reflections on the relationship between nature
and national identity. Begun during the Centennial Exhibition, these medita-
tive essays symbolically connect Whitman's physical rejuvenation with that
of the nation. Herbert's portrait, too, seems oriented toward locating the poet
within the renewing powers of nature. Known only through an old photoen-
graving (fig. 19), the representation shows Whitman seated beneath a giant
tree, perhaps his favorite oak, that
"sturdy old fellow, vital, green,
bushy, five feet thick at the butt,"
under which he composed some of
his most moving meditations.[31]
Certainly, it was a greatly reinvigo-
rated Whitman, strengthened by the
close communion with nature and
revitalized by the Gilchrists' intel-
lectual companionship, that engaged
Herbert's attention across the shaded
vistas at Timber Creek. Alert and
coatless, his shirtsleeves rolled up to
his elbows, Whitman appears as
sturdy as the tree itself.[32] Indeed, in
both placement and demeanor,
Whitman seems the long-awaited
companion to the companionless
live oak, whose "look, rude, unbend-
ing, lusty, made me think of myself"
(*LG* 126). Shortly before the por-
trait's completion, Whitman wrote
encouragingly to Gilchrist that he
was "making great *calculations*
about it."[33]

FIGURE 19 Herbert Gilchrist, *Walt
Whitman Seated Under a Tree*, c. 1877

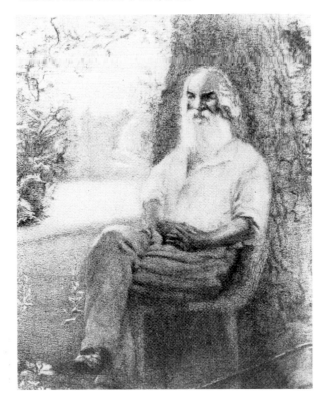

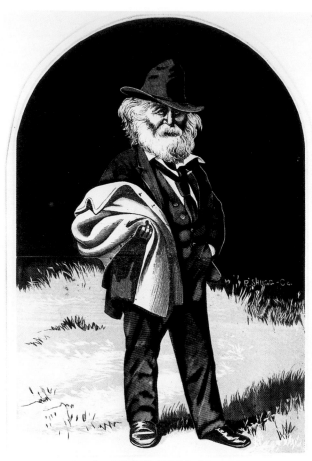

MEN OF THE DAY.
No. 18.
FROM
"THE FIFTH AVENUE JOURNAL."
A Mirror of Art, Literature and Society.
Published every Wednesday at 27 City Hall Square, New York.

FIGURE 20 Frank
Henry Temple Bellew,
Walt Whitman, 1872

Gilchrist's sympathetic rhyming of the poet with the informality and ruggedness of nature stands in stark contrast to the urban dandy who peers out from the page in Frank Henry Temple Bellew's 1872 caricature in *The Fifth Avenue Journal* (fig. 20). Like McLenan, Bellew had been a regular at Pfaff's during the early 1860s (when Whitman recorded Bellew's name and address in one of his notebooks).[34] His caricature, published as No. 18 in the "Men of the Day" series, thoroughly recast the idiosyncratic Hollyer/Harrison Whitman. In it a decidedly urbane, worldly Whitman stands in a grassy but unspecified outdoor setting. As in the Hollyer, one hand jams into his pants pocket; the other hand, bent, holds a fashionable overcoat. A broad-brimmed, high-crowned hat pulled low over his nose and eyes rests atop a broad expanse of white hair and beard, the whole framed by an open-collared dress shirt and low-slung necktie reminiscent of the Hine/Schoff representation. Upon first viewing it, Whitman termed the work both a "tip-top caricature" and "a palpable hit."[35] By the late 1870s, however, Bellew's decidedly urbane Whitman

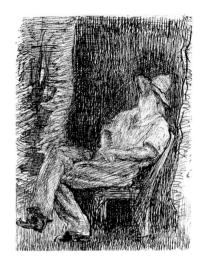

FIGURE 21 (LEFT) Herbert Gilchrist, sketch of Walt Whitman at Timber Creek, 1878

FIGURE 22 (BELOW) Herbert Gilchrist, sketch of Walt Whitman at Timber Creek, 1878

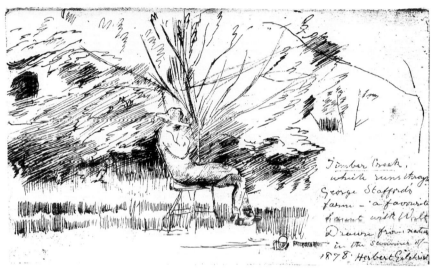

bore little resemblance to the poet who now prided himself in having traded "the whole cast-iron civilizee life," with its "tailordom and fashion's clothes," for the "watery, shaded solitudes" of Timber Creek.[36]

Gilchrist would continue to explore the interplay between the rejuvenation of Whitman's physical and spiritual selves and the healing powers of nature in at least two additional Timber Creek sketches. In both, Whitman sits contentedly under a sheltering tree in his signature broad-brimmed hat (figs. 21 and 22). One bears the inscription "Drawn from nature in the summer of 1878," and in it the poet clasps to his chest what appears to be a book or perhaps a notebook. The configuration of the bowed head and tightly held book, presumably *Leaves of Grass* or the small notebook in which Whitman recorded his Timber Creek impressions, artfully elides the man, his writing, and the natural setting.[37] A similar elision engages the reader across the essay "Straw-Color'd and Other Psyches" in *Specimen Days.* The essay describes the multitude of brightly colored butterflies, those "beautiful, spiritual

insects! straw-color'd Psyches!" that enlivened Whitman's Timber Creek experiences. One in particular, a "big and handsome moth," attracted special attention: Whitman wrote that "it knows and comes to me, likes me to hold him up on my extended hand."[38] A photograph on the page opposite seemed to bear this out. Wearing a sweater and seated on a rustic twig chair, Whitman communes with a large moth or perhaps a butterfly prominently positioned on his raised hand (fig. 23). While lacking the plein-air authenticity of Gilchrist's sketches (the insect is a cardboard prop and the photograph taken in a photographer's studio), this representation, too, rhetorically reinforces the triadic relationship between Whitman, his text, and the natural world.[39]

Gilchrist made several additional sketches of the poet over the remainder of his first American visit, among them one that Whitman characterized as a "large picture, life size, in rocking chair (?'the old gray poet')."[40] Ten years later, a much-matured Gilchrist would revisit this early conceptu-

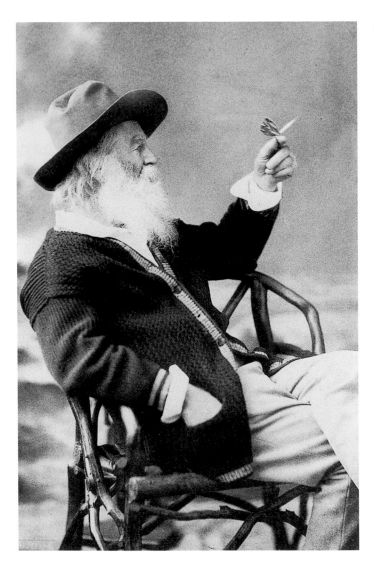

FIGURE 23
Phillips and Taylor,
Walt Whitman

alization of a rocking-chair raconteur in a large oil portrait now at the University of Pennsylvania and discussed in the following chapter. Far less modest in conception was a work Whitman recorded in his notebook on Christmas Day, 1877, as "Herbert's crayon with the hand up."[41] Although unknown today, it seems to have projected a Christlike pose, with the hand raised in a sign of blessing. Such an overtly religious characterization was not at all uncommon among Whitman's closest admirers, who fully accepted the poet's projection of himself as a poet-prophet. Mrs. Gilchrist, for one, likened her own first reading of the poems to "a new birth of the soul"[42] and exclaimed, upon seeing the Hollyer engraving in the 1855 *Leaves of Grass*: "Here at last is the face of Christ, which the painters have so long sought for."[43]

Edward Carpenter, too, likened Whitman to Christ. A letter he wrote just after his meeting with the poet on 2 May 1877 provided verbal and visual testimonials to that effect. In the letter, addressed to an unidentified "Benjamin," Carpenter extolled the physiognomic characteristics of Whitman's head.

> The thing which strikes one about his face is the great interval between his eyes and eyebrows. That 'space in which the soul seems to move' is very large. The eyebrows very much arched so as to make the bridge of the nose very long—the nose itself straight & well-proportioned. The mouth and chin are covered with a fall of white hair, but the forehead is clear and high. As to his eyes of course it is impossible to put them into words—the impression they produce on me is of an immense, immense, background: Yet it is very characteristic of them that the pupils are small & distinct, the likeness to Christ is quite marked. . . . Put into it the extravagant prophetic look of genius, intense perceptive power, and as much sentiment as you like, and you have something like.[44]

Many of the physical features identified in the letter are discernible also in the accompanying sketch (fig. 24). Chief among these are the arched eyebrows, elongated nose, high forehead, and "small & distinct" pupils. Far more compelling than these individuating characteristics, however, are the figure's structural and conceptual affinities to images of Christ. In its insistent frontality, the image projects a timeless, iconic presence, much like familiar representations of Christ. The beard and hair, too, recall such popular images.

Even granting Carpenter's obvious lack of artistic skill, the work is noteworthy more for its religious allusions than its mimetic specificity. According to Ernst Gombrich, all art commences "not with [a] visual impression but with [an] idea or concept." Individuating visual information is then mapped onto this "pre-existing blank or formulary."[45] Such was certainly the case with Carpenter, for whom the idea of Whitman as the new Christ served as a potent filter that screened out other sensory information. This filter—more than Carpenter's direct sensory encounters with the poet—provided the prime lens through which the Englishman recorded his visual impressions.[46]

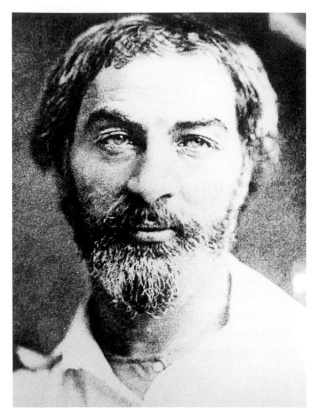

FIGURE 24 (ABOVE) Edward Carpenter, sketch of Walt Whitman, 1877

FIGURE 25 (RIGHT) Gabriel Harrison, *Walt Whitman*, 1854

Twenty years later Carpenter likened Whitman to "some old god" and his quarters in the Gilchrist home to "a kind of prophet's chamber" in *Days with Walt Whitman*.[47] Corroborating such views was the book's frontispiece (fig. 25), the so-called Christ likeness. Its iconic simplicity, Whitman's followers thought, inscribed the "moment when this carpenter too became a seer."[48]

In the spring of 1878, some twenty months after their arrival, Herbert, his mother, and his sisters made preparations to leave Philadelphia. With their art collection in safe hands at the New Century Club, Mrs. Gilchrist and her daughters relocated to the Boston area, where Beatrice had been accepted as an intern in the New England Hospital for Women and Children, one of the country's outstanding medical institutions for women.[49] Herbert, anxious to get on with his art, settled in New York, the undisputed center of the American art world and the site of Whitman's own early art triumphs. "I dont wonder you like, & are exhilarated by, New York & Brooklyn—," Whitman wrote shortly after Gilchrist's arrival. "They are the places *to live*."[50] Once there, Gilchrist quickly made friends with other young artists, including Wyatt Eaton and William Rudolph O'Donovan (who, more than a decade later, would himself journey to Camden to model the poet's likeness).[51] "Pleas'd to hear that you go around with the New York artists, designers, young fellows, & folk in the picture trade, publishing, &c—," Whitman told his young friend. "I think with the superb *foundation* you have

it will be just the thing for you, fetch you *up* & make you aware of what's going at latest advices, &c. which is very desirable—."[52]

While Herbert explored the intricacies of the New York art world, Whitman consoled himself with visits to the Stafford farm and sporadic contact with artists in the Philadelphia-Camden area. He continued to enjoy the company of the Camden artist Col. Johnston—probably more so after the Gilchrists were no longer present. In September 1878, while having tea at Johnston's home, he made the fortuitous acquaintance of Truman Howe Bartlett, a Boston sculptor who would facilitate his all-important viewing of the works of Jean-François Millet three years later. Whitman also socialized with the young prize-winning Philadelphia sculptor Howard Roberts, whose *First Pose* had taken top honors at the Centennial Exhibition,[53] and John O'Brien Inman, son of artist Henry Inman, an intimate of Whitman's old friend William Cullen Bryant. Inman appeared on Whitman's doorstep in December 1878, seemingly at the poet's behest. Whitman and Inman had probably met or perhaps renewed an old acquaintance at Bryant's funeral in New York the previous June. A specialist in portrait and genre paintings, Inman had recently returned from twelve years of painting and travel in Europe.

Within months of Inman's return, Whitman commissioned him to paint copies of two photographic portraits of Whitman's parents for inclusion in *Specimen Days*.[54] And when Whitman moved to his own home two years later—a small frame structure at 328 Mickle Street—he proudly displayed the pair in the parlor, flanking the fireplace. An old photograph shows Inman's framed portraits displayed amid an eclectic profusion of paintings, photographs, and sculptures, including two Morse statuettes and his bust of Elias Hicks (fig. 26). The painting of Walter Whitman Sr., only partially visible in the photograph, hangs to the left of the fireplace above the photograph of Whitman's mother; the painted portrait of his mother occupies a spot in the

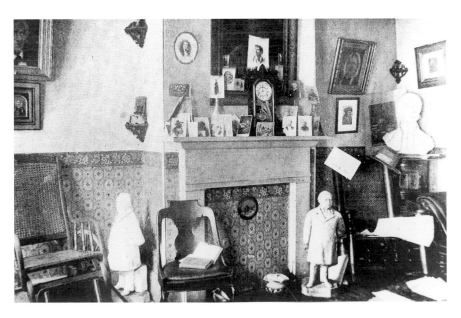

FIGURE 26
John Johnston,
photograph of
Whitman's parlor,
1890–91

corner to the right.[55] The decision to have treasured family photographs enlarged and transcribed into paint (and to prominently display the painted versions in his Mickle Street parlor) casts doubt on the claim that Whitman consistently preferred photography to more traditional visual media. Whitman seems to have been motivated, at least in part, by the desire to celebrate his ancestry in the established medium of paint. Indeed, directly above the fireplace—in a recognized position of cultural and familial authority—hung a large painted portrait that, Whitman believed, represented one of his Dutch ancestors. By hemming this somber eighteenth-century copy of a seventeenth-century portrait within painted portraits of his parents, Whitman was constructing a genealogy in paint. He would expand it in the coming years with painted portraits of himself.[56]

During the fall Herbert joined the poet for several weeks of painting at Timber Creek, and in November Whitman excitedly wrote Mrs. Gilchrist about a landscape that Herbert was calling *September Days.* "[N]ame not very good," Whitman admitted. But, he declared, "Picture itself . . . *very good,* the best he has painted, such opulence, mellowness of color that would . . . fill you as it did me." The work's simple masses appealed to Whitman's aesthetic sensibilities, and he described the scene with great sensitivity to nuance. "[I]t is a very simple scene (story)," he explained, "only well shaded opening in the creek, with water 'way to the foreground, & five or six ducks & drakes—foliage meeting at top, no sky, every thing very broad, foliage in masses, all the handling easy & large, yet sufficiently defined—really a *fine, original,* rich picture, & in treatment no following of any thing Herb has done before—."[57] The scene no doubt reminded Whitman of his own verbal tributes to Timber Creek, that "naked source-life of us all" that inspired so much of his own late nature writing.[58]

Once back in New York, Herbert enrolled at the Art Students' League, where he studied with the "experienced & able" William Merritt Chase. Just returned from six years in Munich and Venice, Chase had a reputation, Gilchrist gleefully informed Whitman, as an unrivaled "manipulator of the brush." By February the impressionable Gilchrist announced that he had "gained tenfold facility with my brush" and was anxious to try out his new skills in another portrait of the poet, one that he proposed to complete "in *one* sitting," a Chase trademark.[59] Whitman was pleased but not surprised by Gilchrist's progress: "That you improve in handling & dexterity is nothing more than I expected—You have it in you I am sure—." Whitman was also delighted that Mrs. Gilchrist and Grace had joined Herbert in New York, thereby assuring the young artist of a more stable living situation. "Herb," Whitman wrote in the conclusion to his letter, "why don't you all get a big cheap house in Brooklyn by the month or quarter, with the privilege of keeping it for two or three years?"[60] Whitman's proposal seems to have been prompted as much by self-interest as by a concern for the comfort and well-being of the Gilchrists. With ample living quarters, the Gilchrists would once again be in a position to provide Whitman with a place to stay, and with it access to the city's thriving art scene, a world to which Herbert had reawak-

ened Whitman's sensibilities. "I would come on & stay & pay a moderate board—," Whitman explained. "Can't we make it pay?"[61]

Twice in the past two years, Whitman had made extended visits to New York, and both times, thanks to the efforts of his host, the jeweler John H. Johnston, he had enjoyed stimulating encounters with some of the city's leading artists and art patrons. Whitman was particularly delighted that the gatherings at Johnston's residence included "lots of artists, many fine ladies & not a few ministers & journalists."[62] Both Jasper Cropsey, whose landscapes had received favorable notice at the Centennial Exhibition, and marine painter Edward Moran, brother of acclaimed landscape painter Thomas Moran, attended.[63] Like some of the poet's other friends, Johnston was particularly swayed by the religiosity of Whitman's verse. In an article published after Whitman's death, he recalled that upon reading *Leaves of Grass* he and his wife "felt that here was a man who had found *in himself* what we had hoped to find in the 'sweet bye and bye.'" A trip to Camden to meet the poet reinforced his initial impression. "That first two hours' interview can never be described," he wrote. "I came away feeling that I had met a man who knew God, and that I, too, knew God as never before."[64]

Prompted by the intensity of his feelings, Johnston commissioned George W. Waters, a portrait and landscape painter from Elmira, New York, to paint Whitman's portrait. Johnston arranged for Waters to stay with the family during Whitman's month-long visit in March 1877; the portrait was complete by 24 March.[65] In it Whitman confronts the viewer directly, an alert expression unfolding across his expressive face (fig. 27). His beard, lengthier than in previous representations, largely obscures the unorthodoxy of his open-collared dress shirt, while the silky-white treatment of his thinning hair and beard conveys an air of distinguished refinement. Whitman, who pronounced the work "*grand,*"[66] appears less a religious icon than an established elder statesman. But for one friend, the naturalist John Burroughs, the painting's air of refinement conveyed entirely the wrong message. Burroughs staunchly rejected the work's efforts to locate Whitman within the social and cultural mainstream. To him, the work represented the poet's "benevolent look, but not his power his elemental look. It makes him look rather soft, like a sort of Benjamin Franklin."[67]

A second painting, dated the same year and based on an ink drawing probably made during the March sitting, presents a far less conventional view (fig. 28). It represents Whitman in profile, a pose that has historically been used to effect distance between subject and viewer as a way of suggesting respect, even immortality.[68] In *Essays on Physiognomy* (1789–92), minister and moralist Johann Caspar Lavater embraced the profile for its clear revelation of those features most salient for the interpretation of character—namely, the forehead, nose, and chin, which could be measured against an ideal scale. To Lavater and other physiognomists, the profile most effectively disclosed the subject's interior life and personality.[69] Waters's profile view concentrates considerable attention on the contours of the poet's face, particularly the region around the nose, eyes, and forehead. Although his beard obscures his

FIGURE 27 George W. Waters, *Walt Whitman*, 1877

mouth and chin, his steady gaze and upright posture suggest a resolute personality. As in the three-quarter view, Whitman's hair, while extremely thin on top, falls in soft, gentle waves against the back of his neck; his beard, too, appears soft and thinning. The ink drawing registers a similar emphasis on the nose, eyes, and forehead, but provides a far less refined treatment of the hair and beard (fig. 29). Drawn from life and probably not intended for public consumption, the sketch exhibits a freedom and freshness at odds with the stately seriousness of the painting. In it the hair and beard, particularly where silhouetted against the blank backdrop of the page, assert a distinct counterpoint to the firmness and solidity of the face. The hair is rendered in a series of short, twisted, and broken lines. These wayward facial hairs project a poet at

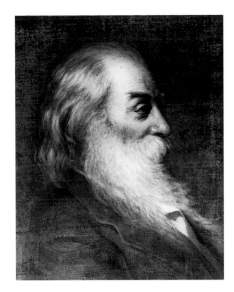 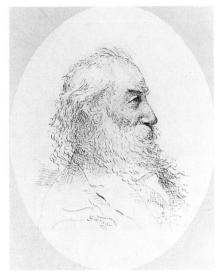

FIGURE 28 George W. Waters,
Walt Whitman, 1877

FIGURE 29 George W. Waters,
Walt Whitman, 1877

odds with the social and literary refinements expected of an established man of letters. Compared with the smoothed and distant figure in the painting, the figure in the drawing appears livelier, more spirited, and considerably less tamed. In this dichotomy lies the conundrum faced by artists: how to balance the liveliness of the sketch against the public expectations of the finished portrait. For Waters, and perhaps also for Johnston, public perceptions took precedence over private observations.[70]

Whitman saw little of the Gilchrists during his several New York visits. Nothing had come of his suggestion that they establish a shared household, and in June 1879, nearly three years after their arrival in America, the Gilchrists returned to England. That fall, Whitman traveled to the West. He made it as far as Denver and Platte Canyon, where he jubilantly declared, "I have found the law of my own poems."[71] On his return he spent three months in St. Louis visiting his brother Jeff, superintendent of the city's waterworks. There Whitman admired James B. Eads's recently completed bridge across the Mississippi River, judging it "a structure of perfection and beauty unsurpassable,"[72] and read with studied attention an article on Raphael's *School of Athens* in *The Journal of Speculative Philosophy*.[73] Whitman was no doubt intrigued by Raphael's commitment to representing abstract philosophical beliefs pictorially, an objective that informed much of his own dealings with artists. (In the years following his death, it would also yoke him to a younger generation of artist-admirers in ways that he could scarcely have predicted.)

In October 1880, following a summer in Canada, Whitman once again found himself hosting a number of younger artists, a phenomenon that would intensify in the years ahead. Percy Ives was the son of painter Lewis Thomas Ives and the grandson of Elisa Seaman Leggett, an ardent Whitman admirer

who schooled all of her children in *Leaves of Grass*.[74] At his grandmother's urging, Ives sought Whitman out shortly after his arrival in Philadelphia to study at the Pennsylvania Academy of the Fine Arts. On 17 October 1880, Whitman recorded in one of his daybooks: "Percy Ives, Mrs. Leggett's grandson, age 16, a student intends to be an artist—lives bachelor's hall fashion in Philadelphia—reads Emerson, Carlyle, etc.—is a son of Lewis T. Ives, artist—Academy of Fine Arts."[75] Over the next four years, as he completed his studies, Ives visited Whitman often at his brother's home on Stevens Street. The two took long walks together and spoke frequently about matters of art. Whitman was particularly eager to know the young artist's thoughts on landscape painting, a subject still dear to his heart, and Ives, who was then studying with Thomas Eakins, kept Whitman apprised of instructional developments at the school.

Despite Whitman's long-standing opposition to schools, his close associations with artists had convinced him of the value of a sound art education. Still, Ives was surprised when Whitman failed to endorse wholeheartedly the Academy's directive, instituted by Eakins, that students paint directly from nature. Whitman concurred in principle, Ives recalled. He believed that an artist should "continually recur to nature for his inspiration," but he found it difficult to comprehend how an artist could maintain authority over his material in the presence of such a powerful force. "I should think when an artist was in the presence of nature he would feel himself overpowered and mastered," Whitman remarked, and would need "to be alone with himself and his picture to master it."[76]

Ives greatly admired Whitman, whom he described as "calm, serene and strong."[77] He was similarly impressed with the pervasive sense of movement in *Leaves of Grass*. "There is a spirit and movement to your work that I feel deeply," Ives wrote Whitman from Paris in 1886.[78] He reiterated those sentiments the following year while "refreshing" himself with a copy of *Leaves of Grass* in the reading room at the British Museum.[79] After Whitman's death, Ives was pleased to discover a number of like-minded artists at the 1896 Chicago meeting of the Association of Western Artists. A reporter for the *Detroit News-Tribune* described the group's concern with nurturing a distinctively American art, one that would "express in all its breadth and bigness—that indefinite but inspiring ideal known as democracy." "Quite easily and naturally" the thoughts of those present turned to Whitman, in "whose inspiring, but formless verse the ideal of democracy seems to have been most fully and impressively realized." Ives was among those who championed Whitman at the meeting, declaring his verse to be the "great west—the big America feeling—breadth and breeziness—the feeling that we, as the west, wanted to get into art." For Ives, as for others, Whitman represented "a symbol—large, majestic, tender, haughty and human—of this unborn, western democratic art." So firm were Ives's convictions that he prophesied that artists, far more than writers, would keep Whitman's memory alive in the years to come.[80]

During his time in Philadelphia, Ives made several sketches and at least two oil paintings of Whitman, only one of which has survived. In 1926,

two years before his death, he would complete a third painting based on his original sketches. The surviving paintings pay tribute to the "big America feeling" Ives admired in the poetry. The earliest, dated 6 April 1882 (fig. 30) and based on a sketch from the previous year (fig. 31), shows Whitman's head and upper torso. In the drawing, Whitman's brow is furrowed, his gaze focused intently to the left, away from the viewer. The painting records a considerably more introspective view. The lighting source has been reversed, and a brightly illuminated forehead, insinuating Whitman's considerable mental capacities, has replaced the furrowed brow. A deep shadow engulfs the left side of his face, almost completely obscuring his left eye, while his right eye, a swirl of nearly black paint, seems directed inward toward himself rather than out to the viewer. Loose, extremely vigorous brushwork provides a counterpoint to this emphasis on interiority. The work's enlivened, activated surface seems a visual trope for the "breadth and breeziness" Ives felt in the poetry and a tangible record of his own physical engagement with the poet. By eschewing descriptive specificity for greater expressive effect, Ives transforms a conventional pose into an assertive and highly personal visual statement.

The most unusual of Ives's drawings, dated 6 December 1881, acknowledges with quiet understatement the fundamental relationship between the poetry and the body. Entitled *Walt's Hand* (fig. 32), it portrays

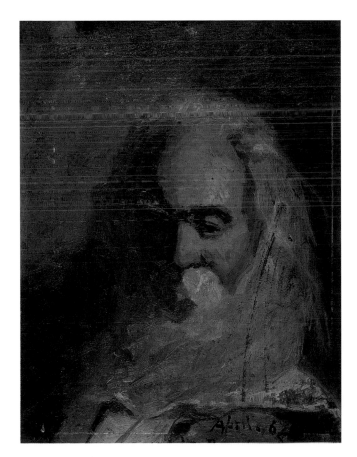

FIGURE 30 (LEFT) Percy Ives, *Walt Whitman*, 6 April 1882

FIGURE 31 (BELOW) Percy Ives, sketch of Walt Whitman, 12 February 1881

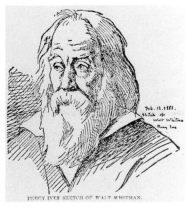

FIGURE 32 (BELOW) Percy Ives,
Walt's Hand, 6 December 1881

FIGURE 33 (RIGHT) Percy Ives, sketch of
Walt Whitman, 21 December 1881

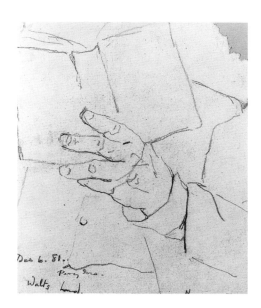

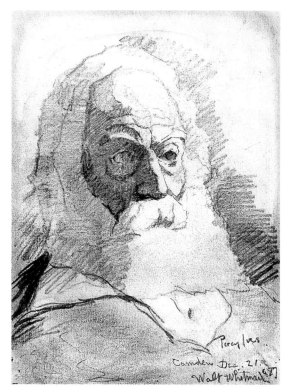

Whitman's hand holding an open book in front of his chest as if to read from it. By eliminating all reference to the poet's head (and mind), Ives offers a provocative alternative reading. Two additional sketches, also done in December 1881 (figs. 33 and 34), present considerably more conventional views focused on the head and upper chest. The two served as models for the now-lost painting and the 1926 oil now in the collection of Detroit's Prismatic Club (fig. 35).[81] As in the earlier portrait, the right side of the head is brightly illuminated and the painting's surface enlivened by an allover textural quality. The exuberance and flamboyant brushwork of the earlier work, however, have been considerably tamed, replaced by a far more deliberate and controlled presentation. Most striking is Whitman's considerably younger and more robust appearance. His broad shoulders and open-necked shirt convey the virile masculinity of a man confronting none of the physical ailments that slowed the poet during his last years. The lively intimacy of the earlier painting has given way to a figure of outsized, invented proportions. No longer introspective and withdrawn, Whitman projects the intensity of religious illumination. His steady gaze and the light that washes across his face collapse the man into the myth. Ives's painting is as much a tribute to Whitman's heightened cultural standing during the decade of the 1920s as it is a response to the "big America feeling."

As Ives completed his studies at the Academy of the Fine Arts and prepared to leave Philadelphia, Whitman met another young artist, Henry McCarter, who had studied with Ives. The two were introduced by Talcott

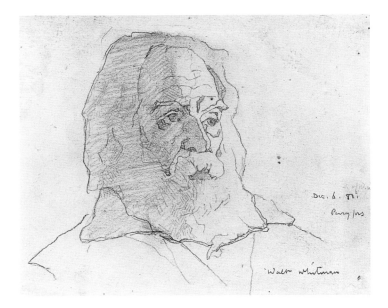

FIGURE 34 Percy Ives, sketch of Walt Whitman, 6 December 1881

FIGURE 35 Percy Ives, *Walt Whitman*, 1926

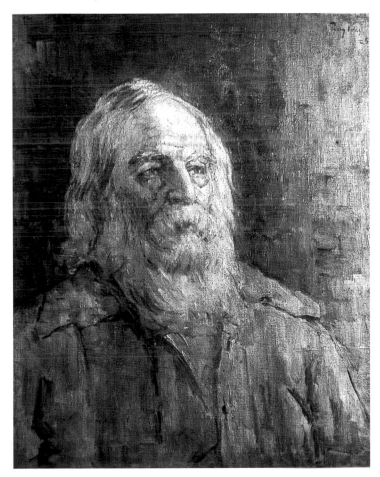

Williams, the chief editorial writer for the *Philadelphia Press* and the person who would later introduce Whitman to Thomas Eakins. McCarter was one of the newspaper's staff artists. Like other artist-illustrators, he was responsible for the newspaper's quickly drawn sketches of the quotidian aspects of Philadelphia life. Where later newspaper illustrators in the circle of Robert Henri would openly embrace Whitman as a knowing comrade, McCarter proved a reluctant visitor, at least initially. Unlike Ives, McCarter had not read Whitman and, in fact, originally thought the poet "might be a charlatan." Once inside his house, however, McCarter experienced a dramatic change of heart and on several return visits recorded his impressions in a number of sketches of the poet, none of which has survived.[82]

McCarter no doubt reminded Whitman of his own days as a journalist, when he, too, strove to record his experiences in vividly rendered prose. At the same time, Whitman was eager to share with McCarter the lessons of a recent and transforming experience. Three years earlier, while in Boston to read proof for the latest edition of *Leaves of Grass,* Whitman had encountered a large selection of the rural scenes of the Barbizon painter Jean-François Millet. Whitman was immediately drawn to Millet's visual transcriptions of spiritual rural existence and, in the years since, had come to regard Millet's work as the counterpart to his verse. "If for nothing else," Whitman said, "I should dwell on my brief Boston visit for opening to me the new world of Millet's pictures."[83] Since the early 1850s, when Boston painter William Morris Hunt became Millet's first American pupil, his art had attracted a substantial American following, mostly centered in Boston. By the late 1880s there were no fewer than thirty Boston collectors of his art, the most significant being Quincy Adams Shaw. It was Shaw's collection that Whitman had visited in April 1881. He encouraged McCarter to visit it as well. Whitman concluded their first meeting by giving McCarter Shaw's card and a copy of *Leaves of Grass,* an acknowledgment of the profound affinity he sensed between Millet and his verse.[84]

A descendant of one of Boston's most prominent families, Shaw began acquiring works by Millet shortly after meeting the artist in France in the 1860s. By 1881 his collection contained more than twenty oils and an even larger number of pastels. Shaw would bequeath his holdings to the Boston Museum of Fine Arts—he was one of the institution's initial benefactors—but during his lifetime he preferred to contemplate them in the privacy of his home in suburban Jamaica Plain.[85] Thus removed from public view, Shaw's collection was not well known outside Boston's elite circles. Whitman gained entrée through the intervention of Truman Howe Bartlett, the sculptor he had met several years earlier at Col. Johnston's.[86] Whitman was already familiar with Millet's work, having seen "fugitive prints—counterfeits: bits about Millet in papers, magazines."[87] At the funeral of William Cullen Bryant, he may have discussed Millet with Wyatt Eaton and Will Low, two young painters who had studied with Millet at Barbizon. Later, Eaton recalled that Whitman reminded him of Millet "in his large and easy manner."[88] Whitman was surely also familiar with Helena de Kay's translation of Alfred Sensier's

life of Millet, whose five installments in *Scribner's* had concluded in January 1881, just months before Whitman's Boston visit. The third of these installments, with *The Sower* featured prominently as the frontispiece, appeared in the same issue as Edmund Clarence Stedman's forceful defense of Whitman's poetry.[89]

Whitman described the impact of his encounter with Millet's art in conversations with Horace Traubel, his young Camden friend and confidant. He recalled that after first browsing Shaw's "wonderful collection of curios," acquired during the Bostonian's extensive travels abroad, he waved the others off so he could contemplate the Millets alone and undisturbed. "I wanted to be alone," he stressed, "and so I got an hour or two to myself—the sweetest, fullest, peaceablest: then I saw Millet." Two works in particular attracted Whitman's attention: *Watering the Cow*, now called *Peasant Watering Her Cow, Evening* (fig. 36), and *The Sower* (fig. 37). Of the former, Whitman remarked: "I remember one picture—a simple scene: a girl holding a cow with a halter: the cow's head was dropped into the creek from which it was drinking: it would be called a commonplace subject: it was that, to be sure: but then it was also vivid and powerful." Its colors were "opulent, thorough, uncompromising, yet not gaudy—never gilt and glitter: emphatic only as nature is emphatic." For Whitman it constituted "the gem of [Millet's] creations." "I can conceive of nothing more directly encountered in nature than this piece," Whitman thought,

> —its simplicity, its grand treatment, the atmosphere, the time of day: not a break in the power of its statement. I looked at it long and long—was fascinated—fastened to it—could hardly leave it at all. This picture more than any other to my judgment confirmed Millet—justified his position, heroism—assured his future.[90]

Millet's *The Sower* elicited similar praise. Whitman said, "I felt the masterfulness of The Sowers [sic]: its dark grays: not overwrought anywhere: true always to its own truth—borrowing nothing: impressive in its unique

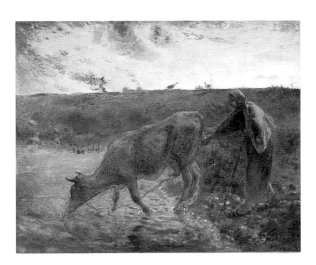

FIGURE 36
Jean-François Millet,
*Peasant Watering Her Cow,
Evening*, c. 1873–74.
Photograph © 2006 Museum
of Fine Arts, Boston

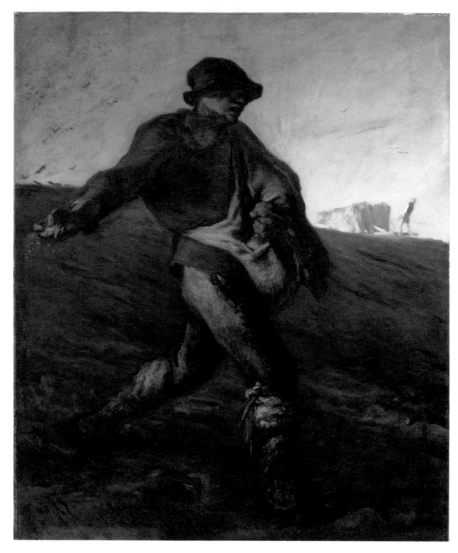

FIGURE 37 (ABOVE)
Jean-François Millet,
The Sower, 1850
17.1485

FIGURE 38 (RIGHT)
Adrien Lavieille, engraving
after Jean-François Millet,
End of the Day, 1858–60

majesty of expression."[91] He was particularly impressed by what he termed its "sublime murkiness and original pent fury," qualities that spoke directly to him of the heroism and tenacity of the French people.[92] In 1888 Felix Adler, founder of the Ethical Society, promised to get Whitman a print of *The Sower*, to the poet's delight. When *The Sower* proved unavailable, Adler substituted a print of *End of the Day* (fig. 38), in which a laborer, silhouetted against an evening sky, puts on his jacket before departing the field after a day's work. Although disappointed not to have *The Sower*, Whitman was pleased to possess a work by Millet. He remarked to Traubel, "it's almost the Sower—it comes to almost as much: it is a piece out of the same cloth. Millet is my painter: he belongs to me: I have written Walt Whitman all over him. How about that? or is it the other way about? Has he written Millet all over me?"[93]

Many of the qualities Whitman admired in Millet he had earlier admired in the American genre paintings of his friend Walter Libbey, despite obvious stylistic differences. Thematically, Millet appealed to Whitman's democratic sensibilities. The poet was equally drawn to the works' subtle color harmonies and their nuanced treatment of nature's moods. Whitman judged Millet's works "all inimitable, all perfect as pictures," yet was quick to stress that their strength did not reside solely or even primarily on their stature as "works of mere art."[94] He, who boasted in "Song of Myself" of wearing "my hat as I please indoors or out" (*LG* 47), felt awed in the presence of Millet's paintings: "Millet excites all the religion in me—excites me to a greater self-respect. I could not stand before a Millet picture with my hat on." Years later, Whitman confided to Traubel that "the thing that first and always interested me in Millet's pictures was the untold something behind all that was depicted—an essence, a suggestion, an indirection, leading off into the immortal mysteries." When Traubel suggested that they might have "somehow dipped in the same spiritual stream," Whitman replied, "I have no doubt of the resemblance." "The Leaves," he added, "are really only Millet in another form—they are the Millet that Walt Whitman has succeeded in putting into words."[95]

Whitman experienced Millet's paintings as visual enactments of many of the concerns that had motivated his poetry. In *The Sower*, the image of the simple workingman "with the strong arm casting forth the seed"[96] no doubt registered as a visual touchstone for his own role as poet-narrator of *Leaves of Grass*. As the coatless laborer in Harrison's daguerreotype, he, too, was "casting forth the seed," not of physical nourishment but of knowledge and self-empowerment—committed to enriching the compost of his native land. (As he chanted in one of his memorable shorter poems, "Behold this compost! behold it well!" [*LG* 368].) Whitman appreciated the directness and immediacy of Millet's art as well. "Millet says more, much more, to us today than Raphael or the medieval painters," Whitman asserted. "He is more immediate—I can feel his presence; he is no half mythical personage; he is a living man."[97] In contrast to the paintings of Libbey, for example, whose glossy surfaces purposely deflect the viewer's attention away from the initiating hand of the artist to focus instead on the mimetic transcription of the object,

Millet's surfaces reverberate with the active residue of the artist's inaugurating presence. Like Whitman's poems, Millet's paintings emphasize process over finished product, the intuitive over the precisely rational; like Ives's more boisterously painted surfaces, Millet's works reflect a shift in the language of art from mimetic transcription to mediated act. In studying the Millets in Shaw's collection, Whitman wondered aloud if "America [would] ever have such an artist out of her own gestation, body, soul?"[98]

Whitman was, for the first time, struck by the possibility that visual representations with no direct referent to either the poet or the narrative details of his verse could effectively inscribe characteristic features of his poetic enterprise. His response signifies a major departure from his long-held belief that the engaging symbiosis between his person and his verse was best conveyed visually through portraits of himself. Although Whitman would not live to witness works by his twentieth-century admirers, he had, without knowing it, discovered one of their characteristic features. Still, he hesitated to disengage himself completely from the conventions that had guided his thinking for so long. Only a few months later he would demonstrate just how conventional some of his visual responses remained.

In August 1881 Whitman sat entranced before the heroicized painting *Custer's Last Rally* (fig. 39) by the Irish immigrant artist John Mulvany. Measuring 11 by 21 feet, the painting differed markedly in almost all respects from Millet's moving peasant scenes. Whitman spent more than an hour examining the painting's every detail, declaring it "painfully real, overwhelming" and finding "the whole scene, dreadful, yet with an attraction and beauty that will remain in my memory." He was particularly impressed with Mulvany's efforts at historical accuracy, including the extended period he had spent at the site, gathering information from a variety of local and military

FIGURE 39 John Mulvany, *Custer's Last Rally*, 1881

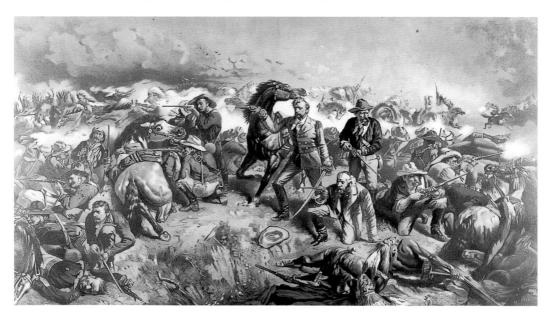

observers. Whitman declared it "altogether a western, autochthonic phase of America, the frontiers, culminating, typical, deadly, heroic to the utter-most."[99] And although the theme was one he had himself addressed five years earlier in the minor poem "From Far Dakota's Cañons," Whitman was all too aware that Mulvany's representation was more historically accurate than his own romanticized gloss, where he had Custer brandishing a sword rather than a gun and addressed him with the stilted "Thou" (*LG* 483).[100] History paint-ing—once revered as occupying the pinnacle in art's self-proclaimed hierarchy of value—had, by the 1880s, become the bastion of conservative academicians. Although still popular with the general public, its stilted, often bombastic manner held no sway among the country's progressive younger artists. That Whitman could admire the work of Millet and Mulvany simultaneously is but one of the many contradictions pervading his complex engagement with the period's visual culture.

A month after viewing the Mulvany, Whitman returned to Boston. During this follow-up visit, just four months after his initial trip, John Boyle O'Reilly, the Irish-born editor of the *Boston Pilot*, invited Whitman to join him, Bartlett, and two others "to see Mr. Quincy Shaw's pictures on Friday at 2 p.m." O'Reilly seems not to have known that Whitman had already seen the collection on his earlier visit to the city, advising him, "Don't say no: you'll enjoy it."[101] Whitman never mentioned seeing the collection a second time, but it is difficult to believe that he would have turned down an opportunity to do so. Whether or not he revisited the Millets, Whitman eagerly toured the recently opened Boston Museum of Fine Arts. Housed in an impressive Ruskinian Gothic structure not far from his hotel, the Museum of Fine Arts displayed for broad public consumption masterworks previously known only to wealthy private collectors. While perusing the galleries Whitman delight-edly encountered Percy Ives and his father and invited them to join him at his hotel the following day.[102] As he gazed into the faces of the Museum's impres-sive array of portraits, Whitman was no doubt reminded of the democratic displays that had captivated his imagination at the Brooklyn Art Union some thirty years before.

Whitman experienced another stunning echo of 1850s Brooklyn when Bartlett and the Boston Whitmanites feted him at a gathering at Bartlett's studio, a spacious, light-filled room located at the end of the Federal Street wharf. A sampling of sculptures, some "unfinished in the clay and muf-fled in mysterious-looking wrappings," crowded the floor, while reliefs and giant cartoons adorned the walls. "If the scene could have been painted," observed Sylvester Baxter in an article in *New England Magazine*, "it would have made a real picture, with some notable portraits."[103] In addition to Bartlett and Baxter, those present included journalists O'Reilly, Francis H. Underwood, Arlo Bates, and Fred Guernsey; painter, architect, and editor Frank Hill Smith; and Whitman's friend, poet and playwright Joaquin Miller. Whitman read from a translation of French poet Henri Murger's poem on death, "The Midnight Visitor," while those present drank punch and lager beer.[104]

Among the models on display, Bartlett had surely included his own

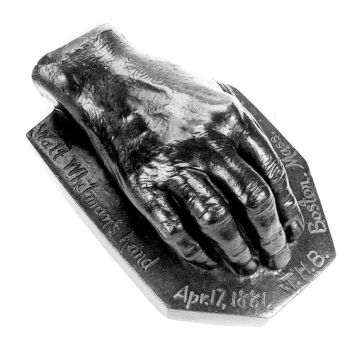

FIGURE 40 Truman Howe Bartlett,
Walt Whitman's Hand, 17 April 1881

plaster cast of Whitman's right hand, made during the poet's visit the previous spring. Now part of the Whitman-Feinberg Collection at the Library of Congress and subsequently cast in bronze (fig. 40), this literal transcription of Whitman's hand is inscribed "Apr. 17, 1881. T. H. B. Boston, Mass." Probably also on display were Smith's informal sketches of Whitman's head produced on the same date and probably at the same sitting (fig. 41). The single sheet of five drawings is signed and dated by Whitman and, revealingly, is identified on the verso as "Agnus Dei," or Lamb of God. In these two opposing modalities— one stressing the physicality of Whitman's being, the other his spiritual essence—are recorded the poles of the poet's identity. The cast of Whitman's hand is a direct replication of that portion of his physical self most intimately involved in the production of his poems. Perhaps more important, it evokes one of the hallmarks of the poetry itself—its emphasis on physicality, on the body's substantiality. In contrast, Smith's several sketches demonstrate little concern with matters of materiality. With no reference to the third dimension (and defying a shared base line), the five randomly positioned sketches occupy an undefined, ethereal space in opposition to the forces of earth's gravity. As in Carpenter's Christlike representation of Whitman's head, Smith's disembodied heads, their gazes fanning out in all directions, evoke the beneficent and caring presence of a spiritual protector of the people.

Despite the evocative appeal of Millet's rural genre scenes, it was in the more familiar art of portraiture that Whitman and members of the country's visual arts community first negotiated the relationship between the poet,

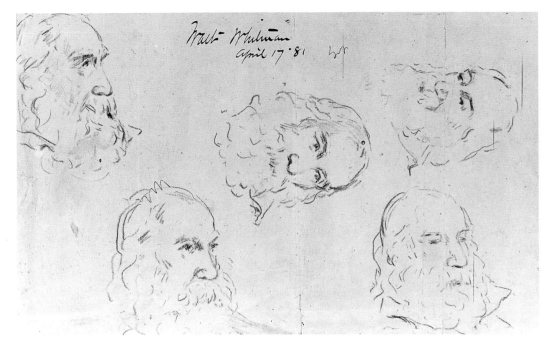

FIGURE 41 Frank Hill Smith,
sketches of Walt Whitman, 1881

his verse, and visual modes of representation. The radically contrasting efforts
of Bartlett and Smith, like the divergent works by Ives, Gilchrist, Bellew, and
Waters, testify to the complexities of the task. As Whitman counseled his
reader toward the conclusion of "Song of Myself," "Do I contradict myself? /
Very well then I contradict myself, / I am large, I contain multitudes" (LG 88).
For Whitman and the artists who congregated around him in the years fol-
lowing the Centennial Exhibition, the challenge was to assess, evaluate, and
finally represent in compelling visual terms these "multitudes." Ultimately
Whitman hoped to nurture an artist whose vision and creative abilities mir-
rored his own. In the years ahead, as he welcomed new artists into his circle,
others, like Morse and Gilchrist, would return, eager to improve upon earlier
efforts and to explore new aspects of his being. Through it all Whitman pre-
sented himself as a patient and willing object of the artist's gaze. Like the fig-
ure in "The Wound-Dresser,"—"[a]n old man bending I come among new
faces"—Whitman continued to dwell among the artists' many representations
of his face, "[n]ow [to] be witness again" (LG 308).

Reception and Representation in the 1880s

IN JUNE 1884, Whitman moved out of his brother's house, where he had lived since arriving in Camden ten years earlier. With the proceeds from the sale of the 1882 edition of *Leaves of Grass*, he purchased an unpainted frame structure with no furnace in a working-class neighborhood a few blocks away at 328 Mickle Street. Whitman lived at the Mickle Street address for eight years, during which he enjoyed his most stimulating and wide-ranging contacts with artists since leaving Brooklyn. (As his friend Thomas Donaldson was to remark, "His latch key was always out.")[1] He also continued to encourage artists intent on representing his likeness. Unable to forget the "vivid and powerful" impression left by the Millets, yet unwilling to forgo the representational possibilities yoking his verse and his person, he set his sights on nurturing "a Millet in portraiture," one "who sees the spirit but does not make too much of it—one who sees the flesh but does not make a man all flesh—all of him body."[2] The conflicting discourses that circulated around Whitman in his last years, in concert with an increasing tendency toward mythologization, elicited a range of responses more varied than even Whitman might reasonably have anticipated.

As he settled into a comfortable, if restricted, routine following his return from Boston, he did so with the knowledge that the country's literary establishment was beginning to reverse its widespread rejection of his verse. Several poetry anthologies, including Linton's *Poetry of America* (1878), had included examples of his poems, and in 1880 former Pfaffian regular Edmund Clarence Stedman brought knowledge of his work to an even larger public in an article in *Scribner's*. Even while continuing to express reservations about the poet's "blunt and open" treatment of procreation, Stedman acknowledged that the verse's "peculiar and uncompromising style" was "yet capable of impressive rhythmical and lyrical effects."[3] In a move that no doubt pleased

Whitman, Stedman seized upon the daguerrean likeness with which Whitman "signed" the 1855 edition as being revealingly emblematic of the oppositional posture of the whole: "The picture of Whitman in trowsers and open shirt, with slouched hat, hand in pocket, and a defiant cast of manner, resolute as it was, had an air not wholly of one who protests against authority, but rather of him who opposes the gonfalon of a 'rough' conventionalism to the conventionalism of culture."[4]

In 1883 Whitman's friend Richard Maurice Bucke, a Canadian physician, added considerably to Whitman's reputation with the publication of an intensely laudatory biography and review of Whitman's poetry. With major, albeit unacknowledged, contributions from Whitman's own pen, Bucke's biography celebrated the poet's physical appearance ("his face is the noblest I have ever seen"), his personal "magnetism," his "exquisite aroma of cleanliness," and the *religious sentiment* that—according to one longtime friend—"pervades and dominates his life."[5] "*Leaves of Grass*," Bucke exclaimed with unabashed enthusiasm, "is a picture of the world as seen from the standpoint of the highest moral elevation yet reached." The future author of *Cosmic Consciousness* went even further: "What the Vedas were to Brahmanism, the Law and the Prophets to Judaism, the Avesta and Zend to Zoroastrianism, the Kings to Confucianism and Taoism, the Pitakas to Buddhism, the Gospels and Pauline writings to Christianity, the Quràn to Mohammedanism, will *Leaves of Grass* be to the future of American civilization."[6]

Such unconcealed attempts to mythologize Whitman figured prominently in the "horizon of expectations" with which audiences and artists received Whitman during the decade prior to his death.[7] By the late 1880s Whitman was routinely lionized by influential members of the press sympathetic to his verse and eager to expand his small but intensely loyal readership. Events surrounding his Lincoln lectures, particularly the 1887 lecture at New York's Madison Square Theatre, reveal Whitman's complicity in efforts to enhance his cultural authority. The 1887 lecture attracted such distinguished cultural emissaries as Richard Watson Gilder (organizer of the first Lincoln lecture), Andrew Carnegie, William Dean Howells, Mark Twain, and Mary Mapes Dodge.[8] A reception at the sumptuous Westminster Hotel followed the lecture, prompting one reviewer to enthuse, "Never has the spectacle of so many eminent persons paying homage to a poor, plain old man been witnessed in New York."[9]

Like Bucke, commentators focused considerable attention on the poet's physical appearance. His "long flowing hair, . . . patriarchal beard . . . [and] shaggy brows" impressed observers with their "snowy" whiteness. In the eyes of Jeannette Gilder, sister of editor and poet Richard Watson Gilder, Whitman's "greater shagginess gave him a still more ancient and bard-like appearance than even the poet Bryant's, who in his later years so well realized the conventional ideal of Time, or Santa Claus."[10] The critic for the *Evening Sun* likened Whitman to a god and his cane to a "shepherd's crook," an allusion calculated to conjure up images of Christ as the Good Shepherd. As befits such a "man of magnetism," the critic noted, at the reception the poet "sat

enthroned in a great armchair, cushioned with dark red plush."[11]

The lecture, which generated more than six hundred dollars in revenue for the poet,[12] seemed designed more to certify Whitman's standing within the pantheon of American men of letters than to celebrate the contested grounds of his poetry. Jeannette Gilder described a "somewhat gaudily upholstered room" with a stage set to imitate a cozy domestic interior. Surrounded by potted palms and a small side table, Whitman engaged his audience from the comfort of a large armchair. A laurel wreath, festooned with silken streamers bearing "various tender messages," adorned a nearby chair. In this setting, reminiscent of the Victorian parlor from which Whitman had so vociferously distanced himself and his verse, the poet "put on a pair of eyeglasses and began to read the 'Death of Lincoln.'"[13] He concluded the lecture with a reading of "O Captain, My Captain!"—his rhyming tribute to the fallen president and one of his least characteristic but most frequently anthologized poems. Both the scene and the emphasis on the poetic crowd-pleaser deflected attention from the more robust and controversial aspects of his verse. Indeed, the lecture was, in the words of a recent critic, "a Barnumesque event on a high scale."[14]

Richard Watson Gilder contributed significantly toward assuring the evening's success. Several of the artists and art critics in attendance were regulars at the weekly gatherings hosted by Gilder and his wife, the painter Helena de Kay, at their home near Union Square. Prominent among these were painters Wyatt Eaton, John White Alexander, Fred Carpenter, and Dora Wheeler, sculptor Augustus Saint-Gaudens, photographer George C. Cox, and art historian Charles Eliot Norton.[15] Despite the conventional nature of his own idealizing poetry, Gilder greatly admired Whitman's verse and carried a well-worn copy of *Leaves of Grass* with him wherever he went.[16] Having first met Whitman at the New York residence of the jeweler John H. Johnston, Gilder mediated the personal and artistic space between the poet and the city's expanding arts community. He did so, moreover, within the framework of the high-culture aspirations of the genteel tradition.[17] Even though Whitman dismissed Gilder's verse as having little more than "the general character of the characterless poetry of the magazines—that of porcelain, fine china, dainty curtains, exquisite rugs—never a look of flowing rivers, waving trees, growing lilies, floating clouds," he stopped short of rejecting the man altogether, noting, "we mustn't be prejudiced against our friends."[18]

In the visual arts, as in poetry, most of Whitman's early admirers filtered their responses to the poet's autochthonous voice through the high-culture norms of their professions. This was particularly true of the artists Gilder encouraged (and in one case commissioned) to paint Whitman's portrait, beginning with Dora Wheeler, the only woman known to have painted Whitman from life. She was acquainted with Gilder through the activities of her mother, the decorator Candace Wheeler. Like Gilchrist, she had studied with the prominent portrait and still-life painter William Merritt Chase. Wheeler straddled the ideological divide between the fine and the applied arts, sharing her studio—a large garret at 115 East 23rd Street—with the Associated

Artists circle of interior designers and craft artists, an organization cofounded by her mother.[19] To circumvent the sexually determined barriers that too often trapped women in the less demanding fields of pattern embroidery, Wheeler trained in the human figure and contributed figural designs for the group's tapestries. She further affirmed her hard-won place in the still largely male-dominated world of painting by initiating a series of portraits of British and American authors, a project not unlike that being undertaken concurrently by Gilder's *Century Magazine*. Mark Twain, William Dean Howells, James Russell Lowell, and Whitman's friend John Burroughs were among those whose portraits she painted and whose faces peered out from the walls of her studio.

The day following Whitman's Lincoln lecture, Gilder, his sister Jeannette, his coeditor Robert Underwood Johnson, and Burroughs accompanied Whitman on a visit to Wheeler's studio.[20] Whitman encouraged Wheeler's independence, no doubt hoping that this energetic female artist might produce as probing and insightful an estimate of his physical self as Mrs. Gilchrist had rendered of his poetic self.[21] Wheeler's portrait—which is signed and dated in the lower left, "Walt Whitman / painted by / Dora Wheeler / Sept 1887"—represents the poet in a frontal pose reminiscent of Edward Carpenter's earlier ink sketch (fig. 42). Both the pose and the attention given the poet's mass of white hair and beard construct an image poised to confirm Whitman's place within the literary pantheon. The extreme whiteness of the poet's mane confers an idealizing, even prophetic, aura on the whole. This is offset somewhat by the rugged individualism of the face, particularly noticeable in the region of the eyes, where wrinkles and sagging eyelids reveal time's inexorable effects on

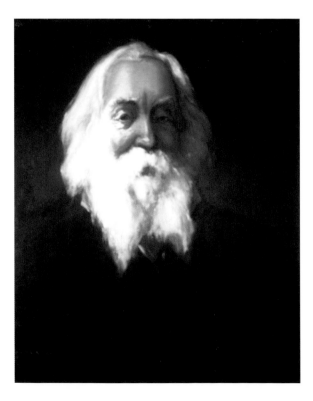

FIGURE 42
Dora Wheeler,
Walt Whitman, 1887

the poet's sixty-eight-year-old visage. The deep vertical crease between his eyes, a line that is considerably more pronounced than in other visual representations from the period, imparts a psychologically disturbing element to this formal and iconic representation. Perhaps Wheeler added this in response to Whitman's admonition that the portrait did not "have devil enough in the old man's eyes." Caught up in the idealizing discourse that circulated around the Lincoln lecture and that pervaded Bucke's biography, Wheeler herself likened Whitman to "a majestic heathen god."[22] Her painting, which hung for a time in Whitman's Mickle Street home, gives physical dimension to the "majestic" and godlike protagonist of the Lincoln lecture.[23]

Shortly after Whitman's return to Camden, another of Gilder's associates, Augustus Saint-Gaudens, prepared to render his own representation of the poet. Since the unveiling of his masterful monument to the Civil War hero Admiral David Glasgow Farragut in Madison Square Park in 1881, Saint-Gaudens had risen to become one of the country's preeminent portrait sculptors. This Irish immigrant found himself increasingly in demand as a portraitist of America's social and intellectual elite. Gilder, who had commissioned the artist to sculpt two bas-relief portraits of members of his own family, hailed him as the "new Donatello."[24] At the time of Whitman's Lincoln lecture, Saint-Gaudens was completing work on his large standing Lincoln, an ennobled yet democratic conception of the sixteenth president that would soon be installed in Chicago's Lincoln Park. *Harper's Bazaar* reported that the sculptor had "accepted with generous enthusiasm the suggestion that he should begin studies for a bust of Walt Whitman, which may take the shape of a commission from the poet's friends."[25] Plans were made for him to sketch the poet in "some quarters in Arch St." in downtown Philadelphia in late April.[26] Four months later the project was still pending, although no sketches had yet been made.[27] Gilder, who was in the best position to push for the commission, was distracted by other matters; in the end, the portrait never progressed beyond the discussion stage. The loss is regrettable. Of all Gilder's associates, Saint-Gaudens might have been most able to construct the "vivid and powerful" collusion of Whitman's physical and poetic selves that the poet envisioned after his encounters with Millet.

The final Gilder associate to undertake Whitman's portrait was already launched on his representation of the poet at the time of Whitman's Lincoln lecture. Like Saint-Gaudens, portraitist John White Alexander had increasingly found favor among the country's wealthy elite. Alexander's figure studies confirmed his skillful appropriation of the vibrant brushwork of Frank Duveneck and the nuanced aestheticism of James McNeill Whistler, artists with whom he had studied during four years abroad. Particularly in his portraits of male sitters, Alexander sought to balance the empirical requirements of realism with the decorative demands of aestheticism. The artist's European pedigree stood him in good stead both with members of the New York art world and with the American public. Until 1891, when he commenced a decade-long stay in Paris, Alexander found his services in great demand at both *Harper's Weekly*, where he had begun his career as a cartoonist in 1875,

and its chief competitor, *Century Magazine.* Assignments took him as far afield as New Orleans, the American West, and North Africa, which he visited in the summer of 1884.[28]

In late 1885 or very early 1886, Gilder and his coeditor commissioned Alexander to produce a series of portraits of distinguished English and American men of letters and politics for inclusion in *Century Magazine.* Aside from Whitman, the series included lawyer, statesman, novelist, and biographer John Milton Hay; novelists Frank Richard Stockton, Robert Louis Stevenson, and Thomas Hardy; historian George Bancroft; and naturalist John Burroughs. Gilder may have planned the Whitman portrait to accompany the article the poet had agreed to write on his Civil War experiences. But when "Army Hospitals and Cases" finally appeared in October 1888, Alexander's portrait was still unfinished and never did appear in Gilder's journal. In April 1892, the month following Whitman's death, it was featured as the frontispiece in *Harper's.*

When Gilder first approached Whitman in May 1885 about the possibility of having his portrait painted, Whitman agreed, on the condition that it be done in Camden. Citing poor locomotion as a factor keeping him close to home, he boasted of the "good . . . north-light" available "here in my own room" and offered to sit for an artist "as many times as he wishes."[29] By offering to make himself freely available to the artist, Whitman was acknowledging one of the fundamental distinctions between the construction of painted (or sculpted) and photographic representations. Where photographers frequently required a sitter to "hold" a pose, sometimes for an extended period, and to sit under harsh lights, painters and sculptors were generally less demanding. Sitters were frequently free to move about, to shift and change positions, sometimes even to walk and engage in other activities. As Whitman aged, he welcomed the prospect of hosting artists in the comfort and convenience of his own home, surrounded by the clutter and mementoes of a lifetime. Sitting for a painter or a sculptor necessitated few changes to his daily routine, making it closer to the lived experience celebrated in his verse. Graham Clarke, a historian of photography, has postulated that Whitman was also attracted by what he now perceived to be the greater sense of "achieved presence" in a painting than in a photograph. Acknowledging the work of Walter Benjamin, Clarke writes: "The individual presence—the aura—on which Whitman [depended] is negated" in a mechanically reproducible photograph.[30] Only in the more traditional media of sculpture and oil painting did that uniqueness continue to resonate.

Alexander arrived to begin sketching the poet on 22 February 1886. Newspapers, letters, photographs, and other memorabilia so littered the floor of Whitman's parlor that Alexander found it impossible to secure a stable footing for his easel and was forced to rest his canvas directly on the floor, propped up against a chair. As he worked, Whitman's housekeeper's parrot squawked and grabbed at his hair whenever he leaned back in his chair, creating still more confusion as the Pennsylvania native plied his trade during three half-days of sketching.[31] Despite these inconveniences, the two men enjoyed each

other's company. In a letter to Susan Stafford written the day of Alexander's departure, Whitman described the artist as "a first rate young fellow, [and] a good talker," who "made it all very interesting, telling me this, that, & the other."[32] Whitman particularly appreciated hearing about Alexander's extensive travels and was reported to have granted him another sitting while in New York to deliver his Lincoln lecture the following year.[33] By the time of the portrait's completion, however, Whitman's favorable impression of the artist was tempered by a largely critical assessment of his artistry. "I liked to have Alexander here—," he reminisced. "He is the right stuff for a man though I am not sure he is the right stuff for a painter."[34]

In Alexander's portrait, Whitman sits erect and remote, a dignified figure whose steady gaze and snow white beard inscribe an image of patriarchal wisdom and remove (fig. 43). The three-quarter pose and indeterminate setting, both of which Alexander favored for male sitters at the time,[35] eschew

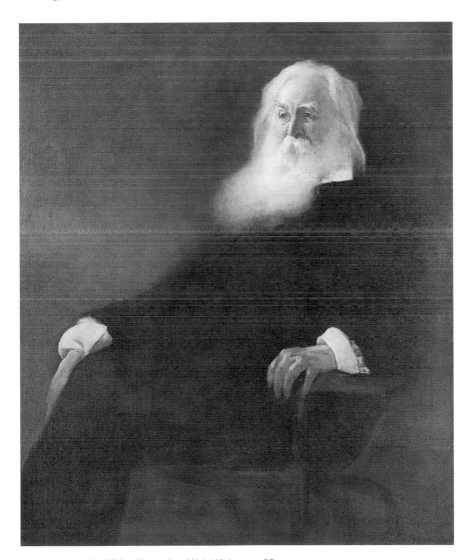

FIGURE 43 John White Alexander, *Walt Whitman*, 1889

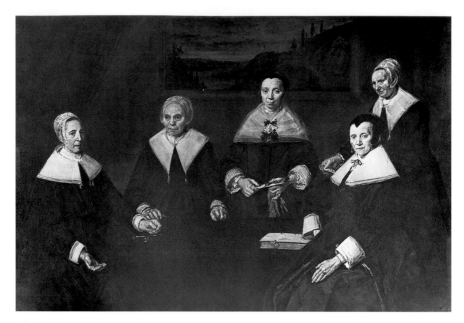

FIGURE 44 Frans Hals, *The Regentesses of the Old Men's Home*, c. 1664

all reference to either the Mickle Street setting or the artist's New York studio. The viewer's gaze circulates freely between the head and widely separated hands, with the head occupying the apex of the right triangle formed by the three. The poet's ruddy complexion and gently nuanced facial features are framed by a mass of intensely white hair and beard. The eyes gaze firmly to the left, away from the viewer. The exaggerated whiteness of the poet's hair and cuffs, in concert with the unyielding blackness of his costume, produce an image of sharp contrasts. One is reminded of a similar emphasis on heads and hands set off by white collars and cuffs in Frans Hals's *The Regentesses of the Old Men's Home* (fig. 44), although the differences between the two works are at least as revealing as the similarities. In the Hals, warm skin tones and expressive demeanors highlight the women's humanity, as does the varied and highly emotive rendering of their sensitively modeled hands. At least two of the women engage the viewer directly with their gaze, powerful reassurance of their continuing involvement with the world around them. In Alexander's representation, the emphasis is more on monumentalizing than humanizing the aging poet. Even the warm, carefully rendered facial features do not mitigate the rigidity and austere formality of the pose. The poet looks not *at* but *past* his viewers. The right hand, the one with which Whitman composed his innovative new verse, is only summarily represented, its form largely obscured behind his right knee. In contrast, Whitman's left hand, the one severely weakened by a series of strokes the previous decade, grasps the arm of the chair in a decisive and forthright manner. Unlike the closely observed hands in the Hals, Whitman's hand defies the harsh realities of the poet's life. Its vigorous presence registers not as a reliable measure of the poet's actual

FIGURE 45 John White Alexander.
Walt Whitman, 1886

physical self but as a trope, an abstract sign for the strength and manliness of his poetry. The poet's attire and the Renaissance-style chair on which he sits are also figured as abstractions. Whitman's rumpled gray suit has been exchanged for one of timeless and impenetrable black, his rugged rocking chair for a delicate one with gently curving arms and legs.[36] Together, the authoritative pose, averted gaze, physical isolation, historicized chair, and unassailable blackness of the costume construct an image of ageless monumentality, one significantly at odds with the expressive humanity celebrated in the Hals.

The finished portrait differs considerably in both realization and conception from the sketch of the poet's head completed during the artist's three-day visit to Camden (fig. 45). In that drawing, which Alexander's widow presented to the American Academy of Arts and Letters shortly after her husband's death, Whitman, who is facing the opposite direction, wears glasses and appears to be reading.[37] (This is the only representation of the poet in any medium to show him in glasses.) The drawing invites the viewer to share an intimate and informal moment with the poet, much as the artist had done. This level of close observation is apparent also in the handling of the hair and beard, which here show considerably more nuance and specificity than in the painting. A second sketch, done in oil and known today only through a brief mention in a newspaper, included such personalized details as the poet's lace collar and cuffs and perpetually rumpled coat.[38] In the finished oil, the rumpled coat has been eliminated altogether and the lace restricted to a portion of the cuff encircling the poet's left wrist—and even there more implied than explicitly rendered.

Even more than Wheeler's iconic bust, Alexander's painting accesses the regal, prophetic Whitman that permeated both Bucke's biography and the 1887 Lincoln lecture. Like others intent on mythologizing the poet, Bucke's biography particularly emphasized the whiteness of the poet's hair and beard and the nobility of his face, which even at age sixty-four showed "no lines that expressed care, or weariness, or age" and had a "habitual expression . . . of repose" that, he claimed, produced a calming effect on all whom he met.[39] While elevating Whitman to a kind of superhuman stature, Bucke rehearsed the poet's own claims of the essential oneness between "his body, his outward life[,] his inward spiritual existence and his poetry." "So it may be said," Bucke observed, "that neither he nor his writings are growths of the ideal from the real, but are the actual real lifted up into the ideal."[40] Like Bucke's verbal gloss, Alexander's painted portrait collapses the real into the ideal, the man into his myth. As late as 1909 a reviewer for *The Book News Monthly* praised the portrait for representing Whitman "in his most appealing aspect, as a lovable patriarch, dignified but winning, majestic but gentle."[41]

If Alexander's Whitman reifies popular constructions of the poet, it harbors the possibility of considerably more subversive readings as well. Alexander's portrait represents an aestheticized Whitman, one whose studied elegance recalls the stylized self-consciousness associated with Oscar Wilde, the flamboyant British poet and apostle of aestheticism. During Wilde's widely publicized 1882 American tour, the British aesthete garnered considerable attention for his extravagant dress and theatrical manner. Wilde's velvet knickers, fur-trimmed coat, floppy ties, lace-trimmed cuffs, and broad-brimmed hats, as Mary Warner Blanchard has observed, "spoke to a nation that was beginning to explore style, not to expose social nonconformity but to create alternate identities." In *Oscar Wilde's America: Counterculture in the Gilded Age*, her probing reappraisal of the Aesthetic movement's cultural significance, Blanchard explains that "aesthetic style, embodied in Wilde, was inseparable from Victorian definitions of sexuality."[42] By the 1880s, the writings of sexologists (such as Karl Ulrichs in Germany) had helped redirect the public's attitudes toward same-sex intimacy away from the idea of sentimental attachment toward the more disturbing perception that it constituted transgressive, erotic behavior. Connections between Wilde's aestheticism and the emergent discourse on the "invert" or male homosexual were strengthened during the British author's American visit by his well-publicized encounters with street boys and other segments of New York's homosexual subculture. "Thus," writes Blanchard, "the reaction to Wilde in the popular press indicated an emergent anxiety not only about the aesthetic ideology, but, more dangerously, about the celebrated and stylized masculine self."[43]

For this reason, among others, Wilde's meeting with Whitman—himself long known for his idiosyncratic style of dress—generated considerable excitement in the press. The day after speaking at Horticultural Hall in Philadelphia (and at Whitman's invitation), Wilde journeyed across the Delaware River to spend a quiet afternoon with the poet in Camden. Helen Gray Cone parodied the meeting in the November 1882 issue of *Century Magazine*:

PAUMANOKIDES:
> Who may this be?
> This young man clad unusually with loose locks, languorous,
> > glidingly toward me advancing,
> Toward the ceiling of my chamber his orbic and expressive
> > eye-balls unrolling?

NARCISSUS:
> O Clarion, from whose brazen throat,
> > Strange sounds across the seas are blown,
> Where England, girt as with a moat,
> > A strong sea-lion, sits alone![44]

After sharing a glass of homemade elderberry wine, the two retired to Whitman's den, where they spoke freely on a variety of subjects. Whitman presented Wilde with photographs of himself, one for Wilde to keep and one to give to poet Algernon Swinburne. The *Philadelphia Press* reported that Whitman characterized Wilde as "frank, and outspoken, and manly." "He seemed to me like a great big, splendid boy," Whitman noted. When the older man agreed to call him "Oscar," Wilde replied, "I like that so much," and laid his hand on Whitman's knee.[45] Four months later, on 10 May, Wilde returned for a second visit. This time there were no published details of their meeting, but privately, Wilde told a young friend and advocate for homosexuality that Whitman had been open about his own homosexual feelings. He claimed, "I have the kiss of Walt Whitman's still on my lips."[46]

Sometime after Wilde's visits, Whitman had his housekeeper attach a lace edging to his shirt collar and cuffs. These decorative edgings were duly noted in each of the published accounts of his 1887 Lincoln lecture, including one from as far away as Boston, where a commentator described the "magnificent display of edging on the collar."[47] The *New York Evening Sun* went so far as to judge his shirt, with its wide collar and cuffs "trimmed with narrow lace of a pretty pattern," the most "striking feature of his toilet."[48] In Alexander's representation, considerable attention is focused on the left hand and adjoining cuff. Wedged between the cuff and the lower edge of the poet's jacket sleeve is a mottled pattern of whites and grays, which in placement and patterning strongly allude to the widely discussed lace edging. Despite having provided a detailed representation of the lace in the previously noted oil sketch, the artist seemed reluctant to do more than suggest its presence in the finished painting, and even then only along one cuff. Significantly (and again, contrary to the poet's weakened condition), the hand that emerges from the lace-trimmed cuff appears vigorous and assertive. However conflicted Alexander may have felt about rendering the lace more explicitly, even at this level of engagement, his painting addresses one of the most vexing questions confronting late-nineteenth-century audiences. The physical confrontation between the hand's virile, determined grip and the delicate lace edging registers the period's ambivalence about masculinity. Deviance confronts defiance; effeminacy, the conventions of Victorian manliness. It was presumably this

very dichotomy that prompted one of the reviewers of the 1887 Lincoln lecture to note the "pretty pattern" of the lace edging and then to praise Whitman for having the "rich red blood of a manly man."[49]

If Alexander's representation gives visual form to the culture's conflicted attitudes toward sexuality, it just as graphically engages the thematics of sexuality that so distinguished Whitman's poetry from that of his contemporaries. In "A Backward Glance O'er Travel'd Roads," published in 1888, Whitman judged it "imperative" that the culture shift its attitude "towards the thought and fact of sexuality" and begin to accept it "as an element in character, personality, the emotions, and a theme in literature. I am not going to argue the question by itself; it does not stand by itself. The vitality of it is altogether in its relations, bearings, significance—like the clef of a symphony" (LG 572). Earlier in the same essay, he explained that his goal was "less to state or display any theme or thought, and more to bring you, reader, into the atmosphere of the theme or thought—there to pursue your own flight" (LG 570). Alexander's aestheticized representation of the aging poet negotiates a similar terrain of atmospheric absorption and creative indirection. In the painting, "the thought and fact of sexuality" are not celebrated in prurient isolation but are subsumed into the substance of the work's signifying structure. Without attempting to "illustrate" the sexual themes that permeate the poetry, Alexander implies their presence, and by extension their importance, through his sexualized treatment of the man. His painting conflates two essential but fundamentally contradictory aspects of this most self-contradictory of American poets: the prophetic bard and the poet of sexuality and manly attachment.

Despite Whitman's public overtures to Wilde and his decision to attach lace edging to his shirts, the poet took steps to distance himself from Wilde's aestheticism. "No one will get at my verses who insists upon viewing them as a literary performance . . . or as aiming mainly towards art and aestheticism," he stressed in "A Backward Glance" (LG 574). In similar fashion Whitman repeatedly sought to deflect the persistent inquiries of the English critic John Addington Symonds, who, since 1871, had sought confirmation of the homosexual theme of the "Calamus" poems.[50] Finally, in August 1890, in an ill-fated attempt to put matters finally to rest, Whitman fabricated the wildly fictitious story that "tho' always unmarried I have had six children— two are dead—One living southern grandchild, fine boy, who writes to me occasionally."[51]

Just six months before Whitman's infamous letter to Symonds, Alexander's portrait went on public display at the Pennsylvania Academy of the Fine Arts' Sixtieth Annual Exhibition. After reading a review in the *Philadelphia Press* that chided the artist for taking "personal liberties . . . with the bard," Whitman, who was essentially housebound by this time, sent his friend Horace Traubel over to examine the painting and report back to him with his findings.[52] "[T]ell me about it," Whitman urged, "—tell me all you know about it!" In due course Traubel returned with a largely negative appraisal of the work. He judged the head "not badly painted, but *pinched*,"

the hands "faulty in [the] extreme," the beard "wooly [sic]" and "defective," and the coat an unfamiliar "black or very dark blue," not the characteristic gray the poet always wore. But if the painting should be judged a failure in the appropriateness and accuracy of its details, Traubel could not dismiss it outright. He conceded that "as a piece of art," Alexander's painting was "probably a good one."[53]

Although Whitman was never able to corroborate Traubel's observations on his own, as ill health kept him from visiting the exhibition, he laughed at this dichotomy. "I see—I see—," he boomed, adding, "they'll have it their own way—the *art*-way,—whatever occurs." Several days later, still without having seen Alexander's painting, Whitman moaned, "The devil with all the artists—or most all—is that they lack veracity—seem to feel under no obligation to produce things as they see them but rather to color up and up, till the public eye is properly titivated. How can there be true art on this basis?—first-class art by first-class men?"[54] Despite his own complicity in its construction, neither Whitman nor his closest associates could accept Alexander's aestheticized representation of the poet. John Burroughs lambasted it as "emasculated."[55] Whitman observed, "I am not sorry the picture was painted, but I would be sorry to have it accepted as final."[56]

Whitman's complaints about the "*art*-way" were not restricted to Alexander's representation. He would express similar misgivings about the portrait Herbert Gilchrist painted of him during the summer of 1887—when, after an absence of nearly a decade, the English artist returned to Camden, paintbrush in hand. Eighteen months earlier his mother, Anne, had died of breast cancer, and Herbert, now in his late twenties, was eager to reestablish ties with the poet and demonstrate the seriousness of his art. In the intervening decade Gilchrist had achieved a modicum of recognition within London art circles. In 1880, two of his drawings appeared in the new edition of his father's *Life of William Blake*; later, the Royal Academy and London's Grosvenor Gallery exhibited examples of his work.[57] The young artist had also garnered the favor of Whitman's London supporters. Buxton Forman owned examples of his art, and in 1885 the artist assisted William Rossetti and his mother in efforts to raise funds for Whitman among his London followers.[58] Buoyed by these experiences and by his own exalted opinion of his artistic capabilities, Gilchrist was determined to paint Whitman's likeness.

Since leaving the States, Gilchrist had made several attempts at Whitman's portrait, including the drawing that served as the frontispiece for Bucke's Whitman biography (fig. 46). That likeness, reproduced by the photo intaglio process, represented the poet in his familiar broad-brimmed hat with his hands prominently clasping the curved top of his cane. The somewhat rakish positioning of the hat hearkened back to Whitman's younger, jauntier days, while the presence of the cane underscored the sobering reality of his present state of health.[59] In a quieter mood was a small crayon sketch showing the poet with downcast eyes, the right half of his face bathed in a soft, luminescent light (fig. 47). Like Alexander, Gilchrist seemed intrigued by the contemplative side of this rugged outdoor poet.

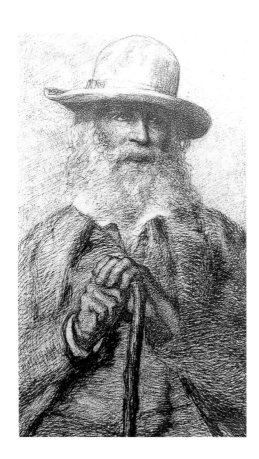

FIGURE 46 (LEFT) Herbert Gilchrist,
Walt Whitman, c. 1882

FIGURE 47 (ABOVE) Herbert Gilchrist,
sketch of Walt Whitman

Considerably more ambitious was Gilchrist's nearly life-sized group portrait, *The Good Gray Poet's Gift*, also known as *The Tea Party* (fig. 48). This was the only group portrait of the poet done in oils and one of the few representations, in any medium, to show the poet in the presence of others. Equally striking was the work's domesticated setting. The painting was begun in early 1882 as a celebration of the familial bond that had developed between Whitman and the Gilchrists during their many months together in Philadelphia. These months, as Marion Walker Alcaro has pointed out, constituted the only time in Whitman's life during which he "was the father figure in a household that included children and was presided over by 'a true wife & mother.'"[60] To render this sense of home and hearth, Gilchrist looked to the work of two highly regarded British artists. Compositionally, the painting owes a considerable debt to the lavish Victorian interior in William Holman Hunt's *The Awakening Conscience* (1852–54). Thematically, the work appropriates the convention of the "conversation piece," popularized in the eighteenth century by William Hogarth. The domesticity of Gilchrist's scene is figured in both the communal aspect of the meal and the rich array of paintings and other family memorabilia that adorns the mantel and adjacent walls. The painting's large size and complex, multi-figural format initially included Whitman and the four Gilchrists grouped around the family table.[61] Over the

FIGURE 48 Herbert Gilchrist,
The Good Gray Poet's Gift, 1885–86

course of its construction, however, Gilchrist transferred the scene from Philadelphia to London. ("We often say," Mrs. Gilchrist had written the poet in April 1881, "'Won't Walt like sitting in that sunny window?' or 'by that cheery open fire' or 'sauntering on the heath'—& picture you here in a thousand different ways.")[62] As part of this transformation, Gilchrist eliminated himself and his sister Beatrice, who had committed suicide in July 1881. In their place he substituted a rather shadowy servant, perhaps the family's "new Scotch lassie," and inscribed "a pretty view of Cannon place, Hampstead" out the window.[63] With Herbert removed from the scene, Whitman is represented in a feminized space, the domestic interior, and exclusively in the company of women—a far cry from the masculine surroundings of Forbes's *Fall in for Soup!*

Herbert worked on the painting for more than three years. The obvious advantage of painting his mother and sister from life is readily apparent in the more three-dimensional handling of their forms and their greater sense of animation. Mrs. Gilchrist looks intently at the poet, her face and ruffled white collar illuminated by the soft light pouring in from the adjacent window. Grace, who was known to be not particularly fond of Whitman, sits opposite the poet, her turned head and distracted demeanor indicative of her conflicted status within the extended family grouping. Both women are considerably more fully realized than Whitman, who appears almost spectral in contrast. Removed from the physical presence of the man, Gilchrist lacked the technical sophistication to translate him adequately into paint. Still, Herbert persisted, and in April 1883 he informed Whitman, "You play a prominent part in this picture—seated at table bending over a nosegay of flowers, poetizing, before presenting them to mother."[64]

In giving visual form to Whitman's domestic arrangement, Gilchrist was secure in his extensive personal knowledge. He was at the same time venturing into an arena from which Whitman had purposely and consistently distanced himself as a poet. With the notable exception of the staged domesticity at the 1887 Lincoln lecture, Whitman rejected all associations of himself and his verse with the interiority and conformity associated with the overstuffed Victorian parlor. In an effort to blunt this aspect of the painting's signifying structure, Gilchrist centered the poet's head against the view out the window and assigned him a gesture calculated to reify his association with the simple pleasures of the natural world.[65] In his biography Bucke recounted the poet's fondness for flowers, "either wild or cultivated," and his habit of gathering and arranging "immense bouquet[s] . . . for the dinner-table, for the room where he sat, or for his bed-room."[66] Gilchrist's painting marks just such an occasion. In the process, however, it veers perilously close to sentimentalizing the poet. Gilchrist's earlier suggestion that *Specimen Days* be published on handmade paper with a gold water lily ornamenting the cover struck a similarly jarring note.[67] The artist's representation of Whitman "poetizing" over a bouquet of flowers in a lavishly ornamented Victorian dining room seems a visual counterpart to the "porcelain, fine china, dainty curtains, exquisite rugs" of Gilder's highly conventional poetry. Even the artist's mother recognized the painting's limitations. "Your figure in the picture is," she wrote,

". . . a fair suggestion of one aspect of you; but not, could not of course be, an adequate portrait."[68]

Gilchrist based his representation of the poet on the life sketches he brought back with him from America, a sampling of photographs, and a swatch of fabric from one of Whitman's suits sent him by the poet.[69] By far the most significant photographic aid was one of Whitman's favorites—the profile portrait the poet had sat for in 1876 to assist Sidney Morse in his initial attempt at sculpting his likeness. A few years later, Whitman would confer supreme status on the photograph, taken by Philadelphian Charles H. Spieler, in selecting it as the frontispiece for *Complete Poems and Prose of Walt Whitman, 1855 . . . 1888* (see fig. 58). "I consider it a hit," Whitman explained, "the looking *out:* the face *away* from the book. Had it looked *in* how different would have been its significance—what a different tale it would tell!"[70] In contrast, in Gilchrist's trans-genre appropriation, the poet looks in toward the family and the domestic appointments of the Victorian interior. Gilchrist thus subverts Whitman's associations with the outward-looking poet. Nor does he seem motivated by Lavater's associations of the profile with the underlying principles of character. In the end, Gilchrist's attraction to the profile orientation of Spieler's photograph seems to have been predicated largely on matters of utility: it suited the formal requirements of the composition.

When Gilchrist returned to Camden in June 1887, full of tales about Whitman's staunch English following, the young Englishman no doubt expected the poet's undistracted attention. Instead, Gilchrist discovered Morse, the sculptor minister, comfortably established in the parlor of Whitman's Mickle Street residence. Morse had returned to Camden the month before and was already at work on the first of at least four clay models and two paintings of the poet, which he would complete before departing the city in December.[71] Like Gilchrist, Morse was determined to represent that all-important likeness of the poet that had eluded him in the earlier stages of his career. As Morse noted, "I still desired . . . to make the 'bust.'" When he learned that he would have to share his space with another artist, however, he balked. "I could illy conceal my disappointment," Morse recalled. "I coveted the whole loaf with no disposition to share it with anybody."[72] Out of deference to Morse, Whitman relegated Gilchrist and his easel to a place "a little way in the rear," thus permitting Morse to keep his place at the window, the spot with the best light nearest the poet. The two artists continued this arrangement for about a week. Finally, as the strain began to show on the aging Whitman, Morse moved to the backyard.[73]

The presence of Morse and Gilchrist and the arrival, later that fall, of Thomas Eakins considerably buoyed Whitman's spirits and contributed significantly toward making 1887 "perhaps the most satisfying year that Whitman had had since coming to Camden."[74] For a period of several months, Whitman's residence assumed a lively workshop atmosphere. While Whitman wrote, the artists plied their trade in an atmosphere of friendly rivalry. "I soon became quite as much interested in Gilchrist's designs and expectations as in my own," Morse acknowledged.[75] Like each of the previous representations of

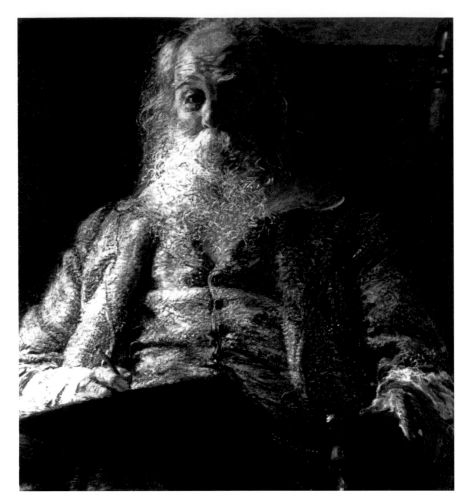

FIGURE 49 Herbert Gilchrist, *Walt Whitman*, 1887–88

the poet, the portraits that issued from the hands of these artists inscribed different and competing realities. None experienced a more convoluted trajectory than Gilchrist's.

Gilchrist worked on his portrait during the summer, and in September, he returned to London with it still unfinished. (Many years later and long after Whitman's death, Gilchrist confided to Traubel that he had never been satisfied with his handling of Whitman's hand. At that time—1906—the painting was still not finished, although he expected "some day" to complete it.)[76] Gilchrist had expressed displeasure with the positioning of the figure with respect to the painting's upper border.[77] Shortly after his arrival in London, presumably to rectify these difficulties, he had constructed a second version of the painting. He characterized it as "a replica, a finished copy" of the first, and the following spring was pleased to have it accepted in a major exhibition at London's prestigious Grosvenor Gallery.[78] In September 1888 Gilchrist returned to Philadelphia with this "replica," which hangs today in the Annenberg Rare Book and Manuscript Library at the University of Pennsylvania.[79]

In sharp contrast to Alexander's stately portrayal of an enthroned and regal Whitman, Gilchrist's portrait represents the Camden bard as a working poet, a genial and accessible man of letters (fig. 49). The poet confronts the viewer from the comfort and convenience of his favorite rocking chair. His shirt is open at the neck, his clothing slightly rumpled, and he balances a writing board on his lap. It was a pose and a setting Gilchrist would have observed many times.[80] In his right hand Whitman holds a pen, poised and ready for writing, while his weakened left hand clutches the arm of his trusty chair. Far removed from either the pompous, book-filled setting commonly associated with writers or the artificially constructed domesticity of the Lincoln lecture, Whitman engages both his writing and the viewer within the familiar, if abstracted, confines of his own home. With the intrusive clutter carefully excised from the field of view, the setting celebrates more the mobility of Whitman's artistic practice (reinforced by the presence of the rocking chair) than the anchoring of that practice within the comforts of a domestic interior. A strong light, no doubt the natural sunlight streaming through his parlor's front window, illuminates the poet's body, drawing special attention to his balding head, hair, beard, and hands. A quizzical expression animates his gently furrowed brow. Broken brushwork and shimmering surface effects woven through with traces of tan and slate blue transform the poet's familiar charcoal gray suit into a tapestry of hues, an acknowledgment of Gilchrist's recent discovery of Impressionism.

In September 1887, with the painting unfinished and Gilchrist's return to London looming, Whitman admitted to a friend that he personally liked the work in what we now know to be its original manifestation, although from the beginning others around him thought it "too *tame*."[81] Later, when confronted with the "finished copy," Whitman commented favorably on Gilchrist's handling of the body: "Herbert has drawn the body superbly: its light and shade is striking—across the clothing, the hand: all that is done with power, without fault."[82] In general, though, neither Whitman nor any of his associates had much good to say about either the painting or its producer. Their growing displeasure with Gilchrist's conservatism suffused their response to his art. Matters were complicated by the inevitable comparisons with Thomas Eakins, whose intellectual grasp of Whitman's poetry and painted portrait (discussed in the following chapter) struck a more responsive chord with Whitman and his colleagues. On almost every count, Gilchrist came up short. "The two pictures sort of bark at each other, they are so unlike," Whitman observed. "The Eakins portrait gets there—fulfils its purpose; sets me down in correct style, without feathers—without any fuss of any sort," he averred. "Now Herbert is determined to make me the conventional, proper old man: his picture is very benevolent, to be sure: but the Walt Whitman of that picture lacks guts."[83]

Gilchrist's conventionality manifested itself in any number of ways— as in his response to the Grosvenor Gallery exhibition of his portrait. Featured in that display were works by revered British artists, including Sir Joshua Reynolds, Thomas Gainsborough, and William Hogarth. Gilchrist was ecstatic

that in such august company, his painting had been "hung on the line," the most prestigious viewing location in any nineteenth-century gallery and one that accorded well with the artist's quest for academic approval. Whitman, however, was not impressed. "That line in a conventional art gallery!" he mused, "—I am not so sure of it, my hearty. I wonder if Leaves of Grass would be hung on the line if the galleries had their way about it?—on the line or on a scaffold?"[84] In his own earlier appropriation of the exhibition experience as a signifying trope in "Pictures," Whitman had studiously eschewed any reference to the hierarchical systems of stratification that governed exhibitions at that time. Gilchrist's willing, even eager, alignment with the conservative exhibition practices of his day only confirmed what Whitman and his friends found to be the essential weakness of his art: "Herbert . . . puts no resisting front to the conventionalities of the time—."[85]

Indeed, according to Whitman and his allies, the painting's failure was epitomized in Gilchrist's transformation of the poet's beard. "He gave you curls in your beard," Thomas Harned remarked in disgust. William Clarke, the reviewer for the London Star, labeled them "Italian curls," a thought so offensive to Whitman and his friends that it became a sort of mantra. "Look what Herbert did with my face when he got it over in London," Whitman exclaimed, "look how he dressed me up—put the barber at work on my hair—put it up in curl-papers and flung me abroad in the exhibitions as a social luminary. I should think they would like a man to come in his own dress and with his own manners not as remade by tailors and turned into a grimacing monkey repeating the platitudes of the parlors." He further remarked, "The head is not so bad if you can rescue it from the curls. The picture needs to be sent to a barber." While there is no evidence to support Whitman's contention that Gilchrist inserted the curls only after his return to London, such a viewpoint gained favor within the poet's inner circle largely because it supported their growing disappointment with the artist's conventionalism. Further, Whitman found the curls symptomatic of the painting's "London drawing-room point of view." "Herbert didn't do the picture bad because he wasn't able to do it better," Whitman reasoned, "but because the people over there demanded a certain kind of Walt Whitman and he gave them what they wanted." Whitman was particularly concerned by what he and others perceived to be the work's endorsement of the aesthetic and philosophical "codes" mandated by the conservative London art establishment. Sir Frederick Leighton, president of the Royal Academy, exemplified for Whitman those artists for whom "technique, style, tradition" held sway over more pressing and substantive issues. Like Longfellow, Leighton was "a great man according to existing rules." But "existing rules" were not enough. Artists, Whitman stressed, needed to concern themselves with more important matters like "origins, sources, inspirations" and the "direct" confrontation of the world around them.[86]

Whitman's growing disappointment with Herbert's sympathy for conservative practitioners like Leighton stood in contrast against his continuing admiration for the progressive views of his mother. "In many respects," Whitman lamented, "Herbert is a complete reaction from his Mother."[87]

As one of Whitman's strongest and most articulate champions, Mrs. Gilchrist had celebrated the poet's pioneering spirit as far back as 1869. Her pathbreaking essay in *The Radical* had applauded the poet's refusal to be bound by professional expectations and praised the musical qualities of his verse, which "no counting of syllables" could ever justify.[88] Even in her last essay, issued just months before her death and less than three years before Herbert's painting, Mrs. Gilchrist had continued to champion Whitman as a "daring innovator," whose verse gave "scope and elevation and beauty to the changed and changing events, aspirations, conditions of modern life." The question for his readers, she stressed, was not so much whether we liked or disliked him, but whether we were capable of "stepping out of our habitual selves" to answer his summons.[89]

For all its conventionalism, Gilchrist's portrait is not as devoid of probing and insightful content as the comments of Whitman and his associates would suggest. Far more than in *The Good Gray Poet's Gift*, Gilchrist filtered his representation of the poet through the enlarging lens of the poetry. Whitman's direct, frontal encounter with his viewer—a quality strikingly absent in *Gift* and in the remoteness of Alexander's regal representation—registers effectively as a visual counterpart to the language of direct address, the language that radically distinguished his poetry from that of his contemporaries.[90] The physical and psychological intimacy with which Whitman and the viewer engage one another, together with the realization that they encounter each other across the emergent text of a new line of verse, reify the psychological immediacy and striking sense of presence at the heart of the poetry's signifying structure. On still another plane, the painting's broken brushwork and animating textural effects register as visual tropes both for the process of writing represented in the painting and for the process-oriented emphasis of Whitman's poetry. Gilchrist's alignment with the progressive and still controversial aspects of Impressionism was short-lived, though. Shortly after completing Whitman's portrait, Gilchrist commenced a historical painting entitled *The Entrance of Cleopatra into Tarsus*, a work that Whitman judged "more in the line of [Gilchrist's] abilities, tastes, training."[91] Although Gilchrist remained firm in his commitment to Whitman and soon relocated to Centreport Cove, Long Island, to paint in the vicinity of Whitman's birthplace, he never regained his once favored position within Whitman's intimate circle.[92]

The little-known Sidney Morse poses a striking contrast to both Gilchrist and Alexander. Not only did Morse pay scant attention to the established conventions mandated by the academy, but he also sculpted his sitters with the naive directness of the minister-turned-sculptor that he was. On any number of occasions Whitman praised Morse's efforts, finding more of substance in his work than in the more polished but conventional renderings by Gilchrist and Alexander. At times he even preferred Morse's work to that of Thomas Eakins. "If Morse had got a better start in sculpture he'd have been the high jinks in the business," Whitman once remarked. "He has the capacity . . . but he is not quite steady enough at one thing ever to get the best out of it."[93]

During his eight months in Camden, Morse completed at least nine

representations of the poet, far more than any artist save Gilchrist. These included two bas-reliefs, a seated figurine, four large, nearly identical portrait busts, and two paintings. Neither the paintings nor the reliefs are known today, although Whitman considered one of them, a medallion, "a very significant piece of work."[94] The seated figurine that Morse made to exonerate himself from the debacle surrounding his effort of the previous decade is known only through an old photograph (fig. 50). Even before his arrival in Camden, Morse wrote Traubel that he intended the work to convey the sentiments "I loaf & invite my soul" and assured his friend that the rim of the poet's hat would be "ample enough this time."[95] In the finished piece, the poet relaxes in his rocking chair, one leg crossed gently over the other, his hands resting comfortably on the arms of the chair. The pose recalls Gilchrist's more refined treatment of the seated poet. And although the lack of a hat suggests that Morse had once again lost his battle with the brim, Whitman proudly displayed the figurine in his room alongside the artist's bust of Elias Hicks.[96]

Significantly more imposing and held in much higher regard by Whitman and members of his inner circle were Morse's busts, three of which are owned by the Walt Whitman House in Camden, New Jersey, with the fourth in the Whitman-Feinberg Collection at the Library of Congress (fig. 51). As in the seated figure, the poet is hatless, but has now shed his suit coat, leav-

FIGURE 50
Sidney Morse,
Walt Whitman, 1888

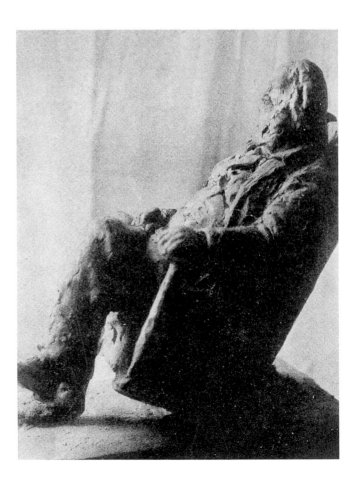

ing him dressed only in a simple shirt left open at the neck. The defiant, unbuttoned disposition of the shirt's top button, although obscured from view by the poet's beard, is driven home by the unusual prominence accorded the neatly buttoned second one. As in the seated figurine, a rough-hewn quality infuses the entire work but is particularly evident in the handling of the hair, beard, and shirt. A slight rightward twist given the hairs in Whitman's beard (especially those located just below his mouth), together with the leftward orientation of his gaze, inject a dynamic sense of movement that builds on and extends the movement inscribed in the work's irregular surface. Still, the bust cannot escape its amateur status, evident especially in the crudeness of the modeling, the lack of clear differentiation between textures, and the rather too insistent erectness of the head. For Whitman and his associates, these very traits only enhanced the work's power by affirming the artist's independence from established art practices. Like Whitman's own deviations from the smooth transitions, predictable diction, and regular rhyming schemes prized by his contemporaries—"I round and finish little," he advised in "A Backward Glance O'er Travel'd Roads" (*LG* 570)—Morse's formal irregularities were considered integral to an understanding of the work's signifying power. They served as tropes for Whitman's unconventionality, his assertive, visionary presence, and his robust energy.

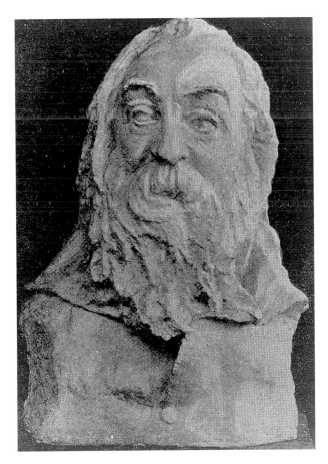

FIGURE 51
Sidney Morse,
Walt Whitman, 1888

Whitman valued the bust's unrefined handling of the surface as a quality "rarely to be found among the artists." To him it registered "rugged power" and "magnificent abandon—utter abandon!"[97] The erect bearing of the head, the slightly forward thrust to the chin, and the inquiring arch of the left eyebrow, qualities Whitman had previously admired in Linton's engraving, became signifiers of "the modern spirit," with its call to be "awake & alert as well as calm."[98] Whitman found additional satisfaction in the treatment of the eyes. Morse had shown them "open, looking forward—not as I am usually shown, but as I spiritually am." Whitman judged it "exceedingly fine—a revelation of what art can do at its best, when it becomes nature!"[99] Even Eakins would be caught short, in Whitman's estimation, when evaluated on his treatment of the poet's eyes.

As with the representations selected for inclusion in the various editions of his books, Whitman was less concerned with issues of mimetic transcription than with the more difficult and elusive questions of identity and symbolic presence. Morse, Whitman observed, "gives up the letter if need be for the spirit." Morse's resistance to the established conventions of his day, his marginal status within the professional mainstream, and his affinity for society's social, political, and artistic radicals helped secure him a place in Whitman's artistic pantheon. Whitman declared his willingness "to go down to the future, to be judged of in days to come—the long, long hereafter—by Sidney's head—by that more than any other—more than all others." Upon further reflection, Whitman noted, "I don't know but that . . . the richest quality that inheres to [Morse's bust is] its amplitude—its ample expression of poise, equanimity, power."[100] Burroughs, too, responded enthusiastically to what he perceived to be the work's untamed power and assertiveness. His principal reservation was that in his haste to assert Whitman's rough-hewn individualism, Morse had neglected altogether the poet's softer, feminine side, that "something fine, delicate, womanly in him."[101]

Whitman's faith in the expressive power of Morse's bust prompted him to seek a permanent home for the work. Not long after its completion, Whitman sent William Sloane Kennedy and Sylvester Baxter a plaster copy of the bust with the request that it be given "to some appropriate permanent gallery" in Boston.[102] In December 1887 the work was exhibited in Williams and Everett's art rooms on Boylston Street, where it received favorable press coverage. The *Daily Evening Transcript* praised it as expressing "forcibly the big, expansive and manly character of the poet."[103] Three days later, in a letter to the editor in the same newspaper, Kennedy reiterated Whitman's own praise for the bust and urged his fellow Bostonians to consider the work something they would be "proud to possess."[104] (Despite their efforts, no permanent home could be found.)

In late December, about the time of the Boston viewing of his work, Morse returned to his Massachusetts studio. Whitman and a group of his friends had hoped to entice the artist to remain in Camden and had considered pooling their resources to purchase "some sort of a comfortable shack" on the outskirts of Camden where Morse could live and work unhindered.[105]

Although the plan never went anywhere, it underscores the affinity Whitman felt toward Morse, who would return for his funeral a little over four years later. The year following Morse's departure, Whitman sought to reproduce Morse's bust as the frontispiece in his new book of poetry and prose, *November Boughs* (1888). He reluctantly abandoned the idea when he was unable to secure a publishable photograph. In the massive *Complete Poems and Prose of Walt Whitman, 1855 . . . 1888*, which included *November Boughs*, Whitman substituted for the Morse a halftone photo reproduction of a work by Philadelphia photographer Frederick Gutekunst (fig. 52). Although visually quite unlike Morse's work, to Whitman it embodied many of the same qualities. He noted in particular its "ruggedness, unstudiedness, unconventionality."[106] In 1889 Whitman succeeded in placing a photograph of Morse's bust in *Camden's Compliment*, a book of reminiscences published by the poet's friends on the occasion of his seventieth birthday. Three years later, following Whitman's death, the bust occupied the place of honor at Kennedy's Belmont home, where the Boston Whitmanites gathered "for an open-air walk and talk." Crowned with myrtle and looking like a victorious Caesar, the bust stood just inside the door.[107]

Like the portraits produced earlier in Whitman's career, the visual representations constructed by Wheeler, Alexander, Gilchrist, and Morse convey a varied and often conflicting interpretative range. The figure gazing out at the viewer from the liminal space of these visual representations bears little relationship to the physically robust poet of the 1850s. Far more than age and the lingering effects of ill health were at issue. Also at play were changes in the concept of the self—and in the specific selves Whitman inhabited and projected. For many, the vicissitudes of time and ill health were constructed less as signifiers of Whitman's physical decline than as markers of his enhanced cultural status. His aging physiognomy seemed only to confirm the mythic status that he and those around him had long projected as his cultural legacy. If Morse's work elicited some of Whitman's highest praise, the representations by Alexander and Gilchrist celebrated those aspects of Whitman's self and daily experiences at odds with his scripted public self. Far from resolving the complex questions of identity raised by the verse, these painted and sculpted versions of the aging poet only intensified the debate.

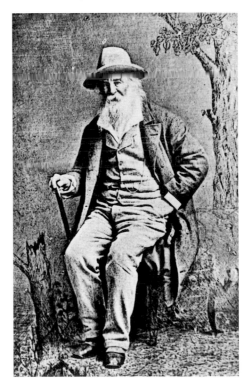

FIGURE 52 Frederick Gutekunst, *Walt Whitman*, c. 1888

Thomas Eakins and the "Solitary Singer"

IN THE SPRING of 1888, shortly after Thomas Eakins completed his portrait of the poet, Whitman remarked to Traubel: "Eakins is not a painter, he is a force."[1] His veins bulged with the "poetical stuff" (*LG* 347) Whitman sought. More than any of the artists who entered Whitman's orbit during his last years in Camden, even the unconventional Morse, Eakins engaged Whitman's presence within the terms of the poet's own radicalism. "I dilate you with tremendous breath, I buoy you up," Whitman advised in "Song of Myself" (*LG* 74), and so it was clearly for Eakins. Throughout his career, but especially during his five-year friendship with Whitman, Eakins focused considerable attention on their shared commitment to the resonant authority of the human voice. "Speech is the twin of my vision," Whitman reminded his readers. "It provokes me forever" (*LG* 55). Twice during the years of their friendship, Eakins paid tribute to the Camden bard in works that entwine the arts of seeing and singing. These works, only one of which references the poet directly, map new dimensions in the creative interplay between painter and poet.

When Whitman and Eakins met, probably in 1887, Whitman was sixty-seven and Eakins forty-three.[2] Although a generation younger and considerably better educated than Whitman, at least formally, Eakins was by all accounts the more conservative of the two. The artist's training at the prestigious École des Beaux Arts in Paris had confirmed his commitment to those areas most often contested by his more progressive colleagues: perspective, academic modeling, the study of anatomy, and an emphasis on the human figure. And although Eakins rejected the École's emphasis on precise drawing and its preference for narrative subjects based on classical, mythological, allegorical, and Orientalist themes, he never wavered in his admiration for the work of his principal instructor, Jean-Léon Gérôme. Perhaps thinking Whitman might share his enthusiasm, Eakins presented the poet with several framed repro-

ductions of Gérôme's work shortly after they met. Whitman, however, was not impressed. "[T]he *grand* does not appeal to me," Whitman explained. "I dislike the simply *art* effect—art for art's sake, like literature for literature's sake, I object to, not, of course, on prude grounds, but because literature created on such a principle (and art as well) removes us from humanity."[3] In the end Whitman concluded, "Gérôme has not much for me: he's not our man."[4]

If Whitman and Eakins failed to agree on the merits of Gérôme's art, there was much that united them. Like Whitman, Eakins paid scant attention to matters of technical brilliance, preferring to ground his work in the direct observation of nature. In a letter to his father composed during his student days in Paris, Eakins expressed his intention to "sail parallel to Nature's sailing." He added, "The big artist does not sit down monkey like & copy a coal scuttle or an ugly old woman like some Dutch painters have done nor a dungpile, but he keeps a sharp eye on Nature & steals her tools."[5] Following his return to America, Eakins, like Whitman, devoted himself to forging an art out of the "poetical stuff" of everyday life. And while Eakins clearly lacked Whitman's democratic inclusiveness, the two celebrated in their art a commitment to the voice, the body, science, and the physical and mental benefits associated with vigorous outdoor activity. In 1881, the noted critic Mrs. Mariana Griswold Van Rensselaer wrote of Eakins what was equally true of Whitman: "his artistic skill is such that he can bring good results from the most unpromising materials."[6]

FIGURE 53 Thomas Eakins, *The Gross Clinic*, 1875

FIGURE 54 Photograph of *The Gross Clinic* in Whitman's house

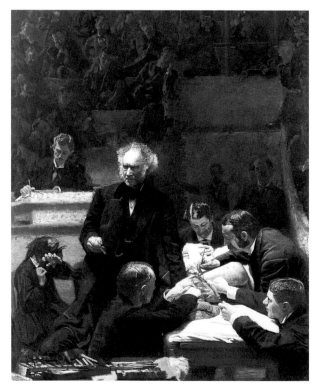

Shortly after they met, Eakins presented Whitman with a black-and-white print of his magnificent *Gross Clinic* (fig. 53).[7] The painting, one of Eakins's most accomplished and controversial, inscribed several of the concerns that informed the personal and professional lives of both men. In offering the print to Whitman, Eakins did more than present his friend with a token of his admiration and respect. He seemed intent on grounding that friendship in the mutuality of shared experience. Whitman, who remarked on the work's "manifold adequacies,"[8] displayed it amidst the clutter of his Mickle Street parlor. An old photograph (fig. 54) shows the unframed print leaning casually atop Morse's bust of Elias Hicks and below Inman's valued painting of the poet's mother.

The Gross Clinic, completed more than a decade earlier, commemorates the achievements of Dr. Samuel D. Gross, a prominent local surgeon and member of the faculty at Jefferson Medical College, where Eakins had studied anatomy. The operation in progress—the removal of dead bone from the thigh of a patient suffering from osteomyelitis—was one Dr. Gross had perfected and for which he was known throughout the medical community. As a portrait, this powerfully dramatic rendering of the balding Dr. Gross, his bloodied hand bearing testimony to his active participation in the operation he helped pioneer, constituted the kind of revealing summation of an individual's personal and professional mettle that Whitman greatly admired. The uncompromising directness with which the patient's semi-nude body lies exposed, its open incision surrounded by the blood-soaked hands and probing medical instruments of the attending medical professionals, recalls Whitman's graphic descriptions of his Civil War hospital experiences, in which young men were hastily operated on in far less sanitary and humane surroundings. No less significant is the fact that the operation being performed saved the patient's leg and replaced the only reliable earlier treatment—amputation. Having witnessed all too many amputations himself (for war injuries, not for diseased limbs), Whitman must have felt a special sympathy for Dr. Gross and his highly regarded surgical skills.

Eakins had undertaken the painting, the largest and most ambitious of his early career, with an eye to exhibiting it in the American display at the Centennial Exhibition, in keeping with the Fair's mandate to celebrate American progress. The painting, however, had proven too blunt for Eakins's more conservative colleagues, who refused to exhibit it with other American paintings in the exhibition's Memorial Hall. Through the intervention of Dr. Gross, the work was eventually hung in the medical section of the exhibition, among other medical exhibits.[9] This effective denial of the painting's "art" value echoed the recurring challenges to the literary merits of Whitman's verse.[10]

In 1886, ten years after joining the faculty at the Pennsylvania Academy of the Fine Arts and four years after being promoted to director of the Schools, Eakins was fired by the head of the school's Committee on Instruction for his controversial teaching methods. School authorities were especially critical of Eakins's habit of photographing his students in the nude

and of encouraging his students to pose nude for him in private sessions. The final blow came when he removed the loin cloth from a male model in the presence of female students.[11] Eakins's detailed emphasis on what one detractor termed the "horrid nakedness" of the human body,[12] coupled with his complete indifference to Victorian standards of modesty and his blunt, often crude, personal manner (Whitman once admitted that Eakins had "no parlor gallantries"[13]), challenged the conservative attitudes of his contemporaries in ways many found intolerable. Just over twenty-one years before, Whitman, too, had been dismissed from his job over charges that his verse violated acceptable moral standards.[14] And as recently as 1882, *Leaves of Grass* had been banned by Boston's district attorney on the grounds that it constituted obscene literature.

Vilified by segments of the general public and marginalized by their peers, Whitman and Eakins thus shared a history of rejection at the hands of their contemporaries. They just as surely shared an advocate in the person of Talcott Williams. A journalist and expert on the Near East, Williams drew praise for his thoughtful editorials on art and literature and would later distinguish himself as the first director of the Columbia University School of Journalism.[15] In 1882, the year after he joined the *Philadelphia Press,* Williams issued a strong editorial decrying the actions of the Boston district attorney. He was no doubt also responsible for the paper's front-page interview with a local minister and member of the Philadelphia Society for the Suppression of Vice and Immorality who forcefully rejected the negative actions of the Society, terming Whitman's verse "robust, virile, but not obscene."[16] Four years later the *Press* defended Eakins during his debacle with the Academy, citing individuals close to the case who continued to regard him as "an excellent instructor" and "a thorough gentleman."[17]

Williams probably met Whitman soon after his arrival in Philadelphia. He entertained the poet in his home in August 1884, shortly after which Whitman submitted several pieces of writing for publication in the *Press.*[18] Williams's relationship with Eakins probably dated from the same year. In 1887, a year after Eakins's dismissal from the Academy, Williams took it upon himself to introduce poet and painter, convinced, perhaps, that such a meeting would help rally Eakins's flagging spirits. Four years before, Williams had introduced Eakins's student Henry McCarter to the poet, and now, under much less fortunate circumstances, it was the teacher's turn. On 4 May 1887, Whitman recorded in his daybook "visit with Talcott Williams & Mr."[19] In all likelihood the unnamed visitor was Eakins, who would return often over the next five years and produce one of the poet's favorite and least understood portraits.

At the time of Eakins's initial visit, Whitman had recently returned from his successful New York Lincoln lecture and was awaiting the arrival shortly of Morse and Gilchrist, competitors in the friendly rivalry for his portrait. Whitman noted how "sick, run down, out of sorts" Eakins appeared. He found him "careless, negligent, indifferent, quiet: you would not say retiring, but amounting to that." Two or three weeks later "Eakins turned up again—

came alone: carried a black canvas under his arm: said he had understood I was willing he should paint me: he had come to start the job. I laughed: told him I was content to have him go ahead: so he set to: painted like a fury. After that he came often—at intervals, for short stretches."[20]

As Eakins's most public sitter, Whitman presented the artist with a challenge unlike any he had previously encountered. In addition to the portraits in progress by Morse, Gilchrist, and Alexander, there were the earlier painted portraits by Gilchrist, Dora Wheeler, Charles Hine, and George Waters, as well as drawings, prints, and dozens of photographic representations spanning more than thirty-five years. These diverse representations of the poet offered competing and often conflicting assessments of the man and his verse. "I meet new Walt Whitmans every day," Whitman observed. "There are a dozen of me afloat. I don't know which Walt Whitman I am." On another occasion, Whitman lamented having been "photographed to confusion."[21]

Eakins's entry into the contested arena of Whitman portraiture probably commenced in the summer of 1887. In all likelihood, Eakins completed his initial oil sketch (fig. 55) before the end of July, when he left for an extended trip west to the Dakota Territory. The sketch is unusual: it concentrates solely on the poet's head, not the head and upper torso represented in the finished portrait. The head is tilted slightly backward and presented in the same three-quarter view as in the finished painting, but the poet's eyes are closed and his mouth and lower jaw completely obscured by a deep shadow that envelops his entire lower face. Although vividly painted in rich, luminescent tones, the likeness remains silent, uncommunicative. An image of advanced old age emerges from the Rembrandtesque depths of the darkened picture space, an image that eerily portends the poet's approaching death and the death mask

FIGURE 55
Thomas Eakins,
Walt Whitman, c. 1887.
Photograph © 2006
Museum of Fine Arts,
Boston

Eakins and Samuel Murray would construct five years later.

The two and one-half months Eakins spent in what is now North Dakota proved a welcome respite from his Philadelphia woes. He rode with the cowboys, roped calves, milked cows, slept out under the stars, and ate beef three times a day. The rigorous demands of his daily existence left him physically and mentally revitalized. Several weeks into his trip, Eakins reported that he was now "in the best of health" and so committed to his demanding, outdoor routine that he considered "living on a round up . . . better in quality than in the palace Pullman dining cars."[22] When the artist returned to Philadelphia in mid- to late October, he had in tow two of his favorite horses, a mustang and a bronco, which he stabled at his sister's farm in Avondale. He also carried with him a number of photographs and quickly brushed oil sketches of cowboys and landscapes, prods for later paintings.

Following his own physical and spiritual decline in the 1870s, Whitman had similarly found renewal amid the natural beauties and challenging daily demands of a life lived close to nature, and he, too, had found personal and professional satisfaction on an extended trip west. Traveling by rail through Missouri, Kansas, and Colorado in the closing months of 1879, Whitman had exulted in what he termed "the vertebrae or back-bone of our hemisphere" while rediscovering "the law of my own poems."[23] "I reckon I'm a Westerner in spirit," Whitman surmised, and he was pleased to detect a similar sensitivity in Eakins. The myth of the frontier, with its promise of rugged independence and personal freedom, seemed reborn in what he characterized as Eakins's "cowboy bronco method" of painting. Whitman was adamant that such a method could not have derived "wholly or even mainly in the studios of Paris" but had "needed the converting, confirming, uncompromising touch of the plains."[24]

When Eakins resumed work on his portrait in late November, Whitman was completing the last poems for a new collection of his writings. *November Boughs,* published in 1888, bore witness to the poet's increasing preoccupation with his declining physical condition while revisiting several of the themes that had figured prominently in his earlier verse. In this, the November of his life—"The brooding and blissful halcyon days!" (*LG* 513)— Whitman wavered between lamenting the physical ravages to his body and celebrating "the jocund heart yet beating in my breast" (*LG* 509). In poems like "The Dead Tenor," written in response to the funeral of the renowned singer Pasquale Brignoli, Whitman celebrated the importance to his verse of the "revelation of the singing voice": "So firm—so liquid-soft—again that tremulous, manly timbre! / The perfect singing voice—. . . trial and test of all" (*LG* 523). Elsewhere Whitman reiterated his identification of the "mystic human meaning" of the voice with the natural rhythms of the sea, crediting the laws that govern the "swell and ebb" of the tides with shaping "the voice that chants this song" (*LG* 516).

In the years leading up to the publication of *November Boughs,* Whitman increasingly identified with the seafaring ways of his ancestors.

His 1885 article in *The Critic* described his room as having "all the rudeness, simplicity and free-and-easy character of the quarters of some old sailor" and his chair as having "posts and rungs like ship's spars." A "mighty trunk" situated against the room's back wall had "double locks and bands of iron" like those transported from abroad by immigrants. Unable to claim credit for any "long sea-voyages" himself, Whitman drew attention to his many friendships among the New York Bay pilots, proudly asserting that he had accompanied them in their boats "sometimes for a week at a time."[25] (As noted above, a male portrait alleged to be one of Whitman's Dutch ancestors enjoyed a place of prominence over the mantel in his Mickle Street parlor. While reviewing William Sloane Kennedy's essay on his Quaker traits, Whitman exulted, "I revel, even *gloat*, over my Dutch ancestry.")[26]

Among the new poems in *November Boughs*, "Old Salt Kossabone"— an ode to Whitman's ancestor, "Dutch Kossabone, Old Salt, related on my mother's side, far back"—synthesizes the poet's multiple concerns with the sea, his Dutch heritage, and the human voice. In a carefully calculated elision of himself and Kossabone, Whitman constructed his ancestor through the prism of his own habits and experiences. Kossabone, represented in the twilight of his years, whiled away the late afternoon and evening hours, "Sometimes, indeed, . . . half the day," like Whitman, "in his great arm chair by the window seated." From his window Kossabone had a clear view of the harbor and the sea, the central focus of his life's work, much the way Whitman looked out over the quotidian world of his verse. On the day he died Kossabone watched as a "struggling outbound brig" which had been "baffled for long" by "cross-tides and much wrong going" was suddenly freed by a favorable breeze. The beleaguered brig constituted only a partially veiled reference to Whitman and the relentless buffeting to which his verse had been subjected by an unsympathetic and often hostile public. The old sailor's final words—"She's free—she's on her destination"—sounded the acceptance Whitman had long prophesied for his verse (*LG* 522).

Whether or not Eakins set out to evoke the poet-sailor analogy of the late prose and poetry, he firmly grasped the need to filter his representation of the poet through the illuminating lens of Whitman's verse. Certainly it is the aging author of "Old Salt Kossabone," more than the youthful provocateur of "Song of Myself," who reverberates across the surface of Eakins's canvas to confound the viewer with a rugged combination of presence and reflection (fig. 56). With his head and upper body tilted slightly backward, as if leaning back in his chair, the poet in Eakins's painting inscribes the physical characteristics of an aging raconteur. Light from the open window next to which Whitman often sat (and where Eakins would photograph him in the coming years) illuminates the poet's right side. His averted gaze and gently shadowed face suggest the self-absorption characteristic of involved storytellers. Reflection, memory, and the summation of a life nearing its conclusion are all evoked in this poignant portrayal of age and its consequences. When Traubel announced that Eakins's portrait reminded him "of a rubicund sailor with his hands folded across his belly about to tell a story," Whitman responded with the satisfac-

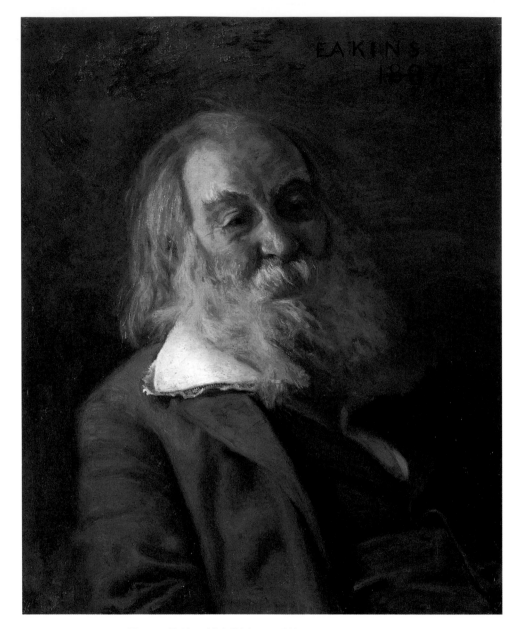

FIGURE 56 Thomas Eakins, *Walt Whitman*, 1888

tion that accompanies recognition.[27] In a letter to Bucke he, too, made an analogy with sailors and the sea, likening the painting to "sharp cold cutting true sea brine."[28]

Eakins's portrait merges Whitman's fragile, fleeting physical self with his constructed and transcendent authorial self. It differs from the artist's earlier portrait productions, which, like *The Gross Clinic*, generally represented the sitter in a three-quarter to full-length pose commanding a psychologically revealing and determinate environment. The Whitman, in contrast, is restricted to a half-length view with the poet occupying a completely undifferentiated

picture space. Even the poet's hands have been eliminated in this highly reductive presentation, which exemplifies the artist's late portrait mode. As Elizabeth Johns has observed, during the later decades of his career "Eakins painted fewer and fewer sitters with environments that defined what they 'did' in order to paint them in bust form to show what they 'were': physical human creatures." Johns attributes this change to Eakins's increasing concern with the materialist emphasis of anthropology and the natural sciences, discounting the importance of what she terms "Whitman's democratic 'being.'"[29] Lloyd Goodrich has proposed an alternative view, stressing instead the late portraits' function as "personal documents, tokens of friendship." Many, he observes, "were inscribed 'To my friend.'"[30]

Between 1886 (when he left the Pennsylvania Academy of the Fine Arts) and 1890, Eakins produced some sixteen bust-length portraits, the first of the late portrait series. Thirteen of these were representations of Eakins's students from the Academy and the Art Students' League. Whitman's inclusion in a group composed largely of Eakins's artist friends reinforces the affinity Eakins sensed between the aging poet and his younger colleagues.[31] The visual orientation of Whitman's verse, its willful disregard of the norms of conventional artistic practice, and its emphasis on the physical beauty and naturalness of the undraped human form were all points of intersection between the poet and Eakins's comrades. In "A Backward Glance O'er Travel'd Roads," one of the long prose essays in *November Boughs*, Whitman reiterated his commitment to representing in his verse "the broadest average of humanity and its identities in the now ripening Nineteenth Century." He indicated further that "compared with establish'd poems," his verse posited a "quite changed attitude of the ego, the one chanting or talking, towards himself and towards his fellow-humanity" (*LG* 564). Through the rhetoric of direct address, Whitman's poetry eschews the remote, omniscient narrator of conventional poetry to effect the intimacy and immediacy of a conversation between equals. Whitman's true instrument, as he tells us in his poetry, is his voice. And it is to the poet's mouth, poised and ready for speech (or song), that Eakins directs our attention. The expansive shadow located just below Whitman's mustache strongly insinuates a mouth that is open and engaged even though the mouth itself is largely shielded from view. By situating the mouth in almost the exact center of the composition, Eakins assures it maximum impact.

In "Now Precedent Songs, Farewell," Whitman reminded his audience, as he had on numerous earlier occasions, that his poems were not just words on paper, "not merely paper, automatic type and ink," but songs, emanating "[f]rom fibre heart of mine—from throat and tongue" (*LG* 534). By investing visual authority in Whitman's voice, Eakins's portrait creatively substantiates that claim.[32] Whitman stressed, in a passage from "A Backward Glance" that no doubt captured Eakins's imagination, the need to develop "a race of singers and poems differing from all others, and rigidly their own." "As long as the States continue to absorb and be dominated by the poetry of the Old World," Whitman advised, as long, that is, as the States "remain unsup-

plied with autochthonous song, to express, vitalize and give color to and define their material and political success, and minister to them distinctively, so long will they stop short of first-class Nationality and remain defective" (*LG* 574). Eakins's portrait celebrates that autochthonous song in a daring deviation from established portrait conventions.

As a genre, portraiture favors the formal and the timeless. Emphasis on the voice, whether speaking or singing, is highly unusual, largely because of its association with the momentary and the contingent.[33] Even Eakins's Dr. Gross remains resolutely mute, despite being posed as if lecturing to his students. Emphasis on the voice is more common in genre painting and had figured prominently in several of Eakins's earlier works in that mode, including *The Pathetic Song* (1881). By directing the viewer's attention to Whitman's voice, Eakins challenges the boundaries that have traditionally separated portraiture and genre painting. Several years later, in *Cowboy Singing* (fig. 57), Eakins would revisit the compositional and narrative strategies of the Whitman to celebrate another native voice. Here the figure is shown at full length and facing the opposite direction, but the mouth is now visibly open and the title of the work and the presence of the guitar confirm that the voice is engaged in song. In rhyming Whitman and the singing cowboy, Eakins produces a powerful resonance between the poet and the western type celebrated in his verse.

In its focus on the singing voice, Whitman's portrait deflects attention from other narratives similarly accessible through the late verse. One such narrative involved the poet's repeated laments over his infirmities and physical decline. Eakins's representation carefully obscures the poet's partially paralyzed left arm and the cane he used to get around. The viewer's attention focuses instead on his ruddy cheeks and healthy right side. Even the natural light that cascades over the poet's right shoulder seems primed to accentuate the physical vitality yet remaining in the poet's aging body, not the loss of vitality brought on by illness and old age. The light, in fact, visually confirms the connection Whitman always made between his voice and his body, the health of the one an affirmation of the health and well-being of the other.

In early December Whitman wrote Bucke that Eakins's portrait promised to be "realistic & severe."[34] Later that month Whitman recorded in his commonplace book that the painting seemed "strong (I don't know but powerful) & realistic—very different from Herbert's— It is pretty well advanced & I think I like

FIGURE 57
Thomas Eakins,
Cowboy Singing,
c. 1892

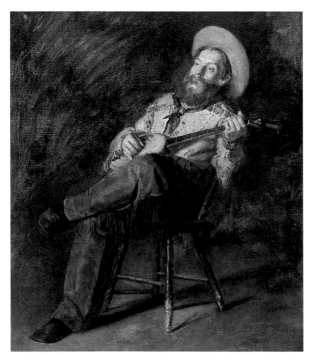

it—but we will see."[35] Shortly after Eakins completed the work in mid-April, Whitman began displaying it in his home. For the most part Whitman defended Eakins's painting, proclaiming it "a masterpiece of work: strong, rugged, even daring."[36] "Of all the portraits of me made by artists I like Eakins's best," Whitman declared a month after its completion. "It is not perfect but it comes nearest being me." As noted above, he expressed particular satisfaction with the work's earthy directness, its unidealized treatment of its subject, and its concern with the materiality of the human form: "The Eakins portrait gets there—fulfills its purpose; sets me down in correct style, without feathers— without any fuss of any sort."[37] To Whitman, the portrait seemed refreshingly unencumbered by artistic conceits and personal whim. "I find I often like the photographs better than the oils," Whitman confessed, "—they are perhaps mechanical, but they are honest. The artists add and deduct: the artists fool with nature—reform it, revise it, to make it fit their preconceived notion of what it should be." "The great strength of . . . Tom Eakins' [portrait]," Whitman insisted, was "that the subject is not titivated, not artified, not 'improved'— but given simply as in nature."[38]

In January 1891 Eakins requested the return of his portrait in order to enter it in the Sixty-first Annual Exhibition of the Pennsylvania Academy of the Fine Arts. This marked the first time Eakins had exhibited there since his firing five years earlier.[39] The *Philadelphia Press* lauded his entries as among "his best and strongest." The reviewer, no doubt Talcott Williams, particularly appreciated the artist's Whitman portrait, which he termed "by odds and far the best portrait yet made of an heroic figure in our letters."[40] Not surprisingly, Gilchrist strongly dissented. From the first time he saw the painting, he claimed that the flesh "lacked in purity" and that the whole "falsified" Whitman. His sentiments were shared by several students at the Academy who faulted Eakins for his "coarseness."[41]

Gilchrist and these students were not the only ones to object to Eakins's portrait. Members of Whitman's inner circle found the work too fleshy, imbued with "too much Rabelais instead of just enough." Whitman, too, had his doubts. He pointed to "an elusive quality which so far" none of the artists had managed to catch. "[E]ven Eakins' picture don't go to the right spot," he remarked, "—even it is inadequate."[42] As Meyer Schapiro and others have argued, the visual counterpart to the language of direct address, the language by which Whitman established himself as poet-prophet, is the frontal view.[43] In such a construction the poet confronts the viewer directly, and the two share a potent psychological space. Whitman's prejudices against Gilchrist had prevented him from appreciating how Gilchrist's seated Whitman, posed in virtually the same location as the Eakins, constructed just such an intimate and psychologically charged viewing environment. In Eakins's representation, however, Whitman looks not at but past the viewer. He appears removed, remote, absorbed more in his own private reveries than in any meaningful exchange with his audience. For Whitman, the unyielding expression in the eyes registered "blindness." Even before the work was complete he likened it to King Lear, the "poor, old, blind, despised & dying King."[44]

Whitman's discomfort with the portrait's treatment of the eyes resulted from the metaphorical significance he attached to acts of seeing. Tropes of vision abound in both *Leaves of Grass* and *Democratic Vistas*. (The latter's very title, as Alan Trachtenberg has observed, makes reference to the "intricate pattern of vision" within.)[45] In Whitman's universe, seeing constituted not merely a passive state of observation but also an assertive act of affirmation and knowing. Acts of seeing revealed the previously hidden, unseen, or unknown. In poem after poem Whitman established contact with his audience, with future generations of readers, through the penetrating power of his gaze, sending "[t]o you who'er you are—a look" (*LG* 382). Whitman once admired a photograph of Emerson that had what he called "that far-in-the-future look which seemed to possess him in the best hours."[46] Of the many photographic representations Whitman sat for over the years, the one which to his mind best captured the "far-in-the-future" quality of his own verse was Charles Spieler's profile photograph taken during the summer of the Centennial Exhibition. In a move that seems intended, in part, as a corrective to the problematics of vision encountered in Eakins's portrait, Whitman selected the Spieler as the frontispiece for *Complete Poems and Prose of Walt Whitman, 1855 . . . 1888*, which was published several months after the completion of Eakins's portrait (fig. 58).

Spieler's photograph, taken on a hot day in the summer of 1876, shows a weary and bedraggled Whitman looking far older than his fifty-seven years. In the book, the photograph occupies the right-hand page, with Whitman facing out, away from the spine, the physical center of the book. Although none of Whitman's friends could get past the work's obvious lack of flattery, Whitman considered its metaphorical significance more important than its visual appeal. He asserted, "I am not looking for art: I am after spiritual expression. Consider it in that way: I am not literary, my books are not literature, in the professional sense: I am after nature first of all: the out look of the face in the book is no chance."[47] When one of Whitman's associates praised the Hollyer representation used in the first edition of *Leaves of Grass*, Whitman defended the Spieler as "the best picture." He considered it good "not only as a piece of art (where it is effective, refined), but because so thoroughly characteristic of me—of the book—falls in line with the purposes we had in view at the start."[48]

In the months and years following the completion of his portrait, Eakins continued to defend his portrait and to insinuate himself into Whitman's inner circle. If anything, Eakins's attachment to Whitman intensified during the poet's last years. He visited Whitman regularly at his home, produced portraits of several Whitman intimates—including Talcott Williams (c. 1890), Thomas B. Harned (1891), and Harrison S. Morris (1896)—and enjoyed lengthy conversations with such Whitman enthusiasts as Harned and Horace Traubel.[49] Eakins also facilitated contact between Whitman and artists in his immediate circle, beginning with two artists who shared his Chestnut Street studio in the early 1890s: New York sculptor William Rudolph O'Donovan and Eakins's former student Samuel Murray. Whitman referred to

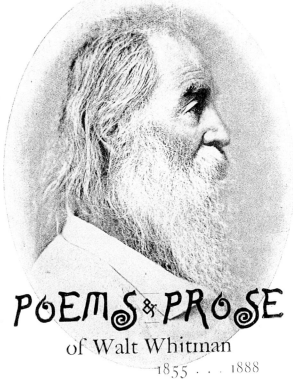

FIGURE 58
Frontispiece for
*Complete Poems
and Prose of
Walt Whitman,
1855...1888*; photo-
graph by Charles
H Spieler, 1876

the group visiting him often at his Mickle Street residence as Eakins's *"entourage."*[50] One of Eakins's students later described the all-male group as "us Whitman fellows."[51] They invite comparison as well with the "close phalanx, ardent, radical and progressive" that Whitman had prophesied some forty years earlier.

Within this self-described gathering of "Whitman fellows," Eakins and O'Donovan were exact contemporaries. Although little known today, O'Donovan was an accomplished painter as well as a sculptor. He served in the Confederate army before settling in New York, where he gained a reputation for his portraits of artists. His move to Philadelphia in April 1891 was precipitated by a commission on which Eakins had agreed to assist him: the modeling of two equestrian reliefs of Abraham Lincoln and Ulysses S. Grant for the Soldiers' and Sailors' Memorial Arch in Brooklyn's Grand Army Plaza.[52] But O'Donovan had other motivations for making the trip to Philadelphia. In the 1870s, while studying alongside Herbert Gilchrist in New York, Gilchrist had praised O'Donovan's creative abilities in a letter to Whitman.[53] Gilchrist's youthful fascination with the poet no doubt impressed O'Donovan, who

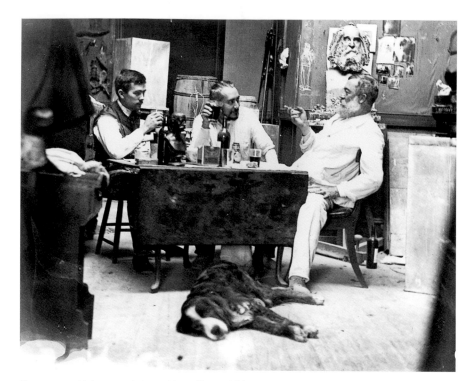

FIGURE 59 Unknown photographer, *Samuel Murray,*
Thomas Eakins, William O'Donovan, and Harry, 1891–93

developed his own keen interest in the author of *Leaves of Grass.* When he
arrived in Philadelphia to collaborate with Eakins, O'Donovan headed imme-
diately to Camden. He had lost touch with Gilchrist many years before, so
O'Donovan appeared at Whitman's doorstep armed with a letter not from
Gilchrist but from George William Childs, a wealthy Whitman supporter and
the owner of the *Philadelphia Public Ledger.*[54]

 During the year or so O'Donovan spent in Philadelphia, he and
Eakins reinforced each other's commitment to the Camden bard. The presence
of Murray—a full generation younger than the other two and one of Eakins's
most loyal students at the Art Students' League—added further to the group's
Whitman focus. A native Philadelphian, Murray had recently secured a posi-
tion as instructor of modeling and anatomy at the Philadelphia School for
Women, a position he would retain for the next forty years.[55] Together, Eakins,
O'Donovan, and Murray made frequent visits to Whitman's Mickle Street res-
idence, and in May 1891 Eakins and O'Donovan joined more than thirty of
Whitman's staunchest admirers to celebrate the poet's seventy-second birth-
day, an annual event of considerable import within Whitman's circle. Along
with such regulars as Traubel, Harned, and Bucke, Eakins and O'Donovan
shared in the festivities at Whitman's home, where those present lionized the
poet and listened as tributes were read from his supporters in other American
cities and abroad.[56]

Whitman had hoped to "hood" his face following the completion of Eakins's painted portrait, but vanity and the stubborn illusion that a full accounting of his personal and poetic selves might yet be achieved in a single artistic representation encouraged him to contemplate additional sittings.[57] At the time of the birthday dinner, O'Donovan was already at work on a bust-length sculpture, which would be the last portrait made of Whitman from life. He made frequent visits to Whitman's home, constructed a wax model, and assembled a collection of more than twenty-five photographs, including one of Whitman's chair. He also requested Eakins's painted portrait (which had been hanging in Whitman's home) so that it, too, could guide him as he worked.[58] Photographs of Eakins's studio confirm the presence of an array of Whitman photographs on the wall behind O'Donovan's modeling station (fig. 59). At a nearby table, O'Donovan, Eakins, and Murray enjoy an animated conversation, accompanied by an open bottle of wine. Visits by Traubel to check on the bust's progress and to converse with Eakins and O'Donovan "about art and Whitman and various kindred affairs" made the studio an even more active nexus of Whitman activity.[59]

Several of the photographic aids at O'Donovan's disposal were photographs taken by Eakins and Murray. Although scholars do not agree on the exact authorship of several of these photographs, as a group, they reveal a weary and enfeebled Whitman seated in his favorite rocking chair by the window.[60] In one, later published in the 1898 edition of *Leaves of Grass* and attributed to Eakins, the poet looks pensively away from the viewer, his weakened left hand grasping his cane, his thinning hair commingled with a wolfskin drape that covers the back of his chair (fig. 60). A raking light from the adjacent window highlights his furrowed brow and aging hands, evoking the loneliness and distress that accompanied Whitman's waning health. A profile view, cropped from a larger photograph taken during the same photo session and safely attributed to Murray, reveals a similarly subdued and aging Whitman (fig. 61),[61] as does a sketch made the previous year by Eakins's former student Jacques Reich (fig. 62).[62] Signed and dated in the poet's own hand,

FIGURE 60 Thomas Eakins,
Walt Whitman in Camden, N.J., c. 1891

FIGURE 61 Samuel Murray,
Walt Whitman in Camden, N.J., c. 1891

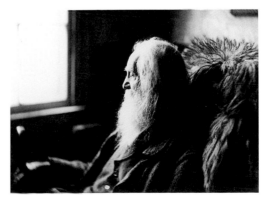

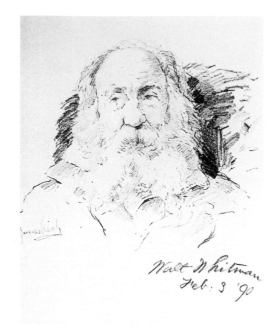

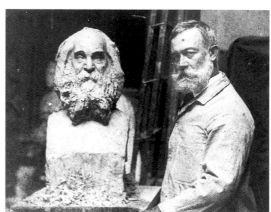

"Walt Whitman Feb: 3 '90," Reich's representation offers a striking alternative to that by Alexander, which was then enjoying its first public display in Philadelphia. The poet in Reich's sketch looks sharply to the side, not directly at the viewer, suggesting a somewhat distracted demeanor not unlike that seen in Eakins's photograph.[63]

In July O'Donovan sent Whitman a photograph (fig. 63) that visually reenacts the poet's own earlier positioning of himself as "one among the well-beloved stonecutters" (*LG* 714). In it O'Donovan stands protectively beside of the life-sized but still unfinished bust, which peers out at the viewer, erect and impassive. In contrast to the frail and sickly old man represented in the photographs and in Reich's sketch, O'Donovan's Whitman appears timeless and immobile. Inscribed in the work's massive physical dimensions is less an accounting of Whitman's actual self than the projection of an ideal. Both the insistent frontality and the prominence accorded the full beard and hair rehearse the poet's oft-stated equation of himself with the Old Testament prophets.[64]

Whitman and his friends scrutinized the photograph intensely, only to find the bust generally "not equal in treatment to the Eakins or Morse interpretations." Whitman in particular found the figure "too hunched," the head "too *intellectual*," claiming that it gave him "a sort of Theodore-Parkerish look." "Good fellow, O'Donovan!" Whitman exclaimed. "But I am afraid for the bust." Invariably Whitman brought up the comparison to Morse, the only other artist to have sculpted Whitman from life.

Think of Morse's bust, how it was made—yes, in less than two hours—dashed off—an inspiration—done there in the back yard. I can see Sidney yet—every now and then he would run in, lift up his head, take a look, touch me, maybe, here or there, to get a point, a protuberance, then rush out again—his hand full of clay—his eye alive—on his lips a smile. The memory of that is wonder, as well as happiness, to me.

Several months later Whitman reiterated his preference for the Morse, calling it "[t]he only substantial thing so far done—the only creative piece . . . — standing for us—for the vital, breathing, yes, and the *seeing* critter. . . . the whole affair throbs with life. . . . I often look at it—feel myself there indeed!"[65]

O'Donovan undertook a radical revision of the bust in response to this negative assessment of his art.[66] As he struggled to reconfigure his work, Eakins labored in another section of the studio on a new and highly unorthodox tribute to the poet. In "Song of Myself," Whitman had cautioned his audience: "He most honors my style who learns under it to destroy the teacher" (*LG* 84). Such was surely the case with Eakins's new undertaking, which is only now, more than a century later, beginning to yield its myriad associations with the Camden bard. Comments Eakins made at Whitman's 1891 birthday celebration provide an important point of entry into the transgressive character of the new undertaking. Speaking about his portrait of the poet, Eakins claimed to have begun the work "in the usual way," only to discover "that the ordinary methods wouldn't do,- that technique, rules and traditions would have to be thrown aside; that, before all else, [Whitman] was to be treated as a *man*, whatever became of what are commonly called the principles of art."[67] Eakins's remarks affirm two essential components in the artist's visual response to Whitman: a compelling desire to align his production with the oppositional strategies celebrated in Whitman's verse, and a concern with Whitman's masculinity. Eakins's new undertaking, while also a portrait, forgoes conventional notions of referentiality, the foundation of the portrait tradition. It interrogates Whitman's presence without explicit reference to his person. The work lacks what Hans-Georg Gadamer calls "occasionality," that link to the human original.[68]

The work in question is *The Concert Singer* (fig. 64), which defies both the long-held conventions of the portrait tradition and the expectations of the viewer. The female singer in the painting, a known friend of Whitman's, stands alone on a concert stage, her hands clasped loosely in front of her, her face and mouth registering intense concentration. To the left, partially cut off by the edge of the canvas, is a palm frond, one of the props identifying this as a concert stage. Along the lower border are the shadows cast by the hooded footlights, while the baton-wielding hand of the conductor rises from the lower left-hand corner of the composition. To the left of the singer's foot, a bouquet of roses lies carelessly on the stage floor, presumably tossed there by an admirer in the audience. *The Concert Singer*—like Eakins's portrait of Whitman—focuses the viewer's attention on the human voice. Carved on the simple chestnut frame that encloses the scene are the opening bars of the aria

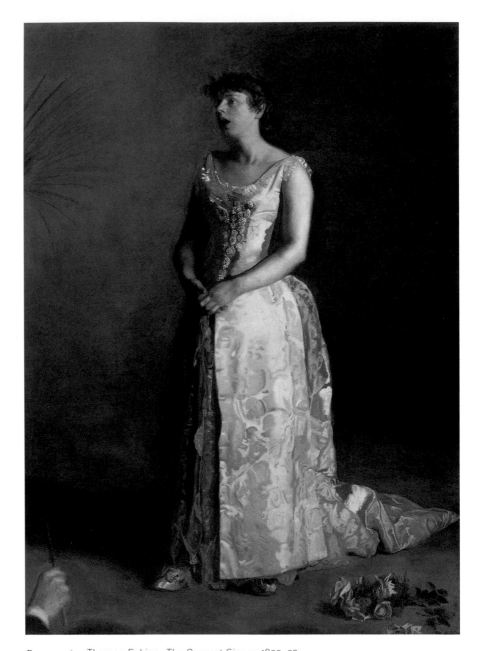

FIGURE 64 Thomas Eakins, *The Concert Singer*, 1890–92

she sings—"O Rest in the Lord," from Mendelssohn's oratorio *Elijah*. The painting is one of nineteen Eakins did on musical themes,[69] but the only one to acknowledge a specific musical text. The singer, Weda Cook, recalled that Eakins commenced each posing session by asking her to sing the aria's opening bars.[70]

Weda Cook was a singer familiar to both Eakins and Whitman. A respected Camden vocalist, she was recognized for her "powerful contralto voice, unassuming manner and thorough training."[71] In 1889 she was the fea-

tured singer at the "Third Annual Riot" sponsored by the Philadelphia Art Students' League, the school where Eakins taught following his dismissal from the Academy.[72] Cook also sang for Whitman and was among the first to set his poems to music. Her most notable effort was her musical version of "O Captain! My Captain!," which she sang at several of Whitman's birthday celebrations, beginning in 1888. Upon hearing it for the first time, Whitman "seemed to be much touched, exclaiming 'Bravo!' several times as she went on and when she was through saying . . . : 'There's fine soil in that girl.'"[73] Cook also sang the aria "O Rest in the Lord" for Whitman. In conversation with Eakins's biographer, Lloyd Goodrich, during the 1930s, Cook recalled that Whitman concluded their first encounter by quoting a line from the aria: "and He shall give thee thy heart's desires." In the years that followed Whitman asked her to sing "O Rest in the Lord" each time they met.[74]

Mendelssohn's *Elijah* was second only to Handel's *Messiah* in popularity among nineteenth-century British and American audiences. The oratorio's success stemmed in large measure from its reassuring blend of the sacred and the secular. Based on Biblical texts drawn from Old and New Testament sources, *Elijah* recounts the confrontation between the prophet Elijah and the rebellious Israelites, whose idolatrous practices posed a serious threat to the nation's spiritual well-being. The aria "O Rest in the Lord" is sung by an angel to comfort and sustain Elijah following an extended period of physical and spiritual dejection. Whitman attended the first American performance of the oratorio at New York's Tabernacle Theater in November 1847, just five days after Mendelssohn's untimely death. Despite his initial finding that the music was "too elaborately scientific for the popular ear,"[75] the poet developed a lifelong enthusiasm for both oratorio and its more dramatic cousin, opera. "But for the opera," Whitman once commented, "I could never have written *Leaves of Grass*."[76] Like the oratorio, Whitman's poetry creatively melds secular and sacred elements, while its melodic line, use of dramatic incident, and repeated emphasis on the expressive potential of the human voice derive much of their potency from the music's emotional power. William Michael Rossetti, brother of painter Dante Gabriel Rossetti and the English editor of the 1868 *Poems by Walt Whitman*, was quick to praise "the glorious music that Whitman commands." "Considered abstractly and as a whole," Rossetti observed, "the sound of the entire book is like a portentous roll of chorus—such as 'the Lord God omnipotent reigneth' in Handel."[77]

Like the oratorio, Whitman's poetry is also firmly grounded in the Bible. The poetry builds on the Bible's rhythmic cadences, long, prose-like lines, and parallel structure, while the narrating "I" exhorts the reader toward personal renewal much as the Old Testament prophet exhorted his people toward more moral and godlike behavior. In an essay entitled "The Bible as Poetry" in *November Boughs*, Whitman reiterated his long-held belief in the Bible's poetic dimension, declaring "its divine and primal poetic structure . . . the fountain heads of song."[78] Connections were equally strong between Whitman and the Old Testament prophets. With his shoulder-length hair and flowing gray beard, Whitman increasingly looked the part of an Old Testament

prophet, as commentators were quick to point out. Weda Cook likened him to Moses,[79] and Richard Maurice Bucke, like others in Whitman's inner circle, discerned "something sacred and superhuman about him." After Whitman's death, Bucke admitted that "there was a period of months during which I could not believe that he was merely a man: there were times when I was almost persuaded that he was a god."[80] Particularly striking were physical and moral similarities between Whitman and Elijah. Like Elijah, Whitman was an outsider among his people, distinguished no less by the ruggedness of his dress than by the moral urgency of his message. His verse, like that of his Old Testament counterpart, advocated personal and communal renewal, and he, too, expressed supreme disappointment when the general public, the masses to whom he directed his verse, overwhelmingly ignored his counsel. "The proof of a poet is that his country absorbs him as affectionately as he has absorbed it" (*LG* 731), Whitman prophesied in the Preface to the 1855 *Leaves of Grass*. Nearly forty years later, as Eakins and others were painfully aware, this long-awaited embrace still eluded Whitman's grasp.

Eakins's *Concert Singer* poignantly mediates the personal and psychological space between Whitman and the many disappointments incurred by the lackluster response of his readers. On one level, it reveals Eakins's sympathy for the mythic Whitman, the Whitman inscribed in the works of O'Donovan and Alexander.[81] Through the voice of Weda Cook, the painting offers Whitman the solace and encouragement the angel offered Elijah in his time of greatest need. The angel's words counsel patience and trust: "O rest in the Lord; wait patiently for Him, and He shall give thee thy heart's desires. Commit thy way unto Him, and trust in Him, and fret not thyself because of evil doers." Shortly after hearing these words, Elijah, his body and spirits fully restored, ascended to the heights of Mount Sinai and was taken into heaven by a fiery chariot and horses.[82] As Whitman approached death amid the meager surroundings of Mickle Street, Eakins offered him the renewing gift of song. The inscription of the aria's opening notes across the bottom of the painting's frame invited others to join in the singing (fig. 65). The notes, Eakins explained, were "ornamental unobtrusive and to musicians I think [they] emphasized the expression of the face and pose of the figure."[83] Whitman had continually urged his compatriots to sing "with open mouths their strong melodious songs" (*LG* 13). Though little inclined toward Whitman's participatory democracy, Eakins, in orienting these notes toward the spectator, provided the rudimentary means by which to turn this solo performance into a rousing choral chant.

During the two years he worked on the painting, Eakins referred to it as *The Singer* and exhibited it under that title in the years following its completion. It was not until just before the painter's death in 1916 that the painting acquired its present title, *The Concert Singer*.[84] By common usage both poets and musical vocalists are singers. In "Out of the Cradle Endlessly Rocking," Whitman's poignant ode to his awakening to death and poetry simultaneously, the warblings of the mockingbird turn to songs within the young boy-poet. "O you singer solitary, singing by yourself, projecting me,"

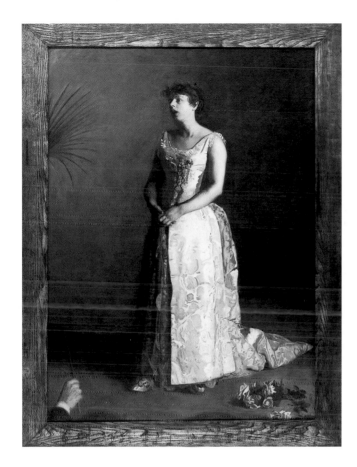

FIGURE 65
Thomas Eakins,
The Concert Singer,
in its frame

the young boy asserts. "My own songs awaked from that hour" (*LG* 252 53). Whitman, the self-styled chanter of songs and the "solitary singer" of *Leaves of Grass*, thus hovers as an implied referent embedded in the painting's original title. As Cook sings to comfort him, his songs in turn help to "project" her and by extension all singers who hearken to "the outsetting bard" (*LG* 251).

Cook represented the kind of hardworking, self made individual admired by both Eakins and Whitman. Her years of training and dedication to her craft resonate poignantly through her straining vocal cords, while her humble origins are inscribed in her homemade dress. Standing alone on a nearly bare stage, Cook embodied Whitman's democratic idealism. Established social practice at the time denied women the full expression of their talents, particularly in the public arena of the concert hall, but Whitman contemplated a more expansive and inclusive cultural space for women. "The Female equally with the Male I sing" (*LG* 1), he announced in the opening lines of *Leaves of Grass*. Years later, in conversation with Traubel, he proudly declared *Leaves of Grass* "essentially a woman's book," which "warns, encourages, persuades, points the way."[85]

Similarly pointing the way, although with more conflicted implications, was the hand of the conductor in the painting, which rises upward from the lower left-hand corner. The hand belonged to Cook's teacher, the noted

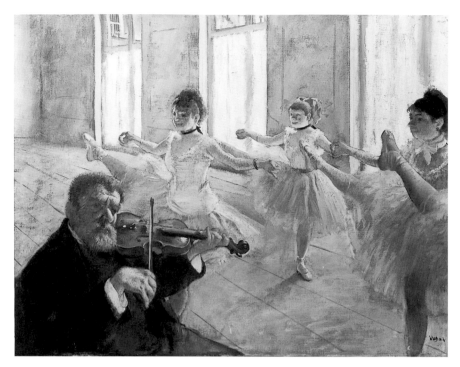

FIGURE 66 Edgar Degas, *The Rehearsal*, c. 1879

Philadelphia conductor Charles Schmitz. Spatially and compositionally the
hand acknowledges Eakins's admiration for the work of the French
Impressionist painter Edgar Degas (fig. 66).[86] It just as surely pays homage to
the unconventionality and assertive bodily presence with which Whitman
challenged both the conventions of his craft and the assumptions of his read-
ers. Cook recalled that during the two years Eakins worked on the painting he
quoted frequently from Whitman's poems, finding especially moving those
passages focused on the human hand—particularly working hands.[87] In "Song
of Myself," Whitman physically reaches out to and touches his reader: "My
left hand hooking you round the waist, / My right hand pointing to landscapes
of continents and the public road" (*LG* 83). (The passage would later capture
the visual imagination of Marsden Hartley.) Through the action of his hand,
the poet transgresses the limitations of the printed page. The hand in Eakins's
painting, while lacking Whitman's bravado, constitutes a disruptive and
unprecedented presence in Eakins's oeuvre. Situated at the juncture where the
liminal space of the singer and the experiential space of the viewer meet, the
hand transcends the conventional boundaries of the frame. But where
Whitman's hand reaches out toward his audience, the conductor's hand proj-
ects inward, toward the singer and the constructed space of the painting. The
hand defies both spatial and artistic conventions as it mediates the space
between the artist and his production, the singer and her audience, the poet
and his song of comfort.

On still another plane, the conductor's hand problematizes the the-

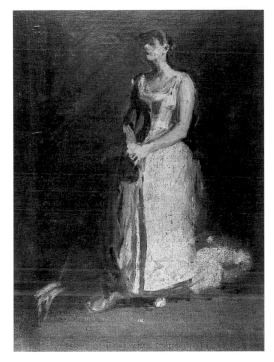

FIGURE 67 Thomas Eakins, sketch
for *The Concert Singer*, c. 1890

matics of writing that Michael Fried has identified as a recurring concern in
Eakins's oeuvre.[88] The conductor's hand seems physically and spiritually fused
with the hands of both Eakins and Whitman. The hand holds the baton much
as a painter holds a paintbrush. This was even more pronounced in the small
oil sketch that served as the principal study for the painting (fig. 67). Grasping
the instrument of its production, the hand draws attention to its presence as
a worked artifact. At the same time it serves to guide the viewer deeper into
the constructed realm of the painting. The hand, like the poetic persona of
Whitman's verse, is "[b]oth in and out of the game and watching and wonder-
ing at it" (*LG* 32).

The hand is further implicated in the painting's negotiations on mat-
ters of gender and sexuality. In a seeming reversal of Whitman's commitment
to gender equality, the male hand of the conductor intrudes into the female
space of the singer in a gesture of assertive masculine agency. The hand and
its gendered symbol of authority, the baton, undermine both the singer's pro-
fessionalism and her female autonomy. Positioned at an angle that leads
directly to Cook's sexual center, the hand is also emphatically phallic. The
complexities of this duality are reinforced by the hand's rich materiality.
Scholars have long acknowledged both Eakins's troubled relationships with
some of his female students and the sensuality of his works' painted surfaces.
"Eakins was like Whitman," writes Elizabeth Johns, "—a sensualist absorbing
the physicality of his sitters and in turn investing in it the complexity of his
own desires."[89] In *Man Made: Thomas Eakins and the Construction of Gilded*

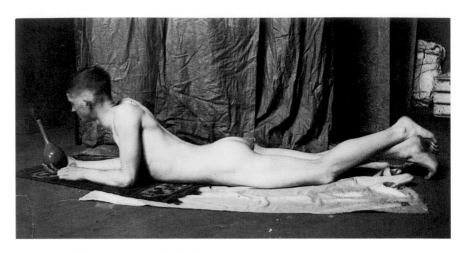

Figure 68 Thomas Eakins, *Bill Duckett Nude, Lying on Stomach, Holding Vase*, c. 1889

Age Manhood, Martin Berger argues that unlike most of his contemporaries, Eakins rejected the conventional binary notions of gender construction. "Given that [Eakins] was rarely, if ever, in sync with the dominant strictures of period manhood," Berger writes, "his interest was rather in disrupting unified understandings of the masculine." By regarding gender as malleable rather than fixed, "Eakins helped redraw the borders of permissible masculine identities."[90] This was already apparent in Eakins's Whitman portrait, where the exquisite detail lavished on the poet's lace collar posits a connection between Whitman and the transgressive masculinity of Oscar Wilde. A year later,

Figure 69
Walt Whitman and Bill Duckett, c. 1886

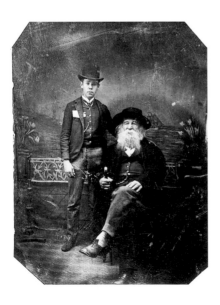

Eakins would revisit issues of gender and sexuality in a series of photographs of Whitman's Camden neighbor and former driver, Bill Duckett.

Duckett was one of several young working-class men with whom Whitman fraternized following his move to Camden. Beginning in 1884, Duckett often drove for Whitman, and in 1887 Duckett accompanied him to New York to present his Lincoln lecture. When Duckett's grandmother died, Whitman's housekeeper allowed him to board at Whitman's Mickle Street residence—but in 1889 took him to court over nonpayment of his bill. At the trial Duckett infuriated Whitman by claiming that the poet had invited him to stay at his home as a guest.[91] Eakins's photographs of Duckett date from the year of the trial. The photographs, all nudes, reveal a slim and youthful Duckett reclining in a variety of poses usually reserved for females.[92] In one, reminiscent of a sleeping hermaphrodite, Duckett contemplates a sensuously phallic vase (fig. 68). In another he lounges before the camera in full frontal nudity.

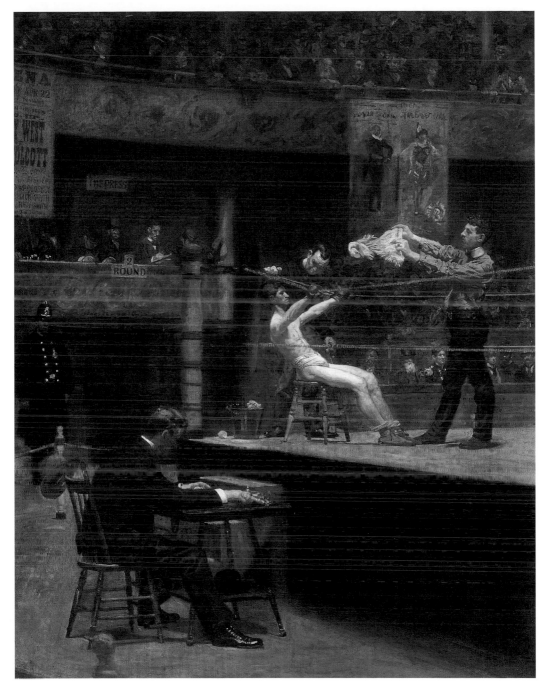

FIGURE 70 Thomas Eakins, *Between Rounds*, 1899

Three years earlier, when Whitman and Duckett were on friendlier terms, they had sat for a photograph modeled on the conventions of a marriage portrait. In it Whitman occupies the dominant, seated position reserved for husbands (fig. 69). The picture is one in a series of photographs in which Whitman poses with one of his young male friends. Ed Folsom has characterized this "revealing subgroup of Whitman photos" as "visual representations of the poet's 'Calamus' relationship." In their "obscurity and encrypted quality," Folsom writes, "these Calamus photographs [represent] hieroglyphs in an emerging sign system of male-male desire."[93]

Eakins shared Whitman's love of nudity and the male body. He may also have shared the poet's desire for men. A decade following his nude photographs of Duckett, Eakins included Whitman as a spectator in *Between Rounds*, one of three paintings that explore the increasingly popular masculine sport of boxing (fig. 70). Seated amid the camaraderie of an exclusively male audience, Whitman occupies a position directly above the nearly nude boxer. A strong light illuminates his bald head, full, gray beard, and the sheet of paper he holds in his right hand. That same light illuminates the ring and the boxer below. Together with the paper in Whitman's hand—a reference to his profession as poet and writer—the light mediates the physical and creative space between the poet and the male body. Just over twenty years earlier, Eakins had represented himself in a similar position—surrounded by an all-male student audience, peering down on a nearly nude male figure, and referencing his profession by a pen held deftly in his hand in *The Gross Clinic*. (Eakins is the figure farthest to the right.)

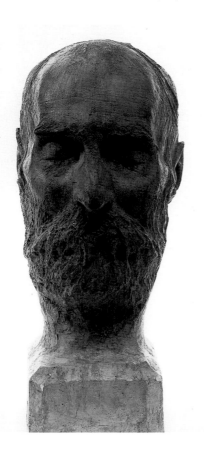

FIGURE 71 Thomas Eakins and Samuel Murray, *Whitman Death Mask*, 1892

In 1890, the year Eakins commenced *The Concert Singer*, he was still reeling from the controversy surrounding *Swimming*, an earlier exploration of male nudity and homoerotic desire.[94] Much as he might have liked to pay tribute to Whitman through their mutual love of the male body, he refrained from doing so for nearly a decade. In *The Concert Singer*, which eschews the question of nudity altogether, all references to gender and sexuality appear couched in the established rhetoric of heterosexuality. Given the feminized pose in which Eakins photographed Bill Duckett, however, it is possible to regard *The Concert Singer* in more expansive sexual terms. The masculine hand of the conductor/painter/poet intrudes into the feminized space of the singer much like Whitman's masculine presence resonates through the nude photographs of the feminized Bill Duckett. In *The Concert Singer*, the object of Whitman's desire is figured by means of displacement. By paying tribute to the poet through the figure of a

woman, Eakins may also have sought to deflect attention away from his own masculine desire.

The Concert Singer occupied a prominent place in Eakins's studio for well more than a year—perhaps two. Traubel reported seeing it there when he went to inspect O'Donovan's bust.[95] On 26 March 1892, work was interrupted by Whitman's death. By prior arrangement, on the day following the death, Eakins and Murray arrived at Whitman's home to make a plaster cast of the poet's head (fig. 71). Casts were also made of Whitman's shoulders and right hand, the counterpart to the conductor's hand and the conveyor of Whitman's own artistic production.[96] On the morning of the funeral Whitman's body lay in state in the parlor of his home, which was adorned with wreaths and palm branches.[97] Nearly four thousand local people filed past the coffin. At least as many availed themselves of the special trains that left from the Market Street ferry to take them to the burial site in Harleigh Cemetery.[98] Eakins and O'Donovan were two of twenty-six honorary pallbearers, an honor they shared with such noted Whitman admirers as John Burroughs, Richard Maurice Bucke, Talcott Williams, Horace Traubel, and Harrison S. Morris, the soon-to-be-hired managing director of the Pennsylvania Academy of the Fine Arts. Following the funeral, Burroughs, Bucke, Traubel, and Weda Cook hurried back to Eakins's studio, where the unfinished Concert Singer, Eakins's portrait of Whitman, and O'Donovan's still unfinished bust confronted each other across the open expanse of the room.[99] "I had not been there very long," recalled Cook, "before Murray, the sculptor, came in with his death mask of Walt." Those present then hoisted Cook onto a high table, where she sang "O Captain! My Captain!" "There was silence when I finished, and I looked up to see tears streaming down the face of Dr. Bucke. In a voice filled with deep emotion he said, 'We have buried the Christ again.'"[100]

It was probably after Eakins resumed work on The Concert Singer following Whitman's death that he added both the bouquet of roses at Weda Cook's feet and the palm leaf, partially visible to the left. Neither was present in the original oil sketch, and close inspection of the bouquet reveals that it was painted over the finished surface of the floor, confirmation that it was added later.[101] Several of the late poems acknowledge the use of such objects in the rituals accompanying death, and both had figured prominently in the funeral displays at Whitman's home. "While Not the Past Forgetting," written for Decoration Day 1888 and first published in November Boughs, urges the setting aside of political differences while decorating the graves of fallen soldiers.

> While not the past forgetting,
> To-day, at least, contention sunk entire—peace, brotherhood uprisen;
> For sign reciprocal our Northern, Southern hands,
> Lay on the graves of all dead soldiers, North or South,
> (Nor for the past alone—for meanings to the future,)
> Wreaths of roses and branches of palm.
>
> (LG 529)

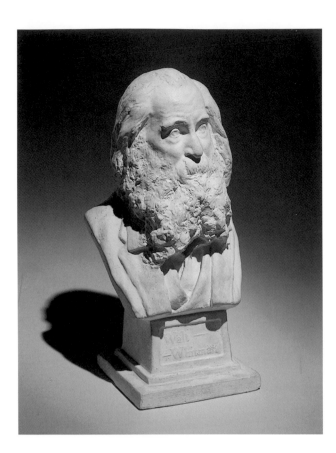

FIGURE 72
Samuel Murray,
Walt Whitman, 1892

In a second poem, a funeral wreath of roses "With pink, blue, yellow, all blanch'd, and the white now gray and ashy" reminded the poet of his deceased friend. One night the poet awoke "and in that spectral ring saw thee, / Thy smile, eyes, face, calm, silent, loving as ever." Although the flowers themselves had faded, the wreath, he declared, was "not yet dead to me, nor even pallid" (*LG* 542).

Eakins surely had such images in mind when he completed *The Concert Singer*. Although not overtly funereal, the painting pays homage to Whitman, who was gravely ill and would die before its completion. The bouquet, which balances the pale pink of the performer's dress, transforms what we are witnessing from the principal performance to an encore performance. It offers physical evidence of the intangible accolades that greeted the performer's central presentation. Just as Whitman observed the face of his "dear friend" in the blooms of his "pallid wreath," so Eakins, the painter of portraits, offers this portrait of an encore as a soulful tribute to Whitman, poet, performer, and friend. The palm leaf—perhaps a trope for the leaves in Whitman's *Leaves of Grass*—completes this highly charged tribute to the man, his verse, and his voice.

Murray's collaboration on the construction of the death mask stimulated in him a desire to construct his own sculptural representation of the poet. As O'Donovan's bust languished in a perpetual state of incompletion,

Murray launched his own smaller portrait of the poet, which he modeled using the death mask and photographs as guides (fig. 72). Although not modeled from life, his bust reveals a liveliness reflective of the artist's many personal encounters with the poet. In contrast to the imposing frontality of O'Donovan's bust, Murray's representation projects an accessible informality. Like Morse's coatless Whitman, Murray's Whitman faces slightly to the side in a non-static pose suggestive of the poet's commitment to the beauty and daily distractions of the world around him.

The Concert Singer occupies a pivotal position within the nexus of visual and verbal responses that circulated around Whitman during the poet's last years. As artists around him, even those in his immediate circle, continued to seek communion with Whitman through the conventions of the portrait tradition, Eakins boldly challenged those conventions. The Concert Singer inaugurates a paradigmatic shift in the interartistic dialogue between painter and poet. By reformulating the conventions of both portraiture and mimetic transcription, Eakins gave visual form to the artistic possibilities raised by Millet's rural genre scenes. As if to confirm the significance of his achievement, Eakins retained possession of the painting until his death in 1916, some twenty-four years after Whitman's death. Eakins even refused to sell it to Cook when she asked to purchase it. He claimed to have too many memories tied up in it, "some happy, some sad."[102] While historians have long attributed Eakins's decision not to sell the painting to his resentment of Cook's repeated refusals to pose for him in the nude, it is far more likely that it centered on his attachment to the work's many embedded associations with Whitman.

Where Eakins's portrait of Whitman concludes one era, The Concert Singer ushers in the next. The painting mediates the cultural and artistic space between the conservative practices of Eakins's nineteenth-century colleagues and the diverse and vastly expanded representational strategies in the arsenal of the first generation of visual modernists. Whitman and Eakins modeled for this new generation the contested arena of their own conflicted relationship with the past and their optimistic hope for a more diverse and progressive future. Indeed, Eakins's example seems to confirm the poet's own projection for that future. As he admonished his readers in "Poets to Come,"

Arouse! For you must justify me.

I myself but write one or two indicative words for the future,
I but advance a moment only to wheel and hurry back in the darkness.

I am a man who, sauntering along without fully stopping, turns a casual look
 upon you and then averts his face,
Leaving it to you to prove and define it,
Expecting the main things from you.

 (LG 14)

Whitman and the Modernists

The Twentieth Century

Part Two

Chapter 6

Marsden Hartley's Masculine Landscapes

THE FIRST GENERATION of American modernists straddled the cultural and artistic divide between the Victorian and the modern worlds. Born during the closing decades of the nineteenth century, they cut their artistic teeth during the cultural and artistic upheavals that radically transformed the international art world during the early years of the twentieth century. Like their encounters with modern society generally, these artists' engagements with Whitman were both deep and broad. As Bliss Perry, one of the poet's early-twentieth century biographers, remarked, "A generation trained to the enjoyment of Monet's landscapes, Rodin's sculptures, and the music of Richard Strauss will not be repelled from Whitman merely because he wrote in an unfamiliar form."[1] But it was not just the formal qualities of Whitman's verse that attracted and held their attention. Nor was there one essential "Whitman" who triumphed above the many competing constructions of the poet. In death as in life, Whitman resisted fixed interpretation.

The relatively straightforward relationship between the portraitist and his/her sitter that had dominated Whitman's associations with nineteenth-century artists was displaced, for this generation, by a complex matrix of associations allied with the discursive practices of modernism. The protean nature of Whitman's verse, together with its emphasis on personal self-discovery, correlated well with the transgressive spirit of modernism. Matters of personal and sexual identity, the intersection between the mystical and the physical, and the spectacle of modern society added stimulating new dimensions to the trans-genre linkages between Whitman and his modernist admirers. As the country moved inexorably toward a culture of specialization and fragmentation, Whitman evoked a refreshingly vital spirit of wholeness and personal possibility. His example helped artists ground their modernist pursuits in the familiarity of shared American experience. Whether they directed

their gaze inward toward themselves or outward toward the external world, Whitman's modernist allies filtered their vision through the transforming lens of the poetry.

In the years following Whitman's death, those who had known the poet in life demonstrated an almost compulsory urge to preach "the gospel of the *Leaves*" to anyone who would listen.[2] Those in Whitman's inner circle led the drive. In the twenty-seven years between Whitman's death in 1892 and the centennial of his birth in 1919, Whitman's intimates issued a steady stream of books and articles analyzing everything from the poet's literary achievements to the most mundane aspects of his physical appearance and daily habits.[3] The majority espoused the familiar, messianic strains of Bucke's 1883 biography. Even the massive ten-volume *Complete Writings of Walt Whitman*, issued in 1902, couched the poet's literary achievements in the familiar terms of his biography. Personal contacts between Whitman's aging disciples and members of the modernist community helped mobilize a new generation of Whitman enthusiasts. Led by the indefatigable Horace Traubel, members of Whitman's inner circle mediated the personal and artistic space between the poet and the country's emerging modernists. In their eagerness to extend Whitman's reputation into the twentieth century, Traubel and his associates constructed a Whitman with impressive modernist credentials and the spiritual standing of a demigod.

The early career of painter and poet Marsden Hartley provides important access to the networks of diffusion that mediated Whitman's reception within the country's expanding modernist community. In advance of many of his colleagues, Hartley negotiated a complex and shifting dialogue within what one scholar has termed the "collectivities of interest" that circulated around Whitman in the years after his death.[4] This chapter excavates the myriad complexities of Hartley's early engagement with Whitman's poetry— that extended moment during the first decade of the twentieth century when he characterized himself as "all Whitmanic."[5] More than any artist of his generation, Hartley established the foundations of his modernist vision in the company of a small but intense group of Whitman supporters (far more than in the company of artists). These associations, which included Traubel, afforded Hartley a compelling sense of intimacy and familiarity with the deceased poet. Above all, they stimulated his desire to infuse his art with his sexual attraction to men. Hartley's early landscape paintings, his first mature works and the core of his inaugural exhibit at Alfred Stieglitz's 291 gallery, construct a coded narrative of Whitman's ideal of manly comradeship. Bound up in the artist's turn-of-the-century friendships and erotic relationships with men, these richly colored paintings reveal a complex interaction of sexual, spiritual, and musical engagements with Whitman's work: "Through me forbidden voices, / Voices of sexes and lusts, voices veil'd and I remove the veil, / Voices indecent by me clarified and transfigur'd" (*LG* 53). For Hartley, who accented this passage in his copy of *Leaves of Grass*, Whitman's unveiling stimulated a personal and artistic unveiling of his own.

Hartley's engagement with Whitman grew out of his immersion in

the writings of fellow New Englander Ralph Waldo Emerson. Emerson's artic-
ulation of the doctrine of divine immanence in the natural order and his sup-
port for the refinement of the self through the instrumentality of art proved
particularly attractive to a society in the throes of intense social and political
change. In his autobiography, Hartley recalled how Nina Waldeck, his first art
teacher, had presented him with a copy of Emerson's *Essays* when he was just
twenty-one and living in Cleveland. By his own admission, for the next five
years he "never went anywhere without it," convinced that the book con-
firmed in him "all the things I was made to know."[6] Emerson would continue
to resonate with Hartley throughout the remainder of his life, but where
Emerson started him simmering, Whitman would bring him decisively to a boil.

In the summer of 1904 Hartley met the first of roughly half a dozen
Whitman supporters who would shift the artist's attention toward Whitman.
William Sloane Kennedy was a widely published journalist and anthologist
who, during the 1880s and early 1890s, had been part of the active coterie of
Whitman enthusiasts who surrounded the poet during his last years in
Camden. Trained as a minister, Kennedy was the author of *The Poet as a
Craftsman* (1886) and *Reminiscences of Walt Whitman* (1896), and he would
later publish *The Fight of a Book for the World. A Companion Volume to
Leaves of Grass* (1926). When he and Hartley met on Kezer Lake near Center
Lovell, Maine, Kennedy was editing *Walt Whitman's Diary in Canada*. Both
Kennedy's literary credentials and his personal ties to Whitman greatly
impressed Hartley, who was at that time "doing a lot of reading," writing
blank verse and listening to music, especially Beethoven and Chopin.[7] In his
writings and no doubt also in conversations with Hartley, Kennedy laid par-
ticular stress on the religious impulse in Whitman's verse, finding especially
in his "poems of friendship" evidence "that irresistibly leads one to compare
him with the Jesus of the Gospels."[8] The Yale-educated Kennedy placed similar
emphasis on the musical depths of Whitman's verse, terming the poems
"symphonic word-music" and likening "their long, winding fiords of sound"
to "summer thunder."[9] Hartley, who expressed similar religious and musical
impulses, was delighted when Kennedy presented him with an autograph note
and photograph of the poet (fig. 73). As he confided to a friend, "One feels that
he has lived a little nearer truth and beauty to have touched in any way the
life of this glorious soul."[10]

The following year, while touring with Proctor's Theater Company, a
small theatrical company where he worked as an extra in 1905 and 1906,
Hartley purchased his first copy of *Leaves of Grass* and during a stopover in
Philadelphia met Traubel.[11] For the next five or so years, a particularly long
time in Hartley's unsettled and often lonely existence, Traubel proved a stable
and nurturing force in his personal and artistic development.[12] A compact,
mustachioed man and a lifelong resident of Camden, New Jersey, Traubel had,
like Hartley, demonstrated a facility in both the verbal and visual arts when
young. His father, Maurice, was a commercial lithographer and had completed
a large charcoal drawing of Whitman based on a photograph by Frederick
Gutekunst.[13] Horace had himself shown early promise as a draftsman, and the

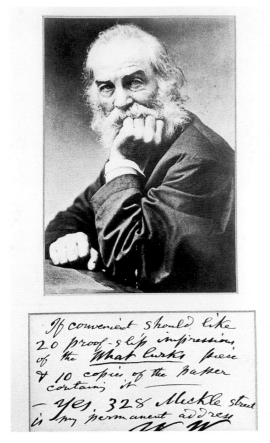

FIGURE 73 Photograph and autograph note of Walt Whitman

elder Traubel had hoped that his son would follow him in a career in the arts.[14] Horace, however, preferred writing to drawing and in the 1880s began contributing poems and editorial assistance to *Commonwealth* and *Chicago Unity*, organs of liberal Unitarianism. Following Whitman's death, Horace devoted the bulk of his energy to expanding the poet's reputation beyond the boundaries of the literary community. From his cluttered office in downtown Philadelphia, Traubel edited numerous books and articles about Whitman and maintained a voluminous correspondence with Whitman supporters internationally.[15] His journal *The Conservator*, founded in 1890 with financial backing from the Ethical Culture Society, constituted the principal mouthpiece of the Walt Whitman Fellowship International, which by the early 1900s had branches in half a dozen American and European cities.

Like others in the Ethical Culture Society, Traubel constructed Whitman as an exemplar of the humanistic concerns central to the Society's commitment to universal human brotherhood. Hartley—who had at one time considered entering the ministry—was well acquainted with the organization's spiritual idealism, having lived for a year with a member of the group's Boston chapter.[16] *The Conservator*'s quasi-religious tone and effusive doctrine of spiritual uplift suited Hartley well. He considered the "Collects," the inspirational sermons with which Traubel opened each issue, directed to him "perhaps a wee bit more than to the others in the world."[17] "Your messages are flashlights across the deserts," Hartley enthused.[18]

Traubel was completing work on the first volume of *With Walt Whitman in Camden*, his single most important and involved effort at advancing Whitman's reputation among a new generation of readers, when he and Hartley met. Eventually running to nine volumes, only three of which were published during Traubel's lifetime (in 1906, 1908, and 1914), *With Walt Whitman in Camden* contributed substantially to furthering the poet's mythic status among early-twentieth-century audiences. Unlike standard Whitman biographies, *With Walt Whitman in Camden* chronicled the poet's last years in a rambling diary format that, to early-twentieth-century readers, seemed as radical as the figure whose conversations it chronicled so minutely.[19] The *Philadelphia Public Ledger* extravagantly hailed the book as "one of the most

remarkable biographical volumes that has appeared in the last hundred years."[20] To Jesse Rittenhouse of the *New York Times*, the volume's unusually strong sense of intimacy with the poet admitted the reader "so directly to the presence of Whitman that one can only apply to it . . . [Whitman's] own words . . . 'This is no book; who touches this, touches a man.'" With great confidence, Rittenhouse predicted that "the unbeliever will be a convert before he closes its pages."[21]

Hartley was already among the "converted" when he encountered the hefty 473-page volume. Still, he shared with others the thrill of discovery that accompanied its many personal revelations. "I cannot convey to you my real delight in words, for the pleasure which I have gained from your 'Whitman in Camden,'" he wrote Traubel. "[N]ight after night I have gone to sleep inspired and spiritually benefited by the great love shown by your devotion to our great friend. One literally passes through the door with you into Walt's presence. . . . I come away from the book with my love and admiration for both writer and subject deeply stirred into flames."[22] Only the year before, Hartley had completed "portraits" of Whitman's Camden homes: the little house at 328 Mickle Street where Whitman had

FIGURE 74 Marsden Hartley, *Walt Whitman's House*, c. 1905

died in 1892, and the residence at 431 Stevens Street where Whitman had feted Oscar Wilde. These two paintings, the only architectural studies of Hartley's long career as a landscape painter, represent the artist's first attempts to give visual expression to his growing Whitmanic sympathies. Of the two, only the Mickle Street painting has survived. Rendered in somber, almost funereal, shades of ocher and gray (fig. 74), the small panel shows the windows dark, the door resolutely shut.[23] Traubel's book did what a pilgrimage to the home could not: it opened the door and brought the poet to life.

"Unscrew the locks from the doors! / Unscrew the doors themselves from their jambs!" (*LG* 52) Whitman exclaimed in "Song of Myself," and so it was certainly for Hartley. If Traubel's book stimulated Hartley's immersion in the intimate details of Whitman's daily life, the personal relationship between Traubel and his young charge unlocked more sexually revealing doors as well. Marginal notations in Hartley's copy of *Leaves of Grass*, preserved in the collection of Kent State University, leave little doubt as to the artist's fascination with those passages explicitly focused on the male body and on the forbidden voice of "manly love." Half encircled is the short poem "To the Reader at Parting," in which Whitman defies the limitations of the printed page to reach out and kiss his reader. "Now, dearest comrade, lift me to your face, / . . . —

Here! take from my lips this kiss; / Whoever you are, I give it especially to you" (*LG* 604). In returning Whitman's kiss, Hartley acknowledged both the participatory thrust of Whitman's verse and its sexual dynamics, a combination that would find striking visual expression in his earliest mature work. If, as Jonathan Weinberg has argued, "Hartley was drawn to Leonardo [da Vinci] not just because of Leonardo's genius but because Leonardo's life legitimized Hartley's relationships with men,"[24] Whitman, with Traubel as his emissary, performed a similar function and at a much earlier period in his life.

As we have already seen, several of Whitman's British followers had pressed the poet, albeit unsuccessfully, to acknowledge both his own homosexual inclinations and the homoerotic content of his verse as early as the 1880s. In the Preface to the 1876 *Leaves of Grass*, Whitman had explicitly linked his ideal of comradeship, that "beautiful and sane affection of man for man," with the life and health of the nation: "it is by this, I say, and by what goes directly and indirectly along with it, that the United States of the future, (I cannot too often repeat,) are to be most effectively welded together, intercalated, anneal'd into a Living Union" (*LG* 753). Particularly among the emerging generation of turn-of-the-century homosexuals, Whitman's ideal of comradeship functioned as a powerful talisman. For them, as Eve Kosofsky Sedgwick has written, *Leaves of Grass* operated "as a conduit from one man to another of feelings that had, in many cases, been private or inchoate."[25] Among them was John Addington Symonds, the English writer who had urged Whitman to acknowledge the physical side of his emphasis on male love. Symonds likened sexual contact with a man to "a scene out of one of Whitman's poems, filling me with the acutest sense of a new and beautiful life."[26] Similarly, Edward Carpenter announced at a meeting of the British Society for the Study of Sex Psychology that "thousands of people date from their first reading of [Whitman's poems] *a new era in their lives*. . . . a new inspiration and an extraordinary access of vitality carrying their activities and energies into new channels."[27]

Hartley shared many of the concerns of his British counterparts and like them experienced Whitman's words "quivering me to a new identity" (*LG* 57). While Traubel, like others in Whitman's inner circle, was initially hostile toward efforts to construct Whitman as a homosexual, after the turn of the century he expressed considerable tolerance toward same-sex love in his writings. In addition, during the years immediately prior to his meeting Hartley, he was himself engaged in what Bryan Garman has characterized as "a remarkably intense adhesive relationship" with Gustave Percival Wiksell, a Boston dentist and Whitman enthusiast who contributed occasional articles to *The Conservator*. Even within the parameters of the intimate language with which turn-of-the-century males often addressed one another, Traubel's letters to Wiksell leave little doubt, as Garman has demonstrated, about the sexual nature of their relationship.[28] The correspondence between Traubel and Hartley partakes of a similar, albeit less effusive, language of adhesiveness. Early in 1907 Hartley enthused, "I think much and often of you, see your maimed and bruised fingers and feel the throbbing of your pulses."[29]

Early in 1906 Traubel introduced Hartley to Wiksell. The three were often joined by Thomas Bird Mosher, a bookseller and publisher from Portland, Maine.[30] When these four gathered, usually in Boston, it was to enact and celebrate Whitman's utopian community of manly comradeship. Hartley characterized their gatherings as "a kind of Whitman feast."[31] Hartley was particularly fond of Wiksell, with whom he often met independently and who facilitated his all-important meeting with Pete Doyle. As a young streetcar conductor in Washington during the Civil War, Doyle and Whitman had become fast friends and probably lovers. Hartley almost certainly read Whitman's letters to Doyle, which were published after Whitman's death and reviewed by Kennedy in the June 1897 issue of *The Conservator*.[32] His meeting with the aging Doyle in May 1906 unleashed a torrent of pent-up feelings that fundamentally deepened his attachment to the homoerotic Whitman. Like Whitman, Hartley was attracted to younger men and to men of the working class. Doyle's job with the New York, New Haven, and Hartford Railroad brought him regularly to Boston. When he and Doyle met, Hartley listened with rapt fascination as Doyle spoke "simply and earnestly of Walt." "[I]n the short hours of my acquaintance with him," Hartley wrote Traubel, "he 'took hold of me.'"[33] Years later, Hartley admitted being "all agog to see this man who figured so richly in Whitman's life."[34]

Stimulated by his active association with these elder Whitmanites and encouraged by his meeting with Doyle, Hartley underwent a period of intense self-examination. One very public component of this personal transformation concerned his decision to change his name from "Edmund" to "Marsden" Hartley. "Marsden" was Hartley's stepmother's maiden name, which his friends in the theater thought much more "glamorous" than his given name.[35] Scholars have speculated on the family dynamics behind his choice[36] but have generally overlooked the important sexual dynamics invested in the decision. At its most basic, Whitman's poetry is about identity, the self, and the self's relation to the universe. Part of the process of mastering the elements of the universe is the ability to name them, a process at the heart of Whitman's catalogues. Just as important is the ability to name oneself. At the very outset of his career, Whitman signified the dramatic shift in his spiritual direction from conventional journalist to the poet of a sexualized democracy by appropriating a new name and with it a new identity. In 1855 Whitman dropped the more formal "Walter" to become "Walt," one of the "roughs," the engaging figure inscribed in Gabriel Harrison's famous daguerreotype. "Names are the turning point of who shall be master," Whitman wrote in one of the notes collected by Traubel and published in *An American Primer* in 1904, a volume with which Hartley was certainly familiar. "Names are a test of the esthetic and of spirituality.—A delicate subtle something there is in the right name—an undemonstrable nourishment that exhilarates the soul."[37] Hartley's transformation from "Edmund" to "Marsden" Hartley constitutes just such an act of self-redefinition. His act of self-naming occurred, too, at the commencement of his artistic career, and while less dramatic than Whitman's, symbolized no less an act of self-mastery.[38]

During the summer of 1907, as Hartley was finalizing this act of self-naming, he took a job pitching tents at Green Acre, a transcendentalist-spiritualist retreat in Eliot, Maine. Here, in a verdant natural setting overlooking the Piscataqua River, he experienced an expansive community of Emersonian transcendentalists, Vedantic philosophers, liberal Protestants, and committed social reformers. Guest speakers that summer included noted American art theorist Arthur Wesley Dow, author Charlotte Perkins Gilman, and Helen Campbell, a friend of Traubel's and proponent of "spiritualized Socialism."[39] Traubel and Wiksell also visited on occasion, and in July, the entire Green Acre community (led by its founder, Sarah Farmer) celebrated "Emerson Day" with readings from the *Bhagavad Gita* and the planting of a Monsalvat pine.[40] In what Traubel termed "an atmosphere of anthems & hallelujahs,"[41] Hartley encountered a conjunction of the sexual, musical, and mystical themes that bound him to Whitman and would suffuse his early work.

While middle-class Progressives spurned Whitman's notions of manly love, the working class embraced at least its rhetoric. As Garman has demonstrated, "a homoerotic attraction, much like that which appeared in Traubel's letters, was both expressed in and constituted by the political solidarity that socialists shared."[42] Green Acre's emphasis on universal brotherhood shared with turn-of-the-century Socialism an enthusiasm for a social order in which idealized love replaced unbridled competition. At the same time, Whitman's belief in the essential unity of the universe found resonance in the group's explorations into what one official termed "the realization of

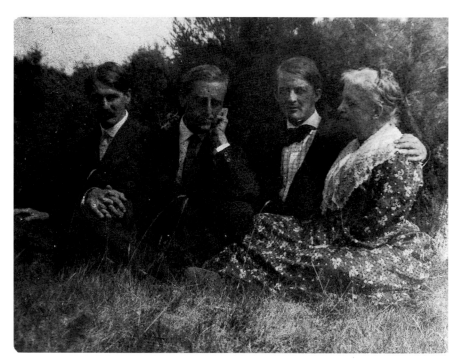

FIGURE 75 Marsden Hartley (second from left),
Helen Campbell, and others at Green Acre, Eliot, Maine, 1907

the universal Oneness."[43] Hartley and his friends Helen Campbell, Fred Lunt, and Harlan Ober read regularly from *The Conservator* and hailed each other as "comrades." Hartley and Campbell peppered their letters to Traubel with allusions to Whitman's poetry. Hartley enthused about the supportive environment between "us comrades in love," exclaiming, "The universe cannot help but dance playfully before us with such love."[44] A contemporary photograph shows the four seated on the grass (Hartley is second from the left) touching and clasping hands (fig. 75).

Green Acre's musical offerings, ranging from Wagner to the works of the American composer Edward MacDowell, proved an important stimulant to Hartley's emerging new sense of self. In early September Hartley wrote Traubel that one of the guest singers, Mrs. Mary Lucas of Boston, "who has a most exquisite voice," was to sing for him, while a "Miss Fuller of Brooklyn [was] to play some MacDowell numbers."[45] About this same time Hartley enjoyed his first solo exhibition at the home of Sara Chapman Thorpe Bull, a longtime member of the Green Acre community and the widow of the distinguished Norwegian violinist Ole Bull. Before his death in 1880, Ole Bull had achieved international acclaim for his moving interpretations of the works of Norwegian composer Edvard Grieg. When someone, perhaps Mrs. Bull, informed Hartley that his painting was "on the plane of Grieg's music," he responded that he considered it "a little complimentary, and something to live up to."[46]

It is not clear how much Hartley knew of Whitman's enthusiasm for Ole Bull, whose concerts the poet had attended in New York during the 1840s and 1850s.[47] Nor is it known if he was aware of Sara Bull's visit to Whitman during the poet's 1881 stay in Boston following Ole Bull's death.[48] Certainly, though, Hartley was enthralled by the musical power of Whitman's verse and the correspondence it posits between the musical and the mystical. Just the year before, the annual meeting of the Walt Whitman Fellowship International had celebrated Whitman's musical achievements in a program that included Weda Cook (now Weda Cook Addicks) and her husband, Stanley Addicks, performing musical renditions of several Whitman poems. Also on the program was a lecture on "The Significance of Whitman's Rhythm to a Musician" and the recitation of several of Whitman's musically rich poems, including "Proud Music of the Storm."[49] Both Hartley's musical awareness of Whitman's poems and his enthusiasm for the particularities of "Proud Music of the Storm" would figure prominently in the work produced following his Green Acre summer.

Even before this experience, Hartley had struggled, as he wrote Traubel, to "cultivate my roots, and produce good fruits," despite finding the metaphysical soil of his native Maine "dry and rocky." "I wish more than all else," he explained, "to have a lick at production, the creation of some of the countless visions and dreams that go serging [sic] through my frame. . . . I am trying to extract some hymn out of the monotone here."[50] Several months later he confided to his friend, the poet Seumas O'Sheel, "I am deeply engrossed in the expression of myself in painting" and "feel a big something

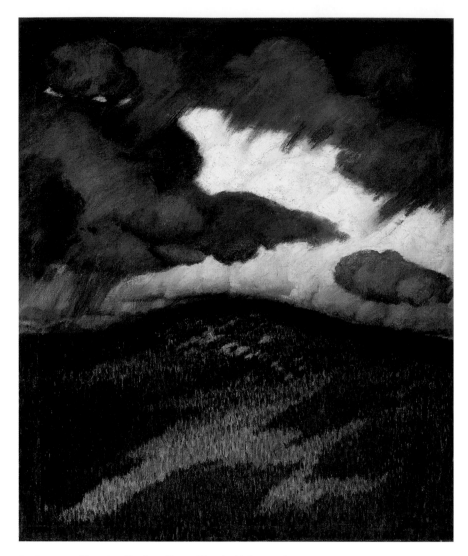

FIGURE 76 Marsden Hartley, *Storm Clouds, Maine*, 1906–7

or other in Nature for which I haven't yet found power to express but I hope one day to be able to tell of the great 'thrills' that come to me at times."[51] It would be more than a year following his immersion in Green Acre before Hartley could synthesize the experiences of Whitman and his Green Acre summer. The tide finally began to turn when Hartley returned to the area around Speckled Mountain, where Kennedy had first stimulated his interest in the Camden bard. There, during the fall and winter of 1908–9, Hartley produced what he considered his first mature paintings. In October 1908 Hartley informed O'Sheel, "I've started again these recent days to express myself and to express influences around me. . . . the mountain madness is on me and the bizarrerie of the hills gives me stranger thoughts than ever— . . . I've got back to dreaming again."[52] Hartley characterized his new paintings as "Romances Sur Paroles" or "Autumn Impressionals." He noted, "They are the product of

wild wander and madness for roaming—little visions of the great intangible."[53]

Hartley produced some forty-five drawings and more than thirty oils in a matter of just a few months.[54] In striking contrast to his earlier efforts, including his portrait of Whitman's house, these canvases assault the viewer with their heightened color harmonies and emboldened surface treatments. Compressed spatial fields and activated zones of intense, saturated color signal a decisive movement away from the atmospheric naturalism of paintings like *Storm Clouds, Maine* of 1906–7 (fig. 76). In May 1909, on the basis of these works, Alfred Stieglitz offered Hartley his first solo exhibition at 291, the country's most progressive New York gallery. Arthur B. Davies, an American visionary painter and one of the future organizers of the Armory Show, attended the exhibition and confided to Hartley that he sensed in the works a strong mystical orientation, a judgment with which Hartley strongly concurred. "[T]he essence which is in me is American mysticism," Hartley declared.[55]

In his review, poet and critic Sadakichi Hartmann characterized the ensemble as representing "extreme and up-to-date impressionism." He described the works as including "winter scenes agitated by snow and wind, 'proud music of the storm'; wood interiors, strange entanglements of tree-trunks; and mountain slopes covered with autumn woods with some island-dotted river winding along their base."[56] *Proud Music of the Storm* is the only painting in Hartley's oeuvre, and one of the few modernist paintings generally, to refer to Whitman's poetry directly in its title. (Hartley bracketed the poem's title in his copy of *Leaves of Grass*.) As an astute student of *Leaves of Grass*, Hartmann was clearly aware that the phrase he enclosed in single quotation marks was the title of a Whitman poem. In the 1880s Hartmann had visited Whitman frequently at his home and later had tried (without success) to found a Whitman club in Boston. He always considered Whitman an important influence on his work and in his early writing had paid exuberant homage to the formal and sexual unorthodoxies of his verse.[57] Despite his extensive familiarity with and admiration for Whitman, Hartmann made no mention of the poet in his review. By his silence he let pass an important opportunity to weigh in on Whitman's significance both for Hartley and for American modernism generally.

Hartley's *Proud Music of the Storm*, like *Hall of the Mountain King* (fig. 77), another work in the exhibition, evokes the experiences of his Green Acre summer. *Hall of the Mountain King* owes its title to the last movement of Grieg's orchestral suite, originally written as incidental music for Ibsen's *Peer Gynt*. Both *Peer Gynt* and "Proud Music of the Storm" map life-altering journeys of self-discovery, and both bristle with intense musical and visionary experience.[58] "Proud Music of the Storm" enacts an ecstatic, visionary journey through a musically rich and visually diverse dreamscape, not unlike the one Gynt encounters in his escape into the fantastical Hall of the Mountain King. As the poet sleeps, the sounds of a raging storm enter his dream, where they are transmuted into a polyphony of natural and man-made sounds. Throughout the poem sounds and movement intertwine in an ever-changing

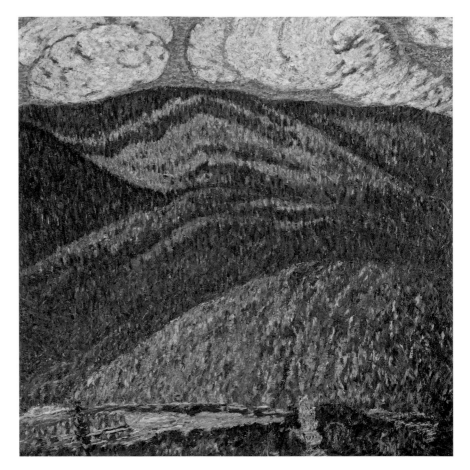

FIGURE 77 Marsden Hartley, *Hall of the Mountain King*, 1908–9

kaleidoscope that transcends time and space to reveal the mystical unity of the universe. The sounds range widely through personal, historical, and religious time to include such diverse aural expressions as the "duet of the bridegroom and the bride" (*LG* 404), the warbling of birds, the "rapt religious dances of the Persians and the Arabs," the "primitive chants of the Nile boatmen" (*LG* 408), strains of Haydn's *Creation* oratorio, and personal reminiscences of some of the poet's favorite musical experiences. "Give me to hold all sounds," the poet exclaims, "madly struggling":

> Fill me with all the voices of the universe,
>
> The tempests, waters, winds, operas and chants, marches and dances,
> Utter, pour in, for I would take them all!
>
> (*LG* 409)

Each of the sounds in this "new composite orchestra" (*LG* 405) is grounded in concrete experience and vividly recounted in rich pictorial vignettes. The poet awakens from his dream, exhilarated and transformed. "Come," he beckons to

his "silent curious Soul," "for I have found the clew I sought so long, / Let us go forth refresh'd amid the day" (*LG* 410). Nourished by the experiences of his dream, the poet sets out with a new and emboldened commitment to the heightened possibilities of his art.

In its intersection of musical, mystical, and visionary experiences, "Proud Music of the Storm" maps many of the concerns central to the discourse on early-twentieth-century visual modernism. Music, the most abstract and non-physical of the arts, had, since the previous century, been figured as a potent vehicle with which to free the visual arts from the tyranny of the material world and the stranglehold of the mimetic tradition.[59] As Hartley struggled to find his artistic voice, Whitman helped him "see into" himself and his environment with a new and clearer vision. The music in "Proud Music of the Storm," as Sydney J. Krause has observed, functions primarily as a "stimulant, releasing energies of the soul which give the poet precious insights into the relations between material and spiritual existence."[60] "I see" and "I hear" operate almost interchangeably, as does the play between sight and insight. As Whitman exulted, "That mystic baffling wonder alone completes all" (*LG* 51). In the preface to *The Book of Heavenly Death*, published by Mosher from extracts from *Leaves of Grass*, Traubel compressed Whitman's intentions into just a few words: "Everything about Whitman was this. See. See life. See love. See the soul."[61] No less significant was Traubel's announcement for *A Little Book of Nature Thoughts*, edited by his wife, Anne Montgomerie Traubel, and also published by Mosher. "Whitman declared that everything has a soul," Traubel explained. "That the trees have souls. That the clouds have souls. Nature thoughts from Whitman, then, are not pictures of trees and creeks and clouds only. They are pictures of souls. He always takes you back of the thing you see to the thing you do not see."[62] For a young and impressionable artist like Hartley, Traubel's verbal interventions proved almost as instructive as the poems themselves.

The Russian artist Wassily Kandinsky, one of the most internationally influential theorists of the modern movement, wrote movingly about what he sensed was a new spiritual epoch dawning in the early years of the twentieth century. He warned that "the nightmare of materialism, which has turned the life of the universe into an evil, useless game, is not yet past," but already there were signs of significant change: "Spiritual experience is quickening, . . . dissolution of matter is imminent, [and] we have reason to hope that the hour of pure composition is not far away."[63] Artists and other creative individuals were among those he judged best equipped to access and disperse this "spiritual revolution" for the benefit of others. Kandinsky cited in particular the efforts of Richard Wagner, Maurice Maeterlinck, and the Italian divisionist painter Giovanni Segantini,[64] whose work was already beginning to captivate Hartley's imagination. A full decade earlier, architect and theosophist Claude Bragdon had similarly announced that "after centuries of purely objective consciousness a spiritual epoch is at last upon us."[65] In 1909, just months before Hartley's exhibition, *Current Literature* gave such beliefs an American face. In an article entitled "The New Spiritual America Emerging," it identified

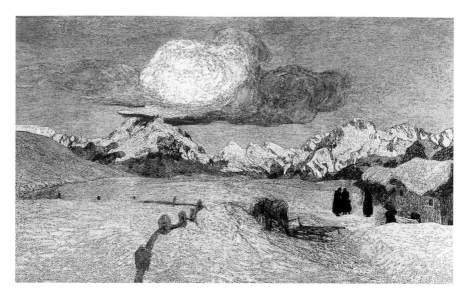

FIGURE 78 Giovanni Segantini,
Death in the Alps, c. 1898–99

Emerson and Whitman as its leading exemplars. "'New America,'" the author explained, "is nothing else than that mystical and spiritual America which centers predominantly about the recognition of new and hitherto unrecognized *powers of Mind*." Emerson was "one of the prophets," and "Whitman wrote its psalms."[66]

Since Bucke's 1883 biography of the poet and particularly after Whitman's death, Traubel and others in the Whitman community seized every opportunity to assert their belief in Whitman's mystical abilities. They routinely presented the poet as having experienced direct mystical illumination. Edward Carpenter's *Days with Walt Whitman* (1906), a book Hartley seems certainly to have read, was particularly explicit. Carpenter credited Whitman with a visionary ability for "seeing things apart from the mundane self," a trait "which brings him—it may perhaps be said—into relation with another order of existence."[67] In an earlier work Carpenter had used the term "cosmic consciousness" to characterize such abilities.[68] "In many ways," Carpenter observed, "Whitman marks a stage of human evolution not yet reached, and hardly suspected, by humanity at large."[69]

Bucke devoted an entire chapter to Whitman in his widely read *Cosmic Consciousness* (1901), revealingly subtitled *A Study in the Evolution of the Human Mind*. With characteristic exuberance, Bucke hailed Whitman as "the best, most perfect, example the world has so far had of the Cosmic Sense."[70] Although Hartley would not encounter Bucke's book for several years, when he did, he immediately declared, "I identify my experiences in his book." He announced his desire "to express a fresh consciousness of what I see & feel around me."[71] In a letter to the German modernist painter Franz Marc, himself an avid consumer of Whitman's verse, Hartley praised Whitman as "our greatest American poet" and *Leaves of Grass* as "for me the keynote of

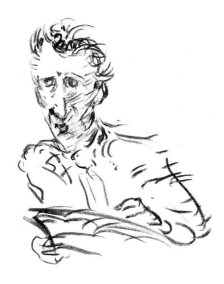

FIGURE 79 Marsden Hartley,
Self Portrait, c. 1908

what the real modern art is to be. The seeing into new depths of ourselves—
and of the universe." To reinforce his point, he cited, albeit in slightly garbled
form, a line from the little-known poem "Assurances": "I do not doubt that
exteriors have their exteriors—interiors have their interiors—and that the eye-
sight has another eyesight & the hearing another hearing & the voice another
voice."[72]

During the long months spent painting in Maine in the aftermath of
his Green Acre encounter, Hartley struggled to give form to his thoughts. Just
as the poem "Proud Music of the Storm" constitutes a kind of musical kalei-
doscope, so Hartley's paintings of this period effect a visual kaleidoscope. The
actual painting entitled *Proud Music of the Storm* is no longer extant, but the
ten surviving paintings from the period share a visual and emotional intensity
that distinguishes them from earlier works. All also acknowledge the mediat-
ing presence of Giovanni Segantini, whose work Hartley had discovered in the
German periodical *Jugend*, possibly given him by Traubel. Two paintings,
both reproduced in color, particularly attracted Hartley's attention. *Plowing in
the Engadin* is a bucolic scene reminiscent of Millet; *Death in the Alps* (fig.
78) represents a winter landscape with large, swirling clouds hovering over a
distant mountain range. In each an activated surface of tiny strokes of color
imparts an allover textural intensity that unites the painting's disparate com-
ponents—trees, people, buildings, animals, mountains, clouds—into one
absorbing and interlocking whole. The journal's material on Segantini was
accompanied by a photograph of the artist climbing the Alps and an iconic
self-portrait, noteworthy for the mesmerizing intensity of its gaze.[73] Such
graphic confirmation of Segantini's mystical/experiential involvement
with his native land created a crucial triangulation that artist, Hartley, and
Whitman. To affirm the connection, Hartley endowed several of his own self-

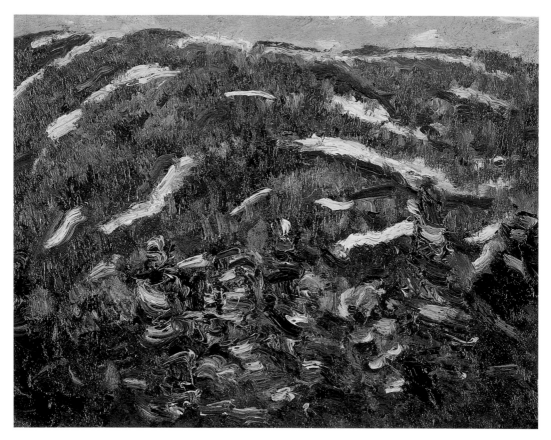

FIGURE 80 Marsden Hartley, *Songs of Winter*, 1908

portraits from the period (fig. 79) with a similar gestural intensity and emphasis on the eyes.

Hartley's adaptation of Segantini's broken brushwork became, by his own account, the essential vehicle with which to express both the robust physicality of the mountain, its essential "THING-ness,"[74] and its invisible, spiritual essence that he characterized as "the God-spirit in the mountains."[75] Still, Hartley went well beyond Segantini in both the gestural physicality and heightened coloration of his painted surfaces. Vibrant and often dissonant color harmonies jostle one another in an ever-changing tonality of visual sound. Whitman's intoxicating "visions of the great intangible" seem visually reconstituted in the forceful brushwork and exaggerated color harmonies of paintings like *Summer* (1908) and *Mountainside* (1909). Even more visceral are the textural effects of the several versions of *Songs of Winter* (fig. 80), where the title evokes poems by both Whitman and William Blake, another Hartley favorite. Like notes on a composer's score, the paintings' individually rendered daubs and streaks of color convey an exuberant, even ecstatic, engagement with the natural world.

If Hartley's colorful and richly textured surfaces are figured in terms of their abilities to impart ecstatic musical harmonies, they are also figured as

evocations of the body. More than a year prior to embarking on these works, while wintering in Lewiston, Maine, Hartley wrote Traubel in a moment of severe loneliness: "I loathe being apart either from my crowd or my mountains and just now I am both, except in my pictures and then I am happily contented to be climbing the heights and the clouds by the brush method when I cannot do it actually by body and soul."[76] Years later he offered essentially the same observation in the essay "Pictures." "Theoretical painting has little or no meaning for me," he wrote, "because it takes place above the eyebrows— I want the whole body, the whole flesh, in painting."[77] By means of this activated "brush method," Hartley's paintings vibrate with the physical residue of his own body and simultaneously project the supportive presence of Whitman's body as experienced through his poetry. In Section 46 of "Song of Myself," the poet-speaker, like Hartley, tramps "a perpetual journey," sensibly outfitted in "a rain-proof coat, good shoes, and a staff cut from the woods." As he informs his reader at the outset of his travels,

> I have no chair, no church, no philosophy,
> I lead no man to a dinner-table, library, exchange,
> But each man and each woman of you I lead upon a knoll,
> My left hand hooking you round the waist,
> My right hand pointing to landscapes of continents and the plain public road.
>
> (LG 83)

As Hartley tramped his "perpetual journey" through the mountains of southern Maine (and later Europe and the American Southwest), he continually felt Whitman's left hand protectively "hooking [him] round the waist." In the act of painting, Hartley's right hand projected the poet's own gesticulating right hand, while his activated brush strokes reaffirmed the physicality of his intense and personal engagement with the mountain. Like the symbolic merger of hands in Eakins's *The Concert Singer*, in Hartley's activated brushwork Hartley and Whitman seem physically reconstituted, their bodies and minds merged in a resounding act of physical and spiritual union.

"Proud Music of the Storm," like Whitman's poetry generally, celebrates not just bodily presence but, more important, the sexualized (male) body. Hartley's desire to evoke "the whole body, the whole flesh, in painting" was predicated on a commitment to insinuate his own homosexual body into his art. In the opening section of "Proud Music of the Storm," the "[s]trong hum of forest tree-tops," "[p]ersonified dim shapes," and "serenades of phantoms with instruments alert" assail the poet. "Trooping tumultuous, filling the midnight late, bending me powerless," they enter his "slumber-chamber" (LG 403). Here, as in other of Whitman's "dream-vision" poems, as Robert K. Martin has demonstrated, sexual experience "is revealed . . . to be the gateway to the visionary experience."[78] Phallic arousal and sexual release precipitate the dream state and with it its clarifying vision of the self. Sexual ecstasy brings with it both a transcendence of self and an activated engagement with the material world. Particularly in the 1855 edition of *Leaves of Grass*—but

continuing throughout the volume's many subsequent editions—the intersection between the sexual and the spiritual is so pervasive that, as one recent critic has observed, "it becomes nearly impossible to say whether sexual language enhances religious themes or religious language is used to exalt sexuality."[79] Sections 28 and 29 of "Song of Myself" would have held special appeal for a landscape painter like Hartley. There, in what Quentin Anderson has termed "one of the most extraordinary accounts of orgasmic experience in all literature," sexual activity has as its "creative issue" "landscapes masculine, full-sized and golden."[80]

The textural and coloristic intensity of Hartley's early landscape paintings practically explode with sensuality and a coded narrative of sexual desire. Whitman's emblematic treatment of such natural phenomena as grass ("Song of Myself") and a live oak ("I Saw in Louisiana a Live-Oak Growing") may have encouraged Hartley's inclination to conceive of nature's forms in symbolic terms. In 1913 the artist wrote Stieglitz that "for me there must always be symbolic shape [in my paintings] . . . —because that element is strong in my nature."[81] The coded sexual language of the German Officer paintings (1914–15) and of Hartley's homage to the homosexual poet Hart Crane (1933) have long been recognized. Less overt, perhaps by virtue of their more naturalized rhetoric, are the sexual codes embedded in his early landscape paintings.

An important key to recovering these paintings' sexual implications is the poem "A Song," later retitled "For You O Democracy," which Hartley marked in his copy of *Leaves of Grass*. The poem was also the subject of a toast at the Walt Whitman Fellowship International's annual meeting in 1907, at the commencement of Hartley's Green Acre summer.[82] "Come," the poet invites his reader, "I will make the continent indissoluble."

> I will make the most splendid race the sun ever shone upon,
> I will make divine magnetic lands,
> With the love of comrades,
> With the life-long love of comrades.
> I will plant companionship thick as trees along all the rivers of America, and along
> the shores of the great lakes, and all over the prairies,
> I will make inseparable cities with their arms about each other's necks,
> By the love of comrades,
> By the manly love of comrades.
>
> (*LG* 117)

Trees, especially those that cluster "along the shores of . . . lakes," figure prominently in Hartley's early landscape paintings. Like the symbolic planting of the Monsalvat pine, their phallic presence inscribes solidarity as well as manly attachment. In both *Carnival of Autumn* (fig. 81) and *The Summer Camp, Blue Mountain* (1909), as well as *Hall of the Mountain King*, a distinctive row of trees edges a placid foreground lake, the combination of deciduous and evergreen varieties forming a richly textured tapestry of bold colors

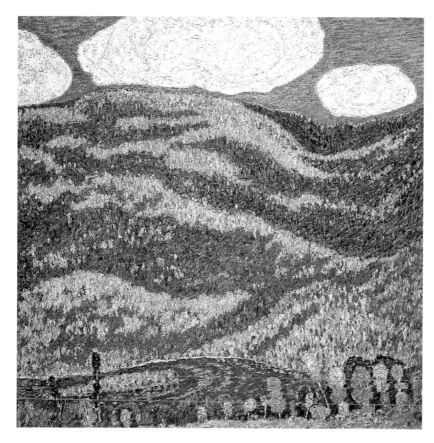

FIGURE 81
Marsden Hartley,
Carnival of Autumn, 1908.
Photograph © 2006
Museum of Fine Arts,
Boston

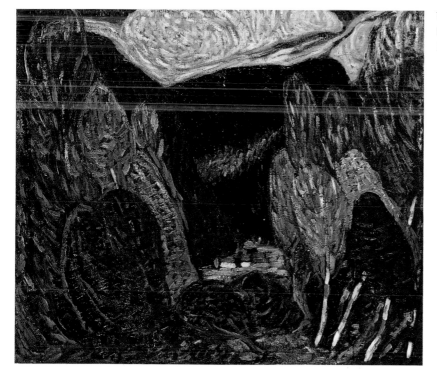

FIGURE 82
Marsden Hartley,
Landscape 36, c. 1908–9

FIGURE 83
Marsden Hartley,
Cosmos, 1908–9

and shapes. In *Autumn* (1908) a dense thicket of foreground trees serves as a kind of screen through which the spectator observes the distant mountain range. Particularly noteworthy is the prominent gap in the trees in *Landscape 36* (fig. 82). That opening, together with the textural excitement evident in the adjacent trees, seems calculated to lure the (male) viewer to enter the scene and position himself physically in the gap in order to close it. In doing so he becomes the missing companion, locked in a loving embrace with his comrades.

In *Cosmos* (fig. 83), craggy branches spread out against the simplified mass of the distant mountain range. Hartley rendered a similar massing of trees in distinctly human terms in "The Mystical Forest," one of his free-verse poems. As the poet ventures "[t]hrough intricate wooded ways," he confronts "The forest [that] gleamed in the distance / Edged against a sapphire sky." There, as in Hartley's paintings, "its trees reached up limbs / That were passionate slender hands."[83] Like the hands in Hartley's poem, the uppermost branches of one of the foreground trees in *Cosmos* is silhouetted against a distant blue sky, its form emblematic of a cross. Particularly among earlier generations of landscape painters, representations of the American land were routinely cast as evocations of the spiritual. Whitman had himself been an avid consumer of the landscapes of artists like Thomas Cole, Jesse Talbot, and

Frederic Edwin Church, who frequently inscribed Christian symbols into their paintings. By twining the sexual and the spiritual, Hartley recast such spiritual encounters with the land in decidedly personal terms. Late in life, while painting again in his native Maine, Hartley would revisit this theme in a series of works in which trees again cluster prominently along the border of a mountain lake. Despite the passage of more than three decades, works like *Mount Katahdin, Maine, Number 2* (fig. 84) reveal the persistent threads of Hartley's early engagement with the manly theme of comradeship.

In 1913, four years after his inaugural exhibition at 291, Hartley sailed for Germany, where he met the leaders of Germany's modernist movement, among them Franz Marc and Wassily Kandinsky. Far more than their American counterparts, Germany's literary and artistic elite were steeped in the expressive possibilities of Whitman's verse and its grounding in sexual (and homosexual) experience.[84] Hartley clearly discussed Whitman with Marc and perhaps also with Kandinsky, whose influential treatise, *Über das Geistige in der Kunst*, had been published the previous year. Even though Hartley would not read Kandinsky's work until after his return to New York, he was already familiar with its basic tenets and cognizant of their visual manifestations in the older man's art.[85] Still, Hartley was not impressed. He faulted Kandinsky's theories as too esoteric and his paintings as being "without (for me) the life germ—It is the philosoph painting—the theorist demonstrating—not the artist's soul bent on creating."[86] Most important was the sense that Kandinsky's art was too distanced from the experiences of everyday life. His paintings "spring out of philosophy & do not burst out of experience," Hartley confided to Stieglitz. "And to me this is what this kind of thing must be—everything I do is attached at once & directly to personal experiences—It is dictated by life itself."[87]

Hartley's attachment to Whitman was similarly anchored in the compelling motivations of personal experience. At times Hartley even seemed to conflate the particulars of his own life with Whitman's. Once, in recounting an incident in which Kandinsky offered to critique his art, Hartley informed Stieglitz: "In myself & K[andinsky] I saw the likeness of the situation between Emerson & Whitman discussing Leaves of Grass on the Boston Common—Whitman listening with reverence to all of Emerson's ideas," yet in the end resolving "to change nothing in his book."[88] Hartley was referring to that moment in 1860 when

FIGURE 84 Marsden Hartley, *Mount Katahdin, Maine, Number 2*, 1939–40

Emerson argued passionately but to no avail against inclusion of the controversial "Enfans d'Adam" poems in the third edition of *Leaves of Grass*. In their explicit sexual references, these poems, later retitled "Children of Adam," proved too extreme for their time and often got Whitman into trouble.[89] Even if Kandinsky's critique did not focus explicitly on the sexual content of Hartley's art, the artist's response reveals a desire to merge his experiences with Whitman's and to acknowledge the transgressive nature of his own sexually charged paintings.

Far more than Emerson (on whose essays Hartley had cut his intellectual teeth), Whitman offered Hartley the example of what W. T. Stace has termed an "extrovertive mysticism," one grounded in the senses and in personal experience.[90] In contrast to Emerson's "transparent eyeball," which, as Paul Zweig has observed, "is curiously abstract, an eye without a body,"[91] Whitman enacted a sexed and full-bodied seer, one who boldly confronted his reader "hankering, gross, mystical, nude" (*LG* 47). Henry Bryan Binns, one of Whitman's early English biographers, hailed him as the "actual incarnation" of Emerson's ideal poet.[92] Before returning to America in November 1913, Hartley confided to Marc that he was "by nature a visionary." Taking pains to distance himself from those who were "subject to visions," he claimed instead, "I live my life in as simple a way as possible always with the fixed idea that no matter where my perceptions and intuitions wander I wish my feet to walk on the earth."[93] Carpenter had made essentially the same claim for Whitman, charging that his was no "thin and other-worldly ecstasy, denying in a kind of spiritual excess the claims of the body and the intellect, but was blent and harmonised, in fiery union, with the very widest practical experiences."[94]

This combination of a visionary nature "dictated by life itself" constituted both the informing principle of Hartley's art and the sustaining element of his involvement with Whitman. In a career that spanned four decades, Hartley would return often to the spiritual, sexual, and visionary themes that first captivated his artistic imagination and yoked him with the Camden bard as he traversed the mountains of southern Maine. Through the mediating presence of Traubel and his circle of aging Whitmanites, Hartley maintained a privileged perspective on Whitman's life and personal attachments, including the poet's relationship with Pete Doyle. This emphasis on and access to the biographical Whitman placed Hartley at the intersection of two distinct generations of Whitman admirers. On the one hand were the nineteenth-century artists who had known Whitman directly and who, for the most part, framed their responses to the poet within the parameters of the portrait tradition. On the other hand were Hartley's contemporaries, the modernists, who encountered Whitman primarily through his writings and the writings of others. Positioned between these two disparate and diverging groups, Hartley rejected the strictures of the portrait tradition to ground his Whitmanic sympathies within the discursive practices of modernism. The coded expressions of homosexual desire embedded in Hartley's early landscape paintings narrate the beginnings of his struggle to locate himself spiritually, physically, and artistically within the company of men.

Robert Coady and
The Soil

IN 1907, AS HARTLEY TRAMPED the mountains of southern Maine, critic Benjamin De Casseres confidently advised readers of Elbert Hubbard's journal, *The Philistine:* "There are multiplying signs that the United States is about to discover its most significant figure. . . . Whitman is in the air."[1] The contested terrain of Whitman's verse was attracting considerable attention among a diverse and expanding audience of artists, writers, critics, and intellectuals by the second decade of the twentieth century, a decade that culminated in the much heralded centenary of Whitman's birth. While still not the masses Whitman had predicted, this new readership contributed substantively toward affirming the poet's position within American modernist culture. To a generation in revolt against the heritage of its predecessors yet at the same time in search of its own cultural and artistic roots, Whitman offered the rare combination of change and rootedness simultaneously. In the inaugural issue of *Glebe* (1913–14), anarchist poet Adolf Wolff spoke for others of his generation when he hailed Whitman's verse as

> A clarion-call to freedom,
> A gesture of revolt,
>
> A declaration of the right of all
> To live, to love, to dare and to do.[2]

Musical America went even further, declaring it "an excellent, even an imperative, time for the re-reading of Whitman by all constructive artistic thinkers Whitman sweeps away outworn and senescent artistic ideals and principles of older civilizations, and clears the way for creations that are fresh, large and simple, and appropriate to our land and time. . . . He is an artistic and intel-

lectual gateway to the future of the New World."[3]

Even before the Armory Show focused massive public attention on the radical art of the European modernists, a growing number of the country's cultural observers were acknowledging a powerful connection between Whitman and modernist culture. Thomas Mufson brazenly declared Whitman "the first Modern Man." Mufson, like others of his generation, constructed Whitman's modernity not in terms of the spirituality that had attracted Hartley, but as centered on issues of democracy. Most important was their enthusiasm for Whitman's courageous and unprecedented embrace of the breadth and diversity of American cultural experience, especially those elements at the margins of elite culture. Whitman's new democratic art, Mufson wrote, "shifts the past, criticizes the present and constructs the future."[4] A significant component of Whitman's democratic idealism involved the dynamic relationship between democracy and individuality. In his advocacy of the broadest range of cultural experience, Whitman opened up a fluid and expansive space that encouraged artists and other creative individuals to put aside the restrictions that traditionally hindered growth and to embrace their surroundings with expanded vision and commitment.

Just before Whitman's death, Harvard philosopher George Santayana had characterized Whitman's verse as "the voice of nature crying in the wilderness of convention."[5] Much the same sentiment issued from the pen of Louis Bredvold nearly a quarter of a century later. Writing in *The Dial*, Bredvold hailed Whitman's poetry as "a liberator from academic narrowness, enlarging as it does the basis of culture." Bredvold made clear that he intended the term "culture" not in the Arnoldian sense of "cultivation" but in the broader context of "expansion." Like growing numbers of his contemporaries, Bredvold demonstrated less concern with the specifics of Whitman's literary achievements than with their cultural implications. "In the poetry of Whitman," he explained, "we do not find a trustworthy constructive criticism of life, but rather the chaotic, unevolved elements of life itself. His poetry serves not as a guide, but as a point of departure."[6] Such sentiments echoed Whitman's own observations in the Preface of *Leaves of Grass*, where he reminded his readers that "the greatest poet has less a marked style and is more the channel of thoughts and things" (*LG* 719).

During the second decade of the twentieth century, New York's modernist community—centered in the eclectic environs of historic Greenwich Village—bristled with enthusiasm for Whitman's democratic idealism. In the vicinity of the remains of Pfaff's beer cellar, one of Whitman's favorite haunts, modernists engaged one another in the kind of lively discussions that had embroiled Whitman and his colleagues more than half a century earlier.[7] The expanding market for books by and about Whitman, coupled with Horace Traubel's increasing prominence within Village vanguard circles, helped secure Whitman's standing among a new generation of radical thinkers. In 1914 Mitchell Kennerley, a leading publisher of advanced contemporary literature and a supporter of progressive American art, became Whitman's official publisher. Kennerley was well known at the time for his committed support

of writers as diverse as Witter Bynner, Max Eastman, Edward Carpenter, Van Wyck Brooks, and D. H. Lawrence.[8] Within just a few years Kennerley issued new "Library" and "Popular" editions of *Leaves of Grass* and *Complete Prose Works*, published the third volume of Traubel's *With Walt Whitman in Camden* (1914), reissued the first two volumes in the series (1915), and published extracts from volumes three and four in his journal, *Forum.*[9] Kennerley also lent his support to the staging of the progressive Forum Exhibition of Modern American Painters, and in 1921 he published *Walt Whitman in Mickle Street* with Marsden Hartley's painting of Whitman's Mickle Street residence (see fig. 74) as the frontispiece.[10]

Even more than Kennerley, Traubel helped strengthen Whitman's reputation among Village modernists. Within six short years, the man whom one admirer called the human "afterglow of the good gray poet"[11] oversaw the publication or republication of three volumes of his own poetry and three books on his life and attachment to Whitman. Charles and Albert Boni, proprietors of the progressive Washington Square Bookshop and fellow socialists, published two of the biographies and in 1914 reissued *Chants Communal*, Traubel's earliest book of verse.[12] That same year Alfred Kreymborg, who first met Traubel at the Bonis' bookstore and hailed the Camden native as Whitman's "successor," devoted an entire issue of the literary journal *Glebe* to Traubel's "Collects." These were the prose poems that had so captivated Hartley and with which Traubel opened each issue of *The Conservator.*[13]

Even more important in helping to extend knowledge of Whitman's democratic idealism among Village radicals were Traubel's efforts on behalf of the Walt Whitman Fellowship International. Founded in Philadelphia in 1894, by the early twentieth century the organization had branches in New York, Boston, Chicago, and Peoria, Illinois, as well as several European cities. The New York chapter met annually at the Hotel Brevoort in the heart of Greenwich Village. Located just a block from Mabel Dodge's salon, the Hotel Brevoort was a favorite gathering spot for American modernists and French expatriates. Alfred Stieglitz lunched there often with artists, and Juliette Roche celebrated conversations in the hotel's café in her visual poem "Brevoort" (1920). Drawing on his wide circle of acquaintances and extraordinary organizational skills, Traubel helped assure an eclectic mix of artists, writers, socialists, and assorted Village radicals at the annual Whitman festivities. By the mid-1910s, these dinners were regularly attracting one hundred or more people, including such mainstays of Village life as Kreymborg; poet James Oppenheim; writers Max Eastman and Walter Lippmann; painters John Sloan, Robert Henri, and Abraham Walkowitz; critic Charles Caffin; cartoonist Art Young; Stieglitz; collector John Quinn; Emma Goldman; and socialists Floyd Dell and William English Walling.[14]

Traubel personally solicited the participation of members of the visual arts community, repeatedly asking Stieglitz to speak to the group.[15] He made additional overtures to Stieglitz in *The Conservator*, publishing a critique of his photographs (quickly reprinted in *Camera Work*) and several other short pieces on Stieglitz and his gallery.[16] Despite these gestures, however, and the

friendship they shared with Marsden Hartley, Stieglitz proved largely unreceptive to either Traubel or Whitman. Regardless of the frequent contributions of people like Sadakichi Hartmann, Benjamin De Casseres, and Marsden Hartley, each of whom discussed Whitman at length in other writings, neither Stieglitz nor his journal was yet ready to accord Whitman a significant place at the table.[17]

By contrast, *The Soil* (1916–17), edited by artist, writer, publicist, and gallery owner Robert Coady, literally feasted on the amplitude of Whitman. If *Camera Work* located its cultural center in the late symbolist writings of European intellectuals like Maeterlinck, Henri Bergson, and Kandinsky, Coady's journal was democratic, urban, and self-consciously American.[18] Where Hartley celebrated Whitman in the cosmos, Coady located him in the common language of the streets, in vaudeville, in the functionalist beauty of the machine, and in the fast-paced narratives of the dime novel. Coady and his journal enacted Whitman's populist sensibilities, expansionist rhetoric, and flagrant hucksterism, eschewing the mystical-spiritual foundations so essential to Stieglitz and members of his circle. Coady's energetic engagement with the democratic Whitman gives evidence of the multifaceted appeal Whitman had for this first generation of modernists. Where poet Ezra Pound disparaged Whitman's "crudity" as "an exceeding great stench,"[19] Coady reveled in the stench.

Stieglitz occupied a position of considerable authority within Village vanguard circles, but Coady was something of an anomaly. Trained as an artist at the Art Students' League, Coady produced no art that has survived and vocally rejected virtually all of the work produced by his American contemporaries. His gallery, founded in 1914 with the help of American painter Michael Brenner and located just across Washington Square from the Hotel Brevoort, adopted a predominantly, if not exclusively, European and non-

FIGURE 85
Robert Coady's
Washington Square
gallery, 1914

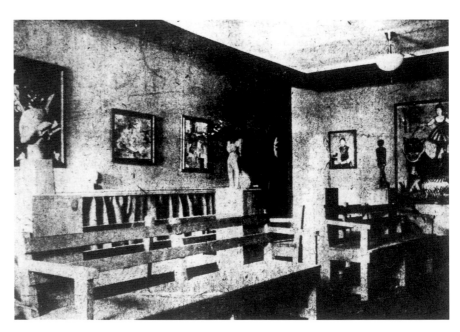

Western focus. Called the Washington Square Gallery, it promoted the efforts of such prominent Parisian modernists as Pablo Picasso, Georges Braque, Henri Matisse, André Derain, Henri Rousseau, Fernand Léger, and Juan Gris, together with examples of African art, carvings from the South Pacific, and children's art (fig. 85). Both the quality of its exhibitions and its dual commitment to European modernism and the "primitive" art of children and non-Western peoples placed it on an equal footing with other progressive New York galleries of the period, including Stieglitz's 291 gallery.[20] But the differences between Coady and Stieglitz are far more revealing than the similarities. Frequenters of 291 repeatedly stressed that gallery's removal from the concerns of everyday life. "You forgot all about New York," Paul Haviland wrote, "the subway and the struggle after the almighty dollar; and when you got back into the street, into the turmoil of everyday life, you felt that you had discovered an oasis, seemingly thousands of miles from the scorching struggle for life . . . a quiet nook in a city of conflict."[21] In contrast, Coady's gallery, like his journal, actively cultivated the easy give-and-take of the street. Culture and commerce were conjoined in a space where old and new art enjoyed an easy coexistence and where reproductions were for sale alongside original works of art.[22]

Coady's unilateral rejection of the visual production of American modernists derived not from a Eurocentric point of view but from a belief that contemporary American fine art lacked the cultural authority of either European modernism or the art of non-Western peoples. Although Coady would continue to operate his gallery (later named the Coady Gallery and located opposite the New York Public Library) with essentially the same focus until 1919, his journal enabled him to expand his horizons significantly without compromising his beliefs. Whitman facilitated such an expansion—not as a strict and programmatic "guide" into the labyrinthine corridors of American cultural production but rather, as Bredvold had suggested, as an unscripted "point of departure." Whitman's democratic idealism and radical iconoclasm energized Coady's desire to stimulate a broader and conceptually bolder frame of reference for assessing American cultural production.

During his years in the Washington Square location, one of Coady's most flamboyant and outspoken neighbors was Guido Bruno, the self-styled prince of Bohemia and a strong Whitman enthusiast. Bruno operated Bruno's Garret, an art gallery and publishing house just east of Coady's gallery. There he hosted regular poetry readings and published a series of short-lived journals, including *Greenwich Village* (1915), which featured Whitmanesque poems and occasional articles on Whitman, including excerpts from Sadakichi Hartmann's conversations with Whitman and a translation of Ferdinand Freiligrath's 1868 tribute to the bard.[23] The journal's eclectic range of articles, its witty and irreverent style, and its grounding in the contemporary concerns of its urban milieu would inspire Coady's new enterprise. One month prior to *The Soil*'s debut, another Village publication, *Seven Arts* (1916–17), allied itself with Whitman's democratic individualism. The journal's editors, as Casey Nelson Blake has observed, were "deeply committed to a cosmopolitan

vision that admitted far greater variations in American cultural life than did . . . mainstream American Progressives."[24] Spiritual engagement and individual self-fulfillment combined with a radical political vision to encourage the energetic embrace of a broad range of American cultural practices. Mystical, visionary, populist, and committed to the spirit of universal brotherhood, *Seven Arts* held that art could regenerate society.

In *America's Coming-of-Age,* issued a year prior to the launching of *Seven Arts,* Van Wyck Brooks placed particular emphasis on Whitman's democratic espousal of widely ranging cultural experiences. Whitman's "real significance," Brooks stressed, was that "for the first time, [he] gave us the sense of something organic in American life. . . . In him the hitherto incompatible extremes of the American temperament were fused."[25] Brooks had earlier decried the peripheral status to which such essentials of the American cultural experience as education, literature, recreation, humor, and art were all too regularly relegated. "All these things in America are somehow *splits* from life," Brooks lamented, "things we reach for on the shelf as it were, each when its turn comes. They grow out of life . . . , but they are cut flowers that hardly stand in the same vase."[26] Brooks and his colleagues were adamant in urging their countrymen and -women to rekindle a sense of the organic wholeness that had fueled the energies of their forefathers. In particular he encouraged Americans to "put aside anything that tends to make us self-conscious in this matter of American tradition and simply *be* American, teach our pulses to beat with American ideas and ideals, absorb American life, until we are able to see that in all its vulgarities and distractions and boastings there lie the elements of a gigantic art." "The great fault of educated Americans," Brooks proclaimed, "is that they are hostile to too many things."[27]

Far more than Brooks and his colleagues at *Seven Arts, The Soil* embraced America's cultural production "in all its vulgarities and distractions and boastings." While clearly no match for *Seven Arts* in the clarity of its thinking, the quality of its writing, or the consistency of its reasoning, *The Soil* was both more daring and more experimental in its pursuit of cultural and artistic change. Unlike most "little magazines" of the period, *The Soil* functioned less as a conventional journal and more as a composite work of art. It offered a provocative and destabilizing alternative to the received expectations of elite culture, especially in the arena of the visual arts. Individual components were not separated into discrete, isolated units according to conventional media boundaries. (There was no "art" section in each issue, for example.) Rather, visual representations were distributed liberally throughout each issue in ways that stimulated rather than stifled cross-disciplinary exchange. Similarly destabilizing was the journal's breezy and often irreverent tone. *The Soil's* articles were more journalistic than analytical, its rhetoric confrontational, its form disjointed. Like Whitman, *The Soil* engaged its reader in a lively, open-ended dialogue that raised more questions than it answered. Henry McBride, art critic for the *New York Sun* and a loyal supporter of the newer tendencies in art, declared it "the most perfect art journal I have ever seen." "It is American," he exclaimed. "It's in line. It's Whitmanic. It's for the open

road, and the free for all, the pure air and the hot scuffle."[28] *The Soil*, more than any "little magazine" of its time, viscerally enacted the lowbrow culture it celebrated.

As a foretaste of things to come and in an apparent effort to solicit support from one of New York's leading patrons of radical modernism, Coady in March 1916 sent the New York lawyer John Quinn photographs of two railroad engines with the provocative claim that they constituted "American Art."[29] Quinn, who was one of the country's most progressive art collectors, had previously purchased works from Coady's gallery and would aggressively defend *The Little Review* against government charges that James Joyce's *Ulysses* constituted obscene literature. Still, he balked at Coady's radical proposition. In returning the photographs—no doubt the same photographs that Coady later reproduced in *The Soil* (fig. 86)—a bewildered Quinn replied: "I should hardly call them 'American Art,' any more than I would call a beautifully designed yacht 'art.'" While conceding that the engines possessed such "elements of art" as "grace, beautiful proportion, . . . and power," Quinn cautioned that "that doesn't make the engines art except in the sense of a definition that would be so broad that it would scarcely mean anything."[30]

Coady's journal challenged such canonical assumptions of elite culture. "Fear not O Muse!" Whitman advised in "Song of the Exposition," "truly new ways and days receive, surround you" (*LG* 199). Like *Leaves of Grass, The Soil* mapped a powerful alternative to traditional cultural practice. Its goals were both iconoclastic and nativist; its objectives, as Coady announced, firmly rooted in "the big spirit here that has grown out of the soil."[31] The simple directness of the journal's title, with its suggestion of indigenous cultural experience grounded in the particularities of something as ordinary and pervasive as the dirt underfoot, announced the earnestness of its objectives. The term's metaphorical richness had made it a popular reference point for others in the early twentieth century intent on nurturing nativist traditions.

Locomotives,
in *The Soil*
(December 1916)

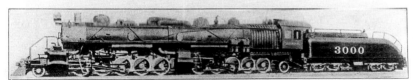

Photo by Underwood & Underwood

"3000," the Big Mallet Compound of The Great Northern Railway

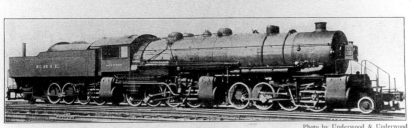

Photo by Underwood & Underwood

The "Matt M. Shay," the Largest Engine in the World

Kreymborg recalled that as he and his associates pondered the possibilities of a title for *Glebe*, "The word, soil, constantly haunted their meditations."[32] But where their choice of the archaic term "glebe" was grounded in its religious suggestiveness, Coady rejected all efforts at the sacralization of culture, preferring instead the simpler, earthier version of the term. "I bequeath myself to the dirt to grow from the grass I love," Whitman wrote in the concluding lines of "Song of Myself." "If you want me again look for me under your boot-soles" (*LG* 89). Surely nothing would have pleased Coady more than to have his journal turn the common soil under the sole of Whitman's boot. At the same time, the irony inherent in aligning his progressive and self-consciously urban journal with a referent that on first blush seemed more allied with the farm than the city could not have escaped Coady's devious imagination.

In the opening pages of the journal's first issue (fig. 87), Coady set the

FIGURE 87
Cover of *The Soil*
(December 1916)

THE SOIL
A · MAGAZINE · OF · ART
PRICE 25 CENTS

December
1916

tone for much that was to follow. With a brashness calculated to recall Whitman's "barbaric yawp" (*LG* 89), Coady boomed: "There is an American Art. Young, robust, energetic, naive, immature, daring and big spirited. Active in every conceivable field."[33] "By American Art," Coady explained in a later issue, "I mean the aesthetic product of the human beings living on and producing from the soil of these United States. By American Art I mean an American contribution to art." Like his counterparts at *Seven Arts*, Coady lamented that as a people, Americans "imitated European art and neglected the things at home." "Our art is, as yet, outside of our art world," Coady observed. "Already we've made our beginnings, scattered here and there, but beginnings with enormous possibilities."[34] Those "beginnings," and their potential as harbingers of an even greater American art, provided the focus of *The Soil*'s five issues.

A compendia of more than 150 of these promising new "beginnings" accompanied Coady's announcement. The technological world of the engineer and the burgeoning arena of commercial culture topped the list. Taken together, Coady explained, the items characterized "an expression of life a complicated life—American life." Included were:

> The Panama Canal, the Sky-scraper and Colonial Architecture. The East River, the Battery and the "Fish Theatre." The Tug Boat and the Steam-shovel The Crazy Quilt and the Rag-mat. . . . The Fife and Drum Corps. . . . Ty Cobb. . . . The Clowns, the Jugglers, the Bareback and the Rough Riders. . . . Coney Island, the Shooting Galleries, Steeplechase Park . . . "Others," "Poetry," "Boxing Record," "The Police Gazette," the Sporting Pages, Krazy Kat, Tom Powers, Old John Brown, Nick Carter, Deadwood Dick, Tom Teaser, Walt Whitman and Poe. . . . "Dixie," "Nobody" and the "By Heck Foxtrot." . . . The Electric Signs and the Railroad Signals. . . . Madison Square Garden on a fight night. . . . The Movie Posters. . . . The Jack Pot. Dialects and Slang. Type. . . . The Carpenters, the Masons, the Bricklayers, the Chimney Builders, the Iron Workers. The Cement Mixers, the Uneeda Biscuit Building. The Pulleys and Hoists. . . . The Cranes, the Plows, the Drills, the Motors, the Thrashers, the Derricks, Steam Hammers, Stone Crushers, Steam Rollers, Grain Elevators, Trench Excavators, Blast Furnaces.[35]

Surrounded by the American vernacular of which he sang, Whitman mediated *The Soil*'s excursions into the daily experiences and commodified pleasures of the early twentieth century. The catalogue format and Whitman's name, prominently positioned in the midst of this heterogeneous sampling of Americana, reinforced the journal's structural and thematic ties to the Camden bard.[36] *The Soil* reads like one of Whitman's journalistic rambles through Manhattan. The logic of the journal, like that of *Leaves of Grass*, is the logic of the *flâneur*. Its articles, poems, editorials, musical fragments, and wide assortment of visual materials coalesce into a celebratory vision of the twentieth-century city as a vast, democratic marketplace, a crucible of modernity awaiting the transformative hand of the artist.

In his drive to confer status on those aspects of the cultural landscape at the margins of elite society, Coady, like Whitman, found much to guide him in his own personal encounters with the city and its inhabitants. Robert Alden Sanborn, the author of several of the journal's articles on boxing, characterized Coady as an enthusiastic consumer of "the amusement side of his New York." He recalled how Coady considered such contemporary phenomena as cartoons, sports (especially boxing), the motion picture, and "the live Seurats and Lautrecs which he found in the smokey galleries of the burlesque houses on 14th street" more indicative "of a truly American art" than the "attenuated and diluted imitations of continental schools of art" that filled the city's traditional art galleries.[37]

The Soil's first issue bore witness to such populist enthusiasms. Beginning with an article on "Making Fun" by Charlie Chaplin, the issue probed the new cultural emporiums of vaudeville, the circus, the rodeo, and the motion picture, concluding with the first installment of the Nick Carter dime novel "The Pursuit of the Lucky Clew." Later issues examined prizefighting (including a discussion of the Arthur Cravan–Jack Johnson fight), the tugboat, swimmer Annette Kellerman, a short story on billiards, excerpts from anthropological and philological treatises, an interview with the engineer of the Woolworth Building, and a photographic essay on industrial machines. There were also reproductions of ancient and modern works of art (much of it drawn from Coady's gallery), an article on Cézanne's studio, satirical commentaries on contemporary visual and discursive practices, a short story by Gertrude Stein, and an occasional musical score. Had *The Soil* not foundered after just five issues, it doubtless would have explored many more of the arenas inventoried in its inaugural catalogue.

In his insightful analysis of the rise of commercial culture in New York in the early decades of the twentieth century, William R. Taylor stressed both the spatial-kinetic emphases of these new cultural emporiums and their connections to the "carnival atmosphere" of the nineteenth-century street. "These new genres," Taylor wrote, "had in common a seemingly random, potpourri organization that continued to dramatize the discontinuity, the kaleidoscopic variety, and the quick tempo of city life."[38] Whitman's poetry, too, derived much of its energy and thematic content from the lively give-and-take of the street. "This is the city and I am one of the citizens," the poet boomed in "Song of Myself" (*LG* 77). The panoramic sweep of Whitman's verse, the piling up of images from all segments of the cultural spectrum, and above all its endorsement of "[t]he popular tastes and employments taking precedence in poems or anywhere" (*LG* 218) seemed to many early-twentieth-century readers a prescient foretaste of the variety and increasingly frenetic pace of contemporary urban life. Similarly provocative was Whitman's construction of the body as a focus of intense physical and theatrical engagement. In its energy, playfulness, and mocking good humor, the body in Whitman's poetry seemed a potent sign of the loosening societal restrictions and cultural norms that were transforming contemporary life. Dancer Isadora Duncan provocatively claimed Whitman as one of her three dance masters, and Gordon Craig,

after witnessing her dance in Germany, was quick to connect the two. "Walt in a book is alive," he exclaimed, "—but Walt walking, dancing is LIFE."[39]

The Soil's interview with Annette Kellerman, a popular swimmer and cinematic star, typified the journal's focus on the intersection of the body, commercial culture, and the emergence of a new American art. Kellerman was known both for her athleticism and for her blatant disregard for the pruderies of Victorian society. On screen and in her act at the Hippodrome, she inscribed Whitman's emphasis on the wholesome physicality of the body. Hers was the strong, athletic body of which Whitman sang: "The Female equally with the Male I sing" (*LG* 1). Her body-hugging bathing costume in the film *Neptune's Daughter*, a photograph of which accompanied the interview (fig. 88), and even bolder nude scenes in *A Daughter of the Gods* caused an utter sensation when first presented to the American public.[40] Like Whitman, she held all parts of the body to be equally beautiful and strenuously distanced herself from "those sick art-pictures" of nudes. "The nude seems always to be a question of posed attitudes, with their suggestiveness," she lamented, while her work was "natural and healthy," requiring "as much training as a sprinter or a prize-fighter."[41]

FIGURE 88 Photograph of Annette Kellerman in *The Soil* (March 1917)

A similar emphasis on skill, individual ingenuity, and the greater authenticity of popular over fine art expressions infused *The Soil*'s coverage of other new urban pleasures. In his masterful reformulation of the elemental language of pantomime, Charlie Chaplin offered audiences a refreshing alternative to what the comedian himself dismissed in "Making Fun" as "the high class subtle sort of thing."[42] An article on the dime novel stressed that genre's Americanness, noting with pleasure that the plots have "less technique and more life" than "the so-called serious stories."[43] Coady's commentary on "The Stampede," a touring rodeo show with performances at the Sheepshead Bay Speedway, praised the performers' "superior . . . skill, daring and art," judging it "the stuff an artist's eye feeds and works on."[44] In each, the kinetic energy, assertive bodily presence, and freedom from the restrictive culture of the traditional art world proved important factors in *The Soil*'s evaluation of its contribution to modernist culture.

The Soil was not alone in locating a strong Whitmanic presence in the commodified pleasures of the early twentieth century. Dime novelists had themselves already discovered Whitman,[45] and in 1921 Emory Holloway

MOVING SCULPTURE SERIES

A Sellers Ten Ton Swinging Jib Crane

FIGURE 89 From Moving Sculpture Series
in *The Soil* (January 1917)

would characterize *Franklin Evans*, Whitman's 1842 temperance novel, as a "dime novelette."[46] Both Van Wyck Brooks and Harrison Reeves perceived glimpses of Whitman's democratic individualist in the person of Nick Carter,[47] while D. W. Griffith and Vachel Lindsay constructed Whitman as a vital and creative force in the development of the motion picture.[48] More recently, Constance Rourke and C. L. R. James have located a strong Whitmanic sensibility in American humor, the comics, and the popular arts generally. "The questions and problems posed by Whitman, Melville and Poe," James argued, "are finding their answer not in T. S. Eliot and Hemingway but in the popular arts of the American people." In his own projected survey of American culture, a work left unfinished at his death in 1989, James had proposed that "in the chapters devoted to contemporary America, the space given to Whitman and Melville [would be] given to the modern film, the radio and the comic

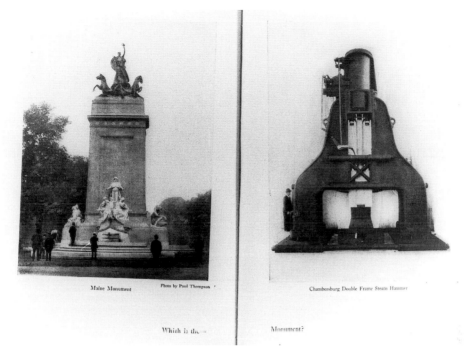

Maine Monument Photo by Paul Thompson

Chambersburg Double Frame Steam Hammer

Which is the Monument?

FIGURE 90 "Which is the Monument?"
in *The Soil* (January 1917)

strip, to Charles Chaplin, Rita Hayworth, Sam Spade, Louis Armstrong, Dick Tracy and Gasoline Alley."[49]

If *The Soil* championed the freedom and kinetic energy of the new commodified pleasures of the early twentieth century, it offered a sustained and sometimes scathing critique of current art world practices. *The Soil* cleverly announced its position through a letter written by a self-identified art-world outsider and published in the journal's inaugural issue. The author admitted to being more captivated by the kinetic energy and streamlined beauty of a steam shovel "ripping out great handfuls of boulders and earth" on a Manhattan street than by the "still pictures and bronzes" on display in the art gallery opposite.[50] Such blatant iconoclasm received potent visual support in two photographic essays in the following issue. In one, six large-scale industrial machines—a Baldwin-built locomotive, a 120-ton wrecking crane, a Sellers 10-ton swinging jib crane, a forging press, a Chambersburg steam hammer, and an Erie hammer manufactured by the Erie Foundry Company—peered out at the viewer on six consecutive pages. The series bore the headline "Moving Sculpture Series" (fig. 89). In the same issue, Attilio Piccirilli's sixty-three-foot-high multi-figural *National Maine Monument*, recently erected in New York's Columbus Circle, confronted a double-framed Chambersburg steam hammer on the page opposite (fig. 90). Piccirilli's artfully refined Beaux Arts tribute to the sinking of the battleship *Maine* during the Spanish-American War, with its allegorical figural groupings, delicate massing, and traditional materials, constituted a continuation of the ideals and

practices of the Renaissance. Not only did the steam hammer pay no heed to the techniques and traditions of the European past, but in its bold simplicity, technological sophistication, and monumental urban scale, this compelling image of American industrial might also left little doubt as to its physical and symbolic superiority over the Piccirilli. *The Soil* asked, "Which is the Monument?" The steam hammer won hands down.

In both scale and industrial significance, the machines recalled those that had captivated Whitman at the 1876 Centennial Exhibition. In his leveling of the artistic hierarchies, Whitman was among the first to celebrate the physical presence, cultural significance, and artistic potential of the emerging technological world of the locomotive and the industrial machine. In "A Song for Occupations," he proclaimed, "In them realities for you and me, in them poems for you and me, / . . . —in them all themes, hints, possibilities" (*LG* 217–18). "Whatever may have been the case in years gone by," Whitman advised in "A Backward Glance O'er Travel'd Roads," "the true use for the imaginative faculty of modern times is to give ultimate vivification to facts, to science, and to common lives, endowing them with the glows and glories and final illustriousness which belong to every real thing, and to real things only" (*LG* 564).

The massive machines in both the "Moving Sculpture Series" and the "Monument" strongly testified to the impressive physicality and cultural significance of the industrial order. Seen through the "nonaesthetic" lenses of commercial photographers and bathed in an even illumination that clarified even their most inconspicuous parts, these machines basked in the "glows and glories" of their own "illustriousness." They celebrated movement, power, and an attendant modernity not as abstract ideals, nor with the ironic inflections characteristic of the work of artists like Marius de Zayas and Francis Picabia, but as vital physical and socioeconomic realities. Far removed from the purely aesthetic emphasis of most art galleries, these "colossal mechanical forms" projected the collective power of thousands of laborers. As Sanborn explained flamboyantly to Coady "these great machines [had] the same relation to the national consciousness as the pantheon of gods had to the mind of the Athenian of the Golden Age of Greece; that is, they have been dreamed, planned, and constructed to express and to augment the greatness of a people."[51] Stated more succinctly, these uninflected presentations, these "crude cultural products," bespoke a legitimacy and authenticity sorely lacking in most gallery presentations.[52]

As one who favored realism over abstraction, Coady believed himself in fundamental alignment with both the substance and sensibility of his age. A major factor in that alignment was his rejection of the theoretical explanations used by modernists to justify their turn toward abstraction. In a letter to an unidentified "Mrs. H—," Coady complained that "our 'new men' are the 'ismists' who are more interested in theories than art. None of this is American. None of it has come from the soil."[53] Nine months before *The Soil*'s debut, a major exhibition of the work of seventeen leading American modernist painters opened at the Anderson Galleries. Sponsored by Mitchell

Kennerley and organized by six prominent American arts advocates, including Alfred Stieglitz and Robert Henri, the Forum Exhibition of Modern American Painters undertook to highlight the achievements of the growing number of American modernists whose accomplishments, they believed, had been overshadowed by the work of their better-known European counterparts. The organizers certified the works on display as constituting a "comprehensive, critical selection" of the country's modernist practitioners.[54] The accompanying catalogue contained brief, explanatory essays by all but one of the exhibiting artists, each placed opposite one of that artist's exhibited works. Marsden Hartley, John Marin, Man Ray, Charles Sheeler, and Stanton MacDonald-Wright (the brother of critic William Huntington Wright, one of the exhibition's organizers) were among the exhibited artists.[55]

Neither the selection of works nor the critical explanations used to justify them satisfied *The Soil*'s commitment to an indigenous American modernism.[56] To point up the folly of what it termed this "dizzy hysteria" of "ismism,"[57] *The Soil* staged a number of witty rebuttals that pitted objects of everyday use against the achievements of the modernists. One of these juxtaposed MacDonald-Wright's *Organization 5*, a Synchromist abstraction that was illustrated in the Forum Exhibition catalogue, and a commercial window display of men's hats (fig. 91). In MacDonald-Wright's painting, a dynamic interplay of carefully orchestrated color harmonies was worked out in an abstract field of overlapping colored disks. In his accompanying statement in the catalogue, MacDonald-Wright, in the theory-laden language of Whitman's "learn'd astronomer," asserted:

From Forum Exhibition Catalogue Copyright by Mitchell Kennerley

"Organization 5," by S. Macdonald Wright.

"RECOGNIZING that painting may extend itself into time, as well as being a simultaneous presentation, I saw the necessity for a formal climax which, though being ever in mind as the final point of consummation, would serve as a *point d' appui* from which the eye would make its excursions into the ordered complexities of the picture's rhythms. Simultaneously my inspiration to create came from a visualization of abstract forces interpreted, through color juxtapositions, into terms of the visual."

"S. MACDONALD WRIGHT."

I DRESSED this window to attract attention to the fact that a hat can be made to feel as light as a feather. A person will invariably be interested in good merchandise when its qualities are properly shown, and more especially when those qualities contribute to comfort, ease and beauty. To attract men to these qualities is my aim. The Window Trimmer is not a Jack-of-all-trades, and should be given free rein in trying out his own ideas. He should be given every aid, for the possibilities of good results are unlimited. Window Dressing—not the old throw-me-in style, but the set-me-right way—brings one face to face with more reality than a mountain of words can.

GILBERT McGOWAN.

FIGURE 91 Stanton MacDonald-Wright, *Organization 5*, and Gilbert McGowan, commercial window display, in *The Soil* (December 1916)

Recognizing that painting may extend itself into time, as well as being a simultaneous presentation, I saw the necessity for a formal climax which, though being ever in mind as the final point of consummation, would serve as a point d'appui from which the eye would make its excursions into the ordered complexities of the picture's rhythms. Simultaneously my inspiration to create came from a visualization of abstract forces interpreted, through color juxtapositions, into terms of the visual.[58]

Gilbert McGowan's window display, too, emphasized a rhythmic arrangement of circular forms. The designer's verbal statement of purpose, however, focused exclusively on the practical and the pragmatic. In the straightforward language of everyday affairs, McGowan explained, "I dressed this window to attract attention to the fact that a hat can be made to feel as light as a feather." In sharp contrast to MacDonald-Wright's obfuscating prose, McGowan enthused, "Window Dressing . . . brings one face to face with more reality than a mountain of words can."[59] Later in the same issue, the caption accompanying a photograph of the bronco-rider Jess Stahl proudly proclaimed: "He has no ism to guide him" (fig. 92).[60]

Just as Hartley preferred the experiential emphasis of Whitman's verse to the abstract reasoning of Kandinsky, so Coady favored Whitman's populism over the often abstruse theories of the modernists.[61] "I and mine do not convince by arguments, similes, rhymes," Whitman wrote. "We convince by our presence" (*LG* 155). "When I Heard the Learn'd Astronomer," one of his most memorable short poems, enacts a vivid demonstration of the potent superiority of the empirical over the theoretical and the abstract.

> When I heard the learn'd astronomer,
> When the proofs, the figures, were ranged in columns before me,
> When I was shown the charts and diagrams, to add, divide, and measure them,
> When I sitting heard the astronomer where he lectured with much applause in
> the lecture-room,
> How soon unaccountable I became tired and sick,
> Till rising and gliding out I wander'd off by myself,
> In the mystical moist night-air, and from time to time,
> Look'd up in perfect silence at the stars.
>
> (*LG* 271)

The real challenge, Whitman chanted in "Song of the Exposition," was to "raise a voice for far superber themes for poets and for art, / To exalt the present and the real" (*LG* 202).

The Soil's populism extended well beyond the populist emphasis of its contents to include the language and rhetorical strategies deployed to promote them. In contrast to other "little magazines" of the period, *The Soil* shunned the elevated tone of either the essay or the critical review, favoring instead the accessibility and breezy informality of journalism. At a time when Emory Holloway and other scholars were just beginning to recover Whitman's

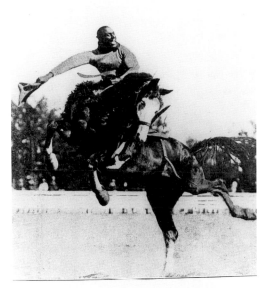

JESS STAHL. He has no ism to guide him

FIGURE 92 Photograph of Jess Stahl
in *The Soil* (December 1916)

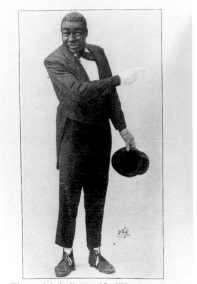

[We must apologize for this picture of Bert Williams, but it is the best we could find in the city.]

FIGURE 93 Photograph of Bert Williams
in *The Soil* (December 1916)

journalistic roots,[62] *The Soil* flaunted a reportorial voice. It embraced the first-person narrative of the interview as part of its leveling of artistic hierarchies. Speaking in their own voices, Annette Kellerman, Charlie Chaplin, and Bert Williams reached out directly to their audiences. Like Whitman's, their voices were not muffled, distorted, or improved by the authoritative voice of a master narrator. In being allowed to speak for themselves they revealed themselves to be little different from anyone else. They emerged as Whitman's "divine average," not elevated icons or indifferent geniuses far removed from the struggles of everyday life. "To make people laugh I have to work it out carefully," Williams reminded readers in *The Soil*'s first issue (fig. 93).[63]

Even closer to Whitman's distinctive rhetorical strategies was *The Soil*'s inventive use of language, earthy diction, engaging conversational manner, and parenthetical asides to its readers. Robert Alden Sanborn opened a discussion on boxing with a description of the "Smoke, fighting and always losing. . . . Smoke, fighting and losing," a description carefully calculated to recall Whitman's distinctive phrasing, repetitive cadences, and creative appropriation of present participles.[64] Elsewhere, the "quaggy ponderosities!" and "en-hugged continents" in Enrique Cross's poem, "A Friend,"[65] and the engaging image of tugboats plying New York's harbors "in their shirt-sleeves all day, tough, dirty and self-possessed. . . . their busy hooting language, hoarse and companionable"[66] vividly invoked Whitman's invented words and companionate themes. Toward the end of "Song of Myself," in a witty aside, Whitman posed one of the many rhetorical questions that so personalized his relationship with his audience: "Do I contradict myself? / Very well then I contradict myself, / (I am large, I contain multitudes.)" (*LG* 88). Mabel Dodge so enjoyed

this cheeky informality that she incorporated the first two lines into an embossed monogram on her stationery. In similar fashion *The Soil* punctuated several of its articles, interviews, and photographic essays with marginal asides that challenged conventional wisdom. One paired a photograph of a bronco rider with the reminder, "Not among the art notes." Others asked challengingly, "Who will paint New York? Who?" and "Who has seen the Battery? Who?"[67] As part of Coady's effort to defy the limitations of the printed page, such asides sought to nudge, entice, cajole, and otherwise stimulate his readers into action. The goal, here as elsewhere, was to raise awareness of the need to transform the country's distinctive raw materials into a viable and authentic American art.

In one of the earliest evaluations of Whitman's poetic structure, published in 1914 by Mitchell Kennerley, Basil De Selincourt described the "detachment and disconnectedness" of *Leaves of Grass,* likening the whole to a patchwork quilt.[68] "His object as a writer," De Selincourt observed, "is to exhibit the universe in samples, with a hint that every sample is an index of the quality of all the wares: to present, at one and the same time, the distinctness of the details of experience and their fluidity, the sharp contrasts and the unfailing reconciliation."[69] The seeming incompatibility of this dual concentration on distinctness and fluidity contributed to the pervasive sense that "the parts are all interchangeable; every key fits every door." "The sentiment throughout," De Selincourt explained, "is as if, by slowly accumulating perceptions and discoveries, some vast, half-obliterated fresco were being rescued from obscurity."[70]

The Soil, too, gave the sense of being a colorful patchwork of fragments, its articles bits and pieces of a larger accumulating whole. "I round and finish little," Whitman advised in "A Backward Glance O'er Travel'd Roads" (*LG* 570), and so it was also with *The Soil.* Its articles were frequently no more than two or three pages long, insufficient to offer more than a tantalizing introduction to the subject, a mere snapshot, as it were, like the iterations or "samples" in Whitman's catalogues. Several articles were themselves fragments, excerpts from longer, published works. Others became further fragmented when continued across several issues. The brevity of the articles, together with their unresolved, open-ended manner of presentation, gave the whole a rapid-fire, staccato rhythm and a sense of introduction rather than finality.

One particularly potent example included fragments of two poems— a six-line segment of Whitman's "Crossing Brooklyn Ferry" and an abbreviated passage from Arthur Cravan's "Sifflet"—paired opposite a full-page commercial photograph by Brown Brothers. Embedded in the fragment from "Crossing Brooklyn Ferry" was a witty reminder of *The Soil*'s unsuccessful bid to align itself with the respected literary journal *Others,* edited by Alfred Kreymborg.[71]

Others will enter the gates of the ferry and cross from shore to shore,
Others will watch the run of the flood-tide,

Others will see the shipping of Manhattan north and west, and the heights of
> Brooklyn to the south and east,
Others will see the islands large and small;
Fifty years hence, others will see them as they cross, the sun half an hour high,
A hundred years hence, or ever so many hundred years hence, others will see them.

> (*LG* 160)

Disengaged from the full text of the poem, the passage focuses attention on
the temporal and spatial parameters linking Whitman with his twentieth-cen-
tury audience. The "others" to whom Whitman directed his verse join him in
looking out toward the distinctive and changing skylines of Brooklyn and
Manhattan as they rhythmically ply the waters between. Cravan's poem, orig-
inally published in French in Cravan's short-lived Parisian journal,
Maintenant, enacts another kind of voyage, the author's transatlantic crossing
from Le Havre. "New York! New York! I should like to inhabit you!" Cravan
exclaims. "I see there science married / To industry, / In an audacious moder-
nity."[72] Visual confirmation of New York's messy and "audacious modernity"
confronts the Whitman and Cravan passages in the dramatic Brown Brothers
photograph of Manhattan skyscrapers looking north along Broadway in the
direction of the world's tallest building, the recently completed Woolworth
Building partially visible in the upper left (fig. 94). Dubbed the "Cathedral of
Commerce" and recognized throughout the world as a potent symbol of the
country's technological prowess, the Woolworth Building symbolized the suc-
cessful wedding of art and industry. In a later issue, the engineer of the
Woolworth Building confidently declared the country's skyscrapers "positively
an outgrowth of American conditions."[73] Still, the Woolworth Building, as
represented in the photograph, shares the poems' status as a fragment. The
photograph of which it is a part represents another fragment, offering neither
a complete view of the city nor of the immediate neighborhood along Lower
Broadway.

Embedded in this collection of fragments are a number of intertwined
and overlapping narratives about New York, technology, movement, and the
dispersal of energy that constituted the early-twentieth-century urban experi-
ence. Here as throughout *The Soil*, recurring themes transcend conventional
media boundaries. The narratives do not unfold in an orderly, linear format.
Nor do they conclude with a concise summation. The content of one informs
and is in turn informed by the content of the others, creating an expansive dia-
logue between and across genres. Despite their obvious and fundamental dif-
ferences, the distinctive movements of the ferry, the "athletic sailors" aboard
the vessel from Le Havre, and the activities of Lower Broadway seem inex-
orably linked not just with each other but also with many of the journal's
other visual and verbal representations—including the "Moving Sculpture
Series," boxing, the dime novel, tugboats, and even the actions of Bert
Williams, Charlie Chaplin, and Annette Kellerman. By dispersing its themes
liberally throughout each issue and across subsequent issues, *The Soil* creates
the sense of an organic, accumulating whole, where the visual and the verbal,

Photo copyright by Brown Bros.

New York by Brown Bros.

FIGURE 94 Brown Brothers,
New York, in *The Soil* (December 1916)

the fine and the commonplace, the old and the new meet in an ever-expanding universe of cultural diffusion and exchange.

If *The Soil* found little of cultural or aesthetic merit among the American offerings on view in the city's modern art galleries, it expressed enthusiastic support for the new art of the motion picture. In *The Art of the Moving Picture* (1915), his pioneering treatise on the genre, poet Vachel Lindsay extolled the silent film for its ability to portray "Whitmanesque scenarios." "The possibility of showing the entire American population its own face in the Mirror Screen has at last come," he exulted. "Sooner or later the kinetoscope will do what he could not, bring the nobler side of the equality idea to the people who are so crassly equal."[74] In her recent book, *Silent Film and the Triumph of the American Myth*, Paula Marantz Cohen acknowledges Whitman's position as one of cinema's nineteenth-century literary precursors. Together with such figures as Emerson and Thoreau, Whitman, she writes, "anticipated film in [his] call for a new, uniquely American form of expression."[75]

Coady clearly had Whitman in mind when he hailed the cinema as "a medium of visual motion" and praised its independence from the temporal, spatial, and narrative structures guiding other contemporary art forms.[76] By virtue of its insistent realism and its direct contact with the rugged elements of life itself, the new art of the cinema seemed firmly grounded in Whitman's celebration of "every real thing, and [of] real things only." In 1920 photographer Paul Strand and painter-photographer Charles Sheeler paid indirect homage to *The Soil*'s prescient endorsement of both Whitman and his city in their experimental seven-minute film, *Manhatta*. Intertitles from Whitman poems frame the film's disjointed views of the city and its inhabitants. Animated by puffs of steam rising from the soaring buildings and by the movement of pedestrians hurrying along the pavement, the film lacks conventional narrative structure. Skyscrapers, construction sites, and the ubiquitous ferries and tugboats on the city's expansive harbor—themes that figured prominently in *The Soil*—celebrate the excitement and vitality of contemporary urban experience. One of the scenes even shares the same general vantage point as the photographic view of the Woolworth Building published in *The Soil*. When the film was first shown at Broadway's Rialto Theatre on 24 July 1921, Robert Allerton Parker enthused about its treatment of Whitman's "proud and passionate city." Devoid of plot but not action, the film, he wrote, revealed the city "most eloquently in the terms of line, mass, volume, movement."[77]

Despite its spirited beginning, *The Soil* proved unable to sustain its early promise and ceased publication after only five issues.[78] With the exception of *Camera Work*, which endured for more than a decade, few "little magazines" of the period enjoyed long and prosperous runs; *Seven Arts*, for instance, published its last issue within months of *The Soil*. Despite its abbreviated existence, *The Soil* managed to sustain a healthy level of interest among a cadre of critical observers. Henry McBride faithfully reviewed each issue, offering extravagant praise and hailing *The Soil*'s judgment as "in advance of the critics."[79] Marcel Duchamp, too, expressed admiration for

Coady, whom he judged "[n]ôtre ami."[80] Still, not everyone was impressed. Poet William Carlos Williams credited *The Soil* with being "a fine lively magazine," but found its "democratic" demeanor compromised by being too "decorative." In the end he leveled much the same criticism against *The Soil* that critics had leveled against *Leaves of Grass* some sixty years earlier: the journal lacked "discrimination."[81] Harry Alan Potamkin, managing editor of *The Guardian*, agreed. Writing during the next decade, Potamkin readily acknowledged that Coady was more "essentially attuned" to the popular pulse than such far-better-known critics as Gilbert Seldes, Edmund Wilson, and Robert Littell. Nevertheless, like Williams, he judged the pugnacious editor "overeager to swallow his environment without mastication."[82] Kreymborg and Gorham Munson were more encouraging. While Munson found Coady neither "profound" nor "comprehensive," he placed considerable value on his spirited challenges to traditional symbols of authority. "More and more," Munson advised in 1925, "he looms as a provocation for new cultural actions that Americans must undertake."[83]

In this cacophony of competing and often conflicting voices, Whitman's commentary on *Leaves of Grass* provides a useful framework with which to assess *The Soil*'s provocative but uneven legacy: "The words of my book nothing, the drift of it everything" (*LG* 13). In open defiance of current art-world practices, *The Soil* endorsed an eclectic amalgam of elite and popular forms of cultural expression. It encouraged change and rootedness simultaneously. Like Whitman, *The Soil* found strength and the seeds of cultural renewal at the margins of elite society. The journal's celebration of the body, the new art of the cinema, and the urban arena of contact sports, its fascination with the machine and the rodeo, and its vociferous rejection of mainstream American modernism set the journal decisively apart from other little magazines of the period. In line with Bredvold's characterization of Whitman's poetry, *The Soil* offered less "a trustworthy constructive criticism of life, . . . [than] the chaotic, unevolved elements of life itself." *The Soil* functioned more as a stimulant to cultural and artistic renewal than as a dependable guidebook. Its scattershot approach left many questions unresolved. In the absence of a clear intellectual focus, its articles often seemed little more than tantalizing introductions to difficult and complex problems.

If *The Soil* suffered from the lack of a coherent and sustainable program, by the middle of the next decade, many of its radical propositions had achieved normative status, at least in vanguard circles. In 1925, eight years after the journal's demise (and four years after Coady's death), the sculptor Arnold Rönnebeck, a friend of Hartley's and spokesman for Stieglitz's newly opened Intimate Gallery of American Art, constructed the Americanness of Stieglitz's artists through the once-inimical lens of Coady's journal. Where earlier Stieglitz had vociferously distanced himself and his artists from the populist gaze of Coady's journal, Rönnebeck actively embraced such populism as a defining element of those artists' Americanness. In answer to the rhetorical question "what *is* essentially American?" Rönnebeck replied: "The skyscrapers, Jack Dempsey, the Five-and-Ten-Cent Store, Buffalo Bill, baseball,

Henry Ford, and perhaps even Wall Street." Further, he continued, the artists used "many of these and other symbols to build universal reality out of the 'reality'" of the everyday: "They belong to the New World, to the world of to-day. They belong to no 'School.' They fit no 'ism.' Their daring self-consciousness forms their harmony."[84] Rönnebeck's ideas, his rhetoric, even his terminology are scripted almost verbatim from the pages of *The Soil.*

Coady doubtless would have been amused by Rönnebeck's unacknowledged appropriation of his once-radical proposition, although he certainly would have taken exception to its association with the fine art production of artists he had himself earlier chided for their elitism. Through its lively constellation of verbal and visual texts, *The Soil* enacted Whitman's populism. It just as forcefully celebrated the complexity and contemporaneity of Whitman's pluralist vision. Its pages bristled with Whitman's democratic idealism, expansionist rhetoric, and boisterous enthusiasm for the broadest range of American cultural experience. The magazine abandoned artistic hierarchies to open up a space where new, untested forms of artistic expression could develop and flourish. *The Soil*'s rejection of the spiritual orientation of artists like Hartley and Kandinsky set it on a collision course with other "little magazines" of the period, especially *Seven Arts* and *Camera Work.* It just as clearly exposed the divergent, even contradictory, tendencies within Whitman's modernist appeal. Like Whitman, Coady was an iconoclast whose feisty rhetoric and unorthodox ways gave exuberant voice to populist tendencies within American art practice in the decades following Whitman's death.

Joseph Stella's *Brooklyn Bridge*

THE GROWING INTERNATIONALISM of Whitman's verse had been gaining steadily since the third quarter of the nineteenth century. Interest was particularly strong in Europe, where translations had begun to appear as early as the 1860s.[1] American intellectuals were generally slow to take seriously the intensity of the European interest in Whitman, often dismissing it as something of an aberration. Even writers like Robert McAlmon, who well understood Whitman's appeal for Americans, expressed little understanding of their foreign-born colleagues' enthusiasm for Whitman.[2] Still, by the early decades of the twentieth century, growing numbers of American artists were encountering that enthusiasm firsthand during periods of study and travel abroad. Immigrants and short-term visitors to this country brought their commitment with them to America. Their presence, particularly within New York's modernist circles, bolstered the response of the city's native-born populations while injecting a reciprocating element into the process of cultural dissemination. "Although Whitman's poems did not exactly celebrate the America I was familiar with," recalled the Russian emigré and artist Maurice Sterne, "I felt in them an elemental power, a beauty, and a sense of comradeship that I had never known before." So enthralled was Sterne with Whitman's ability to speak to him directly that the impoverished artist attempted to steal a copy of *Leaves of Grass* to assure that he would never be without it.[3]

As part of his democratic inclusiveness, Whitman repeatedly extolled the vitality of this country's immigrant populations, boasting in the Preface to *Leaves of Grass* that America was "not merely a nation but a teeming nation of nations" (*LG* 711). In the 1880s, shortly after settling into his Mickle Street residence, Whitman enjoyed several visits from the young German-Japanese poet and critic Sadakichi Hartmann. Hartmann had recently arrived from

Germany and was living with his granduncle in Philadelphia. Whitman recalled finding Hartmann's immigrant observations on America "bright— surprisingly searching"[4] and, at the conclusion of their first meeting, he offered Hartmann a proof sheet copy of "After All, Not To Create Only." He urged Hartmann to read it "over six or eight times" so that he might better grasp its significance.[5] "Song of the Exposition," as the poem was subsequently retitled, constitutes Whitman's most impassioned plea to the country's swelling immigrant populations to learn "the lessons of our New World," confident that "a better, fresher, busier sphere, a wide, untried domain awaits, demands you" (*LG* 196). What was needed, Whitman stressed, was "[n]ot to repel or destroy so much as accept, fuse, rehabilitate" (*LG* 196). Dismissing the centuries-old standards set by European art traditions, "those immensely overpaid accounts" (*LG* 196), Whitman called on his "illustrious emigré" (*LG* 198) to "raise a voice for far superber themes for poets and for art, / To exalt the present and the real" (*LG* 202). In a move that would resonate deeply with his early-twentieth-century readers, Whitman identified among these themes the technological "triumphs of our time," citing in particular "the Atlantic's delicate cable, / The Pacific railroad, the Suez canal [and] . . . the Brooklyn bridge" (*LG* 203).

The Italian immigrant Joseph Stella, an artist best known for his powerful representations of one of those "superber themes"—the majestic Brooklyn Bridge—embodied Whitman's "illustrious emigré." Stella arrived in America in March 1896, exactly four years after Whitman's death. Through extensive travel and personal contacts abroad, particularly in Italy and France, he maintained lasting ties with his native Europe. In the essential duality of his life, Stella enacts the expansive and reciprocating dialogue that facilitated the spread of Whitman's reputation internationally in the decades following his death.[6] His experiences provide a valuable entry into the elaborate networks of diffusion that nurtured Whitman's reception among a diverse group of artists, writers, and intellectuals in Europe and America. Whitman mediated for Stella the seemingly unresolvable distance between Coady's urban populism and Hartley's mystical and spiritual dialogue with the natural world. Steeped in a mythic embrace of both Whitman and America, Stella engaged the Gothic towers of the Brooklyn Bridge, the monumental successor to Whitman's Brooklyn ferry, in a sustained embrace involving Whitman, America, and his Italian heritage.

As was the case with many immigrants, Stella first encountered Whitman's poetry prior to his arrival in America. By 1890 two inexpensive anthologies of Whitman's verse, edited and translated by Luigi Gamberale, were already available in Italy. Both were sufficiently popular to warrant second and third printings before the whole of *Leaves of Grass* was translated in 1907.[7] The anthologies contained virtually all of Whitman's major poems, including "Crossing Brooklyn Ferry" and "Passage to India," which would figure prominently in Stella's extended engagements with Whitman and America. So strong was Stella's interest in literature that before leaving Italy he had considered becoming a poet. The florid tone of his prose writings, por-

tions of which are cited below, reveal his continued fascination with the beauty and potency of words. Joseph and his brother, Antonio—a physician who arrived in the States two years before him—were part of the vast influx of Eastern and Southern European immigrants who flooded America's shores in the late nineteenth and early twentieth centuries. Unlike most of these new-comers, though, the Stellas were educated and fluent in English. Once estab-lished in New York, Joseph strengthened his commitment to Whitman through associations with a number of native and foreign-born artists and writers. Among these were Players Club members who debated the merits of Whitman's verse in the context of symbolist poetry and the urban imagery of Stephen Crane and Henry James. At Renganeschi's, a bohemian restaurant not far from the Hotel Brevoort (the site of the annual Walt Whitman Fellowship International dinners), Stella met caricaturist and fellow immigrant Carlo de Fornaro. Throughout their long friendship, de Fornaro produced several Whitman-inspired caricatures, including a witty drawing for the *New York World* that parodied the diverse attendees at the 1905 Fellowship dinner (fig. 95).[8] In it an obviously bored Emma Goldman assesses the remarks of Canadian poet Bliss Carman while poet and editor Richard Watson Gilder looks on. Although Stella is not known to have participated in the gatherings of the Whitman Fellowship, he fully shared the group's commitment to situ-ating Whitman within the context of modernist culture.

At the New York School of Art, Stella expanded his commitment to *Leaves of Grass* through his association with Robert Henri, a charismatic teacher known for his impassioned lectures and committed social views. Former student Helen Appleton Read hailed his classes as "a rallying ground for eager youth."[9] Henri, like Stella, first read Whitman abroad; Henri encoun-

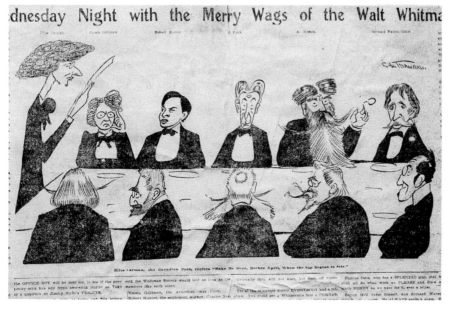

FIGURE 95 Carlo de Fornaro, cartoon
published in *New York World*, 4 June 1905

tered the poetry during his studies in France in the early 1890s. His interest deepened upon his return to Philadelphia several months before Whitman's death, which was extensively covered by the local press. In the years following, Henri and his friends become avid students of *Leaves of Grass.* They were particularly drawn to Whitman's democratic individualism, the expansiveness of his urban sensibility, and his emphasis on matters of personal and national identity. In 1901, shortly after moving to New York, Henri outlined his artistic philosophy in the *Philadelphia Press,* the same newspaper where Talcott Williams had championed Whitman in the 1880s and early 1890s. "Walt Whitman was such as I have proposed the real art student should be," Henri advised. "His work—nothing greater has been done at any time—is an autobiography—not of haps and mishaps, but of his deepest thought, his life indeed."[10] Years later artist Stuart Davis acknowledged the impact of Henri's teaching on his students. "When Henri spoke of writers," he recalled, "what he did was to inspire a desire on the part of the listener to go out, to look up all this stuff and to get involved with it. There was nothing like that in any other art school in New York, in Europe, or anywhere else so far as I know."[11]

Whitman stimulated in Henri and his students a commitment to exploring in their art the everyday experiences of their urban lives. For both Whitman and Henri, the streets of New York radiated the pulse and vitality of the nation. Effusive brushwork and detailed narratives of the grit and substance of urban life distinguished this art from the more genteel offerings of their predecessors. Stella gravitated to the streets of the city's Lower East Side, with its teeming populations of recently arrived immigrants.[12] Although similar in theme, his art differed radically in style and presentation from that of Henri's other students. Stella eschewed the visual bombast and folksy sentiment favored by Henri, preferring to represent this very American subject in the centuries-old style of the Old Masters. Commissions from *Charities and the Commons,* a leading social reform publication, broadened his awareness of the plight of the vast immigrant populations. Assignments at a mining disaster in Monongah, West Virginia, and at Pittsburgh's steel mills awakened his understanding of the powerful symbiosis between immigrant labor and American industrial might. "I was greatly impressed by Pittsburgh," he wrote. "It was a real revelation. Often shrouded by fog and smoke, her black mysterious mass cut in the middle by the fantastic, tortuous Allegheny River . . . was like the stunning realization of some of the most stirring infernal regions sung by Dante."[13] Concerns about the immigrant face of American technology would remain vividly etched on Stella's imagination for years to come. Increasingly, though, the emphasis of his art would shift away from the humanitarian focus of these early works toward a deeper concern with the abstract and the symbolic.

In 1909 Stella returned to Europe for the first of several extended visits. Anxious to affirm his Italian roots, he spent two years in the country of his birth, becoming sufficiently proficient in the Old Master technique of glazing to have one of his works mistaken for a Venetian original. Only at the urging of Walter Pach, one of the future organizers of the Armory Show, did Stella

leave Italy for Paris. Once there, however, Stella "plunged full in it."[14] Far more than Italy, Paris pulsated with the energy and excitement of the new century. The city had for years served as a magnet for a diverse and multinational gathering of artists and writers eager to map new directions in their art. A lively cacophony of competing and often conflicting voices filled the cafes and artists' studios. Fauvism and Cubism "were in full swing," Stella recalled,[15] and Futurism would make its exhibition debut the following year.

Intermingled within this groundswell of enthusiasm for the new was increased interest in America, the most technologically advanced country in the world, and in the American voice of Walt Whitman. French interest in Whitman had been gaining steadily since the first translations of his verse in the 1880s. By the first decade of the twentieth century, the movement known affectionately as "le whitmanisme" had achieved the status of a "force" among French artists and writers. Interest in Whitman was particularly strong among members of the Abbaye de Créteil, a group that, as Betsy Erkkila has observed, attempted "to put into practice the fraternal and communal ideals that Whitman expressed in his poetry."[16] Participants included poet Charles Vildrac and writer Henri-Martin Barzun along with artists Francis Picabia, Marcel Duchamp, and Albert Gleizes, who, together with Barzun, would pay protracted visits to America during the tumult of the First World War. In 1908 the Abbaye published Léon Bazalgette's laudatory biography, *Walt Whitman: L'homme et son oeuvre*, followed a year later by *Feuilles d'herbe*, Bazalgette's French translation of the complete *Leaves of Grass*. It was with this publication, Erkkila asserts, that Whitman "entered the mainstream of French poetry."[17]

Stella immersed himself in the excitement of the city's intellectual and artistic upheavals during his twenty-one month stay in Paris. "There was in the air the glamor of a battle, the holy battle raging for the assertion of a new truth," Stella recalled.[18] Fluent in French, Stella particularly enjoyed evenings at the Closerie des Lilas, which he found always "crowded with the leading painters and writers led by the prince of poets, Paul Fort."[19] Fort, an advocate for the local and the native in literature, was one of Whitman's most outspoken advocates within Parisian literary circles.[20] Even more central to Stella's broadening appreciation of the growing internationalism of Whitman's appeal was his active involvement with the city's community of Italian artists. Among his closest friends were figure painter Amedeo Modigliani and Futurist Gino Severini, who would shortly marry Fort's daughter.[21] In 1909 the first Futurist Manifesto, launched from the pages of the French newspaper *Le Figaro*, had sounded the battle cry for artistic rebellion across Western Europe. The movement's founder, poet and theorist Filippo Marinetti, constructed Whitman as one of the "four or five great precursors of Futurism."[22] His poems appropriated both Whitman's technical innovations and his urban-technological vision. Above all, Marinetti hailed Whitman as the voice of speed, modernity, and technological change.

Stella's Italian roots, his deepening commitment to visual modernism, and his growing awareness of the transatlantic construction of a modernist Whitman would exert a profound impact on his expanded sense of himself and

the possibilities of his art following his return to New York. In late 1912, after an absence of nearly four years, Stella encountered a city in transition. The Woolworth Building, whose impressive Gothic towers would reign for years as an international symbol of the country's dominance in the coveted arena of skyscraper construction, was nearing completion in lower Manhattan. Farther uptown, the Armory Show was about to unleash on a largely unsuspecting American public a monumental display of several hundred examples of international modern art by some of the movement's foremost practitioners. The exhibition and the torrent of responses it generated inaugurated an expansive public debate on modernism's future on American soil.

A major contributor to this discourse was Francis Picabia, the only exhibitor from Europe to visit this country during the display and an associate of the Abbaye de Créteil. In a widely circulated interview in the *New York American*, Picabia praised New York for its "extreme modernity," citing in particular "your stupendous skyscrapers, your mammoth buildings and marvellous subways." This first-time visitor to the United States singled out for special commendation such intangibles as the city's internationalism ("I hear every language in the world spoken") and the feeling of its crowded streets, "their surging, their unrest, their commercialism, and their atmospheric charm." "Your New York is the cubist, the futurist city," he exulted. "It expresses in its architecture, its life, its spirit, the modern thought."[23] Elsewhere, he informed a bewildered American audience that "France is almost outplayed. It is in America that . . . the theories of The New Art will hold most tenaciously."[24]

Picabia's unqualified endorsement of the city's modernity, his praise of its energy and internationalism, and his projection of a radical realignment in the arts between France and the United States generated considerable excitement within the American modernist community. As a European observer on American soil, Picabia's transatlantic perspective held special meaning for Stella. For the majority of Americans the terms "Cubism" and "Futurism" evoked only a vague and somewhat confusing constellation of modernist associations. "Futurism," in particular, was often used as little more than a generic descriptor for modernism.[25] For Stella, however, the associations were much more specific and, in the case of Futurism, irrevocably linked to his Italian heritage. Within months of Picabia's pronouncements Stella issued his own statement in support of the new art. "Cubism and futurism interest me to a very great degree," he declared in an article in *The Trend*. Futurism's value, he asserted, "chiefly lies in creating a new sort of language apt to express the feelings and the emotions of the modern artist."[26] His pride in the movement's Italian origins is evident in a letter he wrote to one of its leading practitioners, praising him for "the bold new conquests made by you and your companions to the Glory of Italy."[27] Following Marinetti's lead, Stella urged those in his adopted country to take heed of "the great futurist work first achieved by Walt Whitman." It would behoove all creative individuals, he intoned, "to follow this glorious example."[28]

Native-born Americans, too, identified Whitman with these new

movements in art. Just as Stella's article appeared, critic Benjamin De Casseres celebrated Whitman as one of "the fathers of the cubists and futurists."[29] Horace Traubel, too, sensed an affinity between Whitman and the Futurists and asked Robert Henri to address the issue at the May 1913 meeting of the Walt Whitman Fellowship International.[30] Most important, however, was the association mapped by critic Basil De Selincourt in *Walt Whitman: A Critical Study*, published jointly in London and New York in 1914. De Selincourt's book followed by two years a major exhibition of Futurist art in London, the same exhibition Stella had seen earlier at the Bernheim-Jeune gallery in Paris. The London showing received massive media attention and attracted a crowd of some 40,000 people, due in no small measure to the electrifying presence of Marinetti, who presented several lectures. The accompanying catalogue included the text in English of both the Futurist Manifesto and the Technical Manifesto, providing English-speaking audiences with their first detailed encounter with the movement's founding beliefs.[31] Like Marinetti, De Selincourt hailed Whitman as "the poet of machinery" and praised his ability "to emancipate the mind from the bondage of accepted symbols." Most important, De Selincourt identified in Whitman's verse examples of the kinds of spatial and temporal disjunctures characteristic of the Futurist technique of simultaneity. De Selincourt cited as an example the poem "Out of the Cradle Endlessly Rocking," where, through "a succession of half-descriptive, half-imitative touches, the whole scene and every actor in it" were presented to the reader "from without and from within." Thus, he concluded, "Years before 'futurism' was heard or thought of," Whitman had "felt and rendered" one of its "core" aspirations.[32]

De Selincourt's assessment of a shared affinity between Whitman and the Futurists struck a responsive chord among the book's reviewers in both London and New York. The reviewer for London's *The Living Age* characterized Whitman as "a Futurist—born out of due season" and took evident pleasure in describing his verse in language calculated to recall that of the fiery Marinetti. His verse "shouts and stamps," the author claimed, finding it "percussive, explosive, . . . [and] supremely egoistic."[33] Herman Scheffauer, writing in the *North American Review*, concurred. Although considerably less taken with the antics of "the ramping madman in Milan," Scheffauer fully accepted the characterization of Whitman as "the futurist of his day."[34]

In the months following the Armory Show, Stella's art underwent a radical transformation as he struggled to integrate the celebrated modernity of Whitman's America and the cultural heritage of his native Italy. The most impressive early work to emerge from this new synthesis—*Battle of Lights, Coney Island, Mardi Gras* (fig. 96)—met with considerable acclaim when shown in the American Cubists and Post-Impressionists exhibition at the Montross Gallery in early 1914. Here, on an impressive scale, Stella paid tribute to the electrified rides, surging sense of movement, and illuminated display of New York's premier amusement park. Stella characterized his painting, which measured some eight feet across, as "my very first American subject."[35] The bright colors, disjointed rhythms, and frenzied activities of the crowd cele-

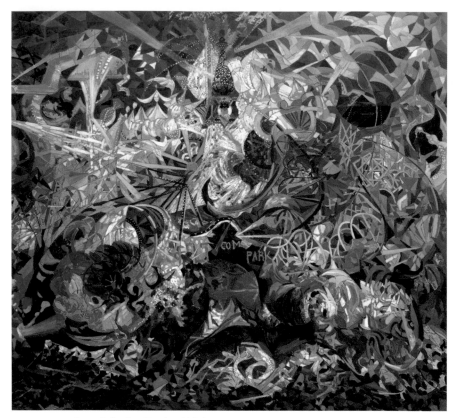

FIGURE 96 Joseph Stella, *Battle of Lights,*
Coney Island, Mardi Gras, 1913–14

brate the energy and vitality of modern America. Pleasure, commerce, and
technology vie for the viewer's attention in a kaleidoscopic display of monu-
mental proportions. Structurally and thematically the painting acknowledges
the work of the Italian Futurists, particularly paintings like Severini's
Dynamic Hieroglyphic of the Bal Tabarin (1912), with its sequined dancer and
colorful vignettes of imaginary and remembered scenes. But Stella moves well
beyond Severini in the greater integration of style and subject to evoke the
technological underpinnings of modern life. In this exuberant tribute to the
spatial and temporal disjunctures of the modern urban environment, Stella
first brokered a fusion of the developing Futurist and Whitmanic impulses in
his art.

During the prolonged period of the First World War, increasing num-
bers of European artists and writers, eager to escape the ravages of the war and
anxious to participate in this country's insistent drive toward modernity, set-
tled in New York, staying anywhere from a few months to a few years. Many
gravitated to the nightly gatherings at the art-filled apartment of Walter and
Louise Arensberg, where they exchanged ideas with members of the American
modernist community.[36] Stella prospered in the fluid give-and-take of this lively
international gathering of visual, verbal, and performing artists. The group's
discussions ranged freely over a host of topics central to the discourse on mod-

ernism. The Europeans were especially intent on establishing what Wanda Corn has characterized as "a transatlantic outpost of modernism in New York."[37] Steeped in a largely mythologized view of America and New York, they came intending to assist their American colleagues in inaugurating their own national art. They came as "missionaries," declared poet Guillaume Apollinaire, "destined to nourish a new production of which we have as yet no idea, but which will doubtless not be inferior to [the efforts of] those two great pioneers," Walt Whitman and Edgar Allen Poe.[38]

Although scholars have yet to explore a possible Whitmanic component in the group's provocative challenges to Euro-American traditions, more than half of the Europeans and most of the Americans were in some way touched by the power of Whitman's verse. Among the Europeans, Francis Picabia was making his first return visit to the States since the Armory Show. With him were two of his colleagues at the Abbaye de Créteil, painter Albert Gleizes and writer Henri-Martin Barzun. Marcel Duchamp, the most prominent member of the group, counted among his favorite poets the symbolist Jules Laforgue, whose early translations of Whitman's poetry had initiated the French reception of Whitman's verse.[39] Other Europeans included poet Arthur Cravan and avant-garde composer Edgar Varèse, who, together with Picabia, took up residence at the Hotel Brevoort. Among the Americans were Marsden Hartley, who continued to explore Whitman's resonance with the American land,[40] and Charles Sheeler, whose filmic tribute to Whitman's New York would debut in 1921. Others, including Wallace Stevens and Alfred Kreymborg, shared Sheeler's interest in Whitman's urban-technological vision, while Isadora Duncan danced Whitman's ode to the body.[41]

Duchamp's friend, the French writer Romain Rolland, expressed the concerns of many in the group when he yoked Whitman with "the high destinies of America." In the inaugural issue of *Seven Arts*, Rolland urged his American audience "to dare to see yourselves; to penetrate within yourselves . . . to make of your culture a symphony," aware of "the elemental Voice of a great pioneer, in whose message you may well find an almost legendary omen of your task to come,—your Homer: Walt Whitman."[42] Not long thereafter, the first issue of *The Blindman*—a short-lived journal backed by members of the Arensberg group to celebrate the 1917 exhibition of the Society of Independent Artists—called on "the spirit of Walt Whitman [to] guide the Indeps." "Long live his memory," exclaimed Henri-Pierre Roché, "and long live the Indeps!"[43] William Carlos Williams expressed much the same sentiment in the November 1917 issue of *Poetry Journal*. In a gesture sure to have warmed Stella's Italian heart, Williams located Whitman within a verbal-visual continuum extending from Dante to the British colorist and Ruskin favorite J. M. W. Turner. Like many of his contemporaries, Williams stressed Whitman's initializing presence. Judging him "above all a colorist—a mood man," Williams placed particular emphasis on his daring rejection of both the received norms of his profession and the expectations of his audience. "He destroyed the forms antiquity decreed him to take and use," Williams declared. "He started again naked. . . . He is our rock, our first primitive.

We cannot advance until we have grasped Whitman and then built upon him."[44]

In an essay published shortly before his death, Stella acknowledged his commitment to both the Adamic quality of Whitman's art and its atmospheric richness. In the grandiose rhetoric characteristic of his writings, he hailed Whitman as one of the "giants towering in the American Olympus of Literature. . . . With Walt Whitman, we are awakened, seized, excited by his morning crystalline hymn celebrating the Redemption of Art. All of a sudden we are struck by a revelation: we are astounded at the candor of the world magically unsealed for us, virginal again. Carried by the intoxicating speed of his free verses, lightly running with the agility of waves, we are thrilled by the vivid pageant of joyful visions storming in front of our bewildered eyes." No less thrilling were the spatial and temporal possibilities unleashed by this "modern Prometheus unbound." "Whitman rouses and guards a new sacred fire of inspiration," Stella exclaimed. "He renders space boundless: he opens infinite fields to future harvests. Even the sky appears enlarged [sic] for new constellations to appear."[45]

Stella's desire to "justify" this "modern Prometheus unbound" reached a crescendo during his six-year affiliation with the Arensberg circle. His principal vehicle was the Brooklyn Bridge, an icon with which he had been "obsessed" since his arrival in the States some twenty years earlier.[46] Between 1919 and 1922 Stella produced two major oil paintings of the Brooklyn Bridge, together with several pastels and watercolors. Four more oils would follow over the next two decades, the last one completed only five years before his death.[47] Prior to commencing the first of his paintings (fig. 97), Stella had taken up residence in Brooklyn, where he lived in relative proximity to Whitman's old haunts. Although the move seems to have been motivated more by economic necessity than by a self-conscious desire to excavate Whitman's Brooklyn roots, it initiated a profound reassessment of the interlocking network of cultural, technological, and spiritual affiliations linking him to Whitman. "Brooklyn gave me a sense of liberation," Stella explained. "The vast view of her sky in opposition to the narrow one of NEW YORK, was a relief—and at night, in her solitude, I used to find, intact, the green freedom of my own self."[48] During his years in Brooklyn, Stella taught Italian to a group of Brooklyn seminarians and immersed himself in Whitman's writings. Even late in his life he could quote Whitman at length.[49]

While in Brooklyn, Stella lived within sight of the Brooklyn Bridge, which would celebrate its fortieth anniversary in 1923. From the window of his apartment in the heavily industrialized Williamsburg section of the city, Stella could see the bridge's massive towers, with their graceful Gothic arches, soaring cables, bifurcated roadway, and elevated pedestrian walkway.[50] Both the Brooklyn Bridge and the Statue of Liberty, whose welcoming torch of freedom symbolized new hope for the thousands of immigrants who daily thronged America's shores, were important icons of American cultural promise. To Stella, Roebling's masterpiece symbolized nothing less than the climax of American civilization.[51] In "The Brooklyn Bridge (A Page of My Life)" he

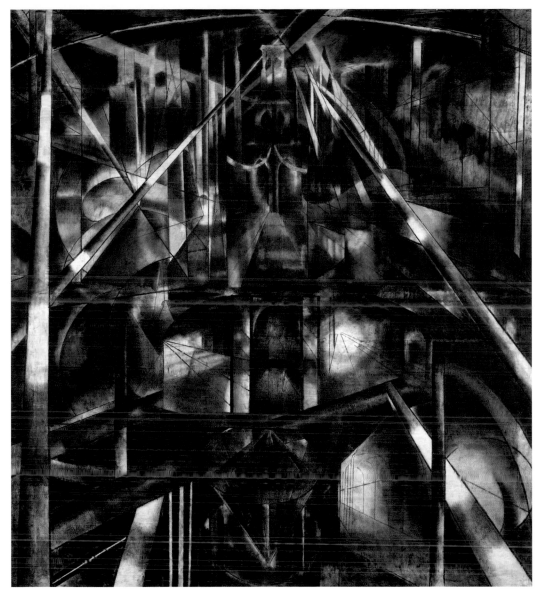

FIGURE 97 Joseph Stella,
Brooklyn Bridge, c. 1919–20

extolled its appeal in an impassioned outburst that illuminates the multiple
associations inscribed for him in the "massive dark towers dominating the
surrounding tumult of the surging skyscrapers." Seen as a "metallic weird
Apparition under a metallic sky," the bridge seemed poised to trace "the con-
junction of WORLDS." Simultaneously sinister and uplifting, the bridge evoked
potent musical and spiritual sensations. The "gothic majesty" of the bridge's
arches registered "purity," while the cables transmitted "divine messages
from above . . . cutting and dividing into innumerable musical spaces the nude
immensity of the sky." The whole was a "shrine containing all the efforts of

the new civilization of AMERICA—the eloquent meeting of all forces arising in a superb assertion of their powers, in APOTHEOSIS."[52]

During the years he resided in Brooklyn, Stella delved once again into the immigrant and industrial themes that had stimulated some of his most poignant early work. In a series of commissions from *The Survey*, the renamed *Charities and the Commons*, Stella probed the impact of the war on Ellis Island detainees, examined the contributions of immigrant and native-born American workers to the war effort, and revisited this country's industrial landscapes. Like his powerful representations of Pittsburgh steel mills, his charcoal drawings of Bethlehem steelworkers and the fiery furnaces they stoked were not witty, ironic commentaries à la Duchamp, but fiery, Dantesque infernos.[53] These experiences no doubt also served as potent reminders that the Brooklyn Bridge, like much of the city's infrastructure and many of its skyscrapers, had been built with immigrant labor.

The prolonged anxiety brought on by the events of World War I converged in Stella's mind with the terrors he confronted in the surrounding industrial landscape. "There was a sense of awe, of terror weighing on everything—obscuring people and objects alike," Stella recalled,[54] a terror not unlike "those sensations of terror" that had gripped him in the writings of Edgar Allen Poe.[55] He likened the "DRAMA" of war to "the impending drama of POE'S tales."

> My artistic faculties were lashed to exasperation of production. I felt urged by a force to mould a compact plasticity, lucid as crystal, that would reflect— with impassibility—the massive density, luridly accentuated by lightning, of the raging storm, in rivalry of poe's granitic fiery transparency revealing the swirling horrors of the Maelstrom.
>
> With anxiety I began to unfold all the poignant deep resonant colors, in quest of the chromatic language that would be the exact eloquence of steely architectures—in quest of phrases that would have the greatest vitriolic penetration to bite with lasting unmercifulness of engravings.[56]

Poe, like Whitman, was one of Stella's favorite American authors. But where Poe appealed principally for his sinister darkness, Whitman inspired hope and a sense of release. "Meanwhile the verse of Walt Whitman—soaring above as a white aeroplane of Help—was leading the sails of my Art through the blue vastity of Phantasy, while the fluid telegraph wires, trembling around, as if expecting to propagate a new musical message, like aerial guides leading to Immensity, were keeping me awake with an insatiable thirst for new adventures."[57] In associating Whitman with the world's newest and most sophisticated mode of transportation, the airplane, Stella acknowledged his close affiliation with the technological enthusiasms of the Futurists.[58] No less implicated was his commitment to Whitman's goal of a globally integrated and spiritually transfigured world order.

In 1910, as he walked across the bridge for the first time, painter John Sloan recorded in his diary that the journey evoked memories of Whitman's

"Crossing Brooklyn Ferry."[59] Nearly thirty years later, the city of Brooklyn proposed naming after the poet a plaza that connected the city with the bridge's eastern terminus. In point of fact, despite his great enthusiasm for American technological progress and his having visited New York several times during the bridge's construction, Whitman wrote very little about the bridge. Whitman's silence, as Arthur Geffen has argued, rested principally in the fact that "bridges for him were simply not in the same league as ferries."[60] For Whitman's twentieth-century audiences, however, the polarity was dramatically reversed. Although the ferry continued to operate until 1924, it was the bridge, not the ferry, through which Stella and members of his generation figured Whitman's compelling ties to modernity and the contemporary urban environment.

Stella, like Sloan, experienced Brooklyn Bridge through the transforming lens of Whitman's poetry. "Crossing Brooklyn Ferry" at its most basic explores the simple act of crossing the river on a ferry and the accompanying spectacle of the other ferry riders, the setting sun, reflections on the water, the dock, and the city in the distance. The poem is both intensely visual and deeply symbolic. One section in particular describes the sinister presence of the foundries along the Brooklyn shoreline, with the "fires from the foundry chimneys burning high and glaringly into the night, / Casting their flicker of black contrasted with wild red and yellow light over the tops of houses, and down into the clefts of streets" (LG 161–62). Stella described a similar scene from the window of his Brooklyn studio: "Opposite my studio a huge factory— its black walls scarred with red stigmas of mysterious battles—was towering with the gloom of a prison. At night fires gave to innumerable windows menacing blazing looks of demons—while at other times vivid blue-green lights rang sharply in harmony with the radiant yellow-green alertness of cats enjewelling the obscurity around."[61]

Stella especially enjoyed the elevated train, the twentieth-century version of Whitman's omnibus, which traversed the bridge and provided a favorite vantage point from which to sketch the urban panorama unfolding all around.[62] Stella's pedestrian encounters with the bridge, facilitated by the anthropocentric design of the bridge itself, stimulated an even more visceral connection to the poet.[63] "Consider, you who peruse me," Whitman advised, "whether I may not in unknown ways be looking upon you" (LG 164). As one of the "men and women of a generation, or ever so many generations hence" (LG 160) movingly absorbed into Whitman's poetic crossing, Stella engaged the poet in a mood that vacillated between angst and ecstasy. In Democratic Vistas Whitman praised that "rare, cosmical, artist-mind, lit with the Infinite, [which] alone confronts his manifold and oceanic qualities" and called on artists to construct the "single image-making work . . . [which] absorb'd the central spirit and the idiosyncrasies which are theirs."[64] Stella achieved nothing less in his iconic and monumental Brooklyn Bridge. In "The Brooklyn Bridge (A Page of My Life)" he exuberantly described the "cosmical" qualities of his own "artist-mind" as he commenced his project: "It was a time when I was awakening in my work an echo of the oceanic poliphony [sic] (never heard

before) expressed by the steely orchestra of modern constructions: the time when, in rivalry to the new elevation in superior spheres as embodied by the skyscrapers and the new fearless audacity in soaring above the abyss of the bridges, I was planning to use all my fire to forge with a gigantic art illimited and far removed from the insignificant frivolities of easel pictures, proceeding severely upon a mathematic precision of intent, animated only by essential elements."[65] *Brooklyn Bridge* constructs a visual synthesis of Stella's experiential, technological, spiritual, and transnational encounters with the bridge, with Whitman's poetry, and with the American urban and technological landscape.

As one of Whitman's most memorable poems, "Crossing Brooklyn Ferry" transforms the daily and generally mundane experience of crossing the river into a spectacle of searing, transcendent beauty that projects in the most vivid and immediate terms the unity and cohesion of the universe. Fragmented and disjointed, the poem is also intensely lyrical. Like the poem, Stella's painting evokes a timeless present in which light and dark, the material and the immaterial, past and future fuse in a symbol of transcendent power and authority. In both painting and poem the spectator is absorbed directly into the kinesthetic and kaleidoscopic rhythms of the crossing. The shimmering cables of the Brooklyn Bridge swoop down like human arms to gather the viewer into the bridge's mysterious inner depths, much as Whitman reaches out to clasp his reader by the hand. "Many nights I stood on the bridge," Stella recalled, "—and in the middle alone—lost—a defenceless prey to the surrounding swarming darkness—crushed by the mountainous black impenetrability of the skyscrapers—here and there lights resembling the suspended falls of astral bodies or fantastic splendors of remote rites—shaken by the underground tumult of the trains in perpetual motion, like the blood in the arteries—at times, ringing as alarm in a tempest, the shrill sulphurous voice of the trolley wires—now and then strange moanings of appeal from tug boats, guessed more than seen, through the infernal recesses below—I felt deeply moved, as if on the threshold of a new religion or in the presence of a new DIVINITY."[66]

"Crossing Brooklyn Ferry" records a similar commingling of the mundane and the mystical, and it, too, resonates with graphic allusions to the spiritual. The poet who "receiv'd identity by my body" (*LG* 162) peers over the side of the ferry into the "stately and rapid river" (*LG* 162) below, his "eyes dazzled by the shimmering track of beams," and "[l]ook'd at the fine centrifugal spokes of light round the shape of my head in the sunlit water" (*LG* 161). These "fine spokes of light" emanating "from the shape of my head, or anyone's head, in the sunlit water!" (*LG* 165) project the distinct and unmistakable image of a halo.[67]

In "Crossing Brooklyn Ferry," as in his other poems, Whitman beguiles his reader with a stunning combination of intimacy and intensity. He confronts each of the myriad and accumulating elements he encounters in his crossing "face to face" (*LG* 159), whether it be the setting sun, fellow passengers on the ferry, the distant spectacle of "mast-hemm'd Manhattan" (*LG* 163), or travelers to come—"[t]he certainty of others, the life, love, sight, hear-

ing of others" (*LG* 160). Stella, too, confronts the bridge, its towers, cables, walkway, and the city in the distance with unflinching frontality and direct-ness. For neither Whitman nor Stella is the experience static or frozen in time. Fragmented forms, pulsating colors, and dramatic contrasts in light and dark envelop the spectator in a potent evocation of the flux of modern urban expe-rience. In their visionary blurring of the real and the ideal, the material and the spiritual, inside and outside, near and far, Whitman and Stella project a dynamic space-time continuum that allies present, past, and future in a throb-bing and kaleidoscopic intensity. Inscribed in their efforts is the Futurist con-cept of simultaneity: "The simple, compact, well-join'd scheme, myself disin-tegrated, every one disintegrated yet part of the scheme" (*LG* 160).

In "Song of the Exposition" Whitman contrasted the technological advances of the present and the future with the architectural achievements of the past. "We do not blame thee elder World, nor really separate ourselves from thee, / (Would the son separate himself from the father?)" (*LG* 199), he wrote—but neither should the contemporary world simply perpetuate the architecture of the past. Whitman predicted that the new architecture would be

Mightier than Egypt's tombs,
Fairer than Grecia's, Roma's temples,
Prouder than Milan's statued, spired cathedral,
More picturesque than Rhenish castle-keeps,

.

As in a waking vision,
E'en while I chant I see it rise, I scan and prophesy outside and in,
Its manifold ensemble.

(*LG* 199)

Stella concurred, likening the country's "steely architectures," as we have seen, to a "shrine containing all the efforts of the new civilization of AMERICA."

Stella's exuberant rendering of the Gothic Brooklyn Bridge seems a graphic reenactment of a symbolic contest he had himself encountered between Milan's flamboyant Gothic cathedral (fig. 98) and the mod-ernism of Marinetti's Futurist enter-prise, headquartered not far away. Transposed to American soil, Stella's visual restatement echoes both the distinctive, skeletal characteristics of the Milan structure and its iconic presence. Shrouded in the dark of night and illuminated by the lighted cables, those steely transmitters of the spiritual, Stella's bridge rises up

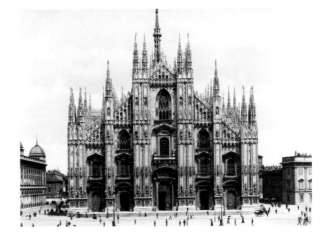

FIGURE 98 The facade of Milan Cathedral, Milan, Italy

dreamlike to assert its dominion over traditional religious monuments. In this marriage of the mystical and the modern, Stella projects an image whose power is fundamentally inscribed in its modernity.

During the protracted upheavals of the First World War, audiences on both sides of the Atlantic embraced Whitman's cosmic internationalism, finding particularly compelling poems like "Passage to India." Excerpts from "Passage to India" accompanied one of Isadora Duncan's New York dance performances, and Apollinaire echoed its transformative powers in "Zone."[68] Like Stella's painting, "Passage to India" is concerned with what Stanley Coffman has termed "the flux of shifting forms."[69] As in Whitman's earlier poems, the feats of modern science—here, the opening of the Suez Canal, the completion of the transcontinental railroad, and the laying of the Atlantic cable—are valued less for their scientific merits than for their aid in international communication and the soul's transcendence. "Lo, soul, seest thou not God's purpose from the first? / The earth to be spann'd, connected by network, / . . . / The lands to be welded together" (LG 412). The hero of the poem is Christopher Columbus, the Genoese explorer and "chief histrion" (LG 417) whose search for the "Passage to India" paralleled Whitman's quest for personal and spiritual transcendence. As part of the poem's Hegelian configuration of progress, Whitman contrasts the achievements of modern science with the "myths and fables of eld, . . . / The far-darting beams of the spirit, the unloos'd dreams, / The deep diving bibles and legends" (LG 412). Here are "[t]owers of fables immortal fashion'd from mortal dreams!" and "fables spurning the known, eluding the hold of the known, mounting to heaven!" (LG 412).

The central image in Stella's *Brooklyn Bridge*—the tiered Gothic tower and its spiritually charged cables radiating messages from above—gives visual form to Whitman's verbal trope. Like Dante's steps to paradise, the ascending form of the bridge's central tower leads out of the Brooklyn "inferno" toward Paradise and "the conjunction of WORLDS."[70] The low-slung arch that crowns the painting's upper register evokes the dome of heaven in traditional religious paintings. In both Whitman and Stella, this heavenly ascent is accompanied by the powerful presence of light, a potent foil for what Whitman described as "the teeming spiritual darkness" (LG 414). The steel cables in *Brooklyn Bridge*, resonant with the glow of spiritual light, echo the "shimmering track of beams" Whitman observed in the water. These streams of heavenly light are simultaneously the electrical "searchlights that plow [New York's] leaden sky in the evening."[71] In their duality, these carriers of the sacred and the profane recall Anne Gilchrist's observation about *Leaves of Grass*—that the words had ceased "to be words, and [had] become electric streams."[72] In both painting and poem a dialectical pairing of opposites—light and dark, ascent and descent, outside and inside—dramatizes the soul's journey into and through the spiritual depths of the "vast terraqueous globe" (LG 416).

Tropes of bridging, both physical and spiritual, figure prominently in *Brooklyn Bridge* and "Passage to India." Whitman's poem maps a network of connectors that mediate the individual's journey through time and space.

There are the "duplicate slender lines [of the transcontinental railroad], / Bridging the three or four thousand miles" (*LG* 413–14) between the Atlantic and the Pacific Oceans; the joining of Europe, Asia, Africa, and New York, "the marriage of continents, climates and oceans!" (*LG* 416); and the journey of the soul through the "shapeless vastness of space" (*LG* 419). At its most literal, Stella's painting represents a bridge that spans the physical distance between Brooklyn and Manhattan. A more expansive global bridging is suggested by the pattern of thin black lines that divide the painting into horizontal and vertical zones reminiscent of the latitudinal and longitudinal markings on a map. Metaphorically, the structure's silvery cables bridge the illimitable divide between the physical and spiritual worlds, while its roadways and tunnels construct trajectories to the future.[73] In an essay left unpublished at the time of his death, Stella paid tribute to the bridge's capacity to forge a network of significant and interlocking unions across time and space. He described the bridge as ushering in a "new architecture . . . a new perspective."[74]

Inscribed in this "new perspective" were aspects of Stella's own transnational identity. In his life as in his art he, too, was a bridge—between continents and cultures, between Europe and America, and between Whitman and an international community of modernists. By 1920 Stella had lived in New York, the most modern city in the world and the focus of Whitman's poetic observations, for nearly a quarter of a century, a situation that afforded him intense feelings of privilege and entitlement. "I had witnessed the growth and expansion of New York proceeding parallel to the development of my own life," Stella explained, "and therefore I was feeling entitled to interpret the titanic efforts, the conquests already obtained by the imperial city . . . the center of the world."[75] As an immigrant and a modernist Stella forged important social and artistic connections between Europe and America. He brought knowledge of the European enthusiasm for Whitman to America, and in turn transported vital, firsthand knowledge of Whitman's America to Europe. Stella's immigrant status provided him with a critical perspective outside the purview of his colleagues on either continent. In answer to Whitman's call, this "illustrious emigré" had learned "the lessons of our New World" (*LG* 196), combining them in his art with the cultural heritage of his native Italy. "Both in and out of the game and watching and wondering at it" (*LG* 32), Stella embodied the duality of Whitman's protean poet/speaker.

Stella lived for years in New York's Little Italy, spoke English with a proud Italian accent, enjoyed his first solo exhibition at the Italian National Club, and gave frequent interviews for the Italian American press. An essential component of his Italian identity comprised the religious doctrines of Catholicism. Since relocating to America, Stella had lost touch with the daily exercise of his religion (de Fornaro characterized him as a "pagan Catholic"[76]), although not with the potency of its visual symbols. Religious allusions abound in such paintings from this period as *A Child's Prayer* (1918), *Tree of My Life* (1919–20), and *Nativity* (1919–20; fig. 99), where a Gothic trefoil provides a sheltering frame for an elongated fragment of arches silhouetted against a resonant blue background, the traditional color of heaven and the

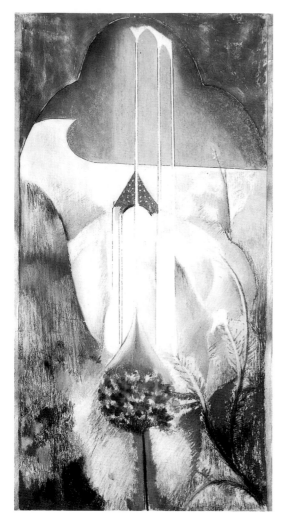

FIGURE 99 Joseph Stella, *Nativity*, 1919–20

Blessed Virgin. The cultural criticism of Van Wyck Brooks and Randolph Bourne gave added impetus to Stella's reflections on his Catholic heritage. In their search for cultural renewal, both Brooks and Bourne praised the communitarian ethos of Catholicism. Brooks, in particular, as Casey Nelson Blake has demonstrated, "looked back fondly to medieval Catholicism," whose "fusion of mysticism and science" seemed a compelling alternative to Protestant worldliness.[77] In his seminal article, "Trans-National America," Bourne urged the country's Anglo-Saxon majority to applaud the diverse cultural heritage of the new Eastern European immigrants, whose non-Anglo-Saxon traditions (including Catholicism) were contributing to the cultural pluralism and cosmopolitan ideal promulgated by Whitman. "We have needed the new peoples," he insisted, "to save us from our own stagnation."[78]

Whitman, who shunned aligning his verse with any of the world's organized religions, nevertheless characterized *Leaves of Grass* as "the most religious book among books: crammed full of faith."[79] Through the distinctive religious symbolism of Catholicism, Stella evokes the "spiritual welding" central to Whitman's and Bourne's conception of a new, revitalized America.[80] The symbolic merger of the bridge's physically separate and distinct towers and their crowning with an imaginary third tower create the illusion of a church steeple, its soaring, Gothic forms pointing heavenward, its tripartite form inscribing the Trinity. These same Gothic arches evoke the pointed windows in a Gothic church, their iconic presence reinforced by their frontality, their surface suggestive of the rich patterning of a stained-glass window. The crisscrossing web of delicate black lines that isolate and contain the painting's many colored units evoke the window's leaded superstructure, while the intense, flickering light that darts across the surface of the painting recalls the shifting patterns of natural and spiritual light animating the window's colored panes. Inscribed within the scattered fragments of tunnels, towers, cables, and lights are suggestions of both "the vivid pageant of joyful visions" Stella admired in Whitman's verse and the multiplicity of interrelated scenes constituting a medieval window's narrative program. Stella surely would have concurred

with architect Will Price, Traubel's partner in the short-lived Rose Valley arts and crafts experiment, who noted a striking correspondence between Whitman's verse and the "crudeness and barbaric splendor of the Gothic."[81]

Stella shared with his fellow modernists an enthusiasm for the restless energy and dynamic sense of movement that transformed the city into a vibrant, living organism. He once likened the city's skyline to a "[g]igantic jaw of irregular teeth"[82] and entitled his epic five-panel portrait of the city *The Voice of the City of New York Interpreted* (fig. 100). Spanning a range of the city's distinctive urban features, the painting included representations of the city's port, the light-filled Great White Way, the steely skyscrapers, and the Brooklyn Bridge, the whole projecting a rhapsodic vision of the city, as Stella wrote, that was "highly spiritual and crudely materialistic alike."[83] The enlarged central panel, he explained, was "to show the beating heart, the life-giving dynamo, from which the movement in the four other panels, like the blood in the veins to the heart, permanently flows back."[84] He had constructed his first *Brooklyn Bridge* in similar terms, likening the movement of the trains through the bridge's midsection to the life-giving "blood in the arteries," while overhead was heard "the shrill sulphurous voice of the trolley wires" and underneath the "strange moanings of . . . [the] tug boats, guessed more than seen" in the dark water below.[85] Not to be overlooked was the skeletal structure of the bridge's towers and cables, which constituted a creative reworking of the humanized central tower in *Battle of Lights, Coney Island, Mardi Gras* that cast its steadying gaze over the frenzied festivities all around.

Stella once described "the metallic skeleton of the gigantic metropolis" as flashing "with sparkling light."[86] In *Brooklyn Bridge* the blood that courses through the structure's arteries emanates from a faceted, diamond-shaped "heart" positioned in the center along the painting's lower border. Like a beating human heart, the organ's distinctive red coloring permeates the bridge's adjoining tunnels much the way blood infuses a body's arterial network. This effect is even more dramatically represented in *Old Brooklyn Bridge* from

FIGURE 100 Joseph Stella, *The Voice of the City of New York Interpreted*, 1920–22

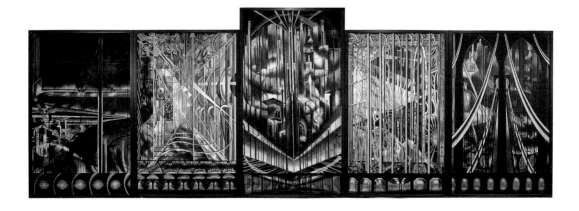

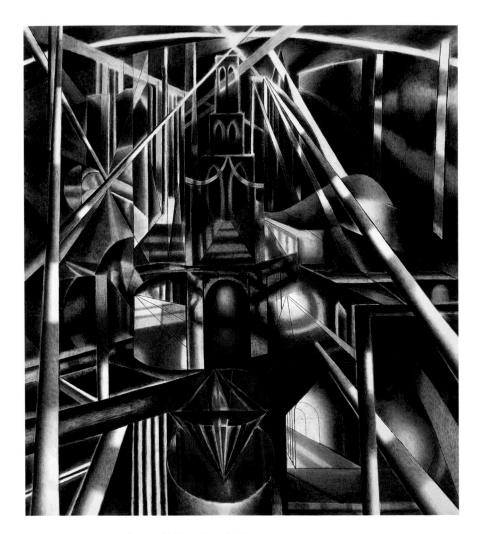

FIGURE 101 Joseph Stella, *Old Brooklyn Bridge*, c. 1940.
Photograph © 2005 Museum of Fine Arts, Boston 1980.197

about 1940 (fig. 101). On a spiritual plane, the heart echoes the popular
Catholic devotional image of the Sacred Heart of Jesus (fig. 102). Bust and half-
length renderings of the Sacred Heart of Jesus, with Christ pointing to his
exposed red heart, were immensely popular in Europe and America in the late
nineteenth century.[87] The image on popular devotional cards reveals Christ's
heart in the same relative size and location as Stella's faceted diamond. Rays
of light radiate outward from the heart's exposed center, symbolizing the
radiant spirituality of Christ's divinity emanating outward from his human
form. In Stella's painting these lines echo Futurist force lines and the radi-
ating trajectories of the bridge's cables, thick with their "divine messages from
above."

Stella's evocation of the Sacred Heart of Jesus embedded in the skeletal
framework of the soaring Brooklyn Bridge recalls Whitman's frequent confla-

tion of the sacred and the profane. Toward the conclusion of "Crossing Brooklyn Ferry," Whitman reminded his reader that

Appearances, now or henceforth, indicate what you are,
You necessary film, continue to envelop the soul,
About my body for me, and your body for you, be hung our divinest aromas,
Thrive, cities—bring your freight, bring your shows, ample and sufficient rivers,
Expand, being than which none else is perhaps more spiritual,
Keep your places, objects than which none else is more lasting.

(LG 165)

Stella seemed almost to paraphrase Whitman as he explained, "Painting is high poetry: things must be transfigured by the magic hand of the *artist*. The greatest effort of an artist is to catch and render permanent (materialize) that blissful moment (inspiration) of his when he sees things out of normal proportion, elevated and spiritualized, appearing new, *as seen for the first time*." "This spiritual *aroma*," Stella continued, "must be enclosed in a most appropriate vase. . . . the language of the painter must be precise and elusive in the same time."[88]

In 1919, the year Stella commenced *Brooklyn Bridge*, the country was celebrating the centenary of Whitman's birth. More than twenty-five books and nearly four hundred articles, over a fivefold increase from the previous year, probed everything from the poet's war experiences to his growing international reception.[89] This sustained outpouring of support for Whitman permeated both elite and popular culture, foregrounding the protean character of Whitman's appeal and infusing the production of both *Brooklyn Bridge* and *The Voice of the City of New York Interpreted*. During this period Stella completed a silverpoint drawing of a balding, bearded man, eyes downcast and head tilted slightly to the side (fig. 103). The representation reveals a highly romanticized construction of an elderly man so absorbed by the intensity of his own thoughts as to be oblivious to the intrusive and inquiring gaze of the spectator. Years after its completion, the drawing was exhibited as a portrait of Whitman.[90] Despite Stella's intense regard for Whitman, the attribution seems highly unlikely. Not only does the portrait bear no resemblance to any known painted, sculpted, engraved, or photographic representation of the poet (the almost universal starting place for posthumous portraits), but Stella is also not known to have produced portraits of non-living people. Even more important was the almost universal sense among artists of Stella's generation that their commitment to the thematic, stylistic, and emotional resonance of Whitman's verse could not be conveyed visually through representations of his person. Even Marsden Hartley never attempted a portrait of Whitman, despite his close associations with a variety of people who

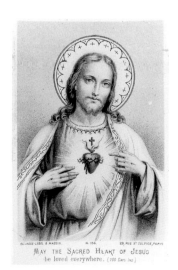

MAY THE SACRED HEART OF JESUS
be loved everywhere. (100 Days Ind.)

FIGURE 102 The Sacred Heart of Jesus

FIGURE 103 Joseph Stella,
Portrait of Walt Whitman [?], 1920

had known Whitman personally. It is far more likely that Stella considered his iconic representation of *Brooklyn Bridge,* with its bodily connotations and its many embedded allusions to Whitman's dynamic vision of a spiritually transformed world order, his true "portrait" of the poet. For Stella and the modernists who shared his deep commitment to the expansive potential of Whitman's verse, the poet's "face" registered far more forcefully in the world around them, in the world Stella readily admitted that Whitman had "magically unsealed for us," than in any portrait of his person.

Stella's status as a transnational purveyor of the American scene, his extensive knowledge of Whitman's reception internationally, and his commitment to filtering his response to Whitman's America through the enlarging lens of the poetry resonate with notable power and authority across the vibrating surface of his work. Where M. Wynn Thomas has proposed "the time-arresting canvases" of the luminists as the "closest painterly analogue" to Whitman's "Crossing Brooklyn Ferry,"[91] Stella's *Brooklyn Bridge* poses a challenging alternative. The painting's richly nuanced and fragmented surface, the pervasiveness of its religious allusions, its conflicted response to modern industry, and its projection of a spiritually resonant and globally integrated world order give visual form to many of the poem's structural and thematic

commitments. In its distinctive melding of notions of flux and stasis, the material and the spiritual, near and far, nationalism and internationalism, *Brooklyn Bridge* inscribes in its very form Stella's exploration of the conjunction between Whitman, modernity, and his Italian soul.

Whitman's encounters with the paintings of Jean-François Millet had awakened in him a sense of the exciting potential for exploring the spiritual dimensions of his verse without recourse to his person. By the early twentieth century, artists like Stella, Hartley, and Coady had transformed that potential in ways and to a degree that Whitman could scarcely have foreseen. Stella's *Brooklyn Bridge,* like Hartley's landscapes and Coady's journal *The Soil,* invokes Whitman's presence through a complex matrix of signifiers that reflect modernist practice. Stella's Futurist encounters with the American city, Hartley's sexual-spiritual immersion in the American land, and Coady's boisterous excursions into American popular culture map a broad cross section of the modernist initiatives transfusing American visual culture in the decades following Whitman's death. In "A Backward Glance O'er Travel'd Roads," as Whitman sat "gossiping in the early candle-light of old age," he acknowledged that though he had "not gain'd acceptance of my own time," he had "fallen back on fond dreams of the future" (*LG* 561–62). Earlier, toward the conclusion of "Crossing Brooklyn Ferry," he had turned in anticipation toward his reader seeking confirmation and assurance.

> We understand then do we not?
> What I promis'd without mentioning it, have you not accepted?
> What the study could not teach—what the preaching could not
> accomplish is accomplish'd, is it not?
>
> (*LG* 164)

For Stella and his fellow modernists, the torch was passed, the challenge accepted. As Stella exclaimed, "Whitman rouses and guards a new sacred fire of inspiration . . . he opens infinite fields to future harvests." In harvesting these fields, Stella and his colleagues extended Whitman's reach into the twentieth century. Their efforts solidly reinforced both the cross-disciplinary appeal of his verse and the creative reciprocity Whitman himself had experienced between verbal and visual modes of representation. Most important, Whitman's poetic excursions into matters of identity construction provided a useful model for artists struggling with similar questions in their own lives and times. The varied achievements of Stella, Coady, and Hartley forcefully confirm George Santayana's prescient observation that Whitman's "work, for the very reason that it is so rudimentary, contains a beginning or rather many beginnings."

Notes

The following abbreviations have been used for frequently cited works.

Correspondence	*Walt Whitman: The Correspondence*, ed. Edwin Haviland Miller, 6 vols. (New York: New York University Press, 1961–77)
LG	Walt Whitman, *Leaves of Grass*, ed. Sculley Bradley and Harold W. Blodgett, Norton Critical Edition (New York: Norton, 1973)
Prose Works 1892	Walt Whitman, *Prose Works 1892*, ed. Floyd Stovall, 2 vols. (New York: New York University Press, 1963–64)
With Walt Whitman in Camden	Horace Traubel, *With Walt Whitman in Camden*, vols. 1–3, ed. Horace Traubel (1906–14; rpt., New York: Rowman and Littlefield, 1961); vol. 4, ed. Sculley Bradley (Philadelphia: University of Pennsylvania Press, 1953); vol. 5, ed. Gertrude Traubel (Carbondale: University of Southern Illinois Press, 1964); vol. 6, ed. Gertrude Traubel and William White (Carbondale: University of Southern Illinois Press, 1982); vol. 7, ed. Jeanne Chapman and Robert MacIsaac (Carbondale: University of Southern Illinois Press, 1992); vols. 8–9, ed. Jeanne Chapman and Robert MacIsaac (Oregon House, California: W. L. Bentley, 1996)

Introduction

1 Ralph Waldo Emerson, "A Letter," in *Walt Whitman: The Measure of His Song*, ed. Jim Perlman, Ed Folsom, and Dan Campion (Minneapolis: Holy Cow! Press, 1981), 1.

2 Anne Gilchrist, "A Woman's Estimate of Walt Whitman," in *The Letters of Anne Gilchrist and Walt Whitman*, ed. Thomas B. Harned (New York: Haskell House, 1973), 22.

3 Richard Maurice Bucke, *Cosmic Consciousness* (1901; rpt., New York: E. P. Dutton, 1969), 225.

4 Alan Trachtenberg, "Walt Whitman: Precipitant of the Modern," in *The Cambridge Companion to Walt Whitman*, ed. Ezra Greenspan (Cambridge: Cambridge University Press, 1995), 197.

5 Adolf Wolff, "Walt Whitman," *Glebe* 1, no. 1 (1913): 66 (rpt., New York: Kraus Reprint, 1967).

6 See, for example, Christopher Sten, ed., *The Savage Eye: Melville and the Visual Arts* (Kent, Ohio: Kent State University Press, 1991); Robert K. Wallace, *Frank Stella's Moby-Dick Series: Of Whales and Waves in Paint, on Metal, in Space* (Ann Arbor: University of Michigan Press, 2000); Glen MacLeod, *Wallace Stevens and Modern Art from the Armory Show to Abstract Expressionism* (New Haven: Yale University Press, 1993); Linda Leavell, *Marianne Moore and the Visual Arts* (Baton Rouge: Louisiana State University Press, 1995); Peter Halter, *The Revolution in the Visual Arts and the Poetry of William Carlos Williams* (Cambridge: Cambridge University Press, 1994); William Marling, *William Carlos Williams and the Painters, 1909–1923* (Athens: Ohio State University Press, 1982); and Wendy Steiner, *Exact Resemblance to Exact Resemblance: The Literary Portraiture of Gertrude Stein* (New Haven: Yale University Press, 1978).

7 F. O. Matthiessen, *American Renaissance* (London: Oxford University Press, 1941), 605.

8 Ed Folsom has written extensively on Whitman and photography. Among his recent publications are "Whitman's Calamus Photographs," in *Breaking Bounds*, ed. Betsy Erkkila and Jay Grossman (New York: Oxford University Press, 1996), 193–219; "Appearing in Print: Illustrations of the Self in *Leaves of Grass*," in *The Cambridge Companion to Walt Whitman*, ed. Greenspan, 135–65; *Walt Whitman's Native Representations* (Cambridge: Cambridge University Press, 1994), 99–177; "Whitman and the Visual Democracy of Photography," *Mickle Street Review* 10 (1988): 51–65; and "'This Heart's Geography's Map': The Photographs of Walt Whitman," *Walt Whitman Quarterly Review* 4, no. 2–3 (1986–87): 1–72.

9 Roberta K. Tarbell, "Whitman and the Visual Arts," in *A Historical Guide to Walt Whitman*, ed. David S. Reynolds (New York: Oxford University Press, 2000), 153–204, provides an overview of the scholarship on Whitman and the pictorial arts. On Whitman and architecture, see Kevin Murphy, "Walt Whitman and Louis Sullivan: The Aesthetics of Egalitarianism," and John Roche, "Democratic Space: The Ecstatic Geography of Walt Whitman and Frank Lloyd Wright," *Walt Whitman Quarterly Review* 6, no. 1 (1988): 1–15 and 16–32; see also Lauren S. Weingarden's "Louis Sullivan's Emersonian Reading of Walt Whitman," in *Walt Whitman and the Visual Arts*, ed. Roberta K. Tarbell and Geoffrey M. Sill (New Brunswick, N.J.: Rutgers University Press, 1992), 99–120; *Louis H. Sullivan: The Banks* (Cambridge, Mass.: MIT Press, 1987); "A Transcendentalist Discourse in the Poetics of Technology: Louis Sullivan's Transportation Building and Walt Whitman's 'Passage to India,'" *Word and Image* 3 (April–June 1987): 202–21; and "Naturalized Technology: Louis H. Sullivan's Whitmanesque Skyscrapers," *The Centennial Review* 30 (Fall 1986): 480–95.

10 See especially Wendy Steiner, *The Colors of Rhetoric: Problems in the Relation Between Modern Literature and Painting* (Chicago: University of Chicago Press, 1982) and *Pictures of Romance: Form Against Context in Painting and Literature* (Chicago: University of Chicago Press, 1988) as well as W. J. T. Mitchell, *Picture Theory: Essays on Verbal and Visual Representation* (Chicago: University of Chicago Press, 1994) and *Iconology: Image, Text, Ideology* (Chicago: University of Chicago Press, 1986).

11 Mitchell, *Picture Theory*, especially 89–107.

12 See, for example, Miles Orvell, *The Real Thing: Imitation and Authenticity in American Culture, 1880–1940* (Chapel Hill: University of North Carolina Press, 1989), 6.

13 Hans Robert Jauss, *Toward an Aesthetic of Reception*, vol. 2, *Theory and History of Literature*, trans. Timothy Bahti (Minneapolis: University of Minnesota Press, 1982).

14 Jonathan Weinberg, *Speaking for Vice: Homosexuality in the Art of Charles Demuth, Marsden Hartley, and the First American Avant-Garde* (New Haven: Yale University Press, 1993). See also Patricia McDonnell, "El Dorado [Marsden Hartley in Imperial Berlin]," in *Dictated by Life: Marsden Hartley's German Paintings and Robert Indiana's Hartley Elegies* (Minneapolis: Frederick R. Weisman Art Museum, distributed by Distributed Art Publishers, New York, 1995), 15–42.

15 George Santayana, "The Genteel Tradition in American Philosophy," in *Winds of Doctrine* (New York: Scribner's, 1913), 203.

Chapter 1

1 Ralph Waldo Emerson in *Walt Whitman: The Measure of His Song*, ed. Perlman, Folsom, and Campion, 1.

2 *With Walt Whitman in Camden*, 2:502.

3 On the expansion of the arts in antebellum New York, see Neil Harris, *The Artist in American Society* (1966; rpt., Chicago: University of Chicago Press, 1982); Lillian B. Miller, *Patrons and Patriotism: The Encouragement of the Fine Arts in the United States, 1790–1860* (Chicago: University of Chicago Press, 1966); Russell Lynes, *The Art-Makers* (New York: Dover, 1970), and Records of the Brooklyn Institute, 1823–73, Brooklyn Museum Records, roll Br-2, Archives of American Art, Smithsonian Institution, Washington, D.C. For Whitman's comments on the exhibition of Powers's *Greek Slave*, see Thomas L. Brasher, ed., *Whitman as Editor of the Brooklyn Daily Eagle* (Detroit: Wayne State University Press, 1970), 215–16.

4 Charles Edwards Lester, *The Artist, the Merchant, and the Statesman* (New York: Paine and Burgess, 1845), 1:viii.

5 Lester was also the author of the biographical essays in Mathew Brady's *Gallery of Illustrious Americans* (1850), a volume that celebrated twelve "representative" Americans through word and image. For an insightful discussion of the relationship between Lester's text and the twelve engraved male images, see Alan Trachtenberg, *Reading American Photographs* (New York: Hill and Wang, 1989), 45–52. On Lester's achievements generally, see *Dictionary of American Biography* (New York: Charles Scribner's Sons, 1961), 6.189–90.

6 On Harrison, see Grant B. Romer, "Gabriel Harrison; The Poet Daguerrean," *Image* 22 (September 1979): 8–18; S. J. Burr, "Gabriel Harrison and the Daguerrean Art," *The Photographic Art-Journal* 1 (March 1851): 169–77; and Virginia Chandler, "Gabriel Harrison," in *The Civil, Political, Professional and Ecclesiastical History and Commercial and Industrial Record of the County of Kings and the City of Brooklyn, N.Y. from 1683 to 1884*, ed. Henry R. Stiles (New York: W. W. Munsell, 1884), 1151–58. Whitman may well have seen Harrison perform at the Park Theatre Company. For Whitman's enthusiasm for the Park Theatre, see *Prose Works 1892*, 1:19–21. In the 1850s Harrison organized and acted in the Brooklyn Dramatic Academy, which held performances at the Brooklyn Museum. He later taught painting at the Brooklyn Art Association and managed the new Park Theatre, which introduced English opera to Brooklyn in the 1860s.

7 *With Walt Whitman in Camden*, 2:506.

8 [Walt] W[hitman], "A Brooklyn Daguerreotypist and His Pictures at the Crystal Palace," *Brooklyn Daily Eagle*, 27 August 1853. Between 1850 and 1853 Whitman extolled Harrison's daguerreotypes in five reviews, including one devoted exclusively to his strong showing at the Crystal Palace exhibition. See Rollo G. Silver, "Whitman in 1850: Three Uncollected Articles," *American Literature* 19 (January 1948): 310; "April Afternoon Ramble,"

Brooklyn Evening Star, 30 April 1850; "An Afternoon Lounge About Brooklyn," *Brooklyn Evening Star*, 24 May 1852; and "An Hour Among the Portraits," *Brooklyn Evening Star*, 7 June 1853.

9 W[hitman], "A Brooklyn Daguerreotypist."

10 Ezra Greenspan, *Walt Whitman and the American Reader* (Cambridge: Cambridge University Press, 1990), 61.

11 Quoted in *The Bryant Festival at "The Century," November 5, M.DCCC.LXIV* (New York: D. Appleton, 1865), 41. Bryant responded: "Among the artists of our country are some of my oldest and best friends. In their conversation I have taken great delight, and derived from it much instruction," 42. The literature on Bryant and the visual arts is extensive. See especially David Shapiro, "William Cullen Bryant and the American Art Union," in *William Cullen Bryant and His America* (New York: AMS Press, 1983), 85–95; Holly Joan Pinto, *William Cullen Bryant and the Hudson River School of Landscape Painting* (Roslyn, N.Y.: Nassau County Museum of Fine Art, 1981), and *William Cullen Bryant, The Weirs and American Impressionism* (Roslyn, N.Y.: Nassau County Museum of Fine Art, 1983), William Cullen Bryant II, "Poetry and Painting: A Love Affair of Long Ago," *American Quarterly* 22 (Winter 1970): 859–82; James T. Callow, *Kindred Spirits: Knickerbocker Writers and American Artists, 1807–1855* (Chapel Hill: University of North Carolina Press, 1967); Donald A. Ringe, "Bryant's Criticism of the Fine Arts," *College Art Journal* 17 (Fall 1957): 43–54, and "Kindred Spirits: Bryant and Cole," *American Quarterly* 6 (Fall 1954): 233–44. On Bryant and Whitman, see Ruth L. Bohan, "Whitman and the Sister Arts," *Walt Whitman Quarterly Review* 16, no. 3–4 (1999): 153–60; Donald A. Ringe, "Bryant and Whitman: A Study in Artistic Affinities," *Boston University Studies in English* 2 (Summer 1956): 85–94; Joan D. Berbrich, *Three Voices from Paumanok* (Port Washington, N.Y.: Ira J. Friedman, 1969), 104–7; and Charles I. Glicksberg, "Whitman and Bryant," *Fantasy* 5 (1935): 31–36.

12 *Prose Works 1892*, 1:166.

13 They also toured the studios of Thomas Prichard Rossiter and Louis Lang (Rome), George Loring (Florence), and William Morris Hunt and Emanuel Leutze (Düsseldorf). See William Cullen Bryant II and Thomas G. Voss, eds., *The Letters of William Cullen Bryant* (New York: Fordham University Press, 1977), 2:409–13.

14 [Walt Whitman], "Hicks, the American Painter," *New Orleans Daily Crescent*, 3 April 1848.

15 *With Walt Whitman in Camden*, 3:500, 2:493, 7:23.

16 Katherine Molinoff, *Some Notes on Whitman's Family* (New York: Comet Press, 1941), 7 and 24–43. On Heyde's art, see *Charles Louis Heyde* (Burlington, Vt.: Robert Hull Fleming Museum, n.d.).

17 Mrs. Talbot Buckny to Walt Whitman, 25 November 1891, Whitman-Feinberg Collection, reel 2, Library of Congress, Washington, D.C. Mrs. Buckny was mistaken in her recollections that the meetings took place in 1832.

18 [Walt Whitman], "American Art—Jesse Talbot," *New York Sunday Dispatch,* 19 May 1850. Whitman also discussed Talbot's art in "April Afternoon Ramble" and "Talbot's Pictures," *American Phrenological Journal* 17 (February 1853): 45.

19 For Mount's appropriations from phrenology, see William T. Oedel and Todd S. Gernes, "*The Painter's Triumph:* William Sidney Mount and the Formation of a Middle-Class Art," *Winterthur Portfolio* 23 (Summer–Autumn 1988): 111–28.

20 *With Walt Whitman in Camden,* 8:407.

21 "Art and Artists," *New York Home Journal,* 5 July 1851.

22 Emory Holloway, ed., *The Uncollected Poetry and Prose of Walt Whitman* (1921; rpt., Gloucester, Mass.: Peter Smith, 1972), 1:237–38. In the same article Whitman criticized Mount's painting of an African American winner of a goose at a raffle for relying on minstrelsy to broadcast its Americanness. "I never could, and never will, admire the exemplifying of our national attributes with Ethiopian minstrelsy, or Yankee Hill characters upon the stage, as the best and highest we can do," Whitman asserted.

23 [Walt Whitman], "Literary Notices," *Brooklyn Daily Eagle,* 10 August 1846.

24 Catherine E. Beecher and Harriet Beecher Stowe, *The American Woman's Home* (1869; rpt., Hartford, Conn.: Stowe-Day Foundation, 1975), 94.

25 Cleveland Rodgers and John Black, eds., *The Gathering of the Forces* (New York: Putnam, 1920), 2:363.

26 O. P. Q. [Walt Whitman], "About the Fashionable World—Fine Pictures," *Brooklyn Evening Star,* 18 November 1845.

27 Rodgers and Black, eds., *Gathering of the Forces,* 2:362–63. Whitman later met Catlin, probably while a clerk in the Bureau of Indian Affairs in Washington during the Civil War, and Catlin gave him a lithograph of his portrait of the Seminole chief Osceola. In the 1880s Whitman displayed the print in his Mickle Street residence, and in 1890 he celebrated the print in the poem "Osceola." See Edgeley W. Todd, "Indian Pictures and Two Whitman Poems," *The Huntington Library Quarterly* 1 (November 1955): 5–11.

28 [Walt Whitman], "About Monuments," *Brooklyn Daily Eagle,* 28 July 1846.

29 For Whitman's comments about the need for a permanent art gallery in Brooklyn, see Rodgers and Black, eds., *Gathering of the Forces,* 2:365. Earlier, in "Fine Arts at the West," *New Orleans Daily Crescent,* 28 April 1848, Whitman had praised the opening of Cincinnati's Western Art Union.

30 The *Evening Post* had previously published two of Whitman's poems and a short story. Over the next several months, it would publish three of Whitman's travelogues about Brooklyn and a letter to the editor. See Holloway, ed., *Uncollected Poetry and Prose,* 1:239–41, 247–59.

31 Ibid., 1:236–37. Whitman also commented on the Brooklyn Art Union in "Works of Beauty and Talent—The New Art Union of Brooklyn," *Brooklyn Daily Advertiser,* 4 April 1850, and "Brooklyn Art Union—Walter Libbey—A Hint or Two on the Philosophy of Painting," *Brooklyn Daily Advertiser,* 21 December 1850.

32 Holloway, ed., *Uncollected Poetry and Prose,* 1:241–47. In "Street Yarn," one of his essays in *Life Illustrated,* Whitman humorously seized on the contrast between his and Bryant's age and physical appearance to reinforce the perception of himself as Bryant's heir. He described Bryant as a "white-bearded, scrawny, striding old gentleman," while representing himself as a "[t]all, large, rough-looking man, in a journeyman carpenter's uniform . . . [with a] strong, bristly, grizzled beard; [and] . . . careless, lounging gait." Emory Holloway and Ralph Adimari, eds., *New York Dissected* (New York: R. R. Wilson, 1936), 132, 130.

33 The other four nominees were Daniel P. Barnard, Dr. Dudley, J. A. Webb, and Walter Beman; see Minutes of the Brooklyn Art Union, Brooklyn Art Union Papers, 1978.141, Brooklyn Historical Society. Each of the country's art unions fell victim to allegations that their distribution of prizes constituted an illegal form of gambling. In a futile attempt to save the Brooklyn Art Union, Harrison proposed that it be restructured along the lines of a Joint Stock Association. The idea, however, got no further than the planning stages. Gabriel Harrison, "Brooklyn Art-Union," *The Photographic Art Journal* 2 (November 1851): 296–97.

34 Bryant II and Voss, eds., *Letters of William Cullen Bryant,* 2:411. See also Wayne Craven, "Henry Kirke Brown in Italy, 1842–1846," *American Art Journal* 2 (Spring 1969): 65–77, and "Henry Kirke Brown: His Search for an American Art in the 1840s," *American Art Journal* 4 (November 1972): 44–58.

35 Holloway, ed., *Uncollected Poetry and Prose,* 1:142–43.

36 Lewis I. Sharp, *John Quincy Adams Ward: Dean of American Sculpture* (Newark: University of Delaware Press; London: Associated University Presses, 1985), 30–31.

37 In its review of *Leaves of Grass, The Crayon* compared Whitman's poems with Alfred Tennyson's *Maud,* finding the latter "as refined in its Art as the most refined," while judging the former "*nonchalant* in everything but its essential ideas." See "Studies Among the Leaves," *The Crayon* 3 (January 1856): 30.

38 *With Walt Whitman in Camden*, 2:502. Samuel Longfellow, the younger brother of poet Henry Wadsworth Longfellow, became pastor of Brooklyn's Second Unitarian Church in October 1853.

39 N. Cleaveland, "Henry Kirke Brown," *Sartain's Magazine* 8 (January 1851): 137. While in Rome, Brown's wife, Lydia, wrote her sister of the difficulty Brown confronted when attempting to maintain his American vision while surrounded by the lure of the classics. She reported that Brown had "metamorphosed his 'Indian Boy' into an Apollino as he has more of the materials around him for the study of the Greek Classic Art, than any other." Brown himself speculated that he could "do the 'Indian Boy' more justice at home." Cited in Craven, "Henry Kirke Brown in Italy," 71.

40 Quoted in Craven, "Henry Kirke Brown: His Search for an American Art," 48.

41 *With Walt Whitman in Camden*, 2:502.

42 Whitman would also have been familiar with the monument commissioned by Ezra P. Prentice for Albany's Rural Cemetery. Entitled *Hope* and exhibited at the National Academy of Design in 1850, the work was described in a contemporary journal as depicting a female figure "leaning upon her anchor and regarding a butterfly which has alighted upon her finger." See "Brown's Studio," *Bulletin of the American Art-Union* 2 (April 1849): 18. It is tempting to think that Whitman, who visited cemeteries often, had this sculpture in mind when he sat for the famous "Butterfly" photograph more than twenty years later. See Chapter 3.

43 Quoted in Craven, "Henry Kirke Brown: His Search for an American Art," 58.

44 *With Walt Whitman in Camden*, 2:503.

45 Ibid., 2:502. Both Betsy Erkkila, *Walt Whitman Among the French* (Princeton: Princeton University Press, 1980), 33, and Gay Wilson Allen, *The Solitary Singer* (Chicago: University of Chicago Press, 1985), 109, identify the person comparing Whitman to Béranger as John Quincy Adams Ward. It is far more likely that it was one of the two French assistants, a founder and a finisher, Brown had hired to help in the casting process. See Craven, "Henry Kirke Brown: His Search for an American Art," 56–57.

46 See, for example, Nell, "An Artist's Studio," *The Knickerbocker* 37 (January 1851): 41–42; Lily Graham, "A Heart-Picture," *The Knickerbocker* 38 (July 1851): 59; and [Mrs.] L. H. S[igorney], "Powers' Statue of the Greek Slave," *The Knickerbocker* 38 (October 1851): 436.

47 Harrison's sympathy for the sister arts is particularly evident in his writings. In the inaugural issue of *The Photographic Art Journal*, he urged photographers to consider their art "the hand-maid to those higher branches of the fine arts." "Who will dare say," he advised, "we cannot compose and put poetry in our types as well as a painter in his

sketchbook." Quoted in Romer, "Gabriel Harrison: The Poet Daguerrean," 14.

48 William Cullen Bryant, "A Funeral Oration, Occasioned by the Death of Thomas Cole," *The Knickerbocker* 32 (July 1848): 71.

49 Bryant II, "Poetry and Painting," 872.

50 Angela Miller, *The Empire of the Eye: Landscape Representation and American Cultural Politics, 1825–1875* (Ithaca: Cornell University Press, 1993), 93.

51 Bryant II, "Poetry and Painting," 872; Whitman, "National Academy of Design," *New York Sunday Dispatch*, 2 June 1850.

52 Walter Libbey produced the first known painted portrait of Whitman sometime before his death in 1852; see *With Walt Whitman in Camden*, 2:506. The painting's whereabouts is today unknown. Talbot's *Christian and the Cross, Pilgrim's Progress* was based on John Bunyan's 1678 verbal allegory.

53 Holloway, ed., *Uncollected Poetry and Prose*, 1:186.

54 J. D. Whelpley, "Lessing's Laocoön: The Secret of Classic Composition in Poetry, Painting, and Statuary," *The American Whig Review* 37 (January 1851): 17–26. Whitman's heavily annotated copy of the article's final six pages is in the Trent Collection at Duke University. I wish to thank J. Samuel Hammond for making this available to me. In keeping with the art-literature analogies of the day, G. W. P.—perhaps George Washington Peck—likened Lessing's book to a stroll "through a vast picture gallery, where, at every step, we are arrested by something that awakens our admiration, more for its own sake than for its connection with what is beside it." See G. W. P., "Lessing's Laocoön," *Bulletin of the American Art-Union* 5 (1 August 1850): 73.

55 Whitman was also familiar with Lessing's drama, *Nathan the Wise*, which he praised for its "Kosmos religious notions." See Richard Maurice Bucke, ed., *Notes and Fragments* (1899; rpt., Folcroft, Pa.: Folcroft Library Editions, 1972), 117.

56 Whelpley, "Lessing's Laocoön," 22.

57 Bucke, ed., *Notes and Fragments*, 58.

58 Walt Whitman, "An English and an American Poet," in *In Re Walt Whitman*, ed. Horace Traubel, Richard Maurice Bucke, and Thomas B. Harned (Philadelphia: David McKay, 1893), 31.

59 Walt Whitman, *Leaves of Grass: A Textual Variorum of the Printed Poems*, ed. Sculley Bradley, Harold W. Blodgett, Arthur Golden, and William White (New York: New York University Press, 1980), 1:11–12.

60 It is not known which version of Miller's painting Whitman knew. See Todd, "Indian Pictures and Two Whitman Poems," 1–5. See also Ron Tyler, ed., *Alfred Jacob Miller: Artist on the Oregon Trail* (Fort Worth: Amon Carter Museum, 1982), 271–72. On possible connections between Whitman's poetry and other works of art, see Henry B. Rule, "Walt

Whitman and George Caleb Bingham," *Walt Whitman Review* 15 (December 1969): 248–53; M. Wynn Thomas, *The Lunar Light of Whitman's Poetry* (Cambridge, Mass.: Harvard University Press, 1987); Miles Tanenbaum, "Walt Whitman and American Art" (Ph.D. diss, University of Tennessee, 1988); Kent Blaser, "Walt Whitman and American Art," *Walt Whitman Review* 24 (September 1978): 108–18; Max Kozloff, "Walt Whitman and American Art," in *The Artistic Legacy of Walt Whitman*, ed. Edwin Haviland Miller (New York: New York University Press, 1970), 29–53. James Dougherty, *Walt Whitman and the Citizen's Eye* (Baton Rouge: Louisiana State University Press, 1993), analyzes Whitman's verse through the lens of popular illustration.

61 Folsom, *Walt Whitman's Native Representations*, 71.

62 See Charles I. Glicksberg, *Walt Whitman and the Civil War* (Philadelphia: University of Pennsylvania Press, 1933).

63 Washington Irving was a close friend of Bryant. Whitman scholars have consistently overlooked the name's visual art referent, focusing instead on its familial connections.

64 *Prose Works 1892*, 2:681.

65 Rodgers and Black, eds., *Gathering of the Forces*, 2:114. Once, while commenting on an exhibition of Jeremiah Gurney's daguerreotypes, Whitman posed the question about the possibility of there ever being "daguerreotypes taken in colors"—only to add that "from what is known at present, there is no substantial basis for anticipating any triumph of the sort." See W. W., "An Hour Among the Portraits."

66 Quoted in Emory Holloway, ed., *Pictures: An Unpublished Poem of Walt Whitman* (New York: The June House; London: Faber and Gwyer, 1927), 8–9.

67 George H. Soule Jr., "Walt Whitman's 'Pictures': An Alternative to Tennyson's 'Palace of Art,'" *ESQ* 22 (1976): 40.

68 Ralph Waldo Emerson, "Art," in *Essays by Ralph Waldo Emerson* (New York: Harper and Row, 1951), 251; Graham, "A Heart-Picture," 59.

69 Quoted in Parke Godwin, *A Biography of William Cullen Bryant* (New York: Russell and Russell, 1883), 2:55.

70 [Whitman], "American Art—Jesse Talbot."

71 Emory Holloway, *Whitman: An Interpretation in Narrative* (New York: Alfred A. Knopf, 1926), 97.

72 John Burroughs, *The Writings of John Burroughs*, vol. 10, *Whitman: A Study* (Boston: Houghton Mifflin, 1904), 143, 139.

73 Orvell, *The Real Thing*; Justin Kaplan, *Walt Whitman: A Life* (New York: Simon and Schuster, 1980).

74 Ed Cutler, "Passage to Modernity: *Leaves of Grass* and the 1853 Crystal Palace Exhibition in New York," *Walt Whitman Quarterly Review* 16, no. 2

(1998): 65–89; Paul Benton, "Whitman, Christ, and the Crystal Palace Police: A Manuscript Source Restored," *Walt Whitman Quarterly Review* 17, no. 4 (2000): 147–65.

75 Whitman, "Brooklyn Art Union—Walter Libbey."

Chapter 2

1 Rodgers and Black, eds., *Gathering of the Forces*, 2:116–17.

2 *With Walt Whitman in Camden*, 2:536.

3 Kenneth M. Price, ed., *Walt Whitman: The Contemporary Reviews* (Cambridge: Cambridge University Press, 1996), 49.

4 Trachtenberg, *Reading American Photographs*, 62–63.

5 Whitman once referred to the image as "the street . . . figure." See *With Walt Whitman in Camden*, 2:412.

6 Whitman, *Leaves of Grass: A Textual Variorum*, 1:31.

7 Price, ed., *Walt Whitman: The Contemporary Reviews*, 18.

8 Ibid., 49, 43, 18.

9 Mitchell, *Picture Theory*, 89.

10 Quoted in William Sloane Kennedy, *The Fight of a Book for the World* (West Yarmouth, Mass.: Stonecroft Press, 1926), 248.

11 Folsom, "Appearing in Print," 138.

12 Matthiessen, *American Renaissance*, 622.

13 Jeffrey Steele, *The Representation of the Self in the American Renaissance* (Chapel Hill: University of North Carolina Press, 1987), 72.

14 Whitman gave this account of the taking of the daguerreotype: "I was sauntering along the street: the day was hot: I was dressed just as you see me there. A friend of mine—Gabriel Harrison (you know him? ah! yes!—he has always been a good friend!) stood at the door of his place looking at passers-by. He cried out to me at once: 'Old man!—old man! come here: come right up stairs with me this minute'—and when he noticed that I hesitated cried still more emphatically: 'Do come: come: I'm dying for something to do.' The picture was the result." See *With Walt Whitman in Camden*, 2:506.

15 Folsom, "Appearing in Print," 141.

16 Quoted in Allen, *The Solitary Singer*, 150.

17 Folsom, "Appearing in Print," 141. Marc S. Reisch has suggested that in the original daguerreotype, Whitman leaned on a support that Hollyer removed in the engraving. See Reisch's "Poetry and Portraiture in Whitman's *Leaves of Grass*," *Walt Whitman Quarterly Review* 27 (September 1981): 115.

18 Paul Zweig, *Walt Whitman: The Making of the Poet* (New York: Basic Books, 1984), 263. See also Christine Stansell, "Whitman at Pfaff's: Commercial Culture, Literary Life and New York Bohemia at Mid-Century," *Walt Whitman*

Quarterly Review 10, no. 3 (1993): 107–26; Martin D. Hyman, "'Where the Drinkers and Laughers Meet': Pfaff's: Whitman's Literary Lair," Seaport 26, no. 1 (1992): 57–61; and Albert Parry, Garrets and Pretenders (New York: Covici, Friede, 1933), 14–64.

19 Elihu Vedder, The Digressions of V (Boston: Houghton Mifflin, 1910), 234, 226. Artists in Vedder's company included William Hennessy, DeWitt C. Hitchcock, Sol Eytinge, and Ben Day.

20 Ibid., 226. See also Regina Soria, Elihu Vedder: American Visionary Artist in Rome (1836–1923) (Rutherford, N.J.: Fairleigh Dickinson University Press, 1970), 35–37.

21 Walt Whitman, Notebooks and Unpublished Prose Manuscripts, ed. Edward F. Grier (New York: New York University Press, 1984), 1:454–55. See also Holloway, ed., Uncollected Poetry and Prose, 2:92–93.

22 Whitman, Leaves of Grass: A Textual Variorum, 1:25.

23 Ibid., 1:75.

24 The caption provided for the square-jawed man in the upper left identifies him as having a head equally balanced by Destructiveness and Benevolence, while the scrawny figure in the upper center is said to have the bump of Benevolence balanced by Caution and Secretiveness, such that "the world will know nothing about his charities until after death." For a fascinating discussion of the considerable connections between phrenology and the visual arts, see Charles Colbert, A Measure of Perfection: Phrenology and the Fine Arts in America (Chapel Hill: University of North Carolina Press, 1997).

25 On Whitman and phrenology, see Edward Hungerford, "Walt Whitman and His Chart of Bumps," American Literature 2 (1931): 350–84, and Madeleine B. Stern, Heads and Headlines: The Phrenological Fowlers (Norman: University of Oklahoma Press, 1971). The phrenological cabinet of Fowler and Wells distributed the first edition of Leaves of Grass and published the 1856 edition anonymously.

26 Whitman, Leaves of Grass: A Textual Variorum, 1:11.

27 Hine's name and New York address appear three times in Whitman's notebooks from the period; see Whitman, Notebooks and Unpublished Prose Manuscripts, 1:431, 444, 453. Whitman traveled to New Haven to visit Hine shortly before his death in 1871. Correspondence, 2:130.

28 "Letter from New York," Boston Daily Evening Transcript, 3 September 1868. I wish to thank Col. Merl M. Moore Jr. for bringing this article to my attention.

29 Charles Hine to Walt Whitman, 21 March 1860, Whitman-Feinberg Collection, reel 7. Whitman kept the portrait in his possession until 1884, when it was purchased by his friend John H. Johnston for $200 in four equal installments. See With Walt Whitman in Camden, 3:331. It is currently owned by Brooklyn College.

30 Years later, Whitman described himself as in "full bloom" and "full-haired" at the time of the Hine portrait; see With Walt Whitman in Camden, 4:378. Similarly, William Dean Howells, who ventured into Pfaff's specifically to meet Whitman, described him as having "a fine head, with a cloud of Jovian hair upon it, and a branching beard and mustache." Quoted in Allen, Solitary Singer, 230.

31 While in Boston to oversee the production process, Whitman exclaimed at how excited he was at having this volume "printed and really published." Correspondence, 1:50.

32 Greenspan, Walt Whitman and the American Reader, 210–13.

33 Quoted in Holloway and Adimari, eds., New York Dissected, 174.

34 Betsy Erkkila, Whitman the Political Poet (New York: Oxford University Press, 1989), 159.

35 Whitman, Leaves of Grass: A Textual Variorum, 2:404.

36 Ibid., 2:320.

37 Allen, Solitary Singer, 244.

38 Correspondence, 1:348.

39 Whitman, Notebooks and Unpublished Prose Manuscripts, 2:503, 502.

40 On Forbes, see William J. Cooper Jr., "Introduction: Edwin Forbes and the Civil War," in Edwin Forbes, Thirty Years After: An Artist's Memoir of the Civil War (Baton Rouge: Louisiana State University Press, 1999), vii–xvi. When originally published, this book was entitled Thirty Years After: An Artist's Story of the Great War (New York: Fords, Howard, and Hulbert, 1890). See also Louis M. Starr, Bohemian Brigade: Civil War Newsmen in Action (New York: Alfred A. Knopf, 1954).

41 Prose Works 1892, 1:34. Because Forbes eschewed the more popular combat scenes, fewer than half of his sketches were selected for reproduction in Frank Leslie's Illustrated Newspaper. After the war, Forbes reclaimed his original sketches, which he engraved himself.

42 Whitman, Leaves of Grass: A Textual Variorum, 2:467, 480.

43 Folsom, "Whitman's Calamus Photographs," 194.

44 Holloway, ed., Uncollected Poetry and Prose, 1:186.

45 Whitman, Notebooks and Unpublished Prose Manuscripts, 2:502. Forbes exhibited his entire portfolio of Civil War prints at the 1876 Centennial Exhibition, where it received a gold medal. Although Whitman visited the exhibition at least twice, there is no record that he saw Forbes's work.

46 Gardner and Brady both photographed Whitman several times during the 1860s. See Folsom, "'This Heart's Geography's Map,'" 9–12, 45–47, 64–66. While in Washington, Whitman also studied John Mix Stanley's collection of Indian paintings at the Smithsonian Institution and admired Emanuel Leutze's Westward the Course of Empire at the

U.S. Capitol. See Whitman, *Notebooks and Unpublished Prose Manuscripts*, 2:530, and Gary Scharnhorst, "Rediscovered Nineteenth-Century Whitman Articles," *Walt Whitman Quarterly Review* 19, no. 3–4 (2002): 183.

47 One exception was the English edition of Whitman's verse, *Poems by Walt Whitman*, ed. William Michael Rossetti (London: John Camden Hotten, 1868), which included a reworking of the 1855 engraving. A disclaimer published with the portrait explained that the editor "considered it on the whole more safe and satisfactory to take this fine record of the poet in his earlier prime than to risk the chances of engraving at first hand from a photograph of his present more matured aspect."

48 Whitman's reluctance to accept the reality of his situation is reflected in his refusal to resign formally from his government post in Washington. He did not resign until August 1874, fifteen months after his arrival in Camden.

49 On Camden, see George R. Prowell, *The History of Camden County, New Jersey* (Philadelphia: L. J. Richards, 1886).

50 *Correspondence*, 2:223.

51 Ibid., 2:240, 248.

52 Ibid., 2:253, 261.

53 Whitman loved panoramas and may have seen this one in New York. For a discussion of Whitman's fondness for panoramas, see Charles Zarobila, "Walt Whitman and the Panorama," *Walt Whitman Review* 25 (June 1979): 51–59. See also Orvell, *The Real Thing*, 20–23.

54 George C. Croce and David H. Wallace, *New-York Historical Society Dictionary of Artists in America, 1564–1860* (New Haven: Yale University Press, 1957), 355.

55 *Correspondence*, 2:256. Johnston's studio was on the third floor at 722 Sansom Street. Walt Whitman, *Daybooks and Notebooks*, ed. William White (New York: New York University Press, 1978), 1:66.

56 Ibid., 1:121. In 1875, while wishing Johnston and his wife a happy anniversary, Whitman confided "how the otherwise monotony of my Camden existence [had] been pleasantly rippled" by their warm hospitality; see *Correspondence*, 2:323.

57 William James Linton, *Threescore and Ten Years: 1820 to 1890* (New York: Charles Scribner's Sons, 1894), 217. See also F. B. Smith, *Radical Artisan: William James Linton, 1812–97* (Manchester: Manchester University Press, 1973).

58 In 1839 Linton published *The Life of Paine*. He also translated several of Béranger's poems into English. See Smith, *Radical Artisan*, 33.

59 Among Linton's published verse are *Claribel and Other Poems* (1865), *Heliconundrums* (1892) and *Love-Lore and Other Early and Late Poems* (1895). Linton also edited *Poetry of America: Selections from One Hundred American Poets from 1776 to 1876* (1878), which included eight of Whitman's

poems, and, with Richard Henry Stoddard, *English Verse* (1883). After settling outside New Haven in 1867, Linton established the Appledore Press, which published many of his later books, several of which are preserved in the W. J. Linton Collection at Yale University. See R. Malcolm Sills, "W. J. Linton at Yale—The Appledore Private Press," *The Yale University Library Gazette* 12 (January 1938): 43–52.

60 F. G. Kitton, "William James Linton," *English Illustrated Magazine* 8 (1891): 492, quoted in Smith, *Radical Artisan*, 48.

61 Alexander Gilchrist, *Life of William Blake*, 2 vols. (London: Macmillan, 1863). Linton probably first learned of Whitman while still in England.

62 Linton also produced engravings for Bryant's *The Song of the Sower* (1871), *The Flood of Years* (1878), and *Thanatopsis* (1879) as well as Julia Hatfield's *The Bryant Homestead-Book* (1870). Through Bryant, Linton became a member of the Century Club, where he met many of the country's leading artists. Linton was also a founding member of the Society of Painters in Watercolour and was elected to membership in the National Academy of Design. See Linton, *Threescore and Ten*, 213, 221.

63 Smith, *Radical Artisan*, ix.

64 In addition to his work as a practicing engraver, Linton published several books and articles on the virtues of wood engraving, among them *Some Practical Hints on Wood Engraving for the Instruction of Reviewers and the Public* (1879); "Art in Engraving on Wood," *Atlantic Monthly* 43 (June 1879): 705–15; *The History of Wood-engraving in America* (1882); and *The Masters of Wood-engraving* (1889).

65 *Correspondence*, 2:172.

66 Ibid., 2:256, 323, 326, 334. The month before he presented Whitman with the finished prints, Linton invited the poet to join him in New Haven "not for a night or two but to stay *indefinitely.*" In proffering the invitation, Linton referred to "your hammock," implying that Whitman had visited him there previously. William J. Linton to Walt Whitman, 19 May 1875, Whitman-Feinberg Collection, reel 8, frame 163.

67 *With Walt Whitman in Camden*, 2:357.

68 Linton's engraving appeared first in *Memoranda During the War* (1875), an essay reprinted in the *Two Rivulets* volume of the Centennial edition. *Memoranda* also included Hollyer's engraving.

69 The poetry in *Two Rivulets* would be incorporated into later editions of *Leaves of Grass*. On technical questions regarding the editions of *Leaves of Grass*, see the editors' introduction to Whitman, *Leaves of Grass: A Textual Variorum*, 1:xx–xxv.

70 *Prose Works 1892*, 2:419.

71 Ibid., 2:368.

72 Ibid., 2:419.

73 In an unsigned article announcing the Centennial edition, Whitman wrote that "Walt Whitman's

artist feeling for deep shadows, streaked with just enough light to relieve them, might find no greater study than his own life." [Walt Whitman], "Walt Whitman's Actual American Position," *West Jersey Press*, 26 January 1876, in Clifton Joseph Furness, *Walt Whitman's Workshop* (Cambridge, Mass.: Harvard University Press, 1928), 246.

74 *Prose Works 1892*, 2:369–70.

75 Ibid., 2:537.

76 *Correspondence*, 2:330.

77 Whitman, *Leaves of Grass: A Textual Variorum*, 3:655.

78 *Prose Works 1892*, 2:363.

79 In "The Iconography of Walt Whitman," in *Artistic Legacy of Walt Whitman*, ed. Miller, 132, Gay Wilson Allen recognized in Pearsall's photograph "the fashion-defying appearance [Whitman] had cultivated since 1855."

80 Whitman autographed both the photographs and the title page of the 1876 edition; Folsom, "Appearing in Print," 148–49.

81 "The Wound-Dresser," originally called "The Dresser," was first published in 1865.

82 Whitman, *Leaves of Grass: A Textual Variorum*, 2:479–80.

83 Ibid., 2:482.

84 [Walt Whitman], "Walt Whitman's Poems," *New York Daily Tribune*, 19 February 1876. Quoted in Harold W. Blodgett, "Whitman and the Linton Portrait," *Walt Whitman Newsletter* 4 (September 1958): 90. Linton later used the engraving as the frontispiece for his *Poetry of America* (London: George Bell and Sons, 1878). That volume contained eight of Whitman's poems, including "The [Wound] Dresser," which Linton included because he found it "indicative of the character and experience of the writer" (x). Like many of Whitman's admirers, Linton was more favorably disposed toward Whitman the person than to Whitman the poet. Despite the generous treatment accorded Whitman in *Poetry of America*, Linton had severe reservations about his friend's poetry. In his autobiography, Linton termed Whitman "a true poet who could not write poetry," attributing his failure largely to "his neglect of form," which he judged "perhaps as fatal a mistake in a poet as in a painter." Linton much preferred Richard Henry Stoddard, whom he characterized in 1894 as "the highest poetic genius now living in America." See *Threescore and Ten*, 217, 213. Regardless of whether he knew of Linton's reservations about his poetry, in 1878 Whitman praised Linton's volume as "a capital compilation," judging it "the best thing of its sort & size I have seen" and pronouncing himself "well content & pleased with the part I am made to bear in it." *Correspondence*, 3:116.

85 Linton's original woodblock is in the Whitman-Feinberg Collection at the Library of Congress. For another perspective on the Linton, see Folsom, "Appearing in Print," 146–49.

86 The subtitle was necessary because the likeness and the poem appeared in separate volumes. Not until 1888 did the two appear together. In subsequent editions, the subtitle was shortened to "To Confront a Portrait." When Whitman first approached Linton with the request to construct the engraving, he intended to use it as the frontispiece. Ted Grenoways, "Two Unpublished Letters: Walt Whitman to William James Linton, March 14 and April 11, 1972," *Walt Whitman Quarterly Review* 17, no. 4 (2000): 189.

87 Whitman, *Leaves of Grass: A Textual Variorum*, 3:665.

88 Verso of letter to Walt Whitman from Minnie Vincent, 11 December 1873, Whitman-Feinberg Collection, reel 17, frame 397. The first line later became "This real Book behind the surface book" before being dropped altogether; the second evolved into "This common curtain of the human face." "Out from this Mask," Whitman-Feinberg Collection, reel 17, frame 389. For an interesting discussion of the distinction between the mask and the face, see E. H. Gombrich, "The Mask and the Face: The Perception of Physiognomic Likeness in Life and in Art," in E. H. Gombrich, Julian Hochberg, and Max Black, *Art, Perception, and Reality* (Baltimore: The Johns Hopkins University Press, 1972), 1–46.

89 Whitman, *Leaves of Grass: A Textual Variorum*, 3:665.

90 Ibid., 3:665–66.

91 After his move to Camden, Whitman did not sit for a photograph until 1878, two years after the publication of his book. The Pearsall photograph, although taken in 1871 before his disabling stroke, was nevertheless one of his most recent photographic representations.

92 Quoted in Harold Blodgett, *Walt Whitman in England* (Ithaca: Cornell University Press, 1934), 14–15. Scott introduced William Rossetti to *Leaves of Grass*. See also Whitman, *Daybooks and Notebooks*, 1:46, *Correspondence*, 3:44.

93 Whitman, *Daybooks and Notebooks*, 1:46; *Correspondence*, 3:60, 51, 56.

94 *Correspondence*, 3:62–63, 39, 446. Ward requested the copies (five sets in all) at the urging of his friend John Swinton. See Kaplan, *Walt Whitman: A Life*, 358.

Chapter 3

1 *Prose Works 1892*, 2:699.

2 Susan Hobbs, *1876: American Art of the Centennial* (Washington, D.C.: Published for the Smithsonian Institution Press by the National Collection of Fine Arts, 1976), 23. On the exhibited works, see United States Centennial Commission International Exhibition 1876, *Official Catalogue: Art Gallery and Annexes: Department IV*, 6th ed.

(Cambridge, Mass.: John R. Nagle, 1876), and Earl Shinn [Edward Strahan, pseud.], *The Masterpieces of the Centennial International Exhibition*, vol. 1, *Fine Arts* (Philadelphia: Gebbie and Barries, 1876).

3 Whitman, *Daybooks and Notebooks*, 1:47.

4 Joaquin Miller, "The Great Centennial Fair and Its Future," *The Independent* 28, no. 1441 (13 July 1876): 1–2.

5 S. G. W. Benjamin, "Fifty Years of American Art: 1828–1878," part 3, *Harper's New Monthly Magazine* 59 (October 1879): 688. For a discussion of changes in the American art world in the years after the exhibition, see David C. Huntington, "The Quest for Unity: American Art Between World's Fairs, 1876–1893," in *The Quest for Unity* (Detroit: Detroit Institute of Arts, 1983), 11–46. See also Sarah Burns, *Inventing the Modern Artist: Art and Culture in Gilded Age America* (New Haven: Yale University Press, 1996).

6 Quoted in Robert J. Scholnick, "'Culture' or Democracy: Whitman, Eugene Benson, and *The Galaxy*," *Walt Whitman Quarterly Review* 13, no. 4 (1996): 189.

7 Ibid., 197.

8 *The Radical* published Anne Gilchrist's moving tribute, "A Woman's Estimate of Walt Whitman," 7 (May 1870): 345–59, reprinted in *Letters of Anne Gilchrist*, ed. Harned, 3–22. It also published [Myron] B[enton], "Walt Whitman's Drum-Taps," 1 (April 1866): 311–12, and several of Whitman's poems, including "Flag of Stars, Thick-Sprinkled Bunting." Whitman's English friend Moncure Conway also wrote for *The Radical*. On the importance of *The Radical* in American literary history, see Clarence L. F. Gohdes, *The Periodicals of American Transcendentalism* (Durham, N.C.: Duke University Press, 1931), chapter 10.

9 Sidney H. Morse, "My Summer with Walt Whitman, 1887," in *In Re Walt Whitman*, ed. Traubel, Bucke, and Harned, 369.

10 In addition to Whitman, Morse modeled likenesses of Emerson, Abraham Lincoln, Theodore Parker, Charles Darwin, Grover Cleveland, and Thomas Paine, among others. Sidney H. Morse, "An Anti-Slavery Hero," *New England Magazine*, n.s., 4 (June 1891): 486–96. See also Sidney H. Morse to Horace Traubel, 12 December 1878, Horace L. and Anne Montgomerie Traubel Papers, box 89, Library of Congress, Washington, D.C. Whitman displayed a copy of the *Cleveland* in his parlor and had agreed to speak out on behalf of the *Paine* when Morse sought to have it displayed in Independence Hall (*Correspondence*, 3:61). Whitman's remarks are included in Sidney H. Morse, "Chips from My Studio," *The Radical Review* 1 (May 1877): 196–97. See also "Art and Artists," *Boston Daily Evening Transcript*, 25 September 1876. I would like to thank Col. Merl M. Moore Jr. for bringing this article to my attention.

11 Morse, "My Summer with Walt Whitman," 369.

The studio was located at 1223 Chestnut Street (Whitman, *Daybooks and Notebooks*, 1:39). The photographer was Charles Spieler, who took two photographs—a three-quarter view and a profile, which Whitman later chose as the frontispiece for his *Complete Poems and Prose of Walt Whitman, 1855 . . . 1888* (Philadelphia: Ferguson Bros., 1888).

12 Morse, "My Summer with Walt Whitman," 369–70.

13 *With Walt Whitman in Camden*, 1:198; Morse, "My Summer with Walt Whitman," 369–70. See the Morse-Traubel correspondence for more on the difficulties Morse encountered with the casting: Traubel Papers, box 89.

14 Cited in *Correspondence*, 3:135.

15 Quoted in Morse, "My Summer with Walt Whitman," 369.

16 *With Walt Whitman in Camden*, 1:199. Whitman dismissed the likeness as "so inexpressive, so paltry, so apologetic."

17 This and other later works by Morse are discussed in Chapter 4. In the intervening years, Morse gave lecture demonstrations on his art and wrote for a variety of publications, including *Unity*, *The Ethical Record*, and *The Radical Review*, which carried his column, "Chips from My Studio." Morse kept in touch with Whitman principally through Horace Traubel, Whitman's young confidant (who fully shared his socialist views, prompting Whitman to characterize the pair as "companions in radicalism"). See *With Walt Whitman in Camden*, 1:402.

18 The Gilchrists arrived on 10 September, although Whitman first met Mrs. Gilchrist on the 13th. Marion Walker Alcaro, *Walt Whitman's Mrs. G* (Rutherford, N.J.: Fairleigh Dickinson University Press; London: Associated University Presses, 1991), 159.

19 *Correspondence*, 3:31.

20 Ibid., 3:88.

21 Ibid., 3:86.

22 Edward Carpenter, *Days with Walt Whitman* (1896; rpt., New York: AMS Press, 1983), 20–23.

23 Herbert Harlakenden Gilchrist, ed., *Anne Gilchrist: Her Life and Writings* (London: T. Fisher Unwin, 1887), 177.

24 Alexander Gilchrist, *Life of William Blake*. See also Alcaro, *Walt Whitman's Mrs. G*, 99.

25 Kaplan, *Walt Whitman: A Life*, 49.

26 Carpenter, *Days with Walt Whitman*, 20.

27 *Correspondence*, 3:84.

28 *Letters of Anne Gilchrist*, ed. Harned, 105.

29 Carpenter, *Days with Walt Whitman*, 31.

30 *Prose Works 1892*, 1:118, 122, 121. In September 1877 Whitman gloated to his friend Pete Doyle, "Pete, if you was to see me to-day you would almost think you saw your old Walt of six years ago—I am all fat & red & tanned" (*Correspondence*, 3:96).

31 *Prose Works 1892*, 1:131.

32 In August an anonymous reviewer, probably

Whitman, reported in the *Washington Star* that the portrait was "now well advanced" with every indication of being "an excellent likeness" (*Correspondence*, 3:90). See also Harrison S. Morris, *Walt Whitman: A Brief Biography with Reminiscences* (1929; rpt., Folcroft, Pa.: Folcroft Library Editions, 1976), 86.

33 *Correspondence*, 3:113. In the spring of 1878, Herbert gave the drawing to Whitman. See Morris, *Walt Whitman*, 86; Whitman, *Daybooks and Notebooks*, 1:94. Following Whitman's death, the drawing entered Bucke's collection. Its present location is unknown.

34 Whitman, *Notebooks and Unpublished Prose Manuscripts*, 1:248.

35 Ibid., 2:903.

36 *Prose Works 1892*, 1:122.

37 In "Whitman's Calamus Photographs," 213, Folsom has identified Whitman as being naked in the Berg Collection drawing. Gilchrist would, of course, have been familiar with the academic tradition of sketching figures in the nude prior to filling in their clothing. His sketch, however, demonstrates less a detailed feeling for anatomy than a summary treatment of the body, a visual shorthand of sorts.

38 *Prose Works 1892*, 1:178–79.

39 Twenty years earlier, the image of a butterfly perched on a disembodied pointing finger had been repeated three times in the 1860 *Leaves of Grass*. See Folsom, "Appearing in Print," 149–52.

40 Whitman, *Daybooks and Notebooks*, 1:80.

41 Ibid., 1:76.

42 Anne Gilchrist, "A Woman's Estimate of Walt Whitman," 3.

43 Quoted in Carpenter, *Days with Walt Whitman*, 17.

44 Edward Carpenter to "Benjamin," 4 May 1877, quoted in Randall Waldron, "Whitman as the Nazarene: An Unpublished Drawing," *Walt Whitman Quarterly Review* 7, no. 4 (1990): 192.

45 E. H. Gombrich, *Art and Illusion* (Princeton: Princeton University Press, 1972), 73.

46 See Norman Bryson, *Vision and Painting: The Logic of the Gaze* (New Haven: Yale University Press, 1983), 13–35.

47 Carpenter, *Days with Walt Whitman*, 17–18.

48 Richard Maurice Bucke quoted in Folsom, "'This Heart's Geography's Map,'" 44.

49 Alcaro, *Walt Whitman's Mrs. G.*, 185.

50 *Correspondence*, 3:118. While in Boston, the Gilchrists spent time with Sidney Morse, who was continuing to model Whitman's likeness; see *Letters of Anne Gilchrist*, ed. Harned, 157. Whitman also notified Linton to expect the Gilchrists, especially "Herbert, the artist, the son—" (*Correspondence*, 3:116).

51 See Chapter 5.

52 *Correspondence*, 3:118.

53 Ibid., 3:175; Whitman, *Daybooks and Notebooks*, 1:137. In April 1880 Whitman sent Roberts copies of *Leaves of Grass* and *Two Rivulets*.

54 Whitman, *Daybooks and Notebooks*, 1:129.

55 Inman's paintings still hang in the Mickle Street residence.

56 I wish to thank Margaret O'Neill, former curator of the Walt Whitman House, for supplying me with information about the Dutch "ancestor" portrait.

57 *Correspondence*, 3:138–39. Herbert was simultaneously engaged in constructing another portrait of Whitman, whose current whereabouts is unknown.

58 *Prose Works 1892*, 1:122.

59 Gilchrist also reported that three of his works were on display at New York's National Academy of Design in a watercolor exhibition. See *Letters of Anne Gilchrist*, ed. Harned, 173.

60 *Correspondence*, 3:147–48.

61 Ibid., 3:148.

62 Ibid., 3:79.

63 "A Reception to Walt Whitman," *New York Tribune*, 6 March 1877.

64 J[ohn] H. Johnston, "Half-Hours with Walt Whitman: IX," *Everywhere* 21 (January 1908): 212.

65 Ibid.

66 *Correspondence*, 3:83.

67 Quoted in Clara Barrus, *Whitman and Burroughs: Comrades* (1931; rpt., Port Washington, N.Y.: Kennikat Press, 1968), 164.

68 Marcia Pointon, *Hanging the Head: Portraiture and Social Formation in Eighteenth Century England* (New Haven: Yale University Press, 1993), 95.

69 On Lavater, see John Graham, *Lavater's Essays on Physiognomy: A Study in the History of Ideas* (Bern: Lang, 1979), and Ellis Shookman, ed., *The Faces of Physiognomy: Interdisciplinary Approaches to Johann Caspar Lavater* (Columbia, S.C.: Camden House, 1993).

70 In 1879, while again a guest of the Johnstons, Whitman sat for another portrait—this one by G. M. Ottinger (*Correspondence*, 3:151), now lost.

71 *Prose Works 1892*, 1:210.

72 Ibid., 1:229.

73 Gertrude Garrigues, "Raphael's School of Athens," *The Journal of Speculative Philosophy* 13 (October 1879): 406–20. That Garrigues wrote her article in St. Louis suggests that perhaps Whitman met her during his brief stay there.

74 Although Mrs. Leggett never knew Whitman personally, she counted William Cullen Bryant among her friends, and her father-in-law, William Leggett, had known both Whitman and Bryant in the 1840s. In 1880, when Whitman visited Canada, Mrs. Leggett invited him to stay with her family in Detroit. So strong was the family's regard for Whitman that Mrs. Leggett's daughter Blanche invited Whitman to her wedding. As she informed her mother, "He seems so much like one of the family." See Thomas Donaldson, *Walt Whitman the Man* (1896; rpt., Folcroft, Pa.: Folcroft Library Editions, 1973), 247. See also Joann P. Krieg, "Walt Whitman's Long Island Friend: Elisa Seaman Leggett," *Long Island Historical Journal* 9, no. 2 (1997): 223–33.

75 Whitman, *Daybooks and Notebooks*, 2:210. On Ives, see J. Gray Sweeney, "Percy Ives (1864–1928)," in *Artists of Michigan from the Nineteenth Century*, ed. Andrea P. A. Belloli and Michael P. DeMarsche (Muskegon, Mich.: Muskegon Museum of Art, 1987), 107–9.

76 Quoted in "Artist Poet!," *Detroit News-Tribune*, 5 April 1896.

77 Ibid.

78 Percy Ives to Walt Whitman, 21 October 1886, Whitman-Feinberg Collection, reel 7, frames 144–45.

79 Percy Ives to Walt Whitman, 5 August 1887, Whitman-Feinberg Collection, reel 7, frames 146–47.

80 "Artist Poet!"

81 On 25 December 1881, Ives wrote to his grandmother about his progress on the now-lost oil painting. He explained that days earlier he had been sufficiently disgusted with the work to have contemplated painting it out, but then, with a few deft strokes of his palette knife, he had "brought it along and along until now it is in a good condition." Quoted in Charles E. Feinberg, "Percy Ives, Detroit, and Walt Whitman," *Detroit Historical Society Bulletin* 16, no. 5 (1960): 6.

82 R. Sturgis Ingersoll, *Henry McCarter* (Cambridge: Privately printed at The Riverside Press, 1944), 20, 6. I wish to thank Barbara Wolanin for bringing this book to my attention. In 1902, McCarter returned to the Academy, where he taught illustration for many years. See *Philadelphia: Three Centuries of American Art* (Philadelphia: Philadelphia Museum of Art, 1976), 560–61.

83 *Prose Works 1892*, 1:268–69.

84 Ingersoll, *Henry McCarter*, 21. On the American enthusiasm for Millet, see Laura L. Meixner, *French Realist Painting and the Critique of American Society, 1865–1900* (New York: Cambridge University Press, 1995). On the Boston collectors of his art, see Alexandra R. Murphy, *Jean-François Millet* (Boston: Museum of Fine Arts, 1984).

85 Greta, "Mr. Quincy A. Shaw's Collection," *The Art Amateur* 5 (September 1881): 72. On the collection, see *Quincy Adams Shaw Collection* (Boston: Museum of Fine Arts, 1918).

86 Bartlett would later publish "Barbizon and Jean-François Millet," part 1, *Scribner's Magazine* 7, no. 5 (May 1890): 531–55, and part 2, no. 6 (June 1890): 735–55. Whitman scrutinized the article with great care, declaring Bartlett "a remarkable, virile, rarely farseeing sort of a man." See *With Walt Whitman in Camden*, 4:437; 6:378, 456.

87 *With Walt Whitman in Camden*, 3:88.

88 Wyatt Eaton, "Recollections of Jean François Millet," *Century Magazine* 38 (May 1889): 99.

89 Alfred Sensier, "Jean-François Millet—Peasant and Painter," trans. Helena de Kay, *Scribner's Monthly* 21 (November 1880): 104–10.

90 *With Walt Whitman in Camden*, 3:89, 5:369–70.

91 Ibid., 3:89.

92 *Prose Works 1892*, 1:268. Whitman discussed the political future of France in conversation with Will Low. See Laura L. Meixner, "Jean-François Millet: His American Students and Influences" (Ph.D. diss, The Ohio State University, 1979), 1:305.

93 *With Walt Whitman in Camden*, 1:63.

94 *Prose Works 1892*, 1:268.

95 *With Walt Whitman in Camden*, 2:31, 407; 1:7.

96 Ibid., 1:83.

97 Ibid., 1:105–6.

98 *Prose Works 1892*, 1:269.

99 Ibid., 1:275–76.

100 See Folsom, *Walt Whitman's Native Representations*, 62–65.

101 *With Walt Whitman in Camden*, 2:136.

102 *Correspondence*, 3:239.

103 Sylvester Baxter, "Walt Whitman in Boston," *New England Magazine*, n.s., 6 (August 1892): 719.

104 Ibid.

Chapter 4

1 Donaldson, *Walt Whitman the Man*, 79.

2 *With Walt Whitman in Camden*, 3:89; 1:131.

3 Edmund Clarence Stedman, "Walt Whitman," *Scribner's Monthly* 21 (November 1880): 54, 56. This essay was reprinted in his *Poets of America* (Boston: Houghton, Mifflin, 1885), 349–95.

4 Ibid., 50.

5 Richard Maurice Bucke, *Walt Whitman* (Philadelphia: David McKay, 1883), 49, 51, 31.

6 Ibid., 178, 185.

7 Jauss, *Toward an Aesthetic of Reception*, vol. 2, *Theory and History of Literature*.

8 As far back as 1878, when the first Lincoln lecture was being planned, Whitman had stipulated that the audience should include "a real mixture of names, representing the young blood, & all the parties, various professions, (especially *journalists, artists, actors*, &c &c—perhaps *some women*)." *Correspondence*, 3:109.

9 Quoted in Walt Whitman, *Daybooks and Notebooks*, 2:421.

10 [Jeannette Gilder], "Walt Whitman on Lincoln," *The Critic* 7 (23 April 1887): 206.

11 Quoted in Whitman, *Daybooks and Notebooks*, 2:417.

12 Jerome Loving, *Walt Whitman: The Song of Himself* (Berkeley and Los Angeles: University of California Press, 1999), 450.

13 [J. Gilder], "Walt Whitman on Lincoln," 206.

14 David S. Reynolds, *Walt Whitman's America* (New York: Alfred A. Knopf, 1995), 554.

15 Gilder's brother-in-law, Charles de Kay, was the art editor of the *New York Times*.

16 It was largely through his efforts that *Scribner's* published Stedman's favorable appraisal of

Whitman's verse. In the period just prior to Whitman's death, Gilder saw to it that *Century Magazine* published roughly one of his poems each year. He also contributed to the purchase of a horse and buggy for Whitman and in 1889 spoke at Whitman's seventieth-birthday celebration. See Herbert F. Smith, *Richard Watson Gilder* (New York: Twayne, 1970), 45–54, 160, and Allen, *The Solitary Singer*, 522. Whitman was always grateful for Gilder's intervention and in his later years praised Gilder for taking "what I offer unhesitatingly, without question, never interjecting a single word or petty criticism" (*With Walt Whitman in Camden*, 4:171). After Whitman's death, Gilder kept a bust of Whitman within easy reach on his desk: see Harrison S. Morris, *Confessions in Art* (New York: Sears, 1930), 36.

17 One of Gilder's poems, "When the True Poet Comes," sings the praises of the "true poet" in rhyme and regular, traditional meter. Bucke chose this poem for inclusion in *Walt Whitman*, 134. See also Smith, *Richard Watson Gilder*, 49, and Barrus, *Whitman and Burroughs*, 343.

18 *With Walt Whitman in Camden*, 1:127, 4:279. Many years later Gilder was wounded to learn "that Walt could not understand my own aims in poetry." "From my point of view," he averred, Whitman "would not have made a ripple in the current of the world's literature" had it not been for his "instinctive" grasp of the very qualities at the heart of all great poetry (including, Gilder implied, his own), namely, "a sense of beauty, a sense of art which is merely the right and proper, the very best and noblest expression." See Rosamond Gilder, ed., *Letters of Richard Watson Gilder* (Boston: Houghton Mifflin, 1916), 408–9.

19 On the Associated Artists, see Amelia Peck and Carol Irish, *Candace Wheeler: The Art and Enterprise of American Design, 1875–1900* (New York: Metropolitan Museum of Art; New Haven: Yale University Press, 2001), and Candace Wheeler, *Yesterdays In a Busy Life* (New York: Harper and Brothers, 1918), 209–68. On Dora Wheeler, see *The National Cyclopaedia of American Biography* (New York: James T. White, 1898), 1:405. See also Karal Ann Marling, "Portrait of the Artist as a Young Woman: Miss Dora Wheeler," *Bulletin of the Cleveland Museum of Art* 65 (February 1978): 47–57.

20 Edward Larocque Tinker, "New Editions, Fine and Otherwise," *New York Times Book Review*, 31 July 1938: 17.

21 Later in the year Whitman offered to give Wheeler additional sittings in Camden, although by then the portrait was complete (*Correspondence*, 4:133).

22 Tinker, "New Editions, Fine and Otherwise," 17.

23 Barrus, *Whitman and Burroughs*, 265.

24 Quoted in Burke Wilkinson, *Uncommon Clay: The Life and Works of Augustus Saint Gaudens* (San Diego: Harcourt Brace Jovanovich, 1985), 120.

25 "Personal," *Harper's Bazaar* 20 (23 April 1887): 291. After leaving Wheeler's studio, Whitman sat for a series of photographs at the studio of George C. Cox. Both the number and variety of views—which included frontal, profile, and three-quarter views, all of vital importance to a sculptor—suggest that Gilder intended the visit to serve more than Cox's own photographic desires. The twelve photographs that can be attributed to the session with assurance are reproduced in Folsom, "'This Heart's Geography's Map,'" 31–34, 56–58. The best known of these was the one Whitman and his friends dubbed the "Laughing Philosopher" likeness. See Folsom, *Walt Whitman's Native Representations*, 128–36. In later years, and particularly after Whitman's death, the "Laughing Philosopher" photograph served as the basis for a variety of portraits of Whitman in other media, among them works by Paul Wayland Bartlett, son of Truman Howe Bartlett (relief sculpture, 1880s), Thomas Johnson (engraving, 1891), J. G. Davis (painting, 1903), Bernhardt Wall (engraving, 1920), R. Tait McKenzie (relief sculpture, 1919), and John Flanagan (relief sculpture, 1919). Photographs of several of these are in the Whitman-Feinberg Collection at the Library of Congress.

26 *Correspondence*, 4:87; William Sloane Kennedy, *Reminiscences of Walt Whitman* (Paisley, Scotland: Alexander Gardner, 1896), 28–29.

27 Elizabeth Johns, *Thomas Eakins: The Heroism of Modern Life* (Princeton: Princeton University Press, 1983), 144. Allen, *Solitary Singer*, 526, reported that Saint-Gaudens was prevented from completing the bust due to Whitman's illness.

28 On Alexander, see Sarah J. Moore, "John White Alexander (1856–1915): In Search of the Decorative" (Ph.D. diss., The City University of New York, 1992), and Mary Anne Goley, *John White Alexander (1856–1915)* (Washington, D.C.: National Museum of American Art, 1976).

29 *Correspondence*, 3:391.

30 Graham Clarke, "'To Emanate a Look': Whitman, Photography, and the Spectacle of Self," in *American Literary Landscapes: The Fiction and the Fact*, ed. Ian F. A. Bell and D. K. Adams (New York: St. Martin's Press, 1989), 92.

31 "Given to the Museum of Art," *New York Sun*, 25 April 1891; scrapbook, John White Alexander Papers, Archives of American Art, Smithsonian Institution, Washington, D.C. I wish to thank Mary Anne Goley for bringing this scrapbook to my attention.

32 *Correspondence*, 4:20.

33 Whitman, *Daybooks and Notebooks*, 2:316.

34 *With Walt Whitman in Camden*, 1:132.

35 Moore, "John White Alexander," 86.

36 Several critics took exception to the chair. The *Philadelphia Transcript* questioned the wisdom of placing the aging poet "on so light a perch," cautioning that if the artist had intended for it to

"represent something in one of Walt's poems," he "ought to have sent along an explanatory diagram." *The Studio* concurred, noting "we see no reason for his fancy for sustaining his sitters in the air, as if they were Hindoo fakirs, or visitors from another world, at a so-called Spiritual *Séance*. Tricks of this kind easily degenerate into mannerisms, and to our thinking, a man of Mr. Alexander's talent ought not to allow himself the indulgence." Unidentified clipping, *Philadelphia Transcript*, 9 February 1890; see also unidentified clipping, *The Studio*, 15 February 1890, scrapbook, Alexander Papers.

37 In her letter offering the drawing to the American Academy, Alexander's widow recalled that her husband "considered it the best drawing he ever made." Quoted in Moore, "John White Alexander," 108. By coincidence, Alexander died on 31 May 1915, the ninety-sixth anniversary of Whitman's birth.

38 "A Sketch of Walt Whitman," *New York World*, 1 November 1890; scrapbook, Alexander Papers.

39 Bucke, *Walt Whitman*, 49.

40 Ibid., 51.

41 *The Book News Monthly* (October 1909): 97. In 1891 Alexander's painting entered the collection of the Metropolitan Museum of Art, the gift of Mrs. Jeremiah Milbank, a wealthy patroness and supporter of Alexander's work: see "Given to the Museum of Art," *New York Sun*, 25 April 1891. Over the next quarter-century, the painting was frequently cited in the press and reproduced. See Doreen Bolger Burke, "John White Alexander," in *American Paintings in the Metropolitan Museum of Art* (New York: The Metropolitan Museum of Art in association with Princeton University Press, 1980), 3:209–10.

42 Mary Warner Blanchard, *Oscar Wilde's America: Counterculture in the Gilded Age* (New Haven: Yale University Press, 1998), 3, 12. For a detailed description of Wilde's dress, see Richard Ellmann, *Oscar Wilde* (New York: Alfred A. Knopf, 1988), 164.

43 Blanchard, *Oscar Wilde's America*, 14–17, 3. On the emergent homosexual subculture, see also George Chauncey, *Gay New York: Gender, Urban Culture, and the Making of the Gay Male World, 1890–1940* (New York: Basic Books, 1994), and Jonathan Ned Katz, *A Gay/Lesbian Almanac* (New York: Harper and Row, 1983). On Whitman's homosexuality, see Michael Moon, *Disseminating Whitman: Revision and Corporeality in Leaves of Grass* (Cambridge, Mass.: Harvard University Press, 1991), and Byrne R. S. Fone, *Masculine Landscapes: Walt Whitman and the Homoerotic Text* (Carbondale: Southern Illinois University Press, 1992).

44 Quoted in Ellmann, *Oscar Wilde*, 168.

45 Quoted in Lloyd Lewis and Henry Justin Smith, *Oscar Wilde Discovers America* (New York: Benjamin Blom, 1936), 75. See also Ellmann, *Oscar*

Wilde, 166–72, and Blanchard, *Oscar Wilde's America*, 13–14.

46 Quoted in Ellmann, *Oscar Wilde*, 171.

47 "The Listener," *Boston Daily Evening Transcript*, 30 April 1887. I wish to thank Col. Merl M. Moore Jr. for bringing this article to my attention.

48 Quoted in Whitman, *Daybooks and Notebooks*, 2:417.

49 Ibid. On Wilde and manliness, see Blanchard, *Oscar Wilde's America*, 27.

50 On the relationship between Whitman and Symonds, see John Addington Symonds, *The Memoirs of John Addington Symonds*, ed. Phyllis Grosskurth (New York: Random House, 1984), and Jonathan Ned Katz, *Gay American History* (New York: Thomas Y. Crowell, 1976), 337–58.

51 *Correspondence*, 5:73.

52 J. L. G. Ferris, "Criticism of Many Works," *Philadelphia Press*, 9 February 1890; *With Walt Whitman in Camden*, 6:291.

53 *With Walt Whitman in Camden*, 6:300. Another unidentified newspaper chided Alexander for minimizing Whitman's "vigorous physical personality," yet judged the work overall "noble, effective, and elevated" (ibid., 6:279).

54 Ibid., 6:300–301, 305.

55 Barrus, *Whitman and Burroughs*, 261.

56 *With Walt Whitman in Camden*, 1:284. Whitman doubtless would also have questioned the finality of the representation the expatriate American portraitist John Singer Sargent desired to construct during his return visit to the States in the spring of 1890. Known for the theatricality of many of his portraits, Sargent, far more than Alexander, celebrated the sensuality and sexuality of his sitters. In *John Singer Sargent: The Sensualist* (New Haven: Yale University Press, 2000), 159, 97, Trevor Fairbrother cites "the veiled but sophisticated homoeroticism at play" in his paintings from the 1890s, noting in particular that many of Sargent's representations "lean toward the daring, risky, unconventional, dramatic, erotically off-center, and odd." Unfortunately, what rhetorical flourishes and painterly effects Sargent might have deployed in his proposed representation of Whitman will never be known. Prior engagements prevented Sargent from traveling to Camden to undertake the portrait. See George M. Williamson to Horace Traubel, 1 and 19 March 1890, Whitman-Feinberg Collection, box 72; *With Walt Whitman in Camden*, 6:315.

57 See *Letters of Anne Gilchrist*, ed. Harned, 236, and Alcaro, *Walt Whitman's Mrs. G*, 209, 256. Gilchrist continued to show his work in the Royal Academy's annual Summer Exhibitions for the remainder of his life.

58 See *Manuscripts, Autograph Letters, First Editions and Portraits of Walt Whitman Formerly the Property of the Late Dr. Richard Maurice Bucke* (New York: American Art Association, 1936; rpt., Folcroft, Pa.: Folcroft Library Editions, 1972);

Alcaro, *Walt Whitman's Mrs. G*, 224; Allen, *Solitary Singer*, 524.

59 Gilchrist gave an artist's proof of the intaglio to the British actress Ellen Terry, whose son, theater designer Gordon Craig, would develop a strong admiration for Whitman; see *Letters of Anne Gilchrist*, ed. Harned, 201. A nearly identical likeness, minus the hat and identified on the verso as deriving from a chalk drawing owned by Buxton Forman, is in the Whitman-Feinberg Collection at the Library of Congress. On the verso are the lines from Whitman's poem "The Wound-Dresser:" "Walt Whitman / An old man bending / I come amongst new faces."

60 Marion Walker Alcaro, "Walt Whitman and Mrs. G.," *Walt Whitman Quarterly Review* 6, no. 4 (1989): 153.

61 *Letters of Anne Gilchrist*, ed. Harned, 205.

62 Ibid., 198.

63 Ibid., 200, 214. Herbert had originally presented himself standing over the pot of tea, the position subsequently assumed by the female attendant.

64 Ibid., 214.

65 A similar contrast between the freedom of nature as seen through an open window and the confines of the domestic interior characterizes *The Awakening Conscience*.

66 Bucke, *Walt Whitman*, 54.

67 *Letters of Anne Gilchrist*, ed. Harned, 195–96.

68 Ibid., 223.

69 Ibid.

70 *With Walt Whitman in Camden*, 2:460. For further discussion of Whitman's interest in the photograph, see Chapter 5.

71 *Correspondence*, 4:121. While in Camden, Morse also modeled portraits of President Cleveland and Elias Hicks.

72 Morse, "My Summer with Walt Whitman," 372, 373.

73 Ibid., 373.

74 Allen, *Solitary Singer*, 526.

75 Morse, "My Summer with Walt Whitman," 373.

76 Herbert Gilchrist to Horace Traubel, 9 September 1906, Traubel Papers, box 5.

77 *With Walt Whitman in Camden*, 2:347.

78 Herbert Gilchrist to Horace Traubel, 9 September 1906; Herbert Gilchrist to Walt Whitman, 10 October 1887, Whitman-Feinberg Collection.

79 Gilchrist retained possession of the original version of the painting. At his death in 1914 it passed to his sister Grace. Today the painting is privately owned and in storage near London. I wish to thank Marion Alcaro for her assistance in contacting the current owner.

80 See "A Backward Glance O'er Travel'd Roads," *LG* 561. Bucke confirmed Whitman's preference for writing on his lap, noting in *Walt Whitman*, "Even in a room with the usual conveniences for writing he did not use a table; he put a book on his knee, or held it in his left hand, laid his paper upon it and wrote so" (54).

81 *Correspondence*, 4:121.

82 *With Walt Whitman in Camden*, 2:450. Upon learning that the painting they were viewing was not the one that Gilchrist had commenced in Camden the previous year, Traubel remarked, "It can't have been changed much or we would have detected it." Whitman agreed (2:347).

83 Ibid., 2:295, 1:153–54.

84 Ibid., 1:266. *The Pictures of 1888*, a supplement published by the *Pall Mall Gazette*, which Gilchrist sent Whitman, included a black-and-white engraving of his Whitman portrait.

85 *With Walt Whitman in Camden*, 5:13.

86 Ibid., 1:154; 2:289, 457–58, 450; 4:227; 2:428, 295.

87 Ibid., 5:150.

88 Anne Gilchrist, "A Woman's Estimate of Walt Whitman," 6.

89 Anne Gilchrist, "A Confession of Faith," *To-Day* (June 1885); reprinted in *Anne Gilchrist: Her Life and Writings*, ed. H. Gilchrist, 333, 331.

90 See Meyer Schapiro, *Words and Pictures* (The Hague: Mouton, 1973), 38ff.

91 *With Walt Whitman in Camden*, 5:493; Alcaro, *Walt Whitman's Mrs. G*, 256.

92 With the publication of the first three volumes of *With Walt Whitman in Camden* in 1906, 1907, and 1914, Herbert learned the full extent of Whitman's reservations about the portrait and about himself. Shortly after the third volume was published, Herbert committed suicide. Alcaro, *Walt Whitman's Mrs. G*, 257.

93 *With Walt Whitman in Camden*, 2:388. "[S]o much of Sidney, is abortive," Whitman lamented, "—he don't get anywhere: he is a child of *ennui*: a child—true, sweet, persuasive—has a beautiful personality: is never discouraged: things go wrong, he falls and picks himself up again. Sidney lacks altogether the world faculty—the power to turn the world to his uses. . . . It is half tragic—the life he leads: the starts made—the ends that never come" (1:158).

94 Ibid., 3:121, 1:410. Morse completed another relief shortly before his death in 1903. Inscribed "A Memory of '87," the work is in the collection of the National Portrait Gallery. Whitman intended the paintings for his sisters.

95 Sidney H. Morse to Horace Traubel, 30 April 1887, Traubel Papers, box 89.

96 Kennedy, *Reminiscences of Walt Whitman*, 31.

97 *With Walt Whitman in Camden*, 2:405.

98 *Correspondence*, 4:112. See also Kennedy, *Reminiscences of Walt Whitman*, 55–56.

99 *With Walt Whitman in Camden*, 6:63.

100 Ibid., 1:410, 2:321, 5:294.

101 Barrus, *Whitman and Burroughs*, 265.

102 *Correspondence*, 4:131.

103 "The Fine Arts," *Boston Daily Evening Transcript*, 8 December 1887. I wish to thank Col. Merl M. Moore Jr. for bringing this and the following article to my attention.

104 "A Bust of Whitman," *Boston Daily Evening Transcript*, 10 December 1887.

105 *With Walt Whitman in Camden*, 4:436.

106 Ibid., 1:192; 2:198–99, 321.

107 Kennedy, *Reminiscences of Walt Whitman*, 49.

Chapter 5

1 *With Walt Whitman in Camden*, 1:284.

2 Several scholars have speculated that the two met earlier—perhaps as early as 1883. See, for example, Folsom, "Whitman's Calamus Photographs," 213–17.

3 *With Walt Whitman in Camden*, 1:72.

4 Ibid., 4:94.

5 Thomas Eakins to his father, 6 March 1868, in Kathleen A. Foster and Cheryl Leibold, eds., *Writing About Eakins: The Manuscripts in Charles Bregler's Thomas Eakins Collection* (Philadelphia: Published for the Pennsylvania Academy of the Fine Arts by the University of Pennsylvania Press, 1989), 206.

6 Quoted in Lloyd Goodrich, *Thomas Eakins* (Cambridge, Mass.: Harvard University Press, 1982), 1:198.

7 Eakins, who completed nineteen paintings, drawings, and watercolors of scullers, undoubtedly also gave Whitman the photograph of a Canadian sculler that Whitman displayed on the wall of his back bedroom. See Allen, *The Solitary Singer*, 521. Mrs. Eakins reported that Eakins "had been an intensive reader of 'Leaves of Grass'" even before meeting Whitman; R. Sturgis Ingersoll, "Thomas Eakins and Walt Whitman," typescript of a lecture given at the Philadelphia Museum of Art, 9 February 1972, 2. Thomas Eakins/Lloyd Goodrich Collection, Philadelphia Museum of Art.

8 *With Walt Whitman in Camden*, 4:105.

9 The jury accepted five of Eakins's other paintings. Despite its poor treatment in the hands of the jury, *The Gross Clinic* was received positively by the press. See Goodrich, *Thomas Eakins*, 1:130–33. Although Whitman visited the fair, he seems not to have seen Eakins's painting. For a detailed discussion of *The Gross Clinic*, see Johns, *Thomas Eakins*, 46–81.

10 Since its first publication, privately and at Whitman's own expense, *Leaves of Grass* had been maligned by both publishers and the reading public as an affront to established literary standards and conventions. Even some of the poet's most vocal supporters continued to regard *Leaves of Grass* as more prose than poetry.

11 See Foster and Leibold, eds., *Writing About Eakins*, 69–79.

12 Quoted in Goodrich, *Thomas Eakins*, 1:283.

13 *With Walt Whitman in Camden*, 4:156.

14 Upon discovering the poet's heavily annotated copy of *Leaves of Grass* in his desk at the Department of the Interior, Secretary Harlan fired Whitman, saying, "I will not have the author of that book in this Department." Quoted in Kaplan, *Walt Whitman: A Life*, 304.

15 On Williams, see Elizabeth Dunbar, *Talcott Williams: Gentleman of the Fourth Estate* (New York: Robert E. Simpson and Sons, 1936).

16 [Untitled], *Philadelphia Press*, 22 May 1882; "Walt Whitman's Work," *Philadelphia Press*, 15 July 1882.

17 "Prof. Eakins' Resignation," *Philadelphia Press*, 16 February 1886. See also "Prof. Eakins Resigns," 15 February 1886, and "Forming a Students' League," 19 February 1886.

18 Whitman, *Daybooks and Notebooks*, 2:339; see also *Correspondence*, 3:378–80. In July 1888, Whitman informed Traubel that "the only thing that saves the Press from entire damnation is the presence of Talcott Williams. Now, there's a man with some stuff to 'im." *With Walt Whitman in Camden*, 1:341.

19 Whitman, *Daybooks and Notebooks*, 2:422.

20 *With Walt Whitman in Camden*, 4:135, 155. No sitting lasted more than an hour (6:315).

21 Ibid., 1:108, 2:454.

22 Quoted in Goodrich, *Thomas Eakins*, 2:16.

23 *Prose Works 1892*, 1:212–13, 210.

24 *With Walt Whitman in Camden*, 4:135.

25 Walt Whitman [George Selwyn, pseud.], "Walt Whitman in Camden," *The Critic* 3 (28 February 1885), 97.

26 *With Walt Whitman in Camden*, 7:1.

27 Ibid., 1:42.

28 *Correspondence*, 4:160.

29 Johns, *Thomas Eakins*, 157.

30 Goodrich, *Thomas Eakins*, 2:215.

31 For the identities of the sixteen sitters, see Martin A. Berger, *Man Made: Thomas Eakins and the Construction of Gilded Age Manhood* (Berkeley and Los Angeles: University of California Press, 2000), 147. In addition to Whitman, one of the three non-students was Talcott Williams.

32 At the same time, Eakins's painting eschews the trivializing, anecdotal qualities that marred Gilchrist's representation of the "poetizing" Whitman in *The Good Gray Poet's Gift*, discussed in Chapter 4.

33 See Richard Brilliant, *Portraiture* (Cambridge, Mass.: Harvard University Press, 1991), 10.

34 *Correspondence*, 4:135.

35 Quoted in ibid., 4:133.

36 *With Walt Whitman in Camden*, 3:526–27. Ownership of the portrait was shared equally between Eakins and Whitman—an unusual arrangement for Eakins, who generally sold his portraits outright to his sitters. See *With Walt Whitman in Camden*, 7:413–14. Upon Whitman's death, the painting entered the collection of Richard Maurice Bucke. At Bucke's death, the work passed to his daughter, from whom the

Pennsylvania Academy of the Fine Arts purchased it in 1917.

37 *With Walt Whitman in Camden*, 1:131, 153.

38 Ibid., 1:131, 6:416.

39 The portrait was not exhibited again until 1908, when it was included in the 103rd Annual Exhibition of the Pennsylvania Academy of the Fine Arts. It was exhibited at the Corcoran Gallery of Art in Washington the following year.

40 "The Pictures Exhibited," *Philadelphia Press*, 29 January 1891.

41 *With Walt Whitman in Camden*, 2:290, 295; 8:36.

42 Ibid., 1:39, 5.225.

43 Schapiro, *Words and Pictures*, 38ff

44 *With Walt Whitman in Camden*, 6:416; see also *Correspondence*, 4:143, 163. For Whitman's views on the importance of the eyes in a photograph, see Rodgers and Black, eds., *Gathering of the Forces*, 2:116–17.

45 Alan Trachtenberg, "Whitman's Visionary Politics," in *Walt Whitman of Mickle Street: A Centennial Collection*, ed. Geoffrey M. Sill (Knoxville: The University of Tennessee Press, 1994), 102.

46 *With Walt Whitman in Camden*, 2:105.

47 Ibid., 2:460.

48 Ibid., 3:254. *Complete Poems and Prose of Walt Whitman, 1855 . . . 1888*, included the Hollyer/Harrison representation opposite "Song of Myself." For an extended discussion of the Spieler in its role as frontispiece, see Folsom, "Appearing in Print," 159–63. The following year Whitman employed another profile portrait of himself, the "Butterfly" photograph discussed in Chapter 3, as the frontispiece for the 1889 *Leaves of Grass*.

49 Eakins also photographed Williams and commenced a portrait of his wife called *The Black Fan (Portrait of Mrs. Talcott Williams)*. The portrait was never finished.

50 *With Walt Whitman in Camden*, 8:201.

51 William Innes Homer, *Thomas Eakins: His Life and Art* (New York: Abbeville Press, 1992), 116.

52 On the Eakins-O'Donovan collaboration, see Cleveland Moffett, "Grant and Lincoln in Bronze," *McClure's Magazine* 5 (October 1895): 419–32; see also Goodrich, *Thomas Eakins*, 2:110–25.

53 *Correspondence*, 3:118.

54 *With Walt Whitman in Camden*, 8:131, 144.

55 See Michael Panhorst, *Samuel Murray: The Hirshhorn Museum and Sculpture Garden Collection, Smithsonian Institution* (Washington, D.C.: Smithsonian Institution Press, 1982).

56 Horace Traubel, "Round Table with Walt Whitman," in *In Re Walt Whitman*, ed. Traubel, Bucke, and Harned, 297–327.

57 *With Walt Whitman in Camden*, 1:131.

58 Ibid., 8:203, 320, 326, 260.

59 Ibid., 8:243–44.

60 On the question of authorship, see William Innes Homer, "Who Took Eakins' Photographs?" *Art News* 82 (May 1983): 112–19; Susan Danly and Cheryl Leibold, *Eakins and the Photograph* (Washington: Smithsonian Institution Press for the Pennsylvania Academy of the Fine Arts, 1994), 6; and Kathleen A. Foster, *Thomas Eakins Rediscovered* (Philadelphia: Pennsylvania Academy of the Fine Arts; New Haven: Yale University Press, 1997), 260n48.

61 Whitman was particularly pleased with Murray's photographic representation, which he hailed as "an eminent hit—one of those curious chances, out of a thousand, which hits a close mark—not to be schemed for—not to be *purposed*—only *discovered*, *revealed*, we might say." He inscribed a cropped copy of the print "Sculptor's profile" and had it reproduced in halftone as the frontispiece of *Good-Bye My Fancy* (1891), the sequel to *November Boughs*. He also ordered five hundred copies of the photograph for his own use. See *With Walt Whitman in Camden*, 8:201, 212.

62 *Correspondence*, 5:24.

63 On 25 January 1890, Frank Fowler (1852–1910), a portrait artist with a studio in New York, produced another pen-and-ink sketch of the poet, now lost. See *Collection of the Works of Walt Whitman Commemorating the Ninetieth Anniversary of the Printing of His "Leaves of Grass"* (Detroit: Detroit Public Library, 1945), 44.

64 Eakins acknowledged the difficulty of representing Whitman's thinning hair. The challenge was to make it appear bushy without conveying too much thickness (*With Walt Whitman in Camden*, 8:203).

65 Ibid., 8:319, 331, 371, 516.

66 In September, when Traubel stopped by Eakins's studio for a look, he was told the bust was not available, having been "pulled apart," "taken to pieces" (ibid., 8:479). Two months later, with progress on the bust stalled, Traubel discouraged Joseph Marshall Stoddart from taking up a collection to purchase it (9:118, 165). The work's present location is unknown.

67 Quoted in Traubel, "Round Table with Walt Whitman," 322.

68 Hans-Georg Gadamer, *Truth and Method* (New York: Seabury Press, 1975); see also Brilliant, *Portraiture*, 7.

69 Johns, *Thomas Eakins*, 115.

70 Goodrich, *Thomas Eakins*, 2:84. See also Synnove Haughom, "Thomas Eakins' *The Concert Singer*," *The Magazine Antiques* 107, no. 6 (1975): 1182–84.

71 Quoted in Johns, *Thomas Eakins*, 138.

72 The program hailed her as "the Favorite Contralto." See Phyllis D. Rosenzweig, *The Thomas Eakins Collection of the Hirshhorn Museum and Sculpture Garden* (Washington: Smithsonian Institution Press, 1977), 120.

73 *With Walt Whitman in Camden*, 1:239. Cook set other Whitman poems to music as well, including "Out of the Rolling Ocean the Crowd" and "O Tan-Faced Prairie-Boy." Weda Cook to Horace Traubel, 5 May 1903, Traubel Papers, box 3. Cook's

husband, Stanley Addicks, also set Whitman poems to music; see Weda Cook, "Memories of Whitman," Traubel Papers, box 36.

74 Goodrich, Thomas Eakins, 2:84.

75 Rodgers and Black, eds., Gathering of the Forces, 2:354. Whitman had earlier expressed great pleasure with the composer's St. Paul. See Emory Holloway, "More Light on Whitman," The American Mercury 1 (February 1924): 186.

76 Quoted in Robert D. Faner, Walt Whitman and Opera (Carbondale: Southern Illinois University Press, 1951), v.

77 Quoted in Anne Gilchrist: Her Life and Writings, ed. H. Gilchrist, 182.

78 Prose Works 1892, 2:549.

79 Goodrich, Thomas Eakins, 2:30–31.

80 R[ichard] M[aurice] Bucke, "Portraits of Walt Whitman," New England Magazine 20 (March–August 1899): 45.

81 Several years later, in constructing the exterior figures for Philadelphia's Witherspoon Building, Eakins and Murray modeled the figure of Moses on Whitman. Mariah Chamberlin-Hellman, "Samuel Murray, Thomas Eakins, and the Witherspoon Prophets," Arts Magazine 53 (May 1979): 135.

82 Felix Mendelssohn, Elijah: An Oratorio (New York: G. Schirmer, n.d.), vii.

83 Quoted in Goodrich, Thomas Eakins, 2:139.

84 The work was first exhibited in 1893 in the Pennsylvania State Building at the World's Columbian Exposition in Chicago; see Pennsylvania Art Contributions (Harrisburg, Pa.: Edwin K. Meyers, 1893), 34. It continued to be called The Singer when exhibited at the Art Club of Philadelphia in 1894 and at the National Academy of Design in 1895. It was only in 1914, less than two years before Eakins's death, that the title was changed to The Concert Singer. See Lloyd Goodrich notes, Eakins/Goodrich Collection.

85 With Walt Whitman in Camden, 2:331.

86 Charles Bregler recalled that in the mid-1880s Eakins discussed Degas in his classes at the Pennsylvania Academy; Goodrich, Thomas Eakins, 1:185. In 1886, nineteen works by Degas were included in the first exhibition of Impressionist works in New York. See Works in Oil and Pastel by the Impressionists of Paris (New York: American Art Association, 1886).

87 Goodrich, Thomas Eakins, 2:31.

88 Michael Fried, Realism, Writing, and Disfiguration: Thomas Eakins and Stephen Crane (Chicago: University of Chicago Press, 1988).

89 Elizabeth Johns, "Swimming: Thomas Eakins, the Twenty-ninth Bather," in Thomas Eakins and the Swimming Picture, ed. Doreen Bolger and Sarah Cash (Fort Worth: Amon Carter Museum, 1996), 71.

90 Berger, Man Made, 18, 84.

91 William White, "Billy Duckett: Whitman Rogue," The American Book Collector 21 (1971): 22. Whitman later characterized Duckett as a "scamp,"

a "scoundrel," and a "young rascal." With Walt Whitman in Camden, 5:64.

92 See Johns, "Swimming: Thomas Eakins," 72–73.

93 Folsom, "Whitman's Calamus Photographs," 197, 206.

94 See Bolger and Cash, eds., Thomas Eakins and the Swimming Picture. See also Whitney Davis, "Erotic Revision in Thomas Eakins's Narratives of Male Nudity," Art History 17, no. 3 (1994): 301–41.

95 With Walt Whitman in Camden, 8:203.

96 Eakins and Murray had earlier made a cast of Whitman's left hand. See ibid., 9:266; Samuel Murray Scrapbook, vol. 3, Hirshhorn Museum and Sculpture Garden, Smithsonian Institution, Washington, D.C. In 1897, all four casts were acquired by Buxton Forman, one of Whitman's English admirers. They are today in the collection of the Houghton Library at Harvard University.

97 Kennedy, Reminiscences of Walt Whitman, 47.

98 "Walt Whitman's Funeral," Philadelphia Times, 30 and 31 March 1892.

99 Thomas Eakins to Thomas B. Harned, 29 March 1892, Whitman-Feinberg Collection, box 73.

100 Cook, "Memories of Whitman."

101 Cook reported that as she posed, O'Donovan supplied her with fresh roses almost daily. Goodrich, Thomas Eakins, 2:84.

102 Haughom, "Thomas Eakins' The Concert Singer," 1184.

Chapter 6

1 Bliss Perry, Walt Whitman: His Life and Work (1906; rpt., New York: AMS Press, 1969), 282–83.

2 Charles B. Willard, Whitman's American Fame (Providence: Brown University Press, 1950), 34.

3 See, for example, Kennedy, Reminiscences of Walt Whitman; Donaldson, Walt Whitman the Man; Carpenter, Days with Walt Whitman; Johnston, "Half-Hours with Walt Whitman: IX," 212–14, and Charles N. Elliott, ed., Walt Whitman as Man, Poet, and Friend (Boston: Richard G. Badger, 1915).

4 Trachtenberg, "Walt Whitman: Precipitant of the Modern," 196. During his lifetime, Hartley published three volumes of poetry: Twenty-Five Poems (1923), Androsoggin (1940), and Sea Burial (1941). Selected Poems (1945) appeared shortly after his death. Hartley also published poems in a number of "little magazines," including Poetry, Playboy, Others, The Little Review, and Contact. Many of Hartley's poems have been reprinted in The Collected Poems of Marsden Hartley, 1904–1943, ed. Gail R. Scott (Santa Rosa: Black Sparrow Press, 1987).

5 Marsden Hartley, "Vignettes: Peter Doyle," Marsden Hartley Papers, Yale Collection of American Literature, Beinecke Rare Book and Manuscript Library, Yale University.

6 Marsden Hartley, "Somehow A Past," Hartley

Papers. Hartley produced variant forms of his autobiography. Because not all variants are included in Marsden Hartley, *Somehow a Past: The Autobiography of Marsden Hartley*, ed. Susan Elizabeth Ryan (Cambridge, Mass.: MIT Press, 1997), I cite from the document's original, unpublished versions.

7 Marsden Hartley to Marguerita Reuwee, 21 July 1904, Bernard Karfiol Papers, Archives of American Art, Smithsonian Institution, Washington, D.C.

8 Kennedy, *Reminiscences of Walt Whitman*, 134.

9 William Sloane Kennedy, *The Poet as a Craftsman* (1886; rpt., Folcroft, Pa : Folcroft Library Editions, 1973), 13, 15.

10 Marsden Hartley to Marguerita Reuwee, 21 July 1904. By his own estimate, Kennedy owned between two and three hundred letters and postcards from Whitman; Kennedy, *Reminiscences of Walt Whitman*, 49. While this chapter concentrates exclusively on Hartley's earliest engagement with Whitman, the bond between painter and poet remained strong throughout his life. Just months before his death in 1943, Hartley confided to a friend that his Whitman memorabilia, including the material from Kennedy, was "the last thing I see at night & the first thing in the morning & they all help me enormously to live." Marsden Hartley to Arnold Rönnebeck, 14 October 1942, Papers of the American Art Research Council, roll x3, Archives of American Art, Smithsonian Institution, Washington, D.C.

11 Minnie Maddern Fiske, one of the actresses in Proctor's Theater Company, was a friend of Traubel's and may have arranged the introduction. Hartley later wrote an essay, left unpublished at his death, entitled "The Voice Is Everything: Minnie Maddern Fiske," in *Sixteen Typed Essays*, Hartley Papers. Hartley knew Traubel by August 1905.

12 Traubel and Hartley actually continued on friendly terms until Traubel's death in 1919. After about 1909, however, their personal contacts became more sporadic and they kept in touch mostly through letters.

13 This work is owned by the Walt Whitman House in Camden, New Jersey.

14 Several of Horace Traubel's sketches are preserved in the Whitman-Feinberg Collection at the Library of Congress. They reveal a competent (if somewhat pedestrian) hand driven by a highly romantic sensibility.

15 According to Percival Wiksell, "Horace Traubel," *The Fra* 7 (July 1911): 119, Traubel wrote between twenty-four and forty letters daily. See Donald Richard Stoddard, "Horace Traubel: A Critical Biography" (Ph.D. diss., University of Pennsylvania, 1970); David Karsner, *Horace Traubel: His Life and Work* (New York: Egmont Arens, 1919); and Mildred Bain, *Horace Traubel* (New York: Albert and Charles Boni, 1913). See also Ed Folsom, "Horace Traubel (1858–1919)," in *With Walt Whitman in Camden*, 9:xiii–xxiii.

16 Townsend Luddington, *Marsden Hartley: The Biography of an American Artist* (Boston: Little, Brown, 1992), 42–43.

17 William Innes Homer, ed., *Heart's Gate: Letters Between Marsden Hartley and Horace Traubel, 1906–1915* (Highlands, N.C.: The Jargon Society, 1982), 24. William Sloane Kennedy, in "Sursum Corda, Comrades!" *The Conservator* 7, no. 9 (1896): 140, hailed Whitman's writings "as a New Protestantism," a corrective to the failings of "historic Christianity," and he assured readers that "the true dawn of Whitmanity is visible."

18 Homer, ed., *Heart's Gate*, 50. Hartley repeatedly solicited new subscribers to the journal and in an act of friendship presented Traubel with a painting, *Revere Beach*, whose whereabouts is today unknown.

19 More traditional early-twentieth-century biographies included Perry, *Walt Whitman*; Henry Bryan Binns, *A Life of Walt Whitman* (New York: E. P. Dutton, 1905); and George Rice Carpenter, *Walt Whitman* (New York: Macmillan, 1909), all of which Hartley seems also to have read.

20 Quoted in Stoddard, "Horace Traubel," 238. Responding to the appearance of the third volume several years later, Van Wyck Brooks judged it "the greatest biographical work in American literature." Quoted in Willard, *Whitman's American Fame*, 55.

21 Quoted in Stoddard, "Horace Traubel," 258–59.

22 Marsden Hartley to Horace Traubel, [1906], Traubel Papers, box 75. John Spargo, editor of *Comrade*, experienced a similar rush of emotion. On 16 June 1906 he wrote Traubel: "I have long repined that I never knew him [Whitman] as a man, never clasped hands with him and looked into his eyes. Your book soothes me in that respect; I feel now that I do know the man. I share your glorious privilege; I linger in the sanctuary with you." See Traubel Papers, box 38.

23 In "Somehow a Past," Hartley intimated that his attraction to the Stevens Street residence was centered on its being the site of Whitman's meeting with Wilde. In the 1920s the Mickle Street residence was opened to the public as a museum. Hartley's painting of the house served as the frontispiece for the memoir of Whitman's housekeeper, Elizabeth Leavitt Keller, *Walt Whitman in Mickle Street* (New York: Mitchell Kennerley, 1921). Twenty years later, Hartley proposed producing another painting of the house, advising his friend and patron, Hudson Walker: "I am the only one who can do it with feeling." Marsden Hartley to Hudson Walker, [August 1942], typed transcript of letter, Hudson Walker Papers, Archives of American Art, Smithsonian Institution, Washington, D.C. I wish to thank Jeanne Hokin for bringing this letter to my attention.

24 Weinberg, *Speaking for Vice*, 132.

25 Eve Kosofsky Sedgwick, *Between Men: English*

Literature and Male Homosocial Desire (New York: Columbia University Press, 1985), 206.

26 Symonds, *Memoirs of John Addington Symonds*, 263.

27 Edward Carpenter, "Some Friends of Walt Whitman: A Study in Sex-Psychology" (London: British Society for the Study of Sex Psychology, [1924]), 16.

28 Bryan K. Garman, "'Heroic Spiritual Grandfather': Whitman, Sexuality, and the American Left, 1890–1940," *American Quarterly* 52 (March 2000): 100–108. The Traubel-Wiksell correspondence is in the Gustave Percival Wiksell Papers at the Library of Congress. Both Traubel and Wiksell were married at the time. Traubel married Anne Montgomerie in Whitman's presence in the bedroom of the poet's Mickle Street residence in 1891.

29 Homer, ed., *Heart's Gate*, 25.

30 Hartley first met Mosher on the New York–Portland ferry. Mosher published several volumes of Whitman's writings, including *A Little Book of Nature Thoughts* (1906)—which was edited by Traubel's wife, Anne Montgomerie Traubel, and included a Preface by Traubel—as well as *The Book of Heavenly Death* (1907). Hartley read both. In 1919, the centennial of Whitman's birth, Mosher published a reprint edition of the 1855 *Leaves of Grass*. See Jean-François Vilain and Philip R. Bishop, *Thomas Bird Mosher and the Art of the Book* (Philadelphia: F. A. Davis, 1992).

31 Marsden Hartley, "Peter Doyle and the Whitman Group," Hartley Papers.

32 Richard Maurice Bucke, ed., *Calamus: A Series of Letters Written During the Years 1868–1880 by Walt Whitman to a Young Friend (Peter Doyle)* (Boston: Laurens Maynard, 1897). William Sloane Kennedy, "Whitman's Letters to Peter Doyle," *The Conservator* 8, no. 4 (1897): 60–61.

33 Marsden Hartley to Horace Traubel, [1906]. Traubel Papers, box 75. Hartley encountered Doyle on at least one other occasion, this time in Traubel's presence. In "Pete Doyle," *The Conservator* 18, no. 7 (1907): 104, Percival Wiksell noted, "You could hardly talk five minutes with him before he was quoting Walt as his authority for some fact or opinion, or was telling some story he got from Walt." At the 31 May 1907 annual meeting of the Walt Whitman Fellowship International held at New York's Hotel Brevoort, Wiksell offered a toast to Doyle, who had recently died. Symonds was similarly fascinated with Doyle.

34 Hartley, "Vignettes: Peter Doyle."

35 C. Maclean Savage, "Recollections of Marsden Hartley," Elizabeth McCausland Papers, Archives of American Art, Smithsonian Institution, Washington, D.C.

36 See Weinberg, *Speaking for Vice*, 131, and Barbara Haskell, *Marsden Hartley* (New York: Whitney Museum of American Art, 1980), 12.

37 Walt Whitman, *An American Primer*, ed. Horace Traubel (1904; rpt., Stevens Point, Wis.: Holy Cow! Press, 1987), 34.

38 Painter Robert Henri was similarly swayed by Whitman's emphasis on the self. In "Progress in Our National Art," *The Craftsman* 15, no. 4 (1909): 389, Henri wrote that "before a man tries to express anything to the world he must recognize in himself an individual, a new one, very distinct from others. Walt Whitman did this, and that is why I think his name so often comes to me. The one great cry of Whitman was for a man to find himself, to understand the fine thing he really is if liberated." Like Hartley, Henri, too, reinvented himself by changing his name from Robert Henry Cozad to Robert Henri, also at the commencement of his artistic career.

39 Helen Campbell to Horace Traubel, 4 March 1908, Traubel Papers, box 2. See also Jeanne Hokin, *Pinnacles and Pyramids: The Art of Marsden Hartley* (Albuquerque: University of New Mexico Press, 1993), 15. The following year Campbell published "A Man and a Book," *Arena* 40 (August–September 1908): 183–91, a biographical essay on Traubel and his commitment to Whitman.

40 Hokin, *Pinnacles and Pyramids*, 15.

41 Homer, ed., *Heart's Gate*, 37.

42 Garman, "'Heroic Spiritual Grandfather,'" 107.

43 Myron H. Phelps, "Green Acre," *The Word* 1, no. 2 (1904): 59.

44 Homer, ed., *Heart's Gate*, 46.

45 Ibid., 40; see also Phelps, "Green Acre," 58–59.

46 In a provocative pairing of Whitman and Grieg, Hartley advised Traubel, "I think nature is never quite so dramatic as when she is bared to the brow and shows her face in sturdy acceptance of the coming cold and dreariness, with the 'cool unfolding' purples and the deep greens that mingle sedately with it, set off here and there with sketches of mauve white or cream gray. . . . I personally have a great preference for this scheme of coloring and its varying scales of harmony in tone. It is like a strong resonant octave out of Chopin, out of Grieg." Homer, ed., *Heart's Gate*, 57. The words "cool unfolding," set off as they are by quotation marks, seem almost certainly to refer to that section of "When Lilacs Last in the Dooryard Bloom'd" that praises "the fathomless universe, / . . . For the sure-enwinding arms of cool-enfolding death" (*LG* 335). It was not uncommon for Hartley to misquote Whitman, whose verse he frequently cited from memory.

47 See Faner, *Walt Whitman and Opera*, 6.

48 Allen, *The Solitary Singer*, 494.

49 "Thirteenth Annual Convention of the Walt Whitman Fellowship: International, at the Hotel Lafayette-Brevoort, New York, May 31," Walt Whitman Fellowship Papers: Twelfth Year, 3 May 1906, Charles Feinberg Collection, box 52, Library of Congress, Washington, D.C.

50 Marsden Hartley to Horace Traubel, 14 August 1906, Traubel Papers, box 75.

51 Marsden Hartley to Seumas O'Sheel, 25 December 1906, Hartley Papers. In an interesting parallel to Whitman's own trans-genre alliances, just as Whitman had preferred the company of artists during the formative stages of his career, so Hartley preferred the company of writers.

52 Marsden Hartley to Seumas O'Sheel, 19 October 1908, Hartley Papers.

53 Ibid.

54 Hokin, Pinnacles and Pyramids, 18.

55 Marsden Hartley to Alfred Stieglitz, [February 1913], Alfred Stieglitz Papers, Yale Collection of American Literature, Beinecke Rare Book and Manuscript Library, Yale University.

56 [Sadakichi Hartmann], "Unphotographic Paint:— The Texture of Impressionism," Camera Work 28 (October 1909): 20.

57 Sadakichi Hartmann was a prolific writer and critic who wrote frequently on art and photography. For collections of his writings, see Harry W. Lawton and George Knox, eds., Valiant Knights of Daguerre (Berkeley and Los Angeles: University of California Press, 1978), and Jane Calhoun Weaver, ed., Sadakichi Hartmann. Critical Modernist (Berkeley and Los Angeles: University of California Press, 1991). For Hartmann's relationship with Whitman, see Sadakichi Hartmann, Conversations with Walt Whitman (1894; rpt., New York: Gordon Press, 1972), and George Knox, The Whitman-Hartmann Controversy (Bern: Herbert Lang, Frankfurt: Peter Lang, 1976). On the Whitmanic content of Hartmann's early writing, see especially Harry Lawton and George Knox, eds., Buddha, Confucius, Christ: Three Prophetic Plays (New York: Herder and Herder, 1971).

58 In a letter to Seumas O'Sheel written at the beginning of his Green Acre summer, Hartley included Ibsen along with Whitman, Emerson, Maeterlinck, and Poe among those authors who had left the strongest impact on him: "In all these . . . I find expressions of myself—and whatever I do will . . . show the contact with these masters." See Marsden Hartley to Seumas O'Sheel, 11 June 1907, Hartley Papers. Hartley's attraction to Peer Gynt was no doubt stimulated by Margaret Lacey's article "Peer Gynt" in The Conservator 18 (August 1907): 88–89. For a possible connection between Peer Gynt and Ole Bull, see John Bergsagel, "Ole Bull," The New Grove Dictionary of Music and Musicians (London: Macmillan, 1980), 3:447.

59 Much has been written on the importance of music for the development of visual modernism. See, in particular, Donna M. Cassidy, Painting the Musical City: Jazz and Cultural Identity in American Art, 1910–1940 (Washington, D.C.: Smithsonian Institution Press, 1997). See also Judith Zilczer's "'Color Music': Synaesthesia and Nineteenth-Century Sources for Abstract Art," Artibus et Historiae 16, no. 7 (1987): 101–26, and "The Aesthetic Struggle in America, 1913–1918: Abstract Art and Theory in the Stieglitz Circle," (Ph.D. diss., University of Delaware, 1975), 43–110, as well as Howard Risatti, "Music and the Development of Abstraction in America: The Decades Surrounding the Armory Show," Art Journal 39 (Fall 1979): 8–13.

60 Sydney J. Krause, "Whitman, Music, and Proud Music of the Storm," PMLA 72 (September 1957): 710. The poem is briefly analyzed in Helen A. Clarke, "The Relations of Music to Poetry in American Poets," Music 6 (June 1894): 169–71. See also James C. McCullagh, "'Proud Music of the Storm': A Study in Dynamics," Walt Whitman Review 21 (June 1975): 66–73.

61 Horace Traubel, "Preface," in The Book of Heavenly Death, comp. Horace Traubel (Portland: Thomas B. Mosher, 1907), xvii.

62 [Horace] T[raubel], "Nature Thoughts from Walt Whitman," The Conservator 17, no. 3 (1906): 43.

63 Wassily Kandinsky, Concerning the Spiritual in Art, trans. M. T. H. Sadler (1914; rpt., New York: Dover, 1977), 2, 47. Kandinsky's book was first published in Germany as Über das Geistige in der Kunst (1912).

64 Ibid., 17.

65 Quoted in Linda Dalrymple Henderson, "Mysticism, Romanticism, and the Fourth Dimension," in The Spiritual in Art: Abstract Painting, 1890–1985 (New York: Abbeville, 1986), 219.

66 "The New Spiritual America Emerging," Current Literature 46 (February 1909): 180.

67 Carpenter, Days with Walt Whitman, 60. William James concurred, terming Whitman's "a classical expression of this sporadic type of mystical experience." William James, Writings, 1902–1910, ed. Bruce Kuklick (New York: Viking, 1987), 357.

68 Carpenter introduced the term "cosmic consciousness" in From Adam's Peak to Elephanta (London: Swan Sonnenschein; New York: Macmillan, 1892).

69 Carpenter, Days with Walt Whitman, 55.

70 Bucke, Cosmic Consciousness, 225. Bucke credited Whitman with having precipitated his own illumination (9–11).

71 Marsden Hartley to Alfred Stieglitz, 22 October 1913, Stieglitz Papers; Marsden Hartley to Gertrude Stein, 18 October 1913, Gertrude Stein Papers, Yale Collection of American Literature, Beinecke Rare Book and Manuscript Library, Yale University.

72 Patricia McDonnell, ed., "Marsden Hartley's Letters to Franz Marc and Wassily Kandinsky, 1913–1914," Archives of American Art Journal 29, nos. 1–2 (1989): 40. The line should read: "I do not doubt interiors have their interiors, and exteriors have their exteriors, and that the eyesight has another eyesight, and the hearing another hearing, and the voice another voice" (LG 448). Hartley headlined the essay that accompanied his second exhibition at Stieglitz's gallery with this same passage.

Marsden Hartley, "Exhibitions at '291,'" *Camera Work*, no. 45 [dated January 1914, published June 1914]: 17.

73 The Segantini material appeared in *Jugend* 3 (1903): 34–41. Hartley wrote two essays on Segantini: "Giovanni Segantini—Painter of Mountains—Worshipper of Nature," Hartley Papers, and "On the Subject of the Mountain: Letter to Messieurs Segantini and Hodler" (1932), reproduced in Hokin, *Pinnacles and Pyramids*, 136. In the latter Hartley credited Segantini with having given him "my first true insight into the mountain in general, and my own mountains in particular." In the ensuing years Hartley would locate many of these same features in the art of Cézanne. In "Giovanni Segantini—Painter of Mountains—Worshipper of Nature," Hartley declared Segantini to be working "with the same spirit directing him . . . that controlled Cézanne." See also Marsden Hartley, "Whitman and Cézanne," *Adventures in the Arts* (1921; rpt., New York: Hacker Art Books, 1972), 30–36.

74 Hartley, "On the Subject of the Mountain," 136.

75 Homer, ed., *Heart's Gate*, 24. Kandinsky concurred with Hartley's construction of Segantini as a painter of the spiritual by means of the material. Kandinsky, *Concerning the Spiritual in Art*, 17.

76 Homer, ed., *Heart's Gate*, 24.

77 Marsden Hartley, "Pictures" (1941), reproduced in *On Art*, ed. Gail R. Scott (New York: Horizon Press, 1982), 118.

78 Robert K. Martin, *The Homosexual Tradition in American Poetry* (Austin: University of Texas, 1979), 15.

79 M. Jimmie Killingsworth, *Whitman's Poetry of the Body* (Chapel Hill: University of North Carolina Press, 1989), 41. It would be instructive to evaluate Hartley's *Christ Held by Half-Naked Men* (1940–41) and other of his studies of bare-chested men in light of this connection.

80 Quentin Anderson, "Whitman's New Man," in *Walt Whitman: Walt Whitman's Autograph Revision of the Analysis of Leaves of Grass (for Dr. R. M. Bucke's Walt Whitman)* (New York: New York University Press, 1974), 35.

81 Marsden Hartley to Alfred Stieglitz, 28 September 1913, Stieglitz Papers.

82 "Walt Whitman Fellowship: International: Program for the Thirteenth Annual Meeting at Hotel Brevoort, New York, May 31," Walt Whitman Fellowship Papers: Thirteenth Year, 31 May 1907, Charles Feinberg Collection, box 52.

83 Marsden Hartley, "The Mystical Forest," in *Collected Poems*, 37.

84 Walter Grünzweig, *Constructing the German Walt Whitman* (Iowa City: University of Iowa Press, 1995).

85 Patricia McDonnell, "American Artists in Expressionist Berlin: Ideological Crosscurrents in the Early Modernism of America and Germany, 1905–1915" (Ph.D. diss., Brown University, 1991), 177–78.

86 Marsden Hartley to Alfred Stieglitz, [May 1913], Stieglitz Papers.

87 Marsden Hartley to Alfred Stieglitz, August 1913, Stieglitz Papers.

88 Marsden Hartley to Alfred Stieglitz, [May 1913].

89 Although the "Children of Adam" poems celebrated heterosexual love, the poems generated more controversy during the nineteenth century than the homosexual poems in the "Calamus" cluster.

90 W. T. Stace, *Mysticism and Philosophy* (London: Macmillan, 1960), 62–80, 85–123, distinguishes between "extrovertive mysticism" and "introvertive mysticism," which is perceived through the mind rather than the senses.

91 Zweig, *Walt Whitman: The Making of the Poet*, 175.

92 Binns, *A Life of Walt Whitman*, 94. Hartley read Binns's biography in May 1906.

93 McDonnell, ed., "Marsden Hartley's Letters to Franz Marc," 38.

94 Carpenter, *Days with Walt Whitman*, 65. Hartley criticized the mysticism of the Swamis for not being more physical.

Chapter 7

1 Benjamin De Casseres, "Enter Walt Whitman," *The Philistine* 25, no. 6 (1907): 162.

2 Wolff, "Walt Whitman," 66.

3 "Walt Whitman as Musical Prophet," *Musical America* 22 (3 July 1915): 18.

4 Thomas Mufson, "Walt Whitman, Poet of the New Age," *Twentieth Century Magazine* 2 (July 1910): 330, 328.

5 George Santayana, "Walt Whitman: A Dialogue," *The Harvard Monthly* 10, no. 3 (1890): 87.

6 Louis I. Bredvold, "Walt Whitman," *The Dial* 53 (1 November 1912): 325.

7 Pfaff's Beer Hall, at 653 Broadway, was demolished in the 1890s. On Greenwich Village in the early twentieth century, see Rick Beard and Leslie Cohen Berlowitz, eds., *Greenwich Village: Culture and Counterculture* (New Brunswick, N.J.: Published for the Museum of the City of New York by Rutgers University Press, 1993); Steven Watson, *Strange Bedfellows: The First American Avant-Garde* (New York: Abbeville Press, 1991); Arthur Frank Wertheim, *The New York Little Renaissance* (New York: New York University Press, 1976); and Caroline Ware, *Greenwich Village, 1920–1930* (Boston: Houghton Mifflin, 1935).

8 Alfred Kreymborg hailed Kennerley as "the white hope among publishers" in *Troubadour* (New York: Boni and Liveright, 1925), 199.

9 See Matthew J. Bruccoli, *The Fortunes of Mitchell Kennerley, Bookman* (San Diego: Harcourt Brace Jovanovich, 1986), 285–86. "With Walt Whitman in Camden," *Forum* 46 (October 1911): 400–414; 46 (November 1911): 589–600; 46 (December 1911):

709–19; 47 (January 1912): 78–89; 54 (July 1915): 77–85; 54 (August 1915): 187–99; 54 (September 1915): 318–27.

10 Keller, *Walt Whitman in Mickle Street.*

11 Yoné Noguchi, quoted in Paul Hanna, "Horace Traubel, Democrat," *Forum* 50 (November 1913): 719.

12 The two biographies are Bain, *Horace Traubel,* and William English Walling, *Whitman and Traubel* (New York: Albert and Charles Boni, 1916). A third biography, Karsner's *Horace Traubel: His Life and Work,* was published three years later by Egmont Arens. *Chants Communal* was first published in 1904.

13 Kreymborg, *Troubadour,* 208, and "Traubel— American: A Notable Figure Article," *New York Morning Telegraph,* 31 May 1914; Horace Traubel, "Collects," *Glebe* 2 (1914). B. W. Huebsch issued Traubel's *Optimos* in 1910.

14 In 1915 the Chicago dinner attracted some 350 people. John L. Hervey, "Communications: The Growth of the Whitman 'Legend,'" *The Dial* 59 (24 June 1915): 12. For a brief history of the organization, whose papers are in the Whitman Feinberg Collection at the Library of Congress, see William White, "The Walt Whitman Fellowship: An Account of Its Organization and a Checklist of Its Papers," *Papers of the Bibliographical Society of America* 51 (1957): 67–84.

15 Traubel also solicited the participation of Robert Henri and John Sloan, both of whom shared Traubel's socialist proclivities.

16 [Horace] T[raubel], "Stieglitz Snapshots," *The Conservator* 23, no. 5 (1912): 76–77, reprinted as "Horace Traubel on Photography," *Camera Work* 46 (April 1914, published October 1914): 49–50. See also [Horace] T[raubel], "Stieglitz," *The Conservator* 27, no. 10 (1916): 137, and [Horace] T[raubel], "What Is '291'?" *The Conservator* 26, no. 1 (1915): 13. Traubel also invited Stieglitz to a birthday dinner in his honor at the Union Square Hotel in December 1915. See "Four Letters," *The Conservator* 26, no. 11 (1916): 167.

17 Stieglitz began to embrace Whitman only in the 1920s, after the demise of both 291 and *Camera Work.*

18 On Coady, see Judith Zilczer, "Robert J. Coady, Forgotten Spokesman for Avant-Garde Culture in America," *The American Art Review* 2, no. 6 (1975): 77–89, and "Robert J. Coady, Man of *The Soil,*" in *New York Dada,* ed. Rudolf E. Kuenzli (New York: Willis Locker and Owens, 1986), 31–43. See also Robert Alden Sanborn, "A Champion in the Wilderness," *Broom* 3 (October 1922): 174–79, and Dickran Tashjian, *Skyscraper Primitives: Dada and the American Avant-Garde, 1910–1925* (Middletown, Conn.: Wesleyan University Press, 1975), 71–90.

19 Ezra Pound, "What I Feel About Walt Whitman," in *Walt Whitman: The Measure of His Song,* ed. Perlman, Folsom, and Campion, 30.

20 Originally located at 46 Washington Square South, the gallery later moved next door to No. 47. In 1916 Coady contemplated opening a branch gallery in Washington, D.C., but he quickly abandoned the idea. Leila Mechlin, "News and Notes of Art and Artists," *Washington Star,* 12 March 1916. Brenner, like Coady, had studied at the Art Students' League and was a regular visitor at the Parisian salon of Gertrude and Leo Stein. Catherine Turrill, "Michael Brenner (1885–1969)," in *Avant-Garde Painting and Sculpture in America, 1910–1925* (Wilmington: Delaware Art Museum, 1975), 36. After Coady's death, Stein memorialized the pair in one of her enigmatic word portraits, "My Dear Coady and Brenner (1923)," in *Painted Lace and Other Pieces (1914–1937)* (New Haven: Yale University Press, 1955), 291–92.

21 Paul B. Haviland, "The Home of the Golden Disk," *Camera Work* 25 (January 1909): 21.

22 Alfred Kreymborg, "The New Washington Square," *New York Morning Telegraph,* 6 December 1914. Whitman, too, saw value in artistic reproductions in the democratizing process. See especially his comments in Rodgers and Black, eds., *Gathering of the Forces,* 2:363.

23 Edward Storer, "The Country Walk," *Greenwich Village* 2 (30 September 1915): 166–67; Sadakichi Hartmann, "Sadakichi and Walt Whitman," *Greenwich Village* 3 (November 1915): 19–22; and [Ferdinand Freiligrath], "Walt Whitman: A German Appreciation in 1868," *Greenwich Village* 1 (28 April 1915): 55–56. In 1919, the one hundredth anniversary of Whitman's birth, Bruno made a pilgrimage to Whitman's Mickle Street residence. A letter commemorating this event was published in Guido Bruno, *The Sacred Band: A Litany of Ingratitude* (New York: Guido Bruno, 1921), and reprinted in Keller, *Walt Whitman in Mickle Street,* 195–206.

24 Casey Nelson Blake, *Beloved Community* (Chapel Hill: University of North Carolina Press, 1990), 123. French critic Romain Rolland praised Whitman in the journal's first issue, hailing his as "the elemental Voice of a great pioneer," and the following year *Seven Arts* published an excerpt from volume 4 of *With Walt Whitman in Camden.* Romain Rolland, "America and the Arts," trans. Waldo Frank, *Seven Arts* 1 (November 1916): 51; Horace Traubel, "With Walt Whitman in Camden," *Seven Arts* 2 (September 1917): 627–37.

25 Van Wyck Brooks, *America's Coming-of-Age,* in *Van Wyck Brooks: The Early Years,* ed. Claire Sprague (New York: Harper and Row, 1968), 128.

26 Van Wyck Brooks, *The Wine of the Puritans,* in *Van Wyck Brooks: The Early Years,* ed. Sprague, 27.

27 Ibid., 57.

28 Henry McBride, "'The Soil,' a Magazine of American Art," *New York Sun,* 17 December 1916.

29 Robert Coady to John Quinn, 20 March 1916, John Quinn Memorial Collection, Manuscripts and

Archives Division, The New York Public Library, Astor, Lenox and Tilden Foundations.

30 John Quinn to Robert Coady, 22 March 1916, Quinn Memorial Collection.

31 Robert J. Coady, quoted in the *New York Sun*, Henry McBride Papers, roll N69-98, frame 667, Archives of American Art, Smithsonian Institution, Washington, D.C.

32 Kreymborg, *Troubadour*, 202.

33 R[obert] J. Coady, "American Art," *The Soil* (December 1916): 3–4.

34 R[obert] J. Coady, "American Art," *The Soil* (January 1917): 54–55.

35 Coady, "American Art," *The Soil* (December 1916): 3–4. *The Soil*'s inaugural issue proved so popular that it had to be reprinted to meet the demand. "To Our Readers," *The Soil* (March 1917): 101. Robert Alden Sanborn recalled that five thousand copies were sold to individuals as far away as Europe, South America, and the Orient, although this figure seems implausibly high. Sanborn, "A Champion in the Wilderness," 174.

36 Each issue of *The Soil* concluded with a list of some fifty books and pamphlets for sale through Coady's gallery. Here, too, the list maps the diversity of Whitman's catalogues. In addition to *Leaves of Grass*, items for sale included copies of *The Excavating Engineer*, *Boxing Record*, Plato's *Republic*, two works by Gertrude Stein, the Deadwood Dick series of detective novels, W. H. Davies's *Autobiography of a Super Tramp*, and several volumes by Whitman's friend John Burroughs.

37 Sanborn, "A Champion in the Wilderness," 176–77.

38 William R. Taylor, *In Pursuit of Gotham: Culture and Commerce in New York* (New York: Oxford University Press, 1992), 70.

39 Quoted in Ruth L. Bohan, "'I Sing the Body Electric': Isadora Duncan, Whitman and the Dance," in *The Cambridge Companion to Walt Whitman*, ed. Greenspan, 173.

40 In April 1917 Coady showed *A Daughter of the Gods* at the Grand Central Palace, which was hosting the Society of Independent Artists exhibition. Watson, *Strange Bedfellows*, 316–17.

41 J. B., "Annette Kellermann [*sic*]," *The Soil* (March 1917): 112–13.

42 Charlie Chaplin, "Making Fun," *The Soil* (December 1916): 5–7.

43 Mr. Rothstein, quoted in Adam Hull Shirk, "The Dime Novel as Literature," *The Soil* (December 1916): 39.

44 R[obert] C[oady], "The Stampede," *The Soil* (December 1916): 24.

45 Michael Denning, *Mechanic Accents: Dime Novels and Working-Class Culture in America* (London: Verso, 1987), 22.

46 Holloway, ed., *Uncollected Poetry and Prose*, 1:xi.

47 Brooks, *America's Coming-of-Age*, 130. Harrison Reeves, "Les epopées populaires américaines," *Les soirées de Paris* 22 (15 March 1914): 171.

48 Miriam Hansen, *Babel and Babylon: Spectatorship in American Silent Film* (Cambridge, Mass.: Harvard University Press, 1991), 199–217, 338. Vachel Lindsay, *The Art of the Moving Picture* (1915; rpt., New York: Liveright, 1970), 93–95. In 1913 Whitman's own life became the focus of a motion picture based on William O'Connor's short story "The Carpenter." Florence B. Freedman, " A Motion Picture 'First' for Whitman: O'Connor's 'The Carpenter,'" *The Walt Whitman Review* 9 (June 1963): 31–34. Whitman was himself very kindly disposed toward actors. In *With Walt Whitman in Camden*, 1:5–6, reissued just prior to the launching of *The Soil*, Whitman affirmed: "These actor people always make themselves at home with me and always make me easily at home with them. I feel rather close to them—very close—almost like one of their kind."

49 C. L. R. James, *American Civilization* (Cambridge: Blackwell, 1993), 35. See also Constance Rourke, *American Humor: A Study of the National Character* (1931; rpt., Tallahassee: Florida State University Press, 1986), 175.

50 George W. Vos, letter to R. J. Coady, *The Soil* (December 1916): 17.

51 Sanborn, "A Champion in the Wilderness," 176, 175.

52 Ibid., 178.

53 Robert J. Coady, "Three Unpublished Letters," *The Guardian* 2 (August 1925): 373.

54 *The Forum Exhibition of Modern American Painters* (New York: Anderson Galleries, 1916), 5.

55 The other artists were Ben Benn, Thomas Hart Benton, Oscar Bluemner, Andrew Dasburg, Arthur Dove, Alfred Maurer, Henry L. McFee, George F. Of, Morgan Russell, Abraham Walkowitz, and William and Marguerite Zorach. Marguerite Zorach, the only woman artist, was excluded from the catalogue.

56 Coady sent a letter to Henry McBride complaining about the exhibition and the claims of its organizers. His letter and a reply from Willard Huntington Wright were published in "Current News of Art and the Exhibitions," *New York Sun*, 12 March 1916. A second letter from Coady was published later that week. Undated newspaper clipping, *New York Sun*, McBride Papers, roll N69-98, frame 667.

57 Coady, "American Art," *The Soil* (January 1917): 54.

58 Quoted in *The Soil* (December 1916): [after 18].

59 Ibid. In a later issue *The Soil* reiterated much the same idea, using photographs of the extravagantly lighted display windows of Monroe Clothes at Broadway and Forty-second Street. In obvious reference to McGowan's earlier comments, the caption stressed the display's emphasis on "solid common sense." It took an additional swipe at Joseph Stella's large and wildly colorful abstract painting *Battle of Lights, Coney Island, Mardi Gras* (1913), (see fig 96) claiming that these windows constituted "the real 'battle of lights.'" See *The Soil* (July 1917): [after 210]. On the increasing importance of window displays in the early twentieth century and of their

distinctly American characteristics, see William Leach, "Strategists of Display and the Production of Desire," in *Consuming Visions*, ed. Simon J. Bronner (New York: W. W. Norton, 1989), 99–132.

60 Coady, "The Stampede," [after 24]. In the following issue, Coady constructed another witty pairing, this time pitting Morgan Russell's abstraction *Cosmic Synchromy*, also reproduced from the Forum Exhibition catalogue, against an egg by one A. Chicken, which bore the pompous title *Invention-Nativity*. A. Chicken's statement of purpose read simply, "Cluck, cluck." *The Soil* (January 1917): [after 66]. The sequence was all the more humorous given the formal similarity between the egg and Constantin Brancusi's *Sculpture for the Blind* (1916), which had recently been exhibited at the Modern Gallery. Sidney Geist, *Brancusi: The Sculpture and Drawings* (New York: Harry N. Abrams, 1975), 181.

61 Whitman's poetry elicited divergent, often conflicting responses from this generation of modernist practitioners. Despite Hartley's own intense engagement with Whitman's verse, Coady reviled Hartley's paintings. The March 1917 issue of *The Soil* reproduced one of Hartley's cosmic abstractions (after p. 138) only to demonstrate its inferiority to a child's collage .

62 In 1920, Cleveland Rodgers and John Black edited *The Gathering of the Forces*, a collection of Whitman's writings from the *Brooklyn Daily Eagle*. The following year Emory Holloway published *The Uncollected Poetry and Prose of Walt Whitman*, which included additional journalistic writings.

63 Quoted in J. B., "Bert Williams," *The Soil* (December 1916): 19.

64 Robert Alden Sanborn, "The Fight," *The Soil* (January 1917): 67.

65 Enrique Cross, "A Friend," *The Soil* (March 1917): 135–36.

66 J. B., "Tugs," *The Soil* (March 1917): 126–27.

67 *The Soil* (December 1916): 25, 7; (January 1917): 73.

68 Basil De Selincourt, *Walt Whitman: A Critical Study* (1914; rpt., New York: Russell and Russell, 1965), 122.

69 Ibid., 139.

70 Ibid., 148.

71 Kreymborg, who had earlier reviewed Coady's gallery, recalled that "most of the 'boys' [at *Others*] were in favor" of aligning the two publications, but after careful consideration he decided against it. Kreymborg, *Troubadour*, 263–64; "The New Washington Square," 1, 3.

72 Arthur Cravan, ["Sifflet"], *The Soil* (December 1916): [36], originally published in *Maintenant* 1 (April 1912): [1]-4.

73 George Simpson, quoted in "The Woolworth Building," *The Soil* (January 1917): 61.

74 Lindsay, *The Art of the Moving Picture*, 93–94.

75 Paula Marantz Cohen, *Silent Film and the Triumph of the American Myth* (New York: Oxford University Press, 2001), 38. For additional connections between Whitman and modern cinema, see Kenneth M. Price, "Walt Whitman at the Movies: Cultural Memory and the Politics of Desire," in *Whitman East and West: New Contexts for Reading Walt Whitman*, ed. Ed Folsom and Gay Wilson Allen (Iowa City: University of Iowa Press, 2002), 36–70; Graham Clarke, *Walt Whitman: The Poem as Private History* (New York: St. Martin's Press, 1991), 142–50; and Alice Ahlers, "Cinematographic Technique in *Leaves of Grass*," *Walt Whitman Review* 12 (December 1966): 93–97.

76 Robert Coady, "Censoring the Motion Picture," *The Soil* (December 1916): 37.

77 Robert Allerton Parker, "The Art of the Camera: An Experimental 'Movie,'" *Arts and Decoration* 15 (October 1921): 369. For more recent assessments of the film, see Jan-Christopher Horak, "Modernist Perspectives and Romantic Desire: Manhatta," *Afterimage* 15 (November 1987): 8–15; Theodore E. Stebbins Jr. and Norman Keyes Jr., *Charles Sheeler: The Photographs* (Boston: Museum of Fine Arts, 1987), 15–23; and Scott Hammen, "Sheeler and Strand's 'Manhatta': A Neglected Masterpiece," *Afterimage* 6 (January 1979): 6–7.

78 In July 1918, more than a year after *The Soil* published its last issue, Coady wrote Katherine Dreier, the future founder of the Société Anonyme, that he was hoping to revive *The Soil*—perhaps as a quarterly. "I have several plans for *The Soil*," he wrote, "and have not decided which to adopt." His plans never materialized and no further issues appeared. Robert Coady to Katherine Dreier, 22 July 1918, Katherine S. Dreier Papers/Société Anonyme Archive, Yale Collection of American Literature, Beinecke Rare Book and Manuscript Library.

79 Henry McBride, "First Aid to Artists from the 'Soil,'" *New York Sun*, 11 March 1917. McBride also discussed *The Soil* in "'The Soil,' a Magazine of American Art," 17 December 1916; "Notes and Activities in the World of Art," 29 April 1917; "Notes and Activities in the World of Art," 13 May 1917; and "News and Comments in the World of Art," 8 July 1917.

80 Marcel Duchamp to Suzanne Duchamp, 20 October [c. 1920], Jean Crotti Papers, roll 2394, frame 158, Archives of American Art, Smithsonian Institution, Washington, D.C.

81 William Carlos Williams, "America, Whitman, and the Art of Poetry," *Poetry Journal* 8 (November 1917): 33–34.

82 Harry Alan Potamkin, "Memoranda," *The Guardian* 2 (October 1925): 466.

83 Gorham B. Munson, "The Skyscraper Primitives," *The Guardian* 1 (March 1925): 169; Kreymborg, *Troubadour*, 210.

84 Arnold Rönnebeck, "Through the Eyes of a European Sculptor," in *Alfred Stieglitz Presents Seven Americans* (New York: Anderson Galleries, 1925), reprinted in Barbara Buhler Lynes, *O'Keeffe, Stieglitz, and the Critics, 1916–1929* (Chicago: University of Chicago Press, 1989), 223.

1 On Whitman's reception abroad, see Grünzweig, *Constructing the German Walt Whitman*; Gay Wilson Allen and Ed Folsom, eds., *Walt Whitman and the World* (Iowa City: University of Iowa Press, 1995); Erkkila, *Walt Whitman Among the French*; Gay Wilson Allen, *The New Walt Whitman Handbook* (New York: New York University Press, 1975); Gay Wilson Allen, ed., *Walt Whitman Abroad* (Syracuse, N.Y.: Syracuse University Press, 1955); and Blodgett, *Walt Whitman in England*.

2 Robert McAlmon, *Being Geniuses Together* (1968; rpt., San Francisco: North Point Press, 1984), 136. On Whitman's appeal to immigrants, see also Raffaello Piccoli, "As an Italian Sees It," in *Civilization in the United States*, ed. Harold E. Stearns (1922; rpt., Westport, Conn.: Greenwood Press, 1971), 523; George Santayana, "The Poetry of Barbarism II: Walt Whitman," in *Santayana on America*, ed. Richard Colton Lyon (New York: Harcourt, Brace and World, 1968), 295–97; and Winifred Kirkland, "Americanization and Walt Whitman," *The Dial* 66 (31 May 1919): 537–39.

3 Charlotte Leon Mayerson, ed., *Shadow and Light: The Life, Friends, and Opinions of Maurice Sterne* (New York: Harcourt, Brace and World, [1965]), 25–32.

4 *With Walt Whitman in Camden*, 2:281–82.

5 Hartmann, *Conversations with Walt Whitman*, 8.

6 By the second decade of the twentieth century, the number of artists active in New York who were either born or trained abroad increased dramatically. In addition to Stella, immigrant contributors to American modernism included painters Abraham Walkowitz, Max Weber, Louis Lozowick, and Maurice Sterne (Russia); Oscar Bluemner and Konrad Cramer (Germany); Jan Matulka (Bohemia, in what is now the Czech Republic); Yasuo Kuniyoshi (Japan); Gaston Lachaise (France); sculptors William Zorach (Lithuania) and Elie Nadelman (Poland); and caricaturist Marius de Zayas (Mexico). For a discussion of the immigrant contribution to American modernism, see especially Cynthia McCabe, *The Golden Door: Artist-Immigrants of America, 1876–1976* (Washington, D.C.: Published for the Hirshhorn Museum and Sculpture Garden by the Smithsonian Institution Press, 1976); see also *Avant-Garde Painting and Sculpture in America, 1910–1925*.

7 Charles S. Grippi, "The Literary Reputation of Walt Whitman in Italy," (Ph.D. diss., New York University, 1971), 91–92. Stella first read Whitman while a student at the Liceo Umberto I in Naples. Carlo de Fornaro, "Joseph Stella: Outline of the Life, Work, and Times of a Great Master," unpublished manuscript, New York, 1939, [1]-2.

8 De Fornaro, "Joseph Stella," 13–14. Two additional de Fornaro caricatures—a watercolor based on Whitman's famous "Butterfly" photograph, and the cover of Henry Hope Saunder's *Whitman Parodies* (1921)—are in the Rare Book Room at the Library of Congress.

9 Quoted in Rebecca Zurier, "Picturing the City: New York in the Press and the Art of the Ashcan School, 1890–1917" (Ph.D. diss., Yale University, 1988), 22. Guy Pène du Bois, another Henri student, characterized Henri's class as a "seat of sedition among the young." Quoted in Joseph J. Kwiat, "Robert Henri and the Emerson-Whitman Tradition," in *Studies in American Culture*, ed. J. J. Kwiat and Mary C. Turpie (Minneapolis: University of Minnesota Press, 1960), 160.

10 Robert Henri, "A Practical Talk to Those Who Study Art," *Philadelphia Press*, 12 May 1901. A slight variant of this statement appears in Robert Henri, *The Art Spirit* (1923; rpt., Philadelphia: J. B. Lippincott, 1960), 84.

11 Quoted in Garnett McCoy, "Reaction and Revolution, 1900–1930: The Artist Speaks: Part Four," *Art in America* 53 (August–September 1965): 70. See also Zurier, "Picturing the City," 21–70.

12 Stella lived on the Lower East Side until about 1909 and modeled his representation of the protagonist Dago Joe in Ernest Poole's documentary novel, *The Voice of the Street* (1906), on his own self-portrait.

13 Joseph Stella, "Autobiographical Notes," in Barbara Haskell, *Joseph Stella* (New York: Whitney Museum of American Art, 1994), 212.

14 Ibid.

15 Ibid.

16 Erkkila, *Walt Whitman Among the French*, 164, 141.

17 Ibid., 142.

18 Stella, "Autobiographical Notes," 212.

19 Ibid. For a contemporary account of the Whitman emphasis at Closerie des Lilas, see Sterling Heilig, "The Home of the Cubists," *Chicago Record-Herald*, 13 April 1913.

20 See Erkkila, *Walt Whitman Among the French*, 100–101.

21 Haskell, *Joseph Stella*, 191.

22 F. T. Marinetti, "We Abjure Our Symbolist Masters, the Last Lovers of the Moon," in *Marinetti: Selected Writings*, ed. R. W. Flint (New York: Farrar, Straus and Giroux, 1972), 68. In the introduction, Flint characterized Marinetti as Whitman's "first important Italian disciple" (6).

23 Francis Picabia, "'How New York Looks to Me,'" *New York American*, 30 March 1913.

24 "Picabia, Art Rebel, Here to Teach New Movement," *New York Times*, 16 February 1913, quoted in William A. Camfield, *Francis Picabia: His Art, Life, and Times* (Princeton: Princeton University Press, 1979), 43.

25 See John Oliver Hand, "Futurism in America: 1909–14," *Art Journal* 41 (Winter 1981): 337–42,

and Margaret R. Burke, "Futurism in America, 1910–1917" (Ph.D. diss., University of Delaware, 1986). Futurist art was not shown in this country until May 1915, when forty-seven paintings and two sculptures were exhibited at the Panama-Pacific Exposition in San Francisco. See John E. D. Trask and J. Nilson Laurvik, eds., *Catalogue De Luxe of the Department of Fine Arts, Panama-Pacific International Exposition*, vol. 2 (San Francisco: P. Elder, 1915). The individual in charge of the display was Christian Brinton, son of Daniel Garrison Brinton, a noted anthropologist and one of Whitman's supporters in the 1880s and 1890s.

26 Joseph Stella, "The New Art," *The Trend* 5 (June 1913): 394.

27 Quoted in Irma B. Jaffe, *Joseph Stella* (Cambridge, Mass.: Harvard University Press, 1970), 30.

28 Stella, "The New Art," 395.

29 Benjamin De Casseres, "The Renaissance of the Irrational," *Camera Work*, special number (June 1913): 23. This was one of the rare mentions of Whitman in *Camera Work*. Several years earlier De Casseres characterized Whitman as "the most significant man who has yet walked the earth." Benjamin De Casseres, "Walt Whitman," *The Fra* 2 (March 1909): 94.

30 Horace Traubel to Robert Henri, 16 May 1913, Robert Henri Papers, Yale Collection of American Literature, Beinecke Rare Book and Manuscript Library, Yale University.

31 Pontus Hultén, ed., *Futurism and Futurisms* (New York: Abbeville, 1986), 471. Marinetti first lectured in London in 1910.

32 De Selincourt, *Walt Whitman: A Critical Study*, 232, 135, 154. Mitchell Kennerley was the book's original New York publisher.

33 "A Futurist of the Sixties," *The Living Age* 281 (18 April 1914): 179.

34 Herman Scheffauer, "Whitman in Whitman's Land," *North American Review* 201 (15 February 1915): 210.

35 Stella, "Autobiographical Notes," 213. De Fornaro parodied both the amply proportioned Stella and his oversized painting in "Seeing New York with Fornaro," a cartoon published in the *New York Evening Sun*, 9 February 1914.

36 Before moving to New York, the Arensbergs had lived at Shady Hill, an estate formerly owned by noted Dante scholar Charles Eliot Norton, who in 1855 had published one of the most perceptive early reviews of *Leaves of Grass*. See "Whitman's *Leaves of Grass*," *Putnam's* 6 (September 1855): 321–23. For additional information on Arensberg, see Francis M. Naumann, "Walter Conrad Arensberg: Poet, Patron, and Participant in the New York Avant-Garde, 1915–20," *Philadelphia Museum of Art Bulletin* 76 (Spring 1980): 2–32, and *New York Dada, 1915–1923* (New York: Harry N. Abrams, 1994), 22–33. See also *The Louise and Walter Arensberg Collection* (Philadelphia:

Philadelphia Museum of Art, 1954). The Arensbergs owned Stella's *Chinatown*, a work now in the collection of the Philadelphia Museum of Art.

37 Wanda M. Corn, *The Great American Thing: Modern Art and National Identity, 1915–1935* (Berkeley and Los Angeles: University of California Press, 1999), 50.

38 Guillaume Apollinaire, "The New Spirit and the Poets," in *Selected Writings of Guillaume Apollinaire*, trans. Roger Shattuck (New York: New Directions, 1971), 236.

39 Duchamp's *Nude Descending a Staircase* was itself inspired by a Laforgue poem.

40 See Marsden Hartley, "America as Landscape," *El Palacio* 5 (21 December 1918): 340–42. A few years later he would explore the commonalities between Whitman and Cézanne in *Adventures in the Arts*, 30–36.

41 See Bohan, "'I Sing the Body Electric,'" 166–93.

42 Rolland, "America and the Arts," 47, 48, 50, 51.

43 Henri-Pierre Roché, "The Blind Man," *The Blindman* 1 (10 April 1917): 6. Stella was one of the founding directors of the Society of Independent Artists and an exhibitor in the 1917 exhibition.

44 Williams, "America, Whitman, and the Art of Poetry," 30–31.

45 Joseph Stella, "For the American Painting," in Haskell, *Joseph Stella*, 210–11.

46 Stella, "The Brooklyn Bridge (A Page of My Life)," in Haskell, *Joseph Stella*, 206. In 1928 this essay was published separately as a pamphlet and reprinted in *transition* 16–17 (June 1929): 86–88.

47 Stella's six oil paintings of the bridge are *Brooklyn Bridge*, 1919–20 (Yale University Art Gallery), *The Bridge* from *The Voice of the City of New York Interpreted*, 1920–22 (The Newark Museum); *American Landscape*, 1929 (Walker Art Center, Minneapolis); *Bridge*, 1936 (San Francisco Museum of Modern Art); *The Brooklyn Bridge: Variation on an Old Theme*, 1939 (Whitney Museum of American Art), and *Old Brooklyn Bridge*, 1941 (Museum of Fine Arts, Boston).

48 Stella, "The Brooklyn Bridge (A Page of My Life)," 206.

49 Jaffe, *Joseph Stella*, 119.

50 Handwritten fragment, Joseph Stella Papers, roll 346, Archives of American Art, Smithsonian Institution, Washington, D.C.

51 In 1876 both the torch-bearing arm and the crown-covered head of the Statue of Liberty were among the thousands of items exhibited at the Philadelphia Centennial Exhibition, which Whitman visited several times. Stella was doubtless also familiar with Roebling's three bridge projects in Pittsburgh, including the Allegheny Bridge from 1860, another suspension bridge.

52 Stella, "The Brooklyn Bridge (A Page of My Life)," 206. On the musical component in Stella's art, see Cassidy, *Painting the Musical City*, 37–68.

53 Stella, "Autobiographical Notes," 212.

54 Stella, "The Brooklyn Bridge (A Page of My Life)," 206.

55 Joseph Stella, "Pittsburgh Notes," in Haskell, *Joseph Stella*, 204.

56 Stella, "The Brooklyn Bridge (A Page of My Life)," 206.

57 Ibid.

58 Stella was not alone in associating Whitman with symbols of flight. During these same years, the American sculptor John Storrs was planning a monument to Whitman based on the winged figure of Pegasus. Noel Frackman, *John Storrs* (New York: Whitney Museum of American Art, 1986), 30–37.

59 John Sloan, *John Sloan's New York Scene*, ed. Bruce St. John (New York: Harper and Row, 1965), 428.

60 Arthur Geffen, "Silence and Denial: Walt Whitman and the Brooklyn Bridge," *Walt Whitman Quarterly Review* 1, no. 4 (1984): 9, 7.

61 Stella, "The Brooklyn Bridge (A Page of My Life)," 206. For discussions of the "dark" side of Whitman's poem, see especially Thomas, *The Lunar Light of Whitman's Poetry*, 92–116, and Moon, *Disseminating Whitman*, 105–13.

62 Joseph Stella, "Life Notes," in Haskell, *Joseph Stella*, 204. In *Man in Elevated (Train)*, 1918 (Washington University Gallery of Art, St. Louis), a collaged, reverse painting on glass, Stella represented himself riding one of the city's elevated trains. See Ruth L. Bohan, "Joseph Stella's *Man in Elevated (Train)*," in *Dada/Dimensions*, ed. Stephen C. Foster (Ann Arbor: UMI Research Press, 1985), 187–219.

63 In "The Brooklyn Bridge at 100," *Art in America* 71 (Summer 1983): 145, Martin Filler characterized the Brooklyn Bridge as the "world's one great anthropocentric bridge."

64 *Prose Works 1892*, 2:376, 388.

65 Stella, "The Brooklyn Bridge (A Page of My Life)," 206.

66 Ibid., 207.

67 A difference between "Crossing Brooklyn Ferry" and Stella's painting, of course, is that the poem's crossing takes place at sundown, not at night.

68 *Dionysian* 1 (1915): n.p, published in conjunction with Duncan's appearance at the Metropolitan Opera House, associated her dance with the spiritual journey of the soul as projected in the poem's lines: "O we can wait no longer, / We too take ship, O soul, / Joyous we too launch out on trackless seas, / Fearless for unknown shores." On Apollinaire, see Erkkila, *Walt Whitman Among the French*, 204.

69 Stanley K. Coffman Jr., "Form and Meaning in Whitman's 'Passage to India,'" *PMLA* 70 (June 1955): 339.

70 Stella, "Interview with Bruno Barilli," in Haskell, *Joseph Stella*, 208. Kenneth M. Price, *Whitman and Tradition: The Poet in His Century* (New Haven: Yale University Press, 1990), 147, notes additional connections between Whitman and Dante in the work of poets Ezra Pound, Edwin Markham, and Muriel Rukeyser. Of related interest is the fact that Walter Arensberg had spent much of his first trip to Italy translating Dante's *Divine Comedy* into English.

71 Joseph Stella, "New York," in Haskell, *Joseph Stella*, 219.

72 Anne Gilchrist, "A Woman's Estimate of Walt Whitman," 3–4.

73 Stella, "New York," 219.

74 Stella, "Autobiographical Notes," 213.

75 Ibid.

76 De Fornaro, "Joseph Stella," 34, also recalled that students addressed him as "reverend" at the Baptist seminary in Brooklyn where he taught.

77 Blake, *Beloved Community*, 58.

78 Randolph S. Bourne, "Trans-National America," in *War and the Intellectuals*, ed. Carl Resek (New York: Harper and Row, 1964), 109.

79 *With Walt Whitman in Camden*, 1:372.

80 Ibid., 123.

81 William L. Price, "Is American Art Captive to the Dead Past?" *The Craftsman* 15 (February 1909): 515. Years later William Carlos Williams, in "Against the Weather: A Study of the Artist," *Twice a Year* 2 (Spring–Summer 1939): 61, made a similar observation when he connected Whitman with the medieval poet Dante, whose verse he found "structurally full of the mystical forms of religious ritual—in which it closely resembles Gothic architecture."

82 Stella, "New York," 219.

83 Stella, "Autobiographical Notes," 214.

84 Quoted in Frank E. W. Freund, "Joseph Stella," *Der Cicerone* 16 (October 1924); rpt. in *Jahrbuch der Jungen Kunst*, ed. Georg Biermann (Leipzig: Verlag Klinkhardt und Biermann, 1924), 313. Translated by the author.

85 Stella, "The Brooklyn Bridge (A Page of My Life)," 207.

86 Stella, "New York," 219.

87 See Michael P. Carroll, *Catholic Cults and Devotions: A Psychological Inquiry* (Kingston, Ontario: McGill-Queen's University Press, 1989), 132–53. For Stella's interest in Catholic devotional images, see Haskell, *Joseph Stella*, 153.

88 Stella, "Notes," 205.

89 Scott Giantvalley, *Walt Whitman, 1838–1939: A Reference Guide* (Boston: G. K. Hall, 1981), 266–91.

90 The portrait was included in a solo exhibition of Stella's work at New York's Zabriskie Gallery, 15 April–17 May 1958, and in an exhibition of Stella's drawings at the Museum of Modern Art, 26 October–13 November 1960. There is no record of the work being exhibited during Stella's lifetime.

91 Thomas, *The Lunar Light of Whitman's Poetry*, 94.

Bibliography

Archival Sources

Annenberg Rare Book and Manuscript Library, University
 of Pennsylvania
 The Walt Whitman Collection
Archives of American Art, Smithsonian Institution
 John White Alexander Papers; American Art
 Research Council Papers; Brooklyn Museum
 Records; Jean Crotti Papers; Bernard Karfiol Papers;
 Henry McBride Papers; Elizabeth McCausland
 Papers; Joseph Stella Papers; Hudson Walker Papers
Beinecke Rare Book and Manuscript Library,
 Yale Collection of American Literature, Yale University
 Katherine S. Dreier Papers/Société Anonyme
 Archive; Marsden Hartley Papers; Robert Henri
 Papers; Gertrude Stein Papers; Alfred Stieglitz Papers
Brooklyn Historical Society
 Brooklyn Art Union Papers
Hirshhorn Museum and Sculpture Garden,
 Smithsonian Institution
 Samuel Murray Scrapbook
Library of Congress
 Charles E. Feinberg Collection; Horace L. and Anne
 Montgomerie Traubel Papers; Whitman-Feinberg
 Collection; Gustave Percival Wiksell Papers
New York Public Library, Manuscripts and Archives
 Division, Astor, Lenox and Tilden Foundations
 John Quinn Memorial Collection
Philadelphia Museum of Art
 Thomas Eakins/Lloyd Goodrich Collection

Newspapers

Boston Daily Evening Transcript
Detroit News-Tribune
New York Home Journal
New York Sun
New York Tribune
Philadelphia Press
Philadelphia Times
Washington Star

Primary Sources

Apollinaire, Guillaume. "The New Spirit and the Poets."
 In Selected Writings of Guillaume Apollinaire, trans.
 Roger Shattuck. New York: New Directions, 1971.
Bain, Mildred. Horace Traubel. New York: Albert and
 Charles Boni, 1913.
Bartlett, Truman Howe. "Barbizon and Jean-François
 Millet." Part 1, Scribner's Magazine 7, no. 5 (May
 1890): 531–55; part 2, no. 6 (June 1890): 735–55.
Baxter, Sylvester. "Walt Whitman in Boston." New
 England Magazine, n.s., 6 (August 1892): 714–21.
Beecher, Catherine E., and Harriet Beecher Stowe. The
 American Woman's Home. 1869. Reprint, Hartford,
 Conn.: Stowe-Day Foundation, 1975.
Benjamin, S. G. "Fifty Years of American Art:
 1828–1878." Part 3, Harper's New Monthly Magazine
 59 (October 1879): 673–88.
Binns, Henry Bryan. A Life of Walt Whitman. New York:
 E. P. Dutton, 1905.
Bourne, Randolph S. War and the Intellectuals. Edited by
 Carl Resek. New York: Harper and Row, 1964.

Brasher, Thomas L., ed. *Whitman as Editor of the Brooklyn Daily Eagle.* Detroit: Wayne State University Press, 1970.

Bredvold, Louis I. "Walt Whitman." *The Dial* 53 (1 November 1912): 323–25.

"Brown's Studio." *Bulletin of the American Art-Union* 2 (April 1849): 17–20.

Bruno, Guido. *The Sacred Band: A Litany of Ingratitude.* New York: Guido Bruno, 1921.

Bryant, William Cullen. "A Funeral Oration, Occasioned by the Death of Thomas Cole." *The Knickerbocker* 32 (July 1848): 71.

Bryant, William Cullen, II, and Thomas G. Voss, eds. *The Letters of William Cullen Bryant.* 2 vols. New York: Fordham University Press, 1977.

The Bryant Festival at "The Century," November 5, M.DCCC.LXIV. New York: D. Appleton, 1865.

Bucke, Richard Maurice. *Cosmic Consciousness.* 1901. Reprint, New York: E. P. Dutton, 1969.

———. "Portraits of Walt Whitman." *New England Magazine* 20 (March–August 1899): 31–50.

———. *Walt Whitman.* Philadelphia: David McKay, 1883.

———, ed. *Calamus: A Series of Letters Written During the Years 1868–1880 by Walt Whitman to a Young Friend (Peter Doyle).* Boston: Laurens Maynard, 1897.

———. *Notes and Fragments.* 1899. Reprint, Folcroft, Pa.: Folcroft Library Editions, 1972.

Burr, S. J. "Gabriel Harrison and the Daguerrean Art." *The Photographic Art-Journal* 1 (March 1851): 169–77.

Burroughs, John. *The Writings of John Burroughs.* Vol. 10, *Whitman: A Study.* Boston: Houghton Mifflin, 1904.

Campbell, Helen. "A Man and a Book." *Arena* 40 (August–September 1908): 183–91.

Carpenter, Edward. *Days with Walt Whitman.* 1896. Reprint, New York: AMS Press, 1983.

———. *From Adam's Peak to Elephanta.* London: Swan Sonnenschein; New York: Macmillan, 1892.

———. "Some Friends of Walt Whitman: A Study in Sex-Psychology." London: British Society for the Study of Sex Psychology, [1924].

Carpenter, George Rice. *Walt Whitman.* New York: Macmillan, 1909.

Chandler, Virginia. "Gabriel Harrison." In *The Civil, Political, Professional and Ecclesiastical History and Commercial and Industrial Record of the County of Kings and the City of Brooklyn, N.Y. from 1683 to 1884,* ed. Henry R. Stiles. New York: W. W. Munsell, 1884.

Clarke, Helen A. "The Relations of Music to Poetry in American Poets." *Music* 6 (June 1894): 169–71.

Cleaveland, N. "Henry Kirke Brown." *Sartain's Magazine* 8 (January 1851): 135–38.

Coady, Robert J. "Current News of Art and the Exhibitions." *New York Sun,* 12 March 1916.

———. "Three Unpublished Letters." *The Guardian* 2 (August 1925): 372–76.

De Casseres, Benjamin. "Enter Walt Whitman." *The Philistine* 25, no. 6 (1907): 161–72.

———. "The Renaissance of the Irrational." *Camera Work,* special number (June 1913): 22–24.

———. "Walt Whitman." *The Fra* 2 (March 1909): 93–94.

De Selincourt, Basil. *Walt Whitman: A Critical Study.* 1914. Reprint, New York: Russell and Russell, 1965.

Dionysian 1 (1915).

Donaldson, Thomas. *Walt Whitman the Man.* 1896. Reprint, Folcroft, Pa.: Folcroft Library Editions, 1973.

Eaton, Wyatt. "Recollections of Jean François Millet." *Century Magazine* 38 (May 1889): 90–104.

Elliott, Charles N., ed. *Walt Whitman as Man, Poet, and Friend.* Boston: Richard G. Badger, 1915.

Emerson, Ralph Waldo. *Essays by Ralph Waldo Emerson.* New York: Harper and Row, 1951.

Flint, R. W., ed. *Marinetti: Selected Writings.* New York: Farrar, Straus and Giroux, 1972.

Forbes, Edwin. *Thirty Years After: An Artist's Story of the Great War.* New York: Fords, Howard, and Hulbert, 1890. Reprint [as *Thirty Years After: An Artist's Memoir of the Civil War*], Baton Rouge: Louisiana State University Press, 1999.

The Forum Exhibition of Modern American Painters. New York: Anderson Galleries, 1916.

"Four Letters." *The Conservator* 26, no. 11 (1916): 167.

[Freiligrath, Ferdinand]. "Walt Whitman: A German Appreciation in 1868." *Greenwich Village* 1 (28 April 1915): 55–56.

"French Artists Spur on an American Art." *New York Tribune,* 24 October 1915. Reprinted in *New York Dada,* ed. Rudolf E. Kuenzli. New York: Willis Locker and Owens, 1986.

Freund, Frank E. W. "Joseph Stella." *Der Cicerone* 16 (October 1924). Reprinted in *Jahrbuch der Jungen Kunst,* ed. Georg Biermann. Leipzig: Verlag Klinkhardt und Biermann, 1924.

Furness, Clifton Joseph. *Walt Whitman's Workshop.* Cambridge, Mass.: Harvard University Press, 1928.

"A Futurist of the Sixties." *The Living Age* 281 (18 April 1914): 175–80.

Garrigues, Gertrude. "Raphael's School of Athens." *The Journal of Speculative Philosophy* 13 (October 1879): 406–20.

Gilchrist, Alexander. *Life of William Blake.* 2 vols. London: Macmillan, 1863.

Gilchrist, Herbert Harlakenden, ed. *Anne Gilchrist: Her Life and Writings.* London: T. Fisher Unwin, 1887.

[Gilder, Jeannette]. "Walt Whitman on Lincoln." *The Critic* 7 (23 April 1887): 206–7.

Gilder, Rosamond, ed. *Letters of Richard Watson Gilder.* Boston: Houghton Mifflin, 1916.

Godwin, Parke. *A Biography of William Cullen Bryant.* 2 vols. New York: Russell and Russell, 1883.

Graham, Lily. "A Heart-Picture." *The Knickerbocker* 38 (July 1851): 59.

Greta. "Mr. Quincy A. Shaw's Collection." *The Art Amateur* 5 (September 1881): 72–73.

Grosskurth, Phyllis, ed. *The Memoirs of John Addington Symonds.* New York: Random House, 1984.

G. W. P. "Lessing's Laocoön." *Bulletin of the American Art-Union* 5 (1 August 1850): 73.

Hanna, Paul. "Horace Traubel, Democrat." *Forum* 50 (November 1913): 708–20.

Harned, Thomas B., ed. *The Letters of Anne Gilchrist and Walt Whitman*. New York: Haskell House, 1973.

Harrison, Gabriel. "Brooklyn Art-Union." *The Photographic Art Journal* 2 (November 1851): 296–97.

Hartley, Marsden. *Adventures in the Arts*. 1921. Reprint, New York: Hacker Art Books, 1972.

———. "America as Landscape." *El Palacio* 5 (21 December 1918): 340–42.

———. "Exhibitions at '291.'" *Camera Work*, no. 45 [dated January 1914, published June 1914]: 17.

———. *On Art*. Edited by Gail R. Scott. New York: Horizon Press, 1982.

Hartmann, Sadakichi. *Conversations with Walt Whitman*. 1894. Reprint, New York: Gordon Press, 1972.

———. "Sadakichi and Walt Whitman." *Greenwich Village* 3 (November 1915): 19–22.

———. "Unphotographic Paint.—The Texture of Impressionism." *Camera Work* 28 (October 1909): 20–23.

Haviland, Paul B. "The Home of the Golden Disk." *Camera Work* 25 (January 1909): 21–22.

Heilig, Sterling. "The Home of the Cubists." *Chicago Record-Herald*, 13 April 1913.

Henri, Robert. *The Art Spirit*. 1923. Reprint, Philadelphia: J. B. Lippincott, 1960.

———. "A Practical Talk to Those Who Study Art." *Philadelphia Press*, 12 May 1901.

———. "Progress in Our National Art." *The Craftsman* 15, no. 4 (1909): 387–401.

Hervey, John L. "Communications: The Growth of the Whitman 'Legend.'" *The Dial* 59 (24 June 1915): 12–14.

Holloway, Emory. "More Light on Whitman." *The American Mercury* 1 (February 1924): 183–89.

———. *Whitman: An Interpretation in Narrative*. New York: Alfred A. Knopf, 1926.

———, ed. *Pictures: An Unpublished Poem of Walt Whitman*. New York: The June House; London: Faber and Gwyer, 1927.

———. *The Uncollected Poetry and Prose of Walt Whitman*. 2 vols. 1921. Reprint, Gloucester, Mass.: Peter Smith, 1972.

Holloway, Emory, and Ralph Adimari, eds. *New York Dissected*. New York: R. R. Wilson, 1936.

Homer, William Innes, ed. *Heart's Gate: Letters Between Marsden Hartley and Horace Traubel, 1906–1915*. Highlands, N.C.: The Jargon Society, 1982.

James, William. *Writings, 1902–1910*. Edited by Bruce Kuklick. New York: Viking, 1987.

Johnston, J[ohn] H. "Half-Hours with Walt Whitman: IX." *Everywhere* 21 (January 1908): 212–14.

Kandinsky, Wassily. *Concerning the Spiritual in Art*. Translated by M. T. H. Sadler. 1914. Reprint, New York: Dover, 1977.

Karsner, David. *Horace Traubel: His Life and Work*. New York: Egmont Arens, 1919.

Keller, Elizabeth Leavitt. *Walt Whitman in Mickle Street*. New York: Mitchell Kennerley, 1921.

Kennedy, William Sloane. *The Fight of a Book for the World*. West Yarmouth, Mass.: Stonecroft Press, 1926.

———. *The Poet as a Craftsman*. 1886. Reprint, Folcroft, Pa.: Folcroft Library Editions, 1973.

———. *Reminiscences of Walt Whitman*. Paisley, Scotland: Alexander Gardner, 1896.

———. "Sursum Corda, Comrades!" *The Conservator* 7, no. 9 (1896): 140–41.

———. "Whitman's Letters to Peter Doyle." *The Conservator* 8, no. 4 (1897): 60–61.

Kirkland, Winifred. "Americanization and Walt Whitman." *The Dial* 66 (31 May 1919): 537–39.

Kreymborg, Alfred. "The New Washington Square." *New York Morning Telegraph*, 6 December 1914.

———. "Traubel—American: A Notable Figure Article." *New York Morning Telegraph*, 31 May 1914.

———. *Troubadour*. New York: Boni and Liveright, 1925.

Lacey, Margaret. "Peer Gynt." *The Conservator* 18 (August 1907): 88–89.

Lawton, Harry, and George Knox, eds. *Buddha, Confucius, Christ: Three Prophetic Plays*. New York: Herder and Herder, 1971.

———. *Valiant Knights of Daguerre*. Berkeley and Los Angeles: University of California Press, 1978.

Lester, Charles Edwards. *The Artist, the Merchant, and the Statesman*. New York: Paine and Burgess, 1845.

Lindsay, Vachel. *The Art of the Moving Picture*. 1915. Reprint, New York: Liveright, 1970.

Linton, William James. *Poetry of America: Selections from One Hundred American Poets from 1776 to 1876*. London: George Bell and Sons, 1878.

———. *Threescore and Ten Years: 1820 to 1890*. New York: Charles Scribner's Sons, 1894.

Manuscripts, Autograph Letters, First Editions and Portraits of Walt Whitman Formerly the Property of the Late Dr. Richard Maurice Bucke. 1936. Reprint, Folcroft, Pa.: Folcroft Library Editions, 1972.

Mayerson, Charlotte Leon, ed. *Shadow and Light: The Life, Friends, and Opinions of Maurice Sterne*. New York: Harcourt, Brace and World, [1965].

McAlmon, Robert. *Being Geniuses Together*. 1968. Reprint, San Francisco: North Point Press, 1984.

McBride, Henry. "First Aid to Artists from the 'Soil.'" *New York Sun*, 11 March 1917.

———. "News and Comments in the World of Art." *New York Sun*, 8 July 1917.

———. "Notes and Activities in the World of Art." *New York Sun*, 29 April 1917; 13 May 1917.

———. "'The Soil,' a Magazine of American Art." *New York Sun*, 17 December 1916.

McCoy, Garnett. "Reaction and Revolution, 1900–1930: The Artist Speaks: Part Four." *Art in America* 53 (August–September 1965): 68–85.

McDonnell, Patricia, ed. "Marsden Hartley's Letters to Franz Marc and Wassily Kandinsky, 1913–1914." *Archives of American Art Journal* 29, nos. 1–2 (1989): 27–44.

Mendelssohn, Felix. *Elijah: An Oratorio.* New York: G. Schirmer, n.d.

Miller, Joaquin. "The Great Centennial Fair and Its Future." *The Independent* 28, no. 1441 (13 July 1876): 1–2.

Moffett, Cleveland. "Grant and Lincoln in Bronze." *McClure's Magazine* 5 (October 1895): 419–32.

Morris, Harrison S. *Confessions in Art.* New York: Sears, 1930.

———. *Walt Whitman: A Brief Biography with Reminiscences.* 1929. Reprint, Folcroft, Pa.: Folcroft Library Editions, 1976.

Morse, Sidney H. "An Anti-Slavery Hero." *New England Magazine,* n.s., 4 (June 1891): 486–96.

———. "Chips from My Studio." *The Radical Review* 1 (May 1877): 184–204.

———. "My Summer with Walt Whitman, 1887." In *In Re Walt Whitman,* ed. Horace Traubel, Richard Maurice Bucke, and Thomas B. Harned. Philadelphia: David McKay, 1893.

Mufson, Thomas. "Walt Whitman, Poet of the New Age." *Twentieth Century Magazine* 2 (July 1910): 325–30.

Munson, Gorham B. "The Skyscraper Primitives." *The Guardian* 1 (March 1925): 164–78.

Nell. "An Artist's Studio." *The Knickerbocker* 37 (January 1851): 41–42.

"The New Spiritual America Emerging." *Current Literature* 46 (February 1909): 180–82.

Norton, Charles Eliot. "Whitman's *Leaves of Grass.*" *Putnam's* 6 (September 1855): 321–23.

Parker, Robert Allerton. "The Art of the Camera: An Experimental 'Movie.'" *Arts and Decoration* 15 (October 1921): 369, 414.

Pennsylvania Art Contributions. Harrisburg, Pa.: Edwin K. Meyers, 1893.

Perlman, Jim, Ed Folsom, and Dan Campion, eds. *Walt Whitman: The Measure of His Song.* Minneapolis: Holy Cow! Press, 1981.

Perry, Bliss. *Walt Whitman: His Life and Work.* 1906. Reprint, New York: AMS Press, 1969.

"Personal." *Harper's Bazaar* 20 (23 April 1887): 291.

Phelps, Myron H. "Green Acre." *The Word* 1, no. 2 (1904): 52–68.

Picabia, Francis. "How New York Looks to Me." *New York American,* 30 March 1913.

Piccoli, Raffaello. "As an Italian Sees It." In *Civilization in the United States,* ed. Harold E. Stearns. 1922. Reprint, Westport, Conn.: Greenwood Press, 1971.

Potamkin, Harry Alan. "Memoranda." *The Guardian* 2 (October 1925): 466–68.

Pound, Ezra. "What I Feel About Walt Whitman." In *Walt Whitman: The Measure of His Song,* ed. Jim Perlman, Ed Folsom, and Dan Campion. Minneapolis: Holy Cow! Press, 1981.

Price, Kenneth M., ed. *Walt Whitman: The Contemporary Reviews.* Cambridge: Cambridge University Press, 1996.

Price, William L. "Is American Art Captive to the Dead Past?" *The Craftsman* 15 (February 1909): 515–19.

Prowell, George R. *The History of Camden County, New Jersey.* Philadelphia: L. J. Richards, 1886.

Quincy Adams Shaw Collection. Boston: Museum of Fine Arts, 1918.

Reeves, Harrison. "Les epopées populaires américaines." *Les soirées de Paris* 22 (15 March 1914): 165–71.

Roché, Henri-Pierre. "The Blind Man." *The Blindman* 1 (10 April 1917): 3–6.

Rodgers, Cleveland, and John Black, eds. *The Gathering of the Forces.* 2 vols. New York: Putnam, 1920.

Rolland, Romain. "America and the Arts." Translated by Waldo Frank. *Seven Arts* 1 (November 1916): 47–51.

Rönnebeck, Arnold. "Through the Eyes of a European Sculptor." In *Alfred Stieglitz Presents Seven Americans.* New York: The Anderson Galleries, 1925. Reprinted in Barbara Buhler Lynes, *O'Keeffe, Stieglitz, and the Critics, 1916–1929.* Chicago: University of Chicago Press, 1989.

Rossetti, William Michael, ed. *Poems by Walt Whitman.* London: John Camden Hotten, 1868.

Sanborn, Robert Alden. "A Champion in the Wilderness." *Broom* 3 (October 1922): 174–79.

Santayana, George. "The Poetry of Barbarism II: Walt Whitman." In *Santayana on America,* ed. Richard Colton Lyon. New York: Harcourt, Brace and World, 1968.

———. "Walt Whitman: A Dialogue." *The Harvard Monthly* 10, no. 3 (1890): 85–92.

———. *Winds of Doctrine.* New York: Scribner's, 1913.

Scheffauer, Herman. "Whitman in Whitman's Land." *North American Review* 201 (15 February 1915): 206–16.

Scott, Gail L., ed. *The Collected Poems of Marsden Hartley, 1904–1943.* Santa Rosa, Calif.: Black Sparrow Press, 1987.

Sensier, Alfred. "Jean-François Millet: Peasant and Painter." Translated by Helena de Kay. *Scribner's Monthly* 21 (November 1880): 104–10.

Shinn, Earl [Edward Strahan, pseud.]. *The Masterpieces of the Centennial International Exhibition.* Vol. 1, *Fine Arts.* Philadelphia: Gebbie and Barries, 1876.

S[igorney], Mrs. L. H. "Powers' Statue of the Greek Slave." *The Knickerbocker* 38 (October 1851): 436.

Silver, Rollo G. "Whitman in 1850: Three Uncollected Articles." *American Literature* 19 (January 1948): 310–17.

Sloan, John. *John Sloan's New York Scene.* Edited by Bruce St. John. New York: Harper and Row, 1965.

The Soil (1916–17).

Sprague, Claire, ed. *Van Wyck Brooks: The Early Years.* New York: Harper and Row, 1968.

Stedman, Edmund Clarence. "Walt Whitman." *Scribner's Monthly* 21 (November 1880): 47–64.

Stein, Gertrude. *Painted Lace and Other Pieces (1914–1937).* New Haven: Yale University Press, 1955.

Stella, Joseph. "The New Art." *The Trend* 5 (June 1913): 393–95.

Storer, Edward. "The Country Walk." *Greenwich Village* 2 (30 September 1915): 166–67.

"Studies Among the Leaves." *The Crayon* 3 (January 1856): 30.

Swinburne, Charles. *William Blake.* London: J. C. Hotten, 1868.

Symonds, John Addington. *The Memoirs of John Addington Symonds.* Edited by Phyllis Grosskurth. New York: Random House, 1984.

Tinker, Edward Laracque. "New Editions, Fine and Otherwise." *New York Times Book Review,* 31 July 1938.

Trask, John E. D., and J. Nilson Laurvik, eds. *Catalogue De Luxe of the Department of Fine Arts, Panama-Pacific International Exposition.* Vol. 2. San Francisco: P. Elder, 1915.

Traubel, Horace. "Collects." *Globe* 2 (1914): 7–128. Reprint, New York: Kraus Reprint, 1967.

———. "Nature Thoughts from Walt Whitman." *The Conservator* 17, no. 3 (1906): 43.

———. "Round Table with Walt Whitman." In *In Re Walt Whitman,* ed. Horace L. Traubel, Richard Maurice Bucke, and Thomas B. Harned. Philadelphia: David McKay, 1893.

———. "Stieglitz." *The Conservator* 27, no. 10 (1916): 137.

———. "Stieglitz Snapshots." *The Conservator* 25, no. 5 (1914): 76–77. Reprinted as "Horace Traubel on Photography," *Camera Work* 46 (April 1914, published October 1914): 49–50.

———. "What Is '291'?" *The Conservator* 26, no. 1 (1915): 13.

———. "With Walt Whitman in Camden." *Seven Arts* 2 (September 1917): 627–37.

———, comp. *The Book of Heavenly Death.* Portland, Me.: Thomas B. Mosher, 1907.

Traubel, Horace, Richard Maurice Bucke, and Thomas B. Harned, eds. *In Re Walt Whitman.* Philadelphia: David McKay, 1893.

United States Centennial Commission International Exhibition 1876. *Official Catalogue: Art Gallery and Annexes: Department IV.* 6th ed. Cambridge, Mass.: John R. Nagle, 1876.

Vedder, Elihu. *The Digressions of V.* Boston: Houghton Mifflin, 1910.

Walling, William English. *Whitman and Traubel.* New York: Albert and Charles Boni, 1916.

"Walt Whitman as Musical Prophet." *Musical America* 22 (3 July 1915): 18.

Weaver, Jane Calhoun, ed. *Sadakichi Hartmann: Critical Modernist.* Berkeley and Los Angeles: University of California Press, 1991.

Wheeler, Candace. *Yesterdays in a Busy Life.* New York: Harper and Brothers, 1918.

Whelpley, J. D. "Lessing's Laocoön: The Secret of Classic Composition in Poetry, Painting, and Statuary." *The American Whig Review* 37 (January 1851): 17–26.

Whitman, Walt. "About Monuments." *Brooklyn Daily Eagle,* 28 July 1846.

——— [O. P. Q., pseud.]. "About the Fashionable World—Fine Pictures." *Brooklyn Evening Star,* 18 November 1845.

———. "An Afternoon Lounge About Brooklyn." *Brooklyn Evening Star,* 24 May 1852.

———. "American Art—Jesse Talbot." *New York Sunday Dispatch,* 19 May 1850.

———. *An American Primer.* Edited by Horace Traubel. 1904. Reprint, Stevens Point, Wis.: Holy Cow! Press, 1987.

———. "April Afternoon Ramble." *Brooklyn Evening Star,* 30 April 1850.

———. "Brooklyn Art Union—Walter Libbey—A Hint or Two on the Philosophy of Painting." *Brooklyn Daily Advertiser,* 21 December 1850.

———. "A Brooklyn Daguerreotypist and His Pictures at the Crystal Palace." *Brooklyn Daily Eagle,* 27 August 1853.

———. *The Complete Writings of Walt Whitman.* Edited by Richard Maurice Bucke, Thomas B. Harned, and Horace L. Traubel. 10 vols. New York: G. P. Putnam's Sons, 1902.

———. *Daybooks and Notebooks.* Edited by William White. 3 vols. New York: New York University Press, 1978.

———. "Fine Arts at the West." *New Orleans Daily Crescent,* 28 April 1848.

———. "Hicks, the American Painter." *New Orleans Daily Crescent,* 3 April 1848.

———. "An Hour Among the Portraits." *Brooklyn Evening Star,* 7 June 1853.

———. *Leaves of Grass: A Textual Variorum of the Printed Poems.* Edited by Sculley Bradley, Harold W. Blodgett, Arthur Golden, and William White. 3 vols. New York: New York University Press, 1980.

———. "Literary Notices." *Brooklyn Daily Eagle,* 10 August 1846.

———. "National Academy of Design." *New York Sunday Dispatch,* 2 June 1850.

———. *Notebooks and Unpublished Prose Manuscripts.* Edited by Edward F. Grier. 4 vols. New York: New York University Press, 1984.

———. "Talbot's Pictures." *American Phrenological Journal* 17 (February 1853): 45.

——— [George Selwyn, pseud.]. "Walt Whitman in Camden." *The Critic* 3 (28 February 1885): 97–98.

———. "Works of Beauty and Talent—The New Art Union of Brooklyn." *Brooklyn Daily Advertiser,* 4 April 1850.

Wiksell, Percival. "Horace Traubel." *The Fra* 7 (July 1911): 117–21.

———. "Pete Doyle." *The Conservator* 18, no. 7 (1907): 104.

Williams, William Carlos. "Against the Weather: A Study of the Artist." *Twice a Year* 2 (Spring–Summer 1939): 53–78.

———. "America, Whitman, and the Art of Poetry." *Poetry Journal* 8 (November 1917): 27–36.

Wolff, Adolf. "Walt Whitman." *Globe* 1, no. 1 (1913): 66. Reprint, New York: Kraus Reprint, 1967.

Works in Oil and Pastel by the Impressionists of Paris. New York: American Art Association, 1886.

BIBLIOGRAPHY

Secondary Sources

Ahlers, Alice. "Cinematographic Technique in *Leaves of Grass*." *Walt Whitman Review* 12 (December 1966): 93–97.

Alcaro, Marion Walker. "Walt Whitman and Mrs. G." *Walt Whitman Quarterly Review* 6, no. 4 (1989): 153–71.

———. *Walt Whitman's Mrs. G*. Rutherford, N.J.: Fairleigh Dickinson University Press; London: Associated University Presses, 1991.

Allen, Gay Wilson. "The Iconography of Walt Whitman." In *The Artistic Legacy of Walt Whitman*, ed. Edwin Haviland Miller. New York: New York University Press, 1970.

———. *The New Walt Whitman Handbook*. New York: New York University Press, 1975.

———. *The Solitary Singer*. Chicago: University of Chicago Press, 1985.

———. *Walt Whitman Abroad*. Syracuse: Syracuse University Press, 1955.

Allen, Gay Wilson, and Ed Folsom, eds. *Walt Whitman and the World*. Iowa City: University of Iowa Press, 1995.

Anderson, Quentin. "Whitman's New Man." In *Walt Whitman: Walt Whitman's Autograph Revision of the Analysis of Leaves of Grass (for Dr. R. M. Bucke's Walt Whitman)*. New York: New York University Press, 1974.

Avant-Garde Painting and Sculpture in America, 1910–1925. Wilmington: Delaware Art Museum, 1975.

Barrus, Clara. *Whitman and Burroughs: Comrades*. 1931. Reprint, Port Washington, N.Y.: Kennikat Press, 1968.

Beard, Rick, and Leslie Cohen Berlowitz, eds. *Greenwich Village: Culture and Counterculture*. New Brunswick, N.J.: Published for the Museum of the City of New York by Rutgers University Press, 1993.

Benton, Paul. "Whitman, Christ, and the Crystal Palace Police: A Manuscript Source Restored." *Walt Whitman Quarterly Review* 17, no. 4 (2000): 147–65.

Berbrich, Joan D. *Three Voices from Paumanok*. Port Washington, N.Y.: Ira J. Friedman, 1969.

Berger, Martin A. *Man Made: Thomas Eakins and the Construction of Gilded Age Manhood*. Berkeley and Los Angeles: University of California Press, 2000.

Bergsagel, John. "Ole Bull." In *The New Grove Dictionary of Music and Musicians*, vol. 3. London: Macmillan, 1980.

Blake, Casey Nelson. *Beloved Community*. Chapel Hill: University of North Carolina Press, 1990.

Blanchard, Mary Warner. *Oscar Wilde's America: Counterculture in the Gilded Age*. New Haven: Yale University Press, 1998.

Blaser, Kent. "Walt Whitman and American Art." *Walt Whitman Review* 24 (September 1978): 108–18.

Blodgett, Harold W. *Walt Whitman in England*. Ithaca: Cornell University Press, 1934.

———. "Whitman and the Linton Portrait." *Walt Whitman Newsletter* 4 (September 1958): 90–92.

Bohan, Ruth L. "'The Gathering of the Forces': Walt Whitman and the Visual Arts in Brooklyn in the 1850s." In *Walt Whitman and the Visual Arts*, ed. Roberta K. Tarbell and Geoffrey M. Sill. New Brunswick, N.J.: Rutgers University Press, 1992.

———. "'I Sing the Body Electric': Isadora Duncan, Whitman, and the Dance." In *The Cambridge Companion to Walt Whitman*, ed. Ezra Greenspan. Cambridge: Cambridge University Press, 1995.

———. "Joseph Stella's *Man in Elevated (Train)*." In *Dada/Dimensions*, ed. Stephen C. Foster. Ann Arbor: UMI Research Press, 1985.

———. "Whitman and the Sister Arts." *Walt Whitman Quarterly Review* 16, no. 3–4 (1999): 153–60.

———. "Whitman's 'Barbaric Yawp' and the Culture of New York Dada." In *Dada New York: New World for Old*, ed. Martin Ignatius Gaughan. New York: G. K. Hall, 2003.

Bradbury, Malcolm, and James McFarlane, eds. *Modernism*. New York: Penguin Books, 1976.

Brilliant, Richard. *Portraiture*. Cambridge, Mass.: Harvard University Press, 1991.

Bruccoli, Matthew J. *The Fortunes of Mitchell Kennerley, Bookman*. San Diego: Harcourt Brace Jovanovich, 1986.

Bryant, William Cullen, II. "Poetry and Painting: A Love Affair of Long Ago." *American Quarterly* 22 (Winter 1970): 859–82.

Bryson, Norman. *Vision and Painting: The Logic of the Gaze*. New Haven: Yale University Press, 1983.

Burke, Doreen Bolger. "John White Alexander." In *American Paintings in the Metropolitan Museum of Art*, vol. 3. New York: The Metropolitan Museum of Art in association with Princeton University Press, 1980.

Burke, Margaret R. "Futurism in America, 1910–1917." Ph.D. diss., University of Delaware, 1986.

Burns, Sarah. *Inventing the Modern Artist: Art and Culture in Gilded Age America*. New Haven: Yale University Press, 1996.

Callow, James T. *Kindred Spirits: Knickerbocker Writers and American Artists, 1807–1855*. Chapel Hill: University of North Carolina Press, 1967.

Camfield, William A. *Francis Picabia: His Art, Life, and Times*. Princeton: Princeton University Press, 1979.

Carroll, Michael P. *Catholic Cults and Devotions: A Psychological Inquiry*. Kingston, Ontario: McGill-Queen's University Press, 1989.

Cassidy, Donna M. *Painting the Musical City: Jazz and Cultural Identity in American Art, 1910–1940*. Washington, D.C.: Smithsonian Institution Press, 1997.

Chamberlin-Hellman, Mariah. "Samuel Murray, Thomas Eakins, and the Witherspoon Prophets." *Arts Magazine* 53 (May 1979): 134–39.

Chauncey, George. *Gay New York: Gender, Urban Culture, and the Making of the Gay Male World, 1890–1940*. New York: Basic Books, 1994.

Clarke, Graham. "'To Emanate a Look': Whitman, Photography, and the Spectacle of Self." In *American Literary Landscapes: The Fiction and the Fact*, ed. Ian F. A. Bell and D. K. Adams. New York: St. Martin's Press, 1989.

———. *Walt Whitman: The Poem as Private History.* New York: St. Martin's Press; London: Vision Press, 1991.

Coffman, Stanley K., Jr. "Form and Meaning in Whitman's 'Passage to India.'" *PMLA* 70 (June 1955): 337–49.

Cohen, Paula Marantz. *Silent Film and the Triumph of the American Myth.* New York: Oxford University Press, 2001.

Colbert, Charles. *A Measure of Perfection: Phrenology and the Fine Arts in America.* Chapel Hill: University of North Carolina Press, 1997.

Collection of the Works of Walt Whitman Commemorating the Ninetieth Anniversary of the Printing of His "Leaves of Grass." Detroit: Detroit Public Library, 1945.

Cooper, William J., Jr. "Introduction: Edwin Forbes and the Civil War." In Edwin Forbes, *Thirty Years After: An Artist's Memoir of the Civil War.* Baton Rouge: Louisiana State University Press, 1999.

Corn, Wanda M. *The Great American Thing: Modern Art and National Identity, 1915–1935.* Berkeley and Los Angeles: University of California Press, 1999.

Craven, Wayne. "Henry Kirke Brown: His Search for an American Art in the 1840s." *American Art Journal* 4 (November 1972): 44–58.

———. "Henry Kirke Brown in Italy, 1842–1846." *American Art Journal* 2 (Spring 1969): 65–77.

Croce, George C., and David H. Wallace. *New-York Historical Society Dictionary of Artists in America, 1564–1860.* New Haven: Yale University Press, 1957.

Cutler, Ed. "Passage to Modernity: *Leaves of Grass* and the 1853 Crystal Palace Exhibition in New York." *Walt Whitman Quarterly Review* 16, no. 2 (1998): 65–89.

Danly, Susan, and Cheryl Leibold. *Eakins and the Photograph.* Washington, D.C.: Smithsonian Institution Press for the Pennsylvania Academy of the Fine Arts, 1994.

Davis, Whitney. "Erotic Revision in Thomas Eakins's Narratives of Male Nudity." *Art History* 17, no. 3 (1994): 301–41.

Denning, Michael. *Mechanic Accents: Dime Novels and Working-Class Culture in America.* London: Verso, 1987.

Dougherty, James. *Walt Whitman and the Citizen's Eye.* Baton Rouge: Louisiana State University Press, 1993.

Dryfout, John. *The Work of Augustus Saint-Gaudens.* Hanover, N.H.: University Press of New England, 1982.

Dunbar, Elizabeth. *Talcott Williams: Gentleman of the Fourth Estate.* New York: Robert E. Simpson and Sons, 1936.

Ellmann, Richard. *Oscar Wilde.* New York: Alfred A. Knopf, 1988.

Erkkila, Betsy. *Walt Whitman Among the French.* Princeton: Princeton University Press, 1980.

———. *Whitman the Political Poet.* New York: Oxford University Press, 1989.

Fairbrother, Trevor. *John Singer Sargent: The Sensualist.* New Haven: Yale University Press, 2000.

Faner, Robert D. *Walt Whitman and Opera.* Carbondale: Southern Illinois University Press, 1951.

Feinberg, Charles E. "Percy Ives, Detroit, and Walt Whitman." *Detroit Historical Society Bulletin* 16, no. 5 (1960): 4–11.

Filler, Martin. "The Brooklyn Bridge at 100." *Art in America* 71 (Summer 1983): 140–52.

Folsom, Ed. "Appearing in Print: Illustrations of the Self in *Leaves of Grass.*" In *The Cambridge Companion to Walt Whitman*, ed. Ezra Greenspan. Cambridge: Cambridge University Press, 1995.

———. "Horace Traubel (1858–1919)." In Horace Traubel, *With Walt Whitman in Camden*, ed. Jeanne Chapman and Robert MacIsaac, vol. 9. Oregon House, Calif.: W. L. Bentley, 1996.

———. "'This Heart's Geography's Map': The Photographs of Walt Whitman." *Walt Whitman Quarterly Review* 4, no. 2–3 (1986–87): 1–72.

———. *Walt Whitman's Native Representations.* Cambridge: Cambridge University Press, 1994.

———. "Whitman and the Visual Democracy of Photography." *Mickle Street Review* 10 (1988): 51–65.

———. "Whitman's Calamus Photographs." In *Breaking Bounds*, ed. Betsy Erkkila and Jay Grossman. New York: Oxford University Press, 1996.

Fone, Byrne R. S. *Masculine Landscapes: Walt Whitman and the Homoerotic Text.* Carbondale: Southern Illinois University Press, 1992.

Foster, Kathleen A. *Thomas Eakins Rediscovered.* Philadelphia: Pennsylvania Academy of the Fine Arts; New Haven: Yale University Press, 1997.

Foster, Kathleen A., and Cheryl Leibold, eds. *Writing About Eakins: The Manuscripts in Charles Bregler's Thomas Eakins Collection.* Philadelphia. Published for the Pennsylvania Academy of the Fine Arts by the University of Pennsylvania Press, 1989.

Foucault, Michel. *The Archaeology of Knowledge.* New York: Pantheon Books, 1972.

Frackman, Noel. *John Storrs.* New York: Whitney Museum of American Art, 1986.

Freedman, Florence B. "A Motion Picture 'First' for Whitman: O'Connor's 'The Carpenter.'" *The Walt Whitman Review* 9 (June 1963): 31–34.

Fried, Michael. *Realism, Writing, and Disfiguration: Thomas Eakins and Stephen Crane.* Chicago: University of Chicago Press, 1988.

Gadamer, Hans-Georg. *Truth and Method.* New York: Seabury Press, 1975.

Garman, Bryan K. "'Heroic Spiritual Grandfather': Whitman, Sexuality, and the American Left, 1890–1940." *American Quarterly* 52 (March 2000): 90–126.

Geertz, Clifford. *The Interpretation of Cultures.* New York: Basic Books, 1973.

Geffen, Arthur. "Silence and Denial: Walt Whitman and the Brooklyn Bridge." *Walt Whitman Quarterly Review* 1, no. 4 (1984): 1–11.

Geist, Sidney. *Brancusi: The Sculpture and Drawings.* New York: Harry N. Abrams, 1975.

Giantvalley, Scott. *Walt Whitman, 1838–1939: A Reference Guide.* Boston: G. K. Hall, 1981.

Glicksberg, Charles I. *Walt Whitman and the Civil War.* Philadelphia: University of Pennsylvania Press, 1933.

———. "Whitman and Bryant." *Fantasy* 5 (1935): 31–36.

Gohdes, Clarence L. F. *The Periodicals of American Transcendentalism.* Durham, N.C.: Duke University Press, 1931.

Goley, Mary Anne. *John White Alexander (1856–1915).* Washington, D.C.: National Museum of American Art, 1976.

Gombrich, E. H. *Art and Illusion.* Princeton: Princeton University Press, 1960.

———. "The Mask and the Face: The Perception of Physiognomic Likeness in Life and in Art." In E. H. Gombrich, Julian Hochberg, and Max Black, *Art, Perception, and Reality.* Baltimore: The Johns Hopkins University Press, 1972.

Goodrich, Lloyd. *Thomas Eakins.* 2 vols. Cambridge, Mass.: Harvard University Press, 1982.

Graham, John. *Lavater's Essays on Physiognomy: A Study in the History of Ideas.* Bern: Lang, 1979.

The Great East River Bridge, 1883–1983. New York: Brooklyn Museum, 1983.

Greenspan, Ezra. *Walt Whitman and the American Reader.* Cambridge: Cambridge University Press, 1990.

Grenoways, Ted. "Two Unpublished Letters: Walt Whitman to William James Linton, March 14 and April 11, 1872." *Walt Whitman Quarterly Review* 17, no. 4 (2000): 189–93.

Grippi, Charles S. "The Literary Reputation of Walt Whitman in Italy." Ph.D. diss., New York University, 1971.

Grünzweig, Walter. *Constructing the German Walt Whitman.* Iowa City: University of Iowa Press, 1995.

Halter, Peter. *The Revolution in the Visual Arts and the Poetry of William Carlos Williams.* Cambridge: Cambridge University Press, 1994.

Hammen, Scott. "Sheeler and Strand's 'Manhatta': A Neglected Masterpiece." *Afterimage* 6 (January 1979): 6–7.

Hand, John Oliver. "Futurism in America: 1909–14." *Art Journal* 41 (Winter 1981): 337–42.

Hansen, Miriam. *Babel and Babylon: Spectatorship in American Silent Film.* Cambridge, Mass.: Harvard University Press, 1991.

Harris, Neil. *The Artist in American Society.* 1966. Reprint, Chicago: University of Chicago Press, 1982.

Haskell, Barbara. *Joseph Stella.* New York: Whitney Museum of American Art, 1994.

———. *Marsden Hartley.* New York: Whitney Museum of American Art, 1980.

Haughom, Synnove. "Thomas Eakins' *The Concert Singer.*" *The Magazine Antiques* 107, no. 6 (1975): 1182–84.

Henderson, Linda Dalrymple. "Mysticism, Romanticism, and the Fourth Dimension." In *The Spiritual in Art: Abstract Painting, 1890–1985.* New York: Abbeville Press, 1986.

Hobbs, Susan. *1876: American Art of the Centennial.* Washington, D.C.: Published for the Smithsonian Institution Press by the National Collection of Fine Arts, 1976.

Hokin, Jeanne. *Pinnacles and Pyramids: The Art of Marsden Hartley.* Albuquerque: University of New Mexico Press, 1993.

Homer, William Innes. *Thomas Eakins: His Life and Art.* New York: Abbeville Press, 1992.

———. "Who Took Eakins' Photographs?" *Art News* 82 (May 1983): 112–19.

Horak, Jan-Christopher. "Modernist Perspectives and Romantic Desire: Manhatta." *Afterimage* 15 (November 1987): 8–15.

Hultén, Pontus, ed. *Futurism and Futurisms.* New York: Abbeville Press, 1986.

Hungerford, Edward. "Walt Whitman and His Chart of Bumps." *American Literature* 2 (1931): 350–84.

Huntington, David C. "The Quest for Unity: American Art Between World's Fairs, 1876–1893." In *The Quest for Unity.* Detroit: Detroit Institute of Arts, 1983.

Hyman, Martin D. "'Where the Drinkers and Laughers Meet': Pfaff's: Whitman's Literary Lair." *Seaport* 26, no. 1 (1992): 57–61.

Ingersoll, R. Sturgis. *Henry McCarter.* Cambridge: Privately printed at The Riverside Press, 1944.

Jaffe, Irma B. *Joseph Stella.* Cambridge, Mass.: Harvard University Press, 1970.

———. "Joseph Stella and Hart Crane: The Brooklyn Bridge." *The American Art Journal* 1 (Fall 1969): 98–107.

James, C. L. R. *American Civilization.* Cambridge: Blackwell, 1993.

Jauss, Hans Robert. *Toward an Aesthetic of Reception.* Vol. 2, *Theory and History of Literature,* trans. Timothy Bahti. Minneapolis: University of Minnesota Press, 1982.

Johns, Elizabeth. "*Swimming:* Thomas Eakins, the Twenty-ninth Bather." In *Thomas Eakins and the Swimming Picture,* ed. Doreen Bolger and Sarah Cash. Fort Worth: Amon Carter Museum, 1996.

———. *Thomas Eakins: The Heroism of Modern Life.* Princeton: Princeton University Press, 1983.

Kaplan, Justin. *Walt Whitman: A Life.* New York: Simon and Schuster, 1980.

Katz, Jonathan Ned. *Gay American History.* New York: Thomas Y. Crowell, 1976.

———. *A Gay/Lesbian Almanac.* New York: Harper and Row, 1983.

Killingsworth, M. Jimmie. *Whitman's Poetry of the Body.* Chapel Hill: University of North Carolina Press, 1989.

Knox, George. "Crane and Stella: Conjunction of Painterly and Poetic Worlds." *Texas Studies in Literature and Language* 12 (Winter 1971): 689–707.

———. *The Whitman-Hartmann Controversy.* Bern: Herbert Lang; Frankfurt: Peter Lang, 1976.

Krause, Sydney J. "Whitman, Music, and *Proud Music of the Storm.*" *PMLA* 72 (September 1957): 705–21.

Krieg, Joann P. "Percy Ives, Thomas Eakins, and Whitman." *Walt Whitman Quarterly Review* 15, no. 1 (1997): 27–28.

———."Walt Whitman's Long Island Friend: Elisa Seaman Leggett." *Long Island Historical Journal* 9, no. 2 (1997): 223–33.

Kwiat, Joseph J. "Robert Henri and the Emerson-Whitman Tradition." In *Studies in American Culture,* ed. J. J. Kwiat and Mary C. Turpie. Minneapolis: University of Minnesota Press, 1960.

Leach, William. "Strategists of Display and the Production of Desire." In *Consuming Visions,* ed. Simon J. Bronner. New York: W. W. Norton, 1989.

Leavell, Linda. *Marianne Moore and the Visual Arts.* Baton Rouge: Louisiana State University Press, 1995.

LeMaster, J. R., and Donald D. Kummings, eds. *Walt Whitman: An Encyclopedia.* New York: Garland Publishing, 1998.

Levine, George. *Constructions of the Self.* New Brunswick, N.J.: Rutgers University Press, 1992.

Lewis, Lloyd, and Henry Justin Smith. *Oscar Wilde Discovers America.* New York: Benjamin Blom, 1936.

Lochridge, Katherine. *Land of Whitman.* Huntington, N.Y.: Heckscher Museum, 2 October–7 November 1982.

The Louise and Walter Arensberg Collection. Philadelphia: Philadelphia Museum of Art, 1954.

Loving, Jerome. *Walt Whitman: The Song of Himself.* Berkeley and Los Angeles: University of California Press, 1999.

Luddington, Townsend. *Marsden Hartley: The Biography of an American Artist.* Boston: Little, Brown, 1992.

Lynn, Purrell. *The Art-Makers.* New York: Dover, 1970.

MacLeod, Glen. *Wallace Stevens and Modern Art from the Armory Show to Abstract Expressionism.* New Haven: Yale University Press, 1993.

Marling, Karal Ann. "Portrait of the Artist as a Young Woman: Miss Dora Wheeler." *Bulletin of the Cleveland Museum of Art* 65 (February 1978): 47–57.

Marling, William. *William Carlos Williams and the Painters, 1909–1923.* Athens: Ohio State University Press, 1982.

Martin, Robert K. *The Homosexual Tradition in American Poetry.* Austin: University of Texas Press, 1979.

Matthiessen, F. O. *American Renaissance.* London: Oxford University Press, 1941.

McCabe, Cynthia. *The Golden Door: Artist-Immigrants of America, 1876–1976.* Washington, D.C.: Published for the Hirshhorn Museum and Sculpture Garden by the Smithsonian Institution Press, 1976.

McCullagh, James C. "'Proud Music of the Storm': A Study in Dynamics." *Walt Whitman Review* 21 (June 1975): 66–73.

McDonnell, Patricia. "American Artists in Expressionist Berlin: Ideological Crosscurrents in the Early Modernism of America and Germany, 1905–1915." Ph.D. diss., Brown University, 1991.

———. "El Dorado [Marsden Hartley in Imperial Berlin]." In Patricia McDonnell, *Dictated by Life: Marsden Hartley's German Paintings and Robert Indiana's Hartley Elegies.* Minneapolis: Frederick R. Weisman Art Museum, distributed by Distributed Art Publishers, New York, 1995.

Meixner, Laura L. *French Realist Painting and the Critique of American Society, 1865–1900.* New York: Cambridge University Press, 1995.

———. "Jean-François Millet: His American Students and Influences." Ph.D. diss., The Ohio State University, 1979.

Miller, Angela. *The Empire of the Eye: Landscape Representation and American Cultural Politics, 1825–1875.* Ithaca: Cornell University Press, 1993.

Miller, Edwin Haviland, ed. *The Artistic Legacy of Walt Whitman.* New York: New York University Press, 1970.

Miller, Lillian B. *Patrons and Patriotism: The Encouragement of the Fine Arts in the United States, 1790–1860.* Chicago: University of Chicago Press, 1966.

Mitchell, W. J. T. *Iconology: Image, Text, Ideology.* Chicago: University of Chicago Press, 1986.

———. *Picture Theory: Essays on Verbal and Visual Representation.* Chicago: University of Chicago Press, 1994.

Molinoff, Katherine. *Some Notes on Whitman's Family.* New York: Comet Press, 1941.

Moon, Michael. *Disseminating Whitman: Revision and Corporeality in Leaves of Grass.* Cambridge, Mass.: Harvard University Press, 1991.

Moore, Sarah J. "John White Alexander (1856–1915): In Search of the Decorative." Ph.D. diss., The City University of New York, 1992.

Murphy, Alexandra R. *Jean-François Millet.* Boston: Museum of Fine Arts, 1984.

Murphy, Kevin. "Walt Whitman and Louis Sullivan: The Aesthetics of Egalitarianism." *Walt Whitman Quarterly Review* 6, no. 1 (1988): 1–15.

Naumann, Francis M. *New York Dada, 1915–1923.* New York: Harry N. Abrams, 1994.

———. "Walter Conrad Arensberg: Poet, Patron, and Participant in the New York Avant-Garde, 1915–20." *Philadelphia Museum of Art Bulletin* 76 (Spring 1980): 2–32.

Oedel, William T., and Todd S. Gernes. "The Painter's Triumph: William Sidney Mount and the Formation of a Middle-Class Art." *Winterthur Portfolio* 23 (Summer–Autumn 1988): 111–28.

Orvell, Miles. "The Artist Looks at the Machine: Whitman, Sheeler, and American Modernism." *Amerikastudien/American Studies* 41 (1996): 361–79.

———. *The Real Thing: Imitation and Authenticity in American Culture, 1880–1940.* Chapel Hill: University of North Carolina Press, 1989.

Panhorst, Michael. *Samuel Murray: The Hirshhorn Museum and Sculpture Garden Collection, Smithsonian Institution.* Washington, D.C.: Smithsonian Institution Press, 1982.

Parry, Albert. *Garrets and Pretenders.* New York: Covici, Friede, 1933.

Peck, Amelia, and Carol Irish. *Candace Wheeler: The Art and Enterprise of American Design, 1875–1900.* New York: Metropolitan Museum of Art; New Haven: Yale University Press, 2001.

Philadelphia: Three Centuries of American Art. Philadelphia: Philadelphia Museum of Art, 1976.

Pinto, Holly Joan. *William Cullen Bryant and the Hudson River School of Landscape Painting.* Roslyn, N.Y.: Nassau County Museum of Fine Art, 1981.

———. *William Cullen Bryant, The Weirs and American Impressionism.* Roslyn, N.Y.: Nassau County Museum of Fine Art, 1983.

Pointon, Marcia. *Hanging the Head: Portraiture and Social Formation in Eighteenth-Century England.* New Haven: Yale University Press, 1993.

Pollock, Griselda. "Agency and the Avant-Garde." *Block* 15 (Spring 1989): 4–15.

Price, Kenneth M. "Walt Whitman at the Movies: Cultural Memory and the Politics of Desire." In *Whitman East and West: New Contexts for Reading Walt Whitman,* ed. Ed Folsom and Gay Wilson Allen. Iowa City: University of Iowa Press, 2002.

———. *Whitman and Tradition: The Poet in His Century.* New Haven: Yale University Press, 1990.

Ratcliff, Carter. "Jackson Pollock and American Painting's Whitmanesque Episode." *Art in America* 82 (February 1994): 64–69.

Reisch, Marc S. "Poetry and Portraiture in Whitman's *Leaves of Grass.*" *Walt Whitman Quarterly Review* 27 (September 1981): 113–25.

Reynolds, David S. *Walt Whitman's America: A Cultural Biography.* New York: Alfred A. Knopf, 1995.

Ringe, Donald A. "Bryant and Whitman: A Study in Artistic Affinities." *Boston University Studies in English* 2 (Summer 1956): 85–94.

———. "Bryant's Criticism of the Fine Arts." *College Art Journal* 17 (Fall 1957): 43–54.

———. "Kindred Spirits: Bryant and Cole." *American Quarterly* 6 (Fall 1954): 233–44.

Risatti, Howard. "Music and the Development of Abstraction in America: The Decades Surrounding the Armory Show." *Art Journal* 39 (Fall 1979): 8–13.

Roche, John. "Democratic Space: The Ecstatic Geography of Walt Whitman and Frank Lloyd Wright." *Walt Whitman Quarterly Review* 6, no. 1 (1988): 16–32.

Romer, Grant B. "Gabriel Harrison: The Poet Daguerrean." *Image* 22 (September 1979): 8–18.

Rosenzweig, Phyllis D. *The Thomas Eakins Collection of the Hirshhorn Museum and Sculpture Garden.* Washington, D.C.: Smithsonian Institution Press, 1977.

Rourke, Constance. *American Humor: A Study of the National Character.* 1931. Reprint, Tallahassee: Florida State University Press, 1986.

Rubin, Joseph Jay. *The Historic Whitman.* University Park: The Pennsylvania State University Press, 1973.

Rule, Henry B. "Walt Whitman and George Caleb Bingham." *Walt Whitman Review* 15 (December 1969): 248–53.

———. "Walt Whitman and Thomas Eakins: Variations on Some Common Themes." *Texas Quarterly* 17 (Winter 1974): 248–53.

Schapiro, Meyer. *Words and Pictures.* The Hague: Mouton, 1973.

Scharnhorst, Gary. "Rediscovered Nineteenth-Century Whitman Articles." *Walt Whitman Quarterly Review* 19, no. 3–4 (2002): 183–86.

Scholnick, Robert J. "'Culture' or Democracy: Whitman, Eugene Benson and *The Galaxy.*" *Walt Whitman Quarterly Review* 13, no. 4 (1996): 189–98.

Sedgwick, Eve Kosofsky. *Between Men: English Literature and Male Homosocial Desire.* New York: Columbia University Press, 1985.

Shapiro, David. "William Cullen Bryant and the American Art Union." In *William Cullen Bryant and His America.* New York: AMS Press, 1983.

Sharp, Lewis I. *John Quincy Adams Ward: Dean of American Sculpture.* Newark: University of Delaware Press; London: Associated University Presses, 1985.

Shookman, Ellis, ed. *The Faces of Physiognomy: Interdisciplinary Approaches to Johann Caspar Lavater.* Columbia, S.C.: Camden House, 1993.

Sill, Geoffrey M., and Roberta K. Tarbell, eds. *Walt Whitman and the Visual Arts.* New Brunswick, N.J.: Rutgers University Press, 1992.

Sills, R. Malcolm. "W. J. Linton at Yale—The Appledore Private Press." *The Yale University Library Gazette* 12 (January 1938): 43–52.

Singal, Joseph. "Towards a Definition of American Modernism." *American Quarterly* 39 (Spring 1987): 7–26.

Smith, F. B. *Radical Artisan: William James Linton, 1812–97.* Manchester: Manchester University Press, 1973.

Smith, Herbert F. *Richard Watson Gilder.* New York: Twayne, 1970.

Soria, Regina. *Elihu Vedder: American Visionary Artist in Rome (1836–1923).* Rutherford, N.J.: Fairleigh Dickinson University Press, 1970.

Soule, George H., Jr. "Walt Whitman's 'Pictures': An Alternative to Tennyson's 'Palace of Art.'" *ESQ* 22 (1976): 39–47.

Stace, W. T. *Mysticism and Philosophy.* London: Macmillan, 1960.

Stansell, Christine. "Whitman at Pfaff's: Commercial Culture, Literary Life and New York Bohemia at Mid-Century." *Walt Whitman Quarterly Review* 10, no. 3 (1993): 107–26.

St. Armand, Barton L. "Transcendence Through Technique: Whitman's 'Crossing Brooklyn Ferry' and Impressionist Painting." *Bucknell Review* 24 (1979): 56–74.

Starr, Louis M. *Bohemian Brigade: Civil War Newsmen in Action.* New York: Alfred A. Knopf, 1954.

Stebbins, Theodore E., Jr., and Norman Keyes Jr. *Charles Sheeler: The Photographs.* Boston: Museum of Fine Arts, 1987.

Steele, Jeffrey. *The Representation of the Self in the American Renaissance.* Chapel Hill: University of North Carolina Press, 1987.

Steiner, Wendy. *The Colors of Rhetoric: Problems in the Relation Between Modern Literature and Painting.* Chicago: University of Chicago Press, 1982.

———. *Exact Resemblance to Exact Resemblance: The Literary Portraiture of Gertrude Stein*. New Haven: Yale University Press, 1978.

———. *Pictures of Romance: Form Against Context in Painting and Literature*. Chicago: University of Chicago Press, 1988.

Sten, Christopher, ed. *The Savage Eye: Melville and the Visual Arts*. Kent, Ohio: Kent State University Press, 1991.

Stern, Madeleine B. *Heads and Headlines: The Phrenological Fowlers*. Norman: University of Oklahoma Press, 1971.

Stoddard, Donald Richard. "Horace Traubel: A Critical Biography." Ph.D. diss., University of Pennsylvania, 1970.

Sweeney, J. Gray. "Percy Ives (1864–1928)." In *Artists of Michigan from the Nineteenth Century*, ed. Andrea P. A. Belloli and Michael P. DeMarsche. Muskegon, Mich.: Muskegon Museum of Art, 1987.

Tanenbaum, Miles. "Walt Whitman and American Art." Ph.D. diss., University of Tennessee, 1988.

Tarbell, Roberta K. "Whitman and the Visual Arts." In *A Historical Guide to Walt Whitman*, ed. David S. Reynolds. New York: Oxford University Press, 2000.

Tashjian, Dickran. *Skyscraper Primitives: Dada and the American Avant-Garde, 1910–1925*. Middletown, Conn.: Wesleyan University Press, 1975.

Taylor, William R. *In Pursuit of Gotham: Culture and Commerce in New York*. New York: Oxford University Press, 1992.

Thomas, M. Wynn. *The Lunar Light of Whitman's Poetry*. Cambridge, Mass.: Harvard University Press, 1987.

Todd, Edgeley W. "Indian Pictures and Two Whitman Poems." *The Huntington Library Quarterly* 1 (November 1955): 5–11.

Trachtenberg, Alan. *Reading American Photographs*. New York: Hill and Wang, 1989.

———. "Walt Whitman: Precipitant of the Modern." In *The Cambridge Companion to Walt Whitman*, ed. Ezra Greenspan. Cambridge: Cambridge University Press, 1995.

———. "Whitman's Visionary Politics." In *Walt Whitman of Mickle Street: A Centennial Collection*, ed. Geoffrey M. Sill. Knoxville: The University of Tennessee Press, 1994.

Turrill, Catherine. "Michael Brenner (1885–1969)." In *Avant-Garde Painting and Sculpture in America, 1910–1925*. Wilmington: Delaware Art Museum, 1975.

Tyler, Ron, ed. *Alfred Jacob Miller: Artist on the Oregon Trail*. Fort Worth: Amon Carter Museum, 1982.

Vilain, Jean-François, and Philip R. Bishop. *Thomas Bird Mosher and the Art of the Book*. Philadelphia: F. A. Davis, 1992.

Waldron, Randall. "Whitman as the Nazarene: An Unpublished Drawing." *Walt Whitman Quarterly Review* 7, no. 4 (1990): 192–93.

Wallace, Robert K. *Frank Stella's Moby-Dick Series: Of Whales and Waves in Paint, on Metal, in Space*. Ann Arbor: University of Michigan Press, 2000.

Ware, Caroline. *Greenwich Village, 1920–1930*. Boston: Houghton Mifflin, 1935.

Watson, Steven. *Strange Bedfellows: The First American Avant-Garde*. New York: Abbeville Press, 1991.

Weinberg, Jonathan. *Speaking for Vice: Homosexuality in the Art of Charles Demuth, Marsden Hartley, and the First American Avant-Garde*. New Haven: Yale University Press, 1993.

Weingarden, Lauren S. *Louis H. Sullivan: The Banks*. Cambridge, Mass.: MIT Press, 1987.

———. "Louis Sullivan's Emersonian Reading of Walt Whitman." In *Walt Whitman and the Visual Arts*, ed. Roberta K. Tarbell and Geoffrey M. Sill. New Brunswick, N.J.: Rutgers University Press, 1992.

———. "Naturalized Technology: Louis H. Sullivan's Whitmanesque Skyscrapers." *The Centennial Review* 30 (Fall 1986): 480–95.

———. "A Transcendentalist Discourse in the Poetics of Technology: Louis Sullivan's Transportation Building and Walt Whitman's 'Passage to India.'" *Word and Image* 3 (April–June 1987): 202–21.

Wertheim, Arthur Frank. *The New York Little Renaissance*. New York: New York University Press, 1976.

White, William. "Billy Duckett: Whitman Rogue." *The American Book Collector* 21 (1971): 20–26, 29.

———. "The Walt Whitman Fellowship: An Account of Its Organization and a Checklist of Its Papers." *Papers of the Bibliographical Society of America* 51 (1957): 67–84.

Wilkinson, Burke. *Uncommon Clay: The Life and Works of Augustus Saint Gaudens*. San Diego: Harcourt Brace Jovanovich, 1985.

Willard, Charles B. *Whitman's American Fame*. Providence, R.I.: Brown University Press, 1950.

Zarobila, Charles. "Walt Whitman and the Panorama." *Walt Whitman Review* 25 (June 1979): 51–59.

Zilczer, Judith. "The Aesthetic Struggle in America, 1913–1918: Abstract Art and Theory in the Stieglitz Circle." Ph.D. diss., University of Delaware, 1975.

———. "'Color Music': Synaesthesia and Nineteenth-Century Sources for Abstract Art." *Artibus et Historiae* 16, no. 7 (1987): 101–26.

———. "Robert J. Coady, Forgotten Spokesman for Avant-Garde Culture in America." *The American Art Review* 2, no. 6 (1975): 77–89.

———. "Robert J. Coady, Man of *The Soil*." In *New York Dada*, ed. Rudolf E. Kuenzli. New York: Willis Locker and Owens, 1986.

Zurier, Rebecca. "Picturing the City: New York in the Press and the Art of the Ashcan School, 1890–1917." Ph.D. diss., Yale University, 1988.

Zweig, Paul. *Walt Whitman: The Making of the Poet*. New York: Basic Books, 1984.

Index

Page numbers in *italics* refer to illustrations.